The Portrait in Britain and America

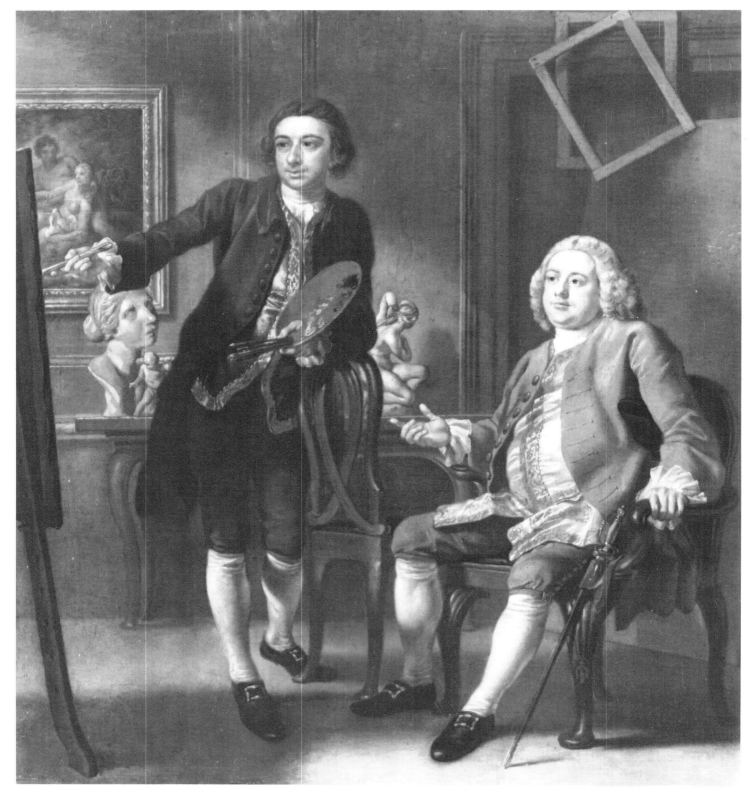

Francis Hayman, *The Artist in his Studio with Grosvenor Bedford*. Oil on canvas, 71.8 × 91.4 cm (28¼ × 36 in). *c.* 1740/5.
London, National Portrait Gallery

THE PORTRAIT

IN BRITAIN AND AMERICA

with a Biographical Dictionary of Portrait Painters 1680-1914

ROBIN SIMON

PHAIDON · OXFORD

For Jo

Phaidon Press Limited, Littlegate House, St Ebbe's Street,
Oxford OX1 1SQ

First published 1987
© Phaidon Press Limited 1987

British Library Cataloguing in Publication Data

Simon, Robin
 The portrait in Britain and America 1680–
 1914.
 1. Portrait painting
 I. Title
 757 ND1309

 ISBN 0–7148–2386–4

Phototypeset in Monophoto Lasercomp Sabon by
Keyspools Limited, Golborne, Lancs
Printed and bound in Great Britain by The Bath Press, Avon

Contents

Preface

The function of recording a likeness has long been taken over by photography, and we are now freer to admire the purely artistic qualities of portrait painting. We no longer feel, as Dr Johnson did in the eighteenth century, that 'the art of the portrait-painter is often lost in the obscurity of his subject'. Yet the specialized art of the portrait painter – and it was the most common way for an artist to make a living – has not had a separate historical account and work of reference devoted to it.

Few countries were so obsessed with portraiture at the expense of other forms of painting as Britain and America. In both countries there was a similar distrust of, for example, the depiction of religious subjects, compounded in America by a horror of nudes and a long-lasting suspicion of life classes. There are, in fact, strong historical links between the two Schools of portraiture, for the art of America had its roots in Britain, while the last great period of portrait painting – the decades preceding the First World War – saw fashionable British portraiture dominated by an American, John Singer Sargent.

The first part of this book provides a critical introduction to the subject. Chapter One consists of a brief historical survey, while emphasizing the circumstances that bound British and American portraiture in a common tradition. In Chapter Two, there follows a discussion of the particular poses employed by professional artists. Chapter Three shows how portrait painters set about their work.

The study of these matters here will show that portrait painting has its own distinct history. Portrait painters looked at earlier portraits, borrowed ideas from other artists, discussed art with other artists, and worried most of all (apart from money) about artistic techniques. Sir Joshua Reynolds's celebrated *Discourses on Art* are, for example, as much about *how* to paint as about *what* to paint.

Clearly, there is a sense in which society or, rather, each stratum of society, got the portrait painters it deserved. To be more accurate, sitters got the painters they could afford. A sitter with one hundred pounds would sit to Sir Joshua Reynolds; another with ten pounds would go to Arthur Pond, however much he might wish to be portrayed more grandly.

The second part of the book is devoted to a biographical dictionary of six

hundred and twenty-six leading portraitists active in Britain and America between about 1680 and 1914. The reasons for setting the limits of the period in this way are, first, that the late seventeenth century saw the rise of Sir Godfrey Kneller in Britain, to be followed by the establishment of the British School in the middle of the eighteenth century; it also coincides with the tentative start of portraiture in America. Nineteen fourteen, at the latter end, follows close on the retirement of John Singer Sargent from international portrait painting and marks, with the outbreak of the First World War, the effective close of the great era of portrait painting that had lasted since Kneller's day.

The list of artists in the dictionary is necessarily selective. It consists exclusively of artists who worked in oils or crayons (pastel) and primarily of specialist professional portrait painters, although a few other artists who made a significant contribution to portraiture have been included. Recorded portraitists whose work is not now traceable, or by whom only one or two insignificant works are now known, are not listed; nor are primitive painters in America after 1800. Artists born in Britain or America but who chiefly worked in other countries have not usually been considered; but foreign artists active in either country to a substantial degree have been included.

Each entry is designed to provide basic biographical information, details of training, historical significance, and an indication of any distinctive aspects of the individual's style of painting, wherever possible. The location of representative portraits by the artist is then noted, although for reasons of space a full list of locations is not attempted. Similarly, the bibliographical reference that follows in most cases is a selective one, directing the reader to a work or works where further information may be obtained.

I owe a general debt of gratitude to my friend Emeritus Professor Alastair Smart for first getting me involved in this subject when, as a new lecturer at the University of Nottingham, and trained in the history of early Italian painting, I was invited to give seven lectures on Hogarth in my first term. Since then, I have benefited from many conversations with him on the subject and from his expert advice. I owe a more recent debt of gratitude to many others, among them Judy Ocker and George Marshall Rogers, III, both graduates of Bowdoin College and the Institute of European Studies, for their help at different stages in the preparation of the dictionary part of this book. I am also grateful to my colleagues at the Institute of European Studies, Elaine Stephenson, Susan Neve and Janet Saraty, and especially Martin Postle for any amount of helpful information and discussion. My thanks also go to all those at Phaidon Press who made the book possible, particularly Roger Sears, Marie Leahy, Rosemary Amos, Denise Hardy and Margaret Fraser – and to Andrew Best of Curtis Brown for fixing it all up. Among those whose help I should also like to acknowledge are: the Bishop of Llandaff and Bishop John Poole-Hughes; Mr John Sunderland and Mr Rupert Hodge of the Witt Library; Dr Brian Allen of the Mellon Centre for Studies in British Art; Ms Jane Wess and other members of staff of the Science Museum,

London; Mr Julian Treuherz, Manchester City Art Gallery; Mrs Janet Gleeson, Bonhams; Mr David Moore-Gwynn, Sotheby's; Messrs P. & D. Colnaghi, Ltd; Mr Edmund Brudenell; Mr J. M. Teesdale; Mr W. Tyrrwhitt-Drake; Professor Graham Hood, Colonial Williamsburg Foundation; Mr Norman Thomas, Administrator of Penrhyn Castle; Mr Jacob Simon, National Portrait Gallery; Dr Andrew Sanders, Birkbeck College, and Miss Clare Godfrey-Fausett, Institute of Directors, London.

ROBIN SIMON
London, 1986

CHAPTER ONE

Portrait Painters in Britain and America

For centuries, British patrons had little interest in commissioning paintings other than portraits, an obsession that often included a British form of ancestor worship. James I, on visiting the castle of Lord Lumley, and seeing the walls surrounded by portraits of Lumley's ancestors, both real and imaginary, drily remarked: 'I did'na ken that Adam's ither name was Lumley.'[1] Until the eighteenth century there was no native British School that could adequately supply this demand, the exceptions being the great miniaturists such as Nicholas Hilliard and Samuel Cooper, and a handful of remarkable painters such as William Dobson in the seventeenth century. British painting, therefore, until the second quarter of the eighteenth century, was dominated by foreign artists. Some of them, like Hans Holbein (1497/8–1543) and Sir Anthony van Dyck (1599–1641), were of international stature, but they were exceptions. It was far more common for foreign artists of lesser quality to arrive in England, in the confident expectation of finding little competition and consequently greater success than they might have expected at home. This pattern was to repeat itself in the American Colonies, where British-born artists such as John Wollaston (*fl.* 1734–*c.* 1775) and John Smibert (1688–1751) assumed a significance and earned an esteem disproportionate to their limited training and abilities. As the diarist George Vertue noted at the time of Smibert's departure: 'he was not contented here, to be on a level with some of the best painters, but desird to be were he might at the present, be lookt on as at the top.'[2]

One of the most successful of all the immigrants to Britain was Sir Peter Lely (1618–80), who seems to have had a cynically accurate view of the situation, if an exchange between a patron and the painter recorded by Jonathan Richardson is to be believed:

> 'For God's sake, Sir Peter, how came you to have so great a reputation? You know that I know you are no painter.'
> 'My Lord, I know I am not, but I am the best you have.'[3]

Lely and his successor Sir Godfrey Kneller (1646–1723) were the last two dominant foreign portrait painters in Britain, and the eighteenth century, which saw the rise of the British School, also witnessed the beginnings of a recognizable school of artists in what was, for most of the century, Colonial America. There, as in Britain, portraiture was, for a long period, the only form of art much in

demand, while the immigrant artists active there were likely to come from Britain itself. A pattern of transatlantic contacts in portrait painting thus established itself between Britain and America, and, even after Independence, aspiring young American artists continued to turn first to Britain to gain both training and experience. By the end of the nineteenth century the situation was reversed, for portraiture in Britain was then dominated, at the highest level, by two expatriate Americans, John Singer Sargent (1856–1925) and J.A.M. Whistler (1834–1903). In order to trace the outline of that history we need to return to the career of Sir Peter Lely.

Lely was born in Germany of Dutch parents and trained in Holland, and his earliest works in England, painted in the years following his arrival in about 1643, are in a charming vein of lightly handled portraits-in-character or pastorale, primarily tonally conceived and painted in a sophisticatedly limited range of colour. Within the next fifteen years or so Lely was to replace this rather thoughtful manner with a more brash and glittering high-key style that was in sympathy with the hedonistic side of Charles II's Restoration Court, although its main features had been developed in the more sober atmosphere of the Commonwealth. As Alexander Pope expressed it:

> In Days of Ease, when now the weary Sword
> Was sheath'd, and *Luxury* with *Charles* restor'd; ...
> Lely on animated Canvas stole
> The sleepy Eye, that spoke the melting soul.[4]

Lely's success was enormous, being equalled only by that of his immediate successor, Sir Godfrey Kneller (a German but also Dutch-trained), who came to England in 1667.

Lely and Kneller both established large studio practices on the continental model, which enabled them to mass-produce portraits and to provide replicas (especially of their royal commissions). The studio, organized on these lines, employed both permanent assistants and apprentices trained to provide draperies, landscape backgrounds and interior accessories to complete the master's design. The master would often paint the head only (Fig. 1) and, in Kneller's case, sometimes only the face (Plate 1), the rest of the picture being filled in by drapery specialists and other painters who relied on a pattern-book or finished sketch. Samuel Pepys visited Lely's studio in 1666 and found his series of portraits of naval commanders (the 'Flagmen') on the production line: 'Allen and I to Mr Lillys the painter's, and there saw the heads, some finished and all begun, of the Flagmen.'[5]

Indeed, in Lely's case, it was evidently possible to order portraits by numbers,[6] while prices were scaled according to the type and size of portrait required: so much for a head and shoulders, more with one hand showing and yet more with both; three-quarter lengths cost more again, while full-lengths were the most prestigious, elaborate and expensive.[7]

Kneller's technique was different from Lely's, and a famous (if partly apocryphal) story survives of the two artists engaging in a competition to paint a head 'against the clock' shortly after Kneller's arrival.[8] Lely's method was painstaking and slow, each layer of paint being carefully built up in the flesh areas. Kneller, on the other hand, valued expressive brushwork, the result of rapid and expert execution, and his skill in that field is evident in his private or semi-private

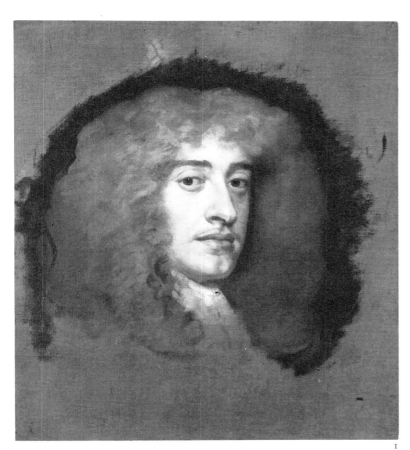

1. Sir Peter Lely, *James II (when Duke of York)*. Oil on canvas, 51.4 × 45.1 cm (20¼ × 17¾ in). *c.* 1665–70. London, National Portrait Gallery

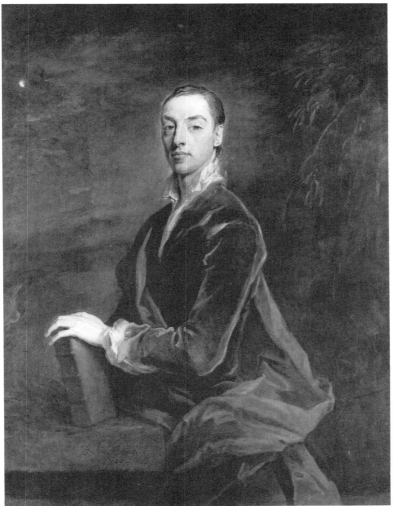

2. Sir Godfrey Kneller, *Matthew Prior*. Oil on canvas, 137.8 × 101.9 cm (54¼ × 40⅛ in). 1700. Cambridge, Trinity College Library

portraits such as those of Pope, Prior (Fig. 2) and Newton. This aspect of his style may well have derived from his experience as a pupil, if not of Rembrandt himself (1606–69), then of one of Rembrandt's most notable pupils, Ferdinand Bol (1616–80).[9] It is not for his individuality that Kneller is most remembered today, however, but rather for his creation of a formulaic, stylized approach to painting a face, together with the use of drapery and background painters, which was his practical response to the great demand for his services; and the majority of his portraits, it must be said, are rather stereotyped, turned out in a vaguely up-to-date, diluted Baroque manner. Kneller's more personal portraits, so vastly superior in quality to the mass of his portraits, proclaim, rather depressingly, a squandered inheritance of the seventeenth-century Dutch tradition of expressive brushwork, rich impasto, and dramatic lighting – at once dashing, decisive and masterly. The phrase 'Kneller mask' has sometimes been used of Kneller's method of painting a face but, significantly, he retained a high reputation for taking a good likeness. Vertue noted: 'In the Talent of an exact likeness Sr. Godfrey has excelld most if not all that have gone before him in this Art.'[10]

Lely was not so highly regarded in this prime respect, and Samuel Pepys's criticism of his portraits of ladies of the Court, (the 'Windsor Beauties'), was that they were 'good, but not like'.[11] A similar distinction was drawn by the poet John Dryden, who was probably referring to Lely when he observed: 'It was objected against a late noble Painter, that he drew many graceful pictures, but few of them were like. And this happen'd to him, because he always studied himself, more than those that sat to him.'[12]

Kneller and Lely were victims, admittedly willing ones, of the stultifying fascination of the British with little in painting other than the record of their own faces. The story was by now a familiar one in the history of painting in Britain. In the sixteenth century Holbein had had to abandon his religious paintings in favour of portraiture; and Van Dyck, owing to his almost exclusive employment as a portraitist, had few opportunities in Britain in the seventeenth century for his delightful exercises in classical and religious subjects, conceived in a manner that might be termed 'boudoir Baroque', and which were among his most original creations.[13] In the eighteenth century the Italian Jacopo Amigoni (c. 1682–1752) was diverted along the same path, as Vertue observed at the time: '... Signor Amiconi ... had painted several historical great works, masterly and well approvd of but in that kind of painting finding not full employment he was persuaded to paint portraits.'[14]

It might seem reasonable to suppose that a knowledge of the working methods of different painters in this period would reveal the individual artist's sense of priorities between the varying demands of portrait painting, which could be identified as ranging from a primary concern with 'likeness' at one extreme to more purely aesthetic considerations at the other. There are portrait painters like Lely, Kneller, Jonathan Richardson (c. 1665–1745), Allan Ramsay (1713–84) and Sir Joshua Reynolds (1723–92), who were happy to use assistants to complete their portraits, either employing them within their own studios or, as was so often the case with drapery, employing specialists from outside. Artists who did not follow this system were actually very few in the eighteenth century and it was not, in fact, possible for most artists to run a successful portrait business without using assistants and outside specialists. If, as was often the case, portraits were an

artist's main source of income, the necessary numbers of likenesses could only be produced within a studio system. Once an artist was really successful, the pressures of demand were often so great that, as supply increased to meet it, there was often a concomitant lowering of quality. Such was the case with Kneller and, for a notorious period in his early career, with Sir Thomas Lawrence (1769–1830) a century later. There are notable exceptions among those artists using a studio system, particularly Allan Ramsay, whose disciplined approach enabled him to maintain very high overall standards. William Hogarth (1697–1764) and Thomas Gainsborough (1727–68) are the leading exponents of the rarer method of portrait painting, and Hogarth is remarkable both for his wholly unaided production of portraits and for his explicit defence of the importance of the individual artist's integrity in portraiture – an attitude which now seems startlingly modern. Even Gainsborough himself – praised by Reynolds in his *Discourses on Art* for forming 'all the parts of his picture together' – had the help of his nephew Gainsborough Dupont (1754–97), and it may be said that Dupont's imitative skill in reproducing the apparent touch of Gainsborough's 'pencil', in face and hair, as well as in drapery, often produced results unnervingly like those of his master.[15]

At this period of the eighteenth century we find ourselves discussing British artists, but their dominance had been a recent development; for, in addition to Lely and Kneller, many other foreign artists had enjoyed English patronage towards the end of the seventeenth century and at the beginning of the eighteenth – Willem Wissing (1655–87), Jacob Huysmans (*fl.* 1650–96), Michael Dahl (1659–1743) and John Closterman (1660–1711) among them – and it was only gradually that a substantial number of native British artists emerged. As it was, many British artists active in the earlier part of the eighteenth century, such as Richardson and Charles Jervas (*c.* 1675–1734), flourished in the shadow of Kneller, who did not die (which he did with as much pomp as he had lived) until 1723.[16] As Hogarth observed, 'Portrait Painting . . . hath allways been engrossed by a very few Monopelisers.'[17] These 'Monopelisers' (*sic*) were hitherto likely to be foreign, and it was only towards the middle of the eighteenth century that the British School, founded as it was on portraiture, became firmly established. Its rise can be identified with the career of the one British artist whose achievement in painting may fairly be compared with that of Shakespeare in drama, William Hogarth; and Hogarth's particular contribution to portrait painting at a crucial period of its development in Britain was highly significant.

Hogarth is one of the few artists who could claim to be the inventor of an art form, the famous 'modern moral subjects', of which *The Harlot's Progress, The Rake's Progress* (see Fig. 51) and *Marriage à-la-Mode* (see Fig. 55) are examples. But in portrait painting also his powerful originality, scorn for compromise, and determination to succeed were as evident as in his many other activities. It was wholly characteristic of this pugnacious genius that he should choose to place a gilded cork head of Van Dyck above his studio door (located in what is now Leicester Square). It was more than a vain gesture, and when Hogarth turned to full-scale portraiture towards the end of the 1730s, it was with a view to forcing his contemporaries to re-examine many of their comfortably received opinions which, he felt, were inhibiting the growth of British art.

Hogarth had made his name and early fortune by perfecting a novel mode of

portraiture, the conversation piece, which may be defined as a comparatively informal, small-scale portrait group, of a kind introduced into England by Philip Mercier, 1689?–1760 (Fig. 3). Much of Hogarth's early success was due not only to the exquisite skill with which he rapidly came to handle paint in these intricate little pictures, but through the sense of humour and fun, mixed occasionally with gentle satire, with which he informed them. However, to succeed in portraiture, to maximize profits, and make the best use of his time, Hogarth felt it necessary to turn to portraits on the scale of life. His first full-length portrait, *Captain Coram,* of 1740 (Fig. 4), was revolutionary, and was fully intended to be so. It was at once a challenge to his British contemporaries, to Van Dyck, and to foreign artists working in Britain. Hogarth recorded the circumstances of its conception in his memoirs (written in a distinctively rugged prose):

> Upon one day at the academy in St Martin's Lane I put this question, if any at this time was to paint a portrait as well as Van Dyck would it be seen and the person enjoy the benefit? They knew I had said I could. The answer made by Mr Ramsay was positively No, and confirmed by about twenty who were present. The reason then given very frankly by Mr R: 'Our opinions must be consulted and we will never allow it.'
>
> Upon which I resolved that if I did do the thing, I would affirm I had done it. I found my advantage in this way of doing myself justice, reconciling this violence to my own modesty by saying Vanity consists chiefly in fancying one doth better than one does. If a man think he does no more that he doth do, he must know it, and if he says it in this art as a watchmaker may say, 'The watch I have made I'll warrant you is as good as any other man can make' and if it really is so the watchmaker is not branded as infamous but on the contrary is esteemed as an honest man who is as good as his word.[18]

It is perhaps difficult nowadays to imagine the extent to which the example of Van Dyck dominated the imaginations of eighteenth-century British artists, who in any case suffered from a general lack of self-confidence and sense of inferiority – feelings which never afflicted Hogarth. Sensitive as Hogarth was to the disproportionate success of foreign artists in Britain, it is surely no coincidence that the conversation which gave rise to Hogarth's Coram portrait should have been with the young Allan Ramsay, himself trained in Italy, and that it should have taken place at a time when the French artist J.B. Van Loo (1684–1745) was much in vogue for English society portraits. Hogarth recalled:

> Vanloo, a French portrait painter, being told by friends that the English are to be run away with, with his grandeur and puffing monopolised all the people of fashion in the kingdom. This monopoly was aggravated by being a foreigner. I exhorted the painters to bear up against this torrent and to oppose him with spirit – my studies being in another way. I spent my own in their behalf, which gave me enemies among his espousers, but I was answered by themselves: 'You talk, why don't you do it yourself?' Provoked at this, I set about this mighty portrait, and found it no more difficult than I thought it.[19]

The final sentence is wholly characteristic. But Hogarth's self-confidence was fully justified, and his attitude vindicated, by the finished portrait of Captain Coram. Ingeniously enough, Hogarth chose as his model for the pose of this English commercial sea captain an engraved portrait after Rigaud of Samuel Bernard (Fig. 5), a source which would have been readily identified by his fellow artists.[20] The late-Baroque trappings of column and drapery visible in the grandiose French portrait now surround a thoroughly down-to-earth English-

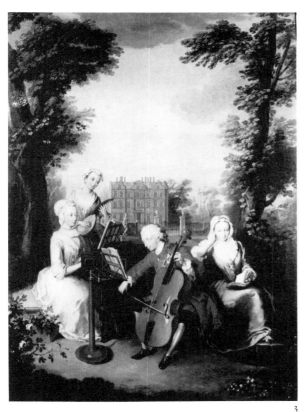

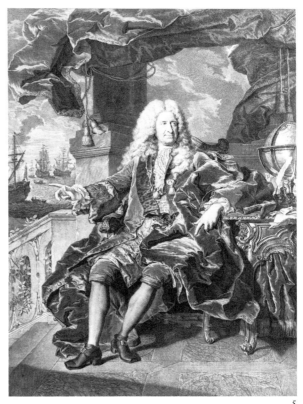

3

5

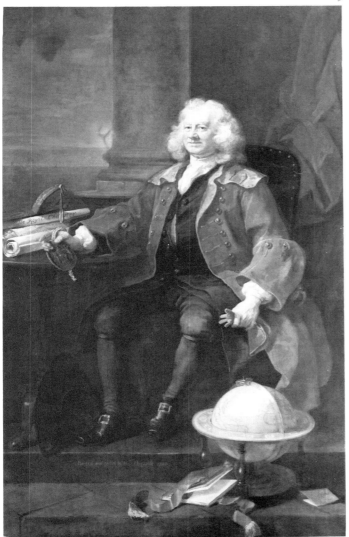

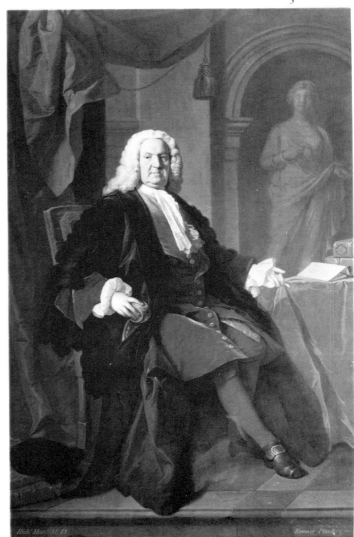

4

6

man, dressed in a rather over-large greatcoat, informally unbuttoned, whose feet, amusingly, only just reach the floor. Coram wears no wig, and his rubicund face is vigorously painted to bring out a strong likeness and a frank record of his advanced years and weatherbeaten features. The effect of this witty adaptation of grand Baroque portraiture to an English middle-class sitter was anything but parodic: at least, if there is a sense of that, it is at the expense of French portraiture. Not the least significant aspects of this portrait are its sheer size – fully on the scale of life and sufficient to challenge the monumentality of a Van Dyck – and its prominent public position in the Foundling Hospital in London which Coram himself had founded, and where the first public exhibitions of painting in England effectively began.[21] If imitation is the sincerest form of flattery, Hogarth must have taken wry satisfaction in the inspiration which his portrait provided for Allan Ramsay's own *Dr Richard Mead*, itself given to the Foundling Hospital in 1747 (Fig. 6).

Hogarth's entry into full-scale portrait painting was, then, a deliberate performance, carried off with characteristic tenacity of purpose.[22] It was an influential performance, too, and Hogarth also succeeded to a remarkable extent in the numerous other types of portrait which he attempted, demonstrating new possibilities for contemporary British portraiture in half-lengths, busts in an oval (as we shall see later) and group portraits. But his method of working alone, as we have noted before, was exceptional. Far more typical was the studio method used by his contemporary, Allan Ramsay, whose conversation with Hogarth had, to some extent, provoked the painting of *Captain Coram*.

The studio method was one of the reasons that it was perfectly possible for far less gifted artists than Ramsay to achieve fashionable success as portrait painters in eighteenth-century Britain. A notable example was Thomas Hudson (1701–79) who, for a period around the middle of the century, was the most popular portraitist in London. Hudson owed much of his success to the outstanding quality of his drapery painter, Joseph van Aken (*c.* 1699–1749), whose magnificent satins and silks, often adorning figures in identical poses, were also to be seen in Ramsay's portraits (see Figs 90, 91, 93). Vertue described Van Aken's business in 1737: 'Mr. Vanaken painter of Antwerp . . . has excelld in painting particularly the postures for painters of portraits who send their pictures when they have done the faces, to be drest and decoratd by him in which he has a very ready Talent. . . .'[23]

He also pointed out that Van Aken's working for so many artists 'puts them so much on a Level that its very difficult to know one hand from another.'[24] Painters who relied to such an extent on a drapery painter were known, Vertue observes, as '*Phiz-mongers* . . . that scarsely coud do any part but the face of a picture.'[25]

In fact, Hogarth was almost alone in finding this an objectionable procedure; but worse, from Hogarth's point of view, was the fact that until the mid-point of the century it was still possible for a second-rate foreign painter like Van Loo to capture the fashionable portrait market, 'with his grandeur and puffing' (in Hogarth's phrase), from under the noses of the natives. Vertue recorded Van Loo's success and its effect on native artists in 1738: 'The great employment in six months from his first comeing exceeds any other painter that is come to England in the memory of any one living . . . but the English painters have had great uneasines it has much blemishd their reputation – and business.'[26] The second half

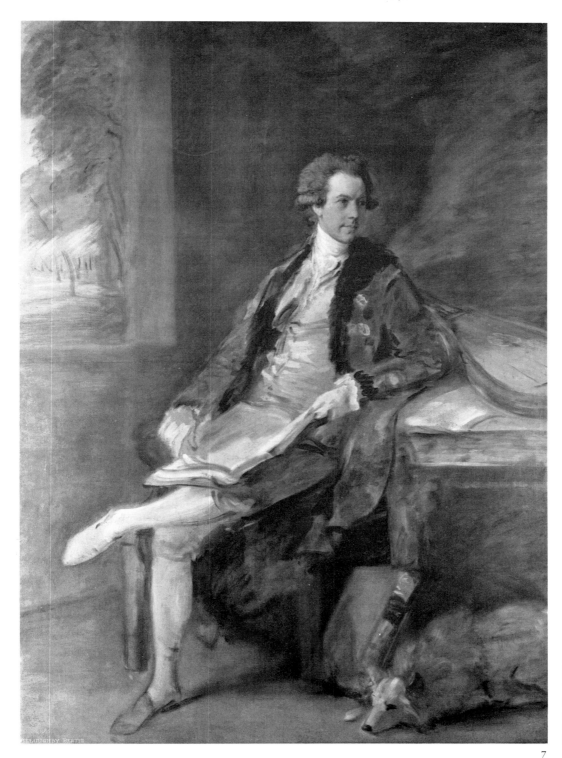

7. Thomas
Gainsborough,
*Willoughby Bertie, 4th
Earl of Abingdon*. Oil on
canvas, 208.3 × 144.8 cm
(82 × 57 in). Mid 1770s.
Private collection

of the century was to see the final establishment of the British School, a process
rightly associated with the careers of Sir Joshua Reynolds and Thomas
Gainsborough.

As painters and as people, Reynolds and Gainsborough could hardly have been
more different. Gainsborough was an instinctive, brilliant, technically impeccable
painter and suberb draughtsman. He was rather hard-living, gay and extravagant,
witty and, if no intellectual, he was a profoundly thoughtful painter. Reynolds's
capacities as a painter were more laboriously acquired. He was no more than an

adequate draughtsman, an artist of powerful conceptions but of uncertain and even (sometimes) notoriously incompetent execution, a theorist, and something of an intellectual. Gainsborough, as Reynolds rather wistfully recognised, formed 'all the parts of his picture together', and so, even with some assistance from Dupont (who may, in fact, have been chiefly involved in copying work), Gainsborough painted landscape, drapery and flesh himself, as can be seen in his unfinished *Willoughby Bertie, 4th Earl of Abingdon* (Fig. 7). Reynolds often used assistants to paint drapery, landscape and accessories, and to produce replicas. One of the joys of Gainsborough's style is his brushwork, the visible touch of the master's brush upon the canvas: we would look in vain, indeed mistakenly, if we sought that pleasure in many of Reynolds's portraits. He himself recognized that he 'finished too much', a rather sad reflection on the fact that, in the parts he painted himself, the personal and expressive touch sometimes vanished from the surface of his canvas as he worked at it.[27]

Ironically, one of the very few things the two painters had in common was a desire to be occupied in painting something other than portraits. Gainsborough was actually as great a landscape painter as he was a portraitist; Reynolds, characteristically, would have liked to paint histories, which he saw as the highest category of art, but when he did so he revealed himself as thoroughly ill-fitted for them. More successfully, he achieved an often striking compromise through 'elevating' portraits by means of visual references to exalted 'history' sources among the great works of art of the past – an original contribution to British portraiture which may well have been prompted by remarks of Jonathan Richardson on the subject in his influential writings.[28]

Unlike Gainsborough, Reynolds was both ambitious and a highly efficient businessman, but he was also ambitious in a greater sense for the British School, and his more sober qualities were vital at this stage of its development. He had a larger vision than Gainsborough and the strength of character to further it, and he rightly became the first President of the Royal Academy when it was founded in 1768. Hogarth, the anti-establishment fighter for British artists, who had died four years earlier, had wanted none of 'the foolish parade of the French academy';[29] but the foundation of the Royal Academy meant that artists now had a firm place within the British establishment from which their most prestigious commissions flowed, and none could benefit more than portrait painters from the Academy's regular exhibitions, in which they could advertise their abilities.

Reynolds reveals some intriguing limitations both as a theorist and as an arbiter of taste in his justly famous *Discourses*.[30] One of his most notable failures, but one which he shared with many contemporaries, was to understand the changing importance of landscape painting in late-eighteenth-century Europe. In Britain the significant figure in this field was his close contemporary Richard Wilson (1713–82), to whom both Turner and Constable, the first great English Romantic landscape artists, were explicitly indebted. The revolution which took place in landscape painting at this time has some parallels in portraiture, notably in the stress which was increasingly placed on the individual artist's execution of his conception. Just as Reynolds, by his adherence to the studio method of production for portraits, implicity valued the conception of a picture over the details of artistic execution, so many British landscape painters in the first part of the eighteenth century had been happy to collaborate in the production of their

works: heads, horses, other animals or flowers would be completed by specialists under the overall direction of the landscape artist.[31]

It was a reasonable procedure to follow in view of the decorative function of most British landscape art of the time, which was usually designed to occupy a specified place on a chimneypiece, in a wall design, or over a door (and indeed it would seem that portraits, too, were sometimes calculated to complete a scheme of interior decoration[32]). From Wilson onwards this inferior status of landscape painting was to change: landscapes were to be appreciated as works of art in their own right, the very interest of the form depending on the fact that each painting was the unique expression of one artist's reaction to nature. In its high estimation of an individual emotional experience, landscape painting is a Romantic art form *par excellence*. However, attitudes to portraiture were also changing to reflect this profound shift in sensitivity, and by the end of the eighteenth century the studio method of portrait production was coming to be distrusted. The higher value now placed on portraits as individual works of art was very much a result of the achievements of Reynolds and his contemporaries such as Gainsborough and George Romney, 1734–1802 (Plate 2) – the latter so clearly a rival to Reynolds that the President of the Royal Academy could never bring himself to use his name, referring only to 'the man in Cavendish Square'.[33]

Although he considered that portraiture was not the highest form of art, Reynolds himself had taken a leading role in ensuring that the British School was founded almost exclusively upon it. People were now willing simply to accept as the truth Sir Richard Steele's ingenious defence of the British obsession with portraits which he had expressed in the *Spectator* as long ago as 6 July 1712: 'What the antique statues and bas-reliefs which Italy enjoys are to the history-painters, the beautiful and noble faces with which England is confessed to abound, are to the face-painters.'

The acceptance of portraiture as a genuinely interesting branch of artistic endeavour was, paradoxically, decisively reinforced by the advent of photography in the middle years of the nineteenth century, for photography rendered obsolete the hitherto paramount function of the portrait in recording the sitter's appearance. In future, the more personally expressive qualities of paint and brushwork were bound to assume a greater significance and, in retrospect, Reynolds's studio system of production makes him appear one of the last of the 'old guard' of portrait painters, in the tradition of Lely and Kneller: Hogarth and Gainsborough, the great masters of brushwork seem, in contrast, to point the way to the future, ultimately, of such luminous talents as John Singer Sargent.

Among Reynolds's conservative, reactionary attitudes to some of the achievements of his contemporaries (notably those which did not accord with his prescriptions), was his unsympathetic, even antagonistic, response to another important field of endeavour in eighteenth-century art. This innovation took the form of an attempt to unite portraiture with history painting in the shape of dramatically-presented group portraits, often on a large scale, centred on contemporary life or an incident from the recent past – 'history in the making', as it were. The finest exponent of this kind of thing was an expatriate American, John Singleton Copley (1738–1815) – although the Irishman James Barry (1741–1806) produced some idiosyncratic combinations of history and portraiture during the same period (Fig. 8).[34] Copley's great achievements in this field

8. James Barry, *Burke and Barry in the Characters of Ulysses and a Companion fleeing from the Cave of Polyphemus*. Oil on canvas, 127 × 100.8 cm (50 × 34⅝ in). *c.* 1776. Cork, Ireland, Crawford Municipal Art Gallery

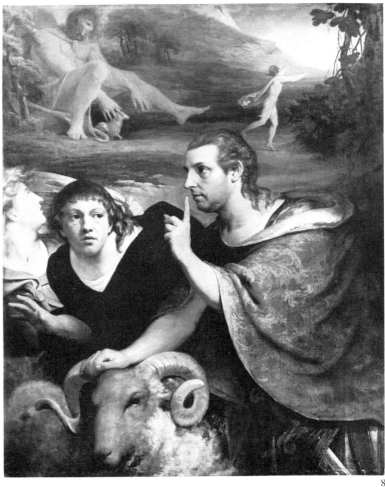

8

were *The Death of Chatham* of 1779–80 (National Portrait Gallery, London), *Admiral Duncan's Victory at Camperdown*, 1779 (Camperdown House, Dundee), *Death of Major Pierson*, 1783 (Tate Gallery, London) and *The Siege of Gibraltar*, 1791 (Guildhall, London) – the finished portrait studies which survive for the last painting, itself no less than twenty feet wide, being of almost unparallelled brilliance (Fig. 9). Copley worked in England at the same time as his fellow-American Benjamin West (1738–1820), who had produced some important pioneering works in this vein (Plate 3) but who, under the flattering encouragement of King George III, turned almost exclusively to classicizing histories of a more pedestrian kind.

Copley has a claim, with Thomas Cowperthwaite Eakins (1844–1916), to be considered America's finest painter, a position he is rarely accorded in America itself, apparently because of his departure for England at the time of the Revolution. Not the least astonishing thing about the many works which he executed in Boston in the years before his emigration in 1774 is that they are the products of an artist who must have been almost wholly self-taught. The circumstances in which his genius first flourished were characteristic of those surrounding the would-be artist in Colonial America: there was little or no opportunity for formal training or apprenticeship; there were, of course, no art schools of any kind.

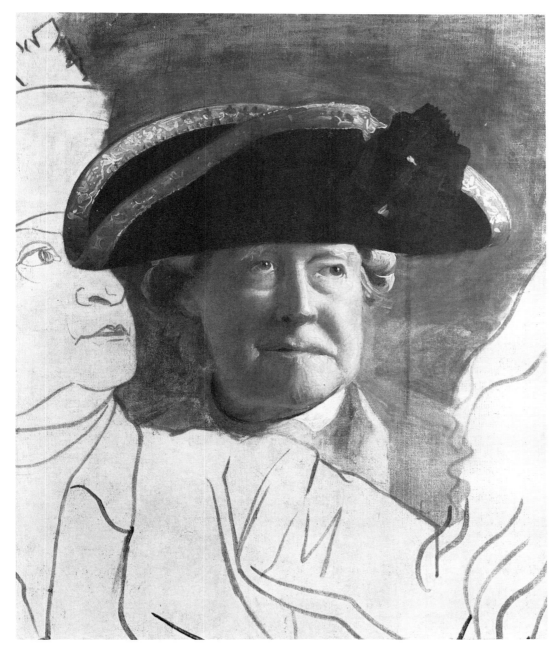

9

Works for painters to emulate in Boston were limited to those of such artists as John Smibert, 1688–1751 (Fig. 10), Robert Feke, 1707–52 (Fig. 13), Joseph Badger, 1708–65 (Fig. 12) and – but only after 1755 – Joseph Blackburn, *fl.* 1752–78 (Fig. 11). Badger is the typical colonial painter of this group for, in addition to the still-mysterious Feke, whose work appears to be that of a professional, both Smibert and Blackburn were certainly English-trained professionals. Badger's wooden portrait style is evidently based on his imitation of artists such as Smibert and Feke rather than upon training by, say, Smibert. The way in which flat decorative patterns in Badger's work are created on the surface of the picture through the 'collision' of different planes of the picture space, as in the telescope and gun in *Captain John Larrabee* (see Fig. 12), is a characteristic habit of primitive artists. In this latter portrait, comparison with Badger's evident

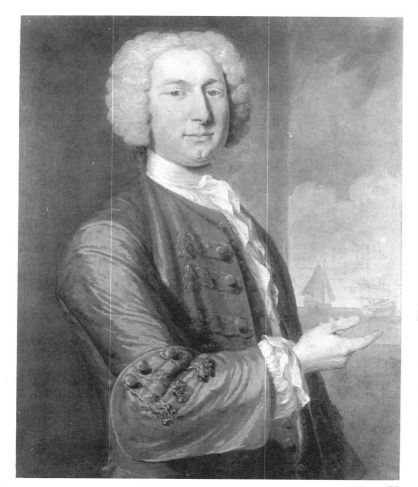

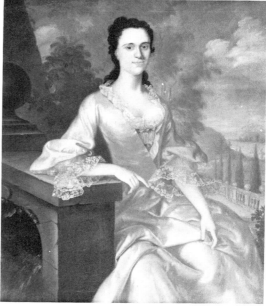

11. Joseph Blackburn,
Portrait of Mary Faneuil.
Oil on canvas,
127 × 102.2 cm
(50 × 40¼ in). 1755.
Springfield, MA,
Museum of Fine Arts.
Gift of Mrs Lewis Tifft

10. John Smibert, *John Turner*. Oil on canvas, 89.5 × 70.5 cm (35½ × 27¾ in). *c.* 1735. Boston, MA, Museum of Fine Arts. Gift of Mrs Horatio A. Lamb in memory of Mr and Mrs Winthrop Sargent

source of inspiration, Feke's confident and spacious *Brigadier General Samuel Waldo* (see Fig. 13), illustrates this habitual stress of the primitive upon two dimensions. Colonial American painters were usually without proper grounding in perspective, figure-drawing, painting techniques or the handling of colour and tone. Most of the results were inevitably primitive, as are Badger's, but the most extraordinary achievements are those of the few artists who arrived, in such unpromising conditions, at a professional standard of excellence: C.W. Peale's, 1741−1827 (Fig. 14), is another noteworthy example to set beside that of Copley. Peale had the most piecemeal training but gradually emerged as one of the most original of all American artists. In the case of Copley, the development of the young artist can only be described as prodigious.

Copley was fortunate at least in that his stepfather, Peter Pelham, was an engraver and something of a portrait painter, and much of Copley's early inspiration came from the engravings after British and European portraits which were in Boston in the possession of Pelham or Smibert.[35] It would seem that, in some important respects, this enforced limitation in his objects of emulation to engraved prints was of positive benefit to the young painter (who was working as a portraitist for money by the age of fourteen or fifteen). Many engravings were mezzotints, and were thus particularly subtle tonal compositions (see Figs 70, 71), and the absence of colour from these works, together with their inherent quality, led Copley early on to the expert manipulation of purely tonal values. It is

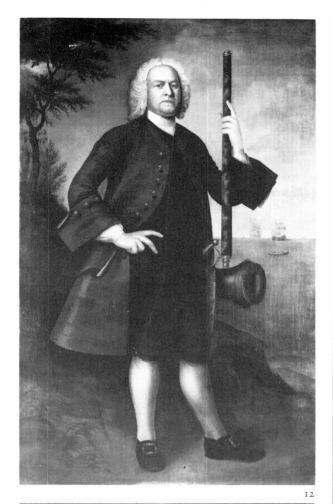

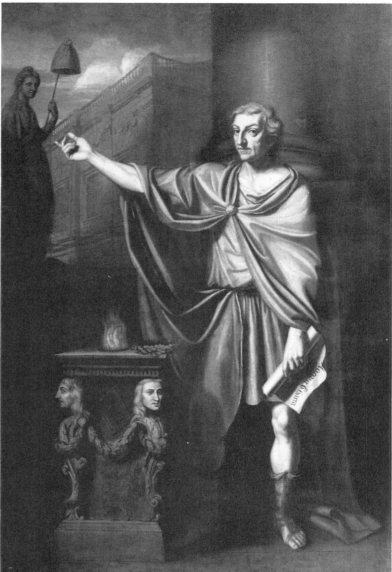

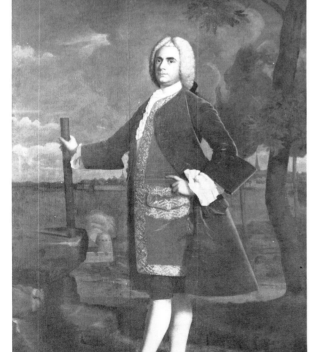

12. Joseph Badger,
Captain John Larrabee.
Oil on canvas,
212.3 × 129.9 cm
(83⅝ × 51⅛ in). *c.* 1760.
Worcester, MA,
Worcester Art Museum

13. Robert Feke,
Brigadier General Samuel Waldo. Oil on canvas,
245.8 × 153 cm
(96¾ × 60¼ in). *c.* 1748.
Brunswick, ME, Bowdoin
College Museum of Art

14. Charles Willson Peale,
William Pitt. Oil on
canvas, 241.9 × 155.6 cm
(95¼ × 61¼ in). 1768.
Montross, VA,
Westmoreland County
Museum

noticeable in many of his Boston works both that the range of colour is minimal and that the more obvious attractions of varieties of local colour are ruthlessly excluded. (One is reminded of Richard Wilson's admonition to his pupils to avoid the use of local colour for the first year of their training, on the grounds that tonal control is one of the hardest elements of painting to master.) *Thadeus Burr* (Plate 4), painted when Copley was about twenty years old, is a good example of this important aspect of his early work. Burr's waistcoat provides the only striking note of local colour, a steely blue; his topcoat is brown, a colour which provides the keynote for the rest of the picture. The effect is of sombre magnificence, even of restrained drama, which owes much to Copley's profound understanding of tonal composition at this remarkably early age.

Closely linked to this capacity for tonal control was an interest in effects of light and shade, to which was added a fascination with reflected light, all of which were details that yielded their secrets readily to Copley's intense empirical observations. It is with a rather self-conscious excitement that he included, in a number of his colonial works, brilliant effects of the reflection of clothes and glinting metal, often caught in the polished surface of a table or in a glass. Such a demonstration of skill was a feature of the picture which Copley decided to send to England for exhibition in 1766, a portrait of his half-brother Henry Pelham known as *The Boy with the Squirrel*.[36] It immediately attracted the favourable attention of Reynolds and Benjamin West, both of whom began to correspond with Copley and suggested that he should come to Europe. Only so much could be accomplished in the artistic isolation of Colonial America, even in a flourishing town like Boston; and technical quirks are certainly evident in much of Copley's work from this period as, for example, his use of a freely-brushed scumble or glaze in a uniform brown or grey to indicate shadow, whatever the local colour might be. When he found himself caught, willy-nilly, between the opposing sides in Boston in 1774 he took the opportunity finally to leave, via Italy, for England.

Copley's achievements in England were many and some, especially his imaginatively-composed portrait groups, were remarkable. His tenacious grip on structure, deep understanding of light, and his richly distinctive handling of paint revealed themselves in an almost sculptural feeling for the forms of the human face (see Fig. 9). It is, however, arguable whether he ever again created such triumphs of idiosyncratic brilliance as the portraits of his Colonial period. That Copley failed to assume a dominant position in England, though he was generally successful, was partly due to certain aspects of his character which became more pronounced in his exile, particularly a rather self-pitying querulousness. But he was one of the most original artists of the age and deserves a better fate than the near-oblivion into which he has been cast by most English art historians, who view him as an American, or the sometimes grudging respect accorded him by Americans who, in the past, have apparently viewed him as at best a coward, at worst a traitor.

Both these latter judgements would appear to be specifically untrue in Copley's own case, and the second view is, in particular, inappropriate. Rather, Copley's move to England merely demonstrates how natural was the urge for American painters to travel to England in the eighteenth century, and vice versa (although the numbers were smaller). As if to prove the point, Reynolds's successor as President of the Royal Academy was Benjamin West, and it remained the case

that, even after Independence, American artists continued to see England as a natural place to visit in search of self-improvement.

Among those who visited England as part of their artistic education were Ralph Earl, 1751–1801 (Fig. 15) – an artist who was certainly forced to depart for England because of his loyalist sympathies – Joseph Wright, 1756–93 (Fig. 16), John Trumbell, 1756–1843 (Fig. 17) and Gilbert Stuart, 1755–1828 (Plate 5, Fig. 18); while those of the next generation included Thomas Sully, 1783–1872 (Plate 6, see Fig. 196), and Washington Allston, 1779–1843 (Fig. 19), and there were any number who continued to arrive in England specifically to train under West.[37] Indeed, it was West who rescued Gilbert Stuart, the most accomplished American artist of the period after Copley and who was, like Copley, an expatriate for much of his career.

Stuart assumes a much greater significance than Copley in the history of American portraiture for the reason that he eventually found it expedient to return to his native country, which had turned itself into a Republic in his absence (which lasted from approximately 1771 to 1793) and because, opportunistically, he made it his business to paint the definitive portraits of Washington, the new nation's leader (Plate 5).[38] As Stuart was possessed of dazzling gifts and blessed, despite his best efforts to the contrary, with longevity, he enjoyed a long period as the most experienced professional artist working in America. An entire generation of young American painters benefited, if not always from his increasingly bad-tempered and befuddled advice, at least from the considerable example of his work.

The prosperous latter part of Stuart's career was another example of his capacity for landing on his feet after getting himself into an awkward and unpromising situation. Indeed, his return to America was part of a steady move westward to escape from debt. He had had to escape from England to Ireland in 1781 where, however, he had continued his ingenious but utterly cynical exploitation of a standard method of payment for portraits. He would collect half the fee at the first sitting, when his ready gifts enabled him to produce a flattering likeness, with the background and drapery barely indicated, if at all. Often enough, these parts of the picture were never completed, and as a result there must be more unfinished pictures by Stuart in existence than by any other artist of comparable stature – more, perhaps, than by any artist of any period. To leave Ireland for America in a hurry in 1793 was the next logical move.

Stuart's highly personal system of making money had a tendency to backfire in other ways, for at one time people began to suggest that he could not paint the whole figure but only the bust because, naturally enough, his facility with the portrait bust meant that he favoured it as a more rapid source of income. The accusation was brilliantly refuted by his exhibition in the Royal Academy of 1782 of the famous full-length *The Skater (Portrait of William Grant)* (see Fig. 18). This remarkable picture effectively marked the beginning of Stuart's great success in England, a career which had two false starts. The first was in 1771 when he arrived in Edinburgh from the colonies with a rather unpromising companion in the shape of Cosmo Alexander (1724–72), a Scottish portraitist of strictly limited ability who had given him some instruction in America. Alexander promptly died, leaving Stuart friendless and penniless in a strange country; resourcefully, he worked his passage back as a sailor to Newport, Rhode Island. He left again for

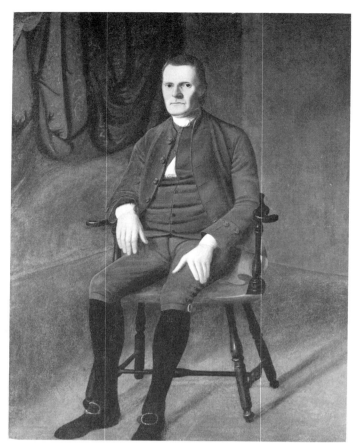

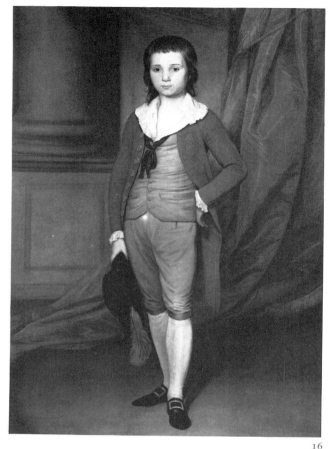

15

16

15. Ralph Earl, *Roger
Sherman*. Oil on canvas,
164 × 126.1 cm
(64⅝ × 49⅝ in). *c.* 1775.
New Haven, CT, Yale
University Art Gallery.
Gift of Roger Sherman
White

16. Joseph Wright, *John
Coats Browne*. Oil on
canvas, 156.8 × 109.8 cm
(65⅓ × 46¹³⁄₁₆ in). *c.* 1785.
San Francisco, CA, Fine
Arts Museum of San
Francisco. Gift of Mr and
Mrs John D. Rockefeller
3rd

England in 1775, in fact, immediately before the battle of Bunker Hill, a move prompted less by political convictions than by a perception that war would interfere with patronage and therefore with his artistic ambitions. He was forced, however, on arrival in England, to maintain himself by playing the organ in a church. He had to face the fact that his colonial success (for such it appears to have been) was irrelevant in London, and that his technique was wholly inadequate. He was again destitute by 1777 and, in effect, was rescued both physically and artistically by Benjamin West, whose studio he now entered for a full five years. Stuart was not the first (and was by no means the last) young American to be substantially helped by the remarkable generosity of West, whose prominent position in England meant that the ties which existed between the new Republic and the old country were, at least artistically, maintained and even strengthened over the very period which saw America win her Independence.[39]

In the first part of the nineteenth century the to-fro traffic of portraitists between both countries continued, although by mid-century there developed a more important openness towards Europe on the part of American painters, who came to study in Paris, Munich and Düsseldorf rather than in London. It is English art, in contrast with American, that begins to appear insular at this time, and towards the end of the century the wheel had turned full circle from the beginning of our period, for the two dominant portrait painters working in Britain were both American: John Singer Sargent (1856–1925) and J.A.M. Whistler (1834–1903). When Copley had died in 1815, however, English portrait painting

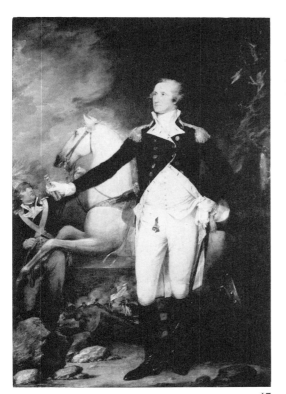

17

17. John Trumbull, *General George Washington*. Oil on canvas, 235 × 160 cm (92½ × 63 in). 1792. New Haven, CT, Yale University Art Gallery. Gift of the Society of the Cincinnati, 1804

18. Gilbert Stuart, *The Skater (Portrait of William Grant)*. Oil on canvas, 245.3 × 147.6 cm (96⅝ × 58⅛ in). 1782. Washington, DC, National Gallery of Art, Andrew W. Mellon collection

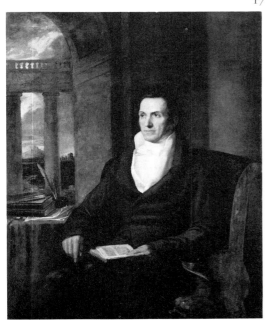

19

19. Washington Allston, *Portrait of Samuel Williams*. Oil on canvas, 127 × 111.8 cm (50 × 44 in). Before 1818. Cleveland, OH, The Cleveland Museum of Art. Purchase, Mr and Mrs William H. Marlatt Fund

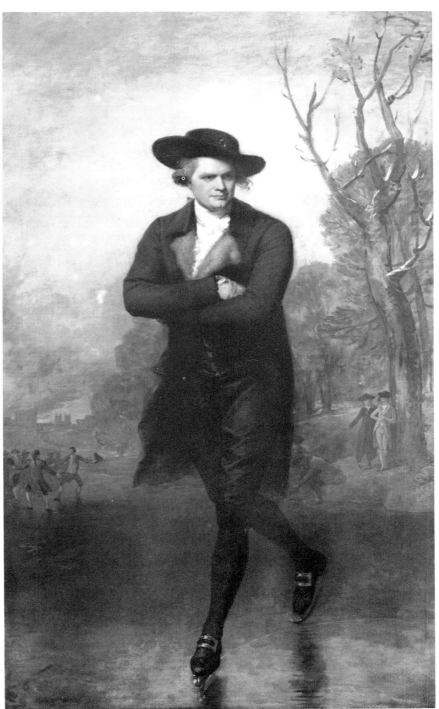

18

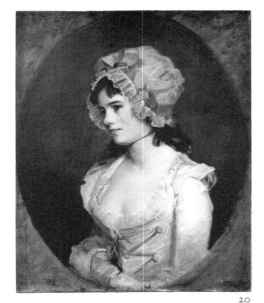

20

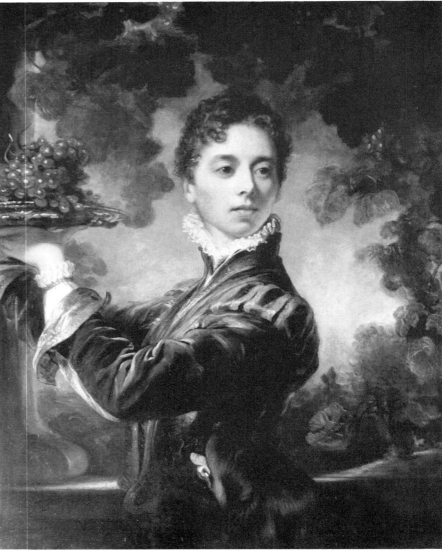

20. John Hoppner, *Mrs Williams*. Oil on canvas, 75.5 × 62.9 cm (29¾ × 24¾ in). *c.* 1790. London, Tate Gallery

21. Thomas Phillips, *Lady Caroline Lamb as a Page*. Oil on canvas, 91.4 × 69.9 cm (36 × 27½ in). 1813. Devonshire collection, Chatsworth

21

was flourishing as perhaps never before, and in that very year circumstances conspired to force upon the European stage one of the greatest masters of technical virtuosity with the brush that England had ever produced, Sir Thomas Lawrence (1769–1830).

The success of the Allies at the Battle of Waterloo offered Lawrence an extraordinary opportunity to paint the victors, and he seized it magnificently. His star had risen early but had then suffered an eclipse. Now he was to become the first English painter to achieve a truly international reputation. His influence was strongly felt in America, notably through the work of Thomas Sully, an English-born American who returned to study in England in 1809 and was directed to Lawrence by Benjamin West. Sully's interest in appealing effects of brushwork was already stimulated by the example of Gilbert Stuart and this prominent feature of his own style, further developed under Lawrence's tuition, perpetuated this most lasting influence of Stuart upon American painting (Plate 6). In an example of the occasionally baffling penchant of the times for identifying artists by reference to other masters, Sully became known as 'the American Lawrence';

Lawrence himself was to be called 'il Tiziano inglese' (the English Titian) as the result of his triumphant visit to Italy to paint Pope Pius VII; while Washington Allston earned (rather unexpectedly and inappropriately) the title 'the American Titian'. Sir Thomas Lawrence's particular virtues fitted him better to occupy this role of a latter-day master in a Venetian manner, however superficial the resemblance between his work and that of Titian. His colour was often spectacular, especially in his dramatic use of different reds, while his brushwork was always fluent and often delightful. He had been a child prodigy, and from an early stage in his career possessed one of the rarest of gifts, a natural capacity to work on large-scale portrait compositions, the necessary skill in handling which is usually hard-won, if indeed it is ever finally mastered; it remained, for example, one of Reynolds's difficulties. After the *succès célèbre* of his full-length seated portrait of Queen Charlotte (Plate 7), a picture painted with astonishing purity of technique and precision of touch at the early age of twenty, Lawrence notoriously over-extended himself. The pressure of work and of financial worries became allied to a Stuart-like habit of collecting half the fee for each portrait at the first sitting, and his work fell victim for a period of some ten years to a studio system of production along Kneller lines, in which the quality of many of his portraits was distressingly weak. He recovered superbly, however, by the end of the first decade of the new century, and his reputation subsequently reached undreamed-of heights as, knighted for the purpose, he toured an exultant Europe painting the victorious Allied leaders after the defeat of Napoleon. He duly succeeded West in 1820 as President of the Royal Academy.

Lawrence's style was the most splendid manifestation of a general liking for expressive handling in British portraiture at the beginning of the nineteenth century: Sir William Beechey, 1753–1839, John Hoppner, 1758–1810 (Fig. 20) and the nowadays underrated Sir Henry Raeburn, 1756–1823 (Plate 8) relied upon effects of brushwork to animate the surface of their pictures. A general air of glamour, which sometimes descends into the merely flashy, is characteristic of much British portraiture from approximately 1790 to 1830, a heady atmosphere in which the superlative but more sober craftsmanship of a distinguished portrait painter like Thomas Phillips (1770–1845) can be easily overlooked (Fig. 21).

Amid the visual pyrotechnics of the age of Lawrence, an era in British portrait painting was coming to an end: it was the last generation in which the majority of leading British painters turned naturally to portraiture as their prime field of professional endeavour. This phenomenon was partly the result of the long-awaited establishment of landscape painting in Britain, a development which is now associated with the careers of J.M.W. Turner (1775–1851) and John Constable (1776–1837); it was also due to a renewed fascination with the chimera of history painting, which was to lead to the decorating of the new public buildings of Victorian England with often lamentably ill-conceived murals celebrating the supposed glories of the Saxon, Norman and Gothic past; and it was in part due to a post-Romantic rise in the popularity of sentimental subject-pictures and genre. The situation in America could hardly have been more different, for, although many of the same demands were made upon painters there as in England, the second half of the nineteenth century was, as we shall see, to witness the development of a school of portrait painting that for splendid painting, immense energy and fertile inventiveness had hardly been equalled in

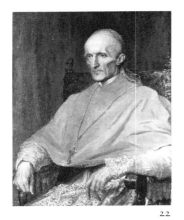

22

22. George Frederic
Watts, *Henry Edward,
Cardinal Manning*. Oil
on canvas, 90.2 × 69.9 cm
(35½ × 27½ in). 1882.
London, National
Portrait Gallery

either country. In America, the painting of portraits became, in a number of important respects, a matter of artistic preference: in England, in rather depressing contrast, the careers of G. F. Watts (1817–1904) and Sir John Everett Millais, Bt (1829–96) may be taken as characteristic, for they were both artists reluctantly forced by circumstance to become portrait painters.

It tells us a lot about Watts that he saw himself as 'England's Michelangelo', and there is much about him personally, and sometimes artistically, that is absurd.[40] After the frustration of endeavours in the historical line, Watts was persuaded to paint portraits, and very successful many of them are. Nonetheless, the surface of many of these thoroughly Victorian icons – *Henry Edward, Cardinal Manning* (Fig. 22), for example – is muddied, overworked and rather unpleasant, and there is little appealing colour.[41] The case of Millais, a better artist, offers a more heartening story, although his 'descent' into portraiture from the austere heights of his early days with the Pre-Raphaelite Brotherhood has, quite wrongly, often been deprecated.

Millais's decision to turn his great technical skill towards portraiture was something of a triumph of character and practicality following his marriage to the fecund (as it transpired) Effie Ruskin in 1855. The resulting portraits are remarkable in their range of handling and their revelation of Millais's adaptability. *Hearts are Trumps* (Fig. 23), for example, a portrait group of the Armstrong sisters, is extravagantly painted in a manner precisely calculated to suit the subject, and Millais himself designed the sitters' sumptuous dresses, the texture of which he celebrates in the painting. In contrast, his male portraits are often austere, the backgrounds plain, and the features strongly delineated. Nor does this kind of distinction mark the limits of Millais's flexibility, for his *John*

23. Sir John Everett
Millais, *Hearts are
Trumps (Portrait of the
Armstrong Sisters)*. Oil
on canvas,
165.7 × 219.7 cm
(65¼ × 86½ in). 1872.
London, Tate Gallery

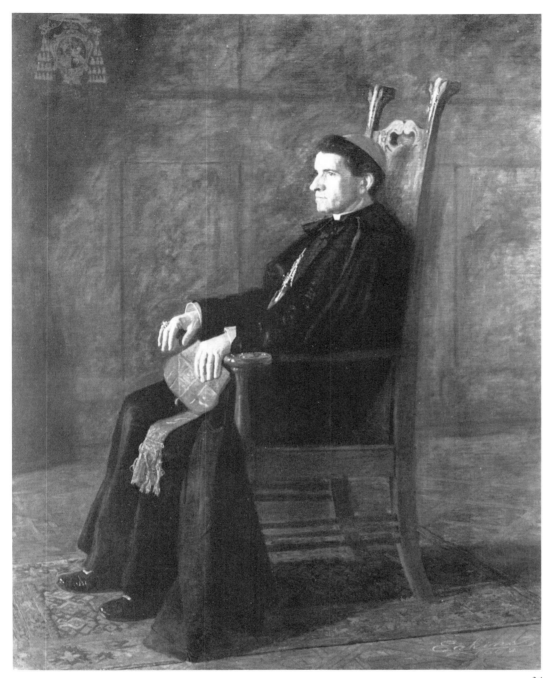

24. Thomas Cowperthwaite Eakins, *Portrait of Sebastiano, Cardinal Martinelli*. Oil on canvas, mounted on panel, 198.9 × 152.3 cm (78 5/16 × 59 15/16 in). 1902. Los Angeles, CA, The Armand Hammer Foundation

24

Henry, Cardinal Newman (Plate 9) forms a telling contrast to Watts's portrait of Newman's fellow-convert, *Henry Edward, Cardinal Manning* (Fig. 22). Millais's portrait of Newman is a subtle distillation of the way in which asceticism sometimes appears to be mingled with a less-acknowledged delight in 'dressing-up' that has occasionally characterized the English convert's fascination with Roman Catholicism – a paradox captured here in the contrast between the stark linearity of the sitter's face and hands and the rippling tonalities of the drapery. A late portrait by Millais's American contemporary, Thomas Eakins, of another cardinal, *Sebastiano, Cardinal Martinelli* (Fig. 24), for example, is a far more straightforward and grave affair. Eakins's picture characteristically reveals the

deep influence of Velásquez upon him, and it is interesting to note that Millais's own diploma picture at the Royal Academy was entitled *Souvenir of Velásquez.* However, whilst the great seventeenth-century Spanish painter was evidently a decisive influence on contemporary European and American portrait painting, his example is difficult to detect in Millais's own work.

Despite the example of Millais, however, much of the strength of Victorian British portrait painting is not be to found among the famous artists of the day in London, but in the provinces – especially Manchester and Liverpool – and in Scotland; although London itself held many celebrated artists who were outstanding portraitists when they turned to it, Lord Leighton, 1830–96 (Plate 10) and the Hon. John Collier, 1850–1934 (Fig. 25) among them. The reverse was true in America, where a great number of the outstanding artists of the second half of the nineteenth-century were portrait painters, and a partial list includes, in addition to the obvious examples of Sargent and Whistler: Thomas Cowperthwaite Eakins, 1844–1916 (Plate 11, see Figs 24, 26), G.P.A. Healy, 1813–94 (Plate 12), Eastman Johnson, 1824–1906 (Fig. 27), William Merritt Chase, 1849–1916, (Plate 13), William Morris Hunt, 1824–79 (Fig. 28), Frank Duveneck, 1848–1919 (Plate 14), F.P. Vinton (1846–1911), J.R. De Camp (1858–1933), Robert Henri, 1865–1929 (Figs 29, 147), F.W. Benson, 1862–1951 (see Fig. 109), Cecilia Beaux, 1863–1942 (Plate 15), E.C. Tarbell, 1862–1938, T.W. Dewing, 1851–1938 (Fig. 30), Irving R. Wiles, 1861–1948 (see Fig. 204) and John White Alexander, 1856–1915 (Plate 16). It represents an astonishing explosion of talent. No less remarkable than the fact that so many of America's leading artists should have been portrait painters to a significant degree is the fact that every single one of these painters chose to train in Europe for an extended period: in Düsseldorf, Munich, Paris, Florence or Venice, or in several of these cities.[42] In England, there are only flashes of inspiration from these sources to be glimpsed intermittently in the work of unusually open-minded (even eclectic) artists such as Solomon J. Solomon (1860–1927), who was himself trained in Paris and Munich. W.M. Chase spoke for at least two generations of American painters when he claimed: 'I'd rather go to Europe than go to heaven.'[43]

Nor was it the case that there were no established art schools and academies in America by this time; on the contrary, Boston, Philadelphia and New York all had flourishing academies which provided substantial initial training. The end result of this openness to European influence was that American artists were to be far more sympathetic than their British contemporaries to such developments as Impressionism and, later still, Abstraction. But, for the time being, the contrast between the exciting atmosphere of exploration in which American portrait painting flourished and the narrower, rather claustrophobic artistic society of Victorian Britain was sufficiently great. Admittedly, British painters such as Millais recognised the genius of influential masters like Velásquez, but there was little of the same dramatic evidence of his influence to be seen in their work as in that of their American contemporaries. Equally, in the case of another great seventeenth-century painter who was revered by many Americans, Frans Hals, an avowed taste in England for his work (and for that of his contemporaries) sometimes seems to have resulted merely in an increase in the number of costume pieces set vaguely in the seventeenth century (Fig. 31). But for painters like Chase, Duveneck and Eakins, the influence of Velásquez, Hals and Rembrandt resulted in

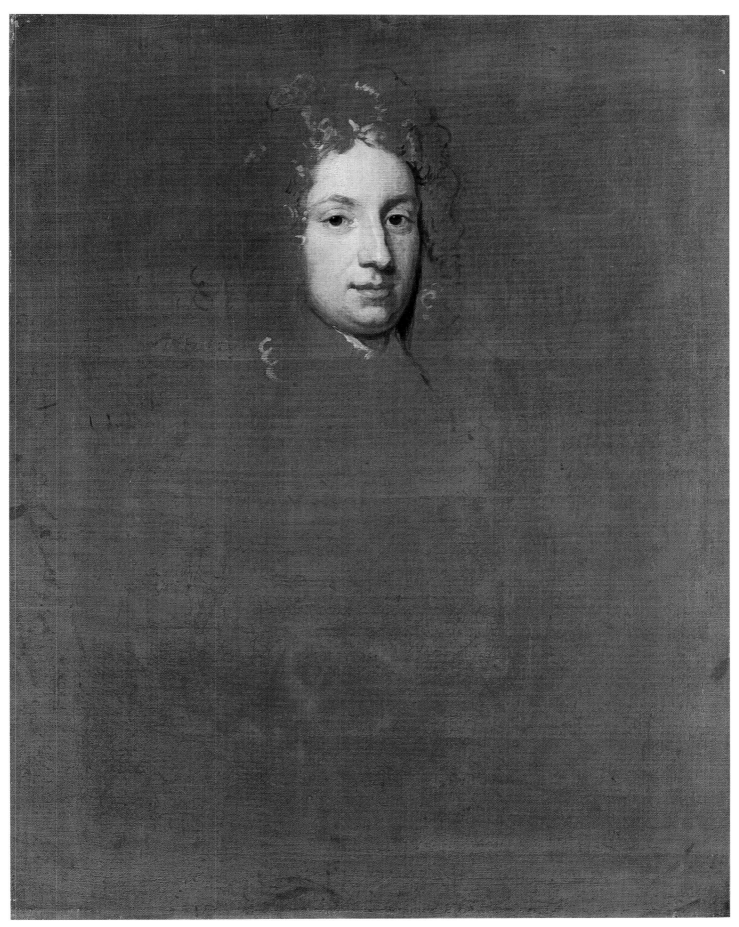

Plate 1 Sir Godfrey Kneller, Bt, *Richard Boyle, 2nd Viscount Shannon*. Oil on canvas, 91.4 × 71.1 cm (36 × 28 in), unfinished. *c.*1715–20.
London, National Portrait Gallery

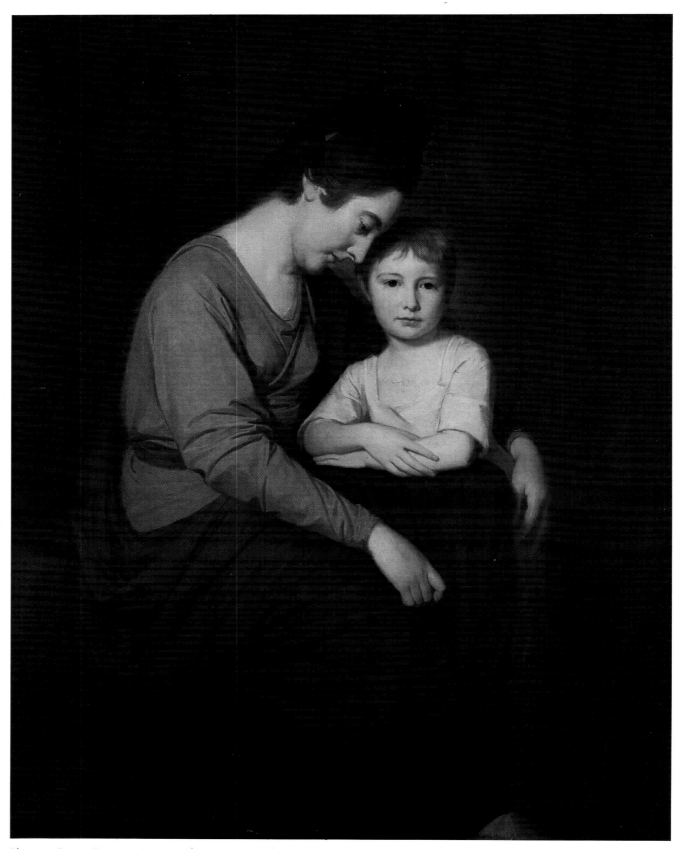

Plate 2 George Romney, *Portrait of Mrs George Wilson and Her Daughter*. Oil on canvas, 124.3 × 100.3 cm (49 × 39½ in). *c.*1776–7.
New Haven, CT, Yale Center for British Art, Paul Mellon Fund

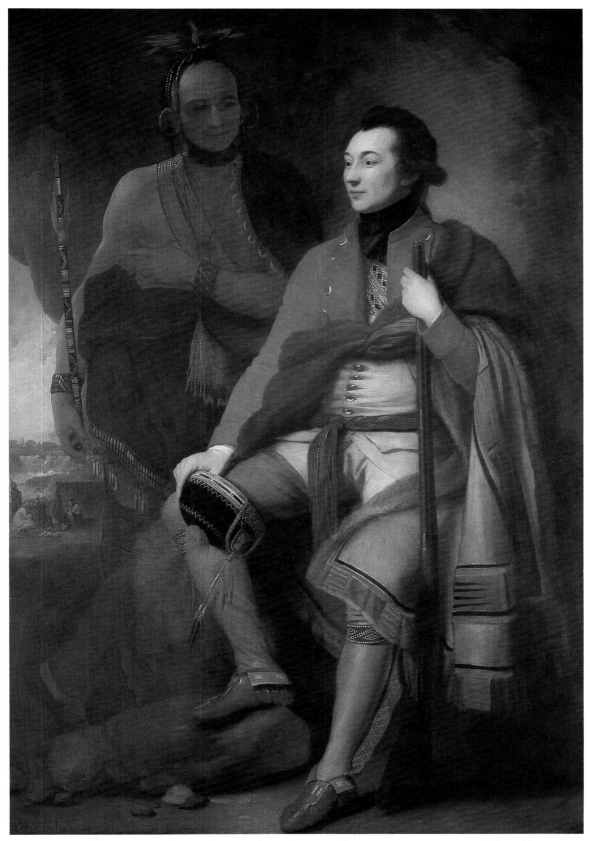

Plate 3 Benjamin West, *Colonel Guy Johnson and Joseph Brant*. Oil on canvas, 203 × 138.5 cm (79¾ × 54½ in).
c.1775–6. Washington, DC, National Gallery of Art, Andrew W. Mellon collection

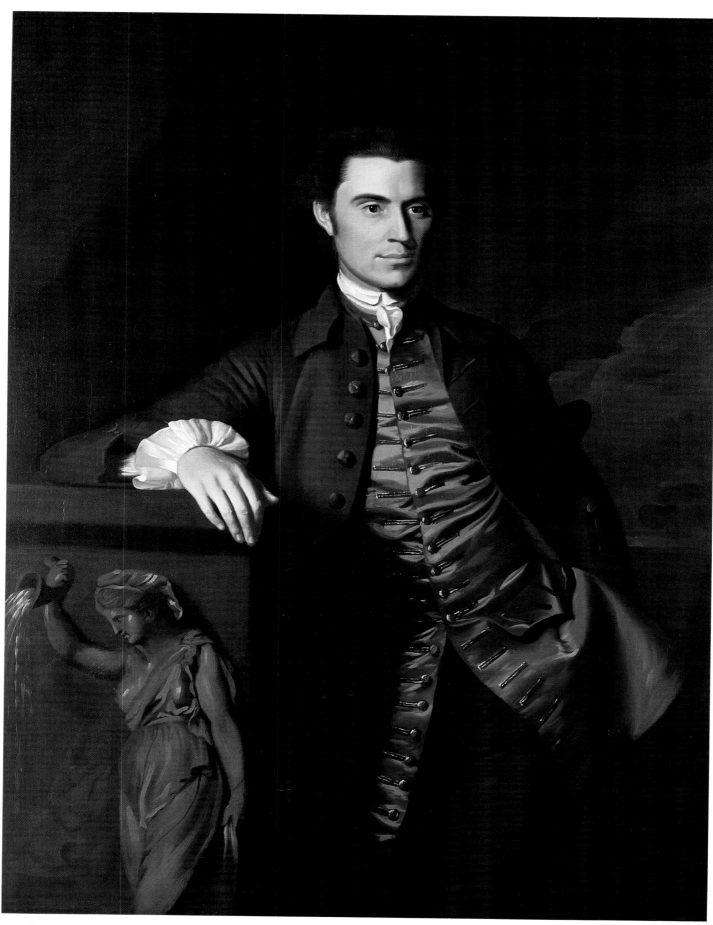

Plate 4 John Singleton Copley, *Thadeus Burr*. Oil on canvas, 128.6 × 101.3 cm (50⅝ × 39⅞ in). 1758–60.
St Louis, MO, The St Louis Art Museum, Museum purchase

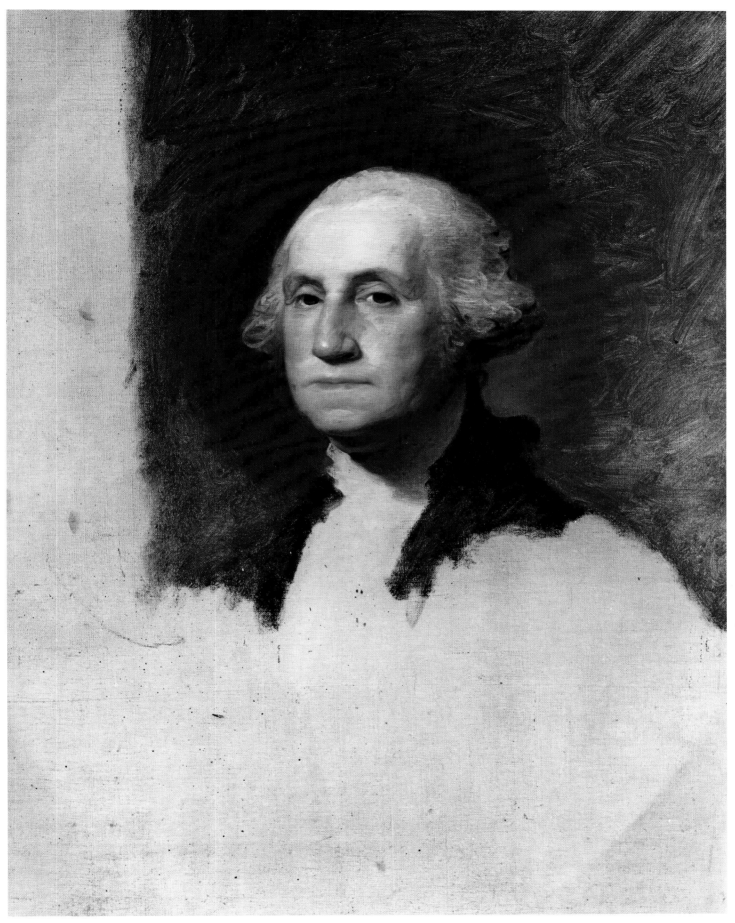

Plate 5 Gilbert Stuart, *George Washington*. Oil on canvas, 121.9 × 94 cm (48 × 37 in). 1796.
Boston, MA, Museum of Fine Arts, jointly owned by the Museum of Fine Arts, Boston, and the National Portrait Gallery, Washington, DC

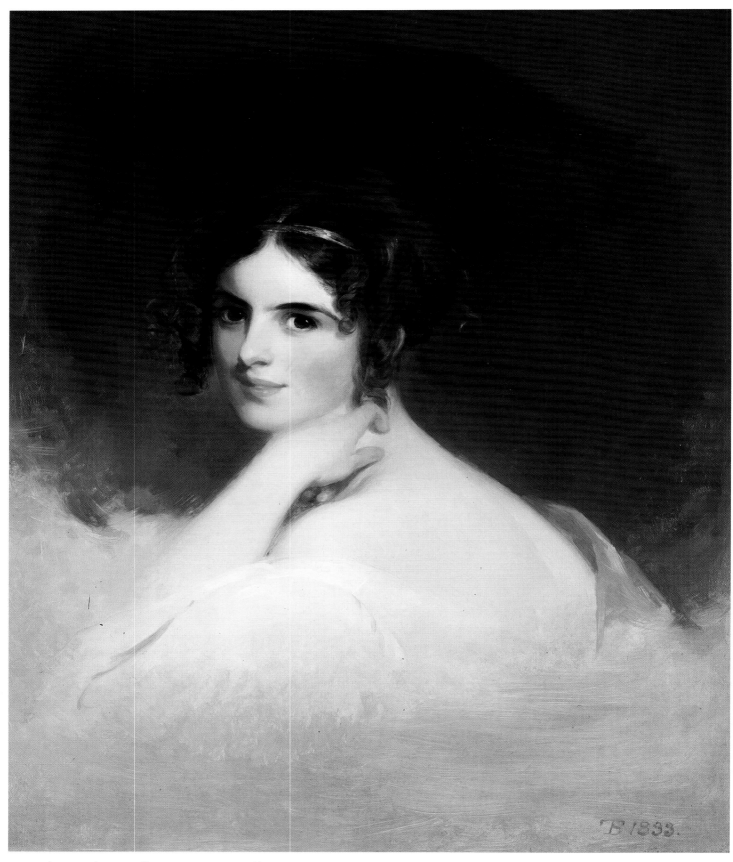

Plate 6 Thomas Sully, *Frances Anne Kemble as 'Beatrice'*. Oil on canvas, 76.2 × 63.8 cm (30 × 25$\frac{1}{8}$ in). 1833.
Philadelphia, PA, Pennsylvania Academy of the Fine Arts, bequest of Henry C. Carey

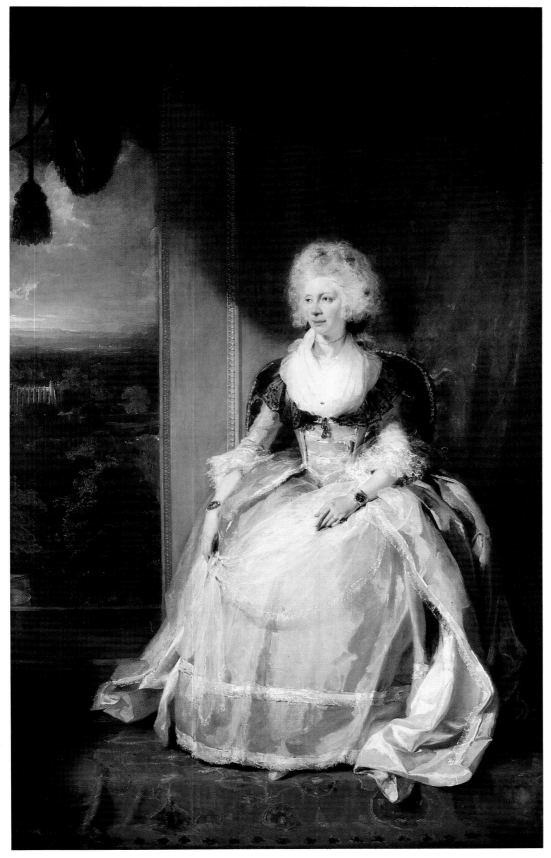

Plate 7 Sir Thomas Lawrence, *Queen Charlotte*. Oil on canvas, 240 × 147.3 cm (94½ × 58 in). 1789–90.
London, National Gallery

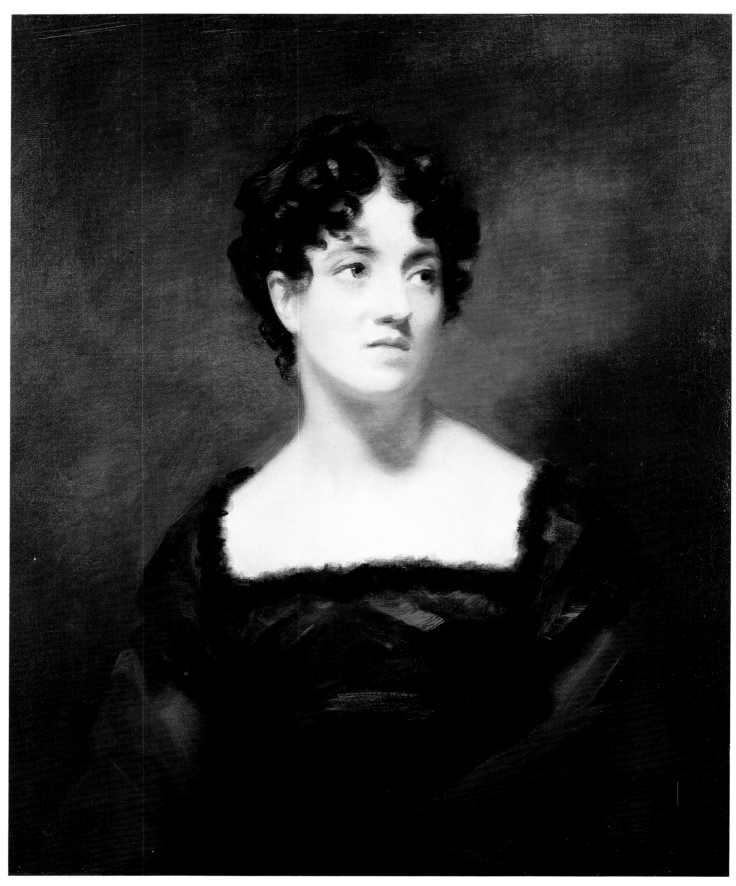

Plate 8 Sir Henry Raeburn, *Mrs Duncan*. Oil on canvas, 76.2 × 63.5 cm (30 × 25 in).
London, P. and D. Colnaghi & Co. Ltd

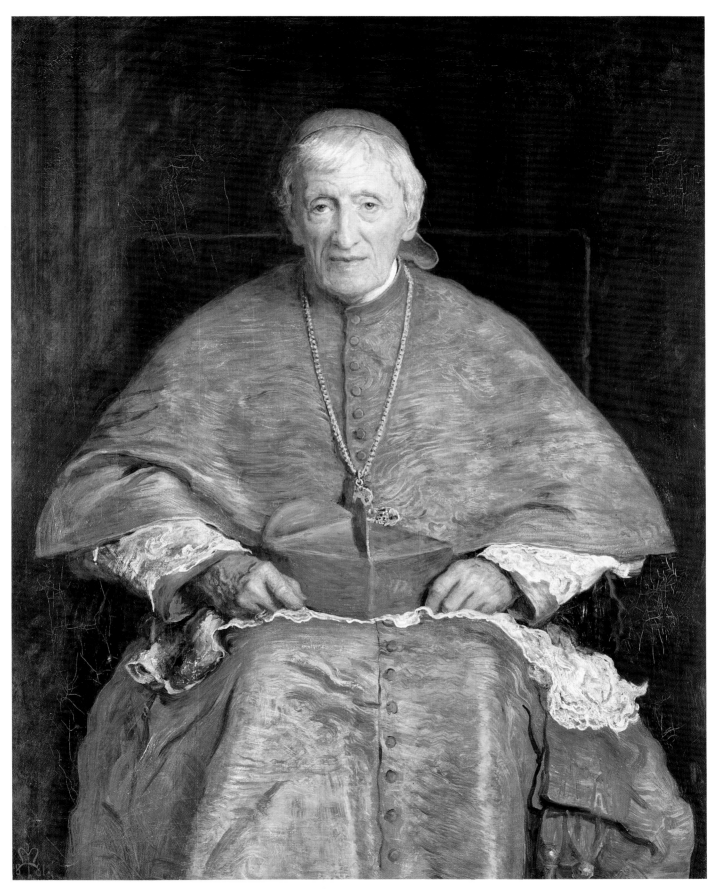

Plate 9 Sir John Everett Millais, Bt, *John Henry, Cardinal Newman*. Oil on canvas, 121.3 × 95.3 cm (47¾ × 37½ in). 1881.
Arundel Castle, on loan from the National Portrait Gallery, London

Plate 10 Frederic, Lord Leighton, *Mrs Evans Gordon (May Sartoris)*. Oil on canvas, 97.5 × 101.5 cm (36 × 37 in). 1875.
London, Leighton House Museum

Plate 11 Thomas Cowperthwaite Eakins, *Amelia C. van Buren*. Oil on canvas, 114.3 × 81.3 cm (45 × 32 in). *c*.1886–90.
Washington, DC, Phillips collection

Plate 12 G. P. A. Healy, *General John C. Fremont*. Oil on canvas, 75.6 × 62.9 cm (29¾ × 24¾ in). *c*.1861. Chicago, Union League Club

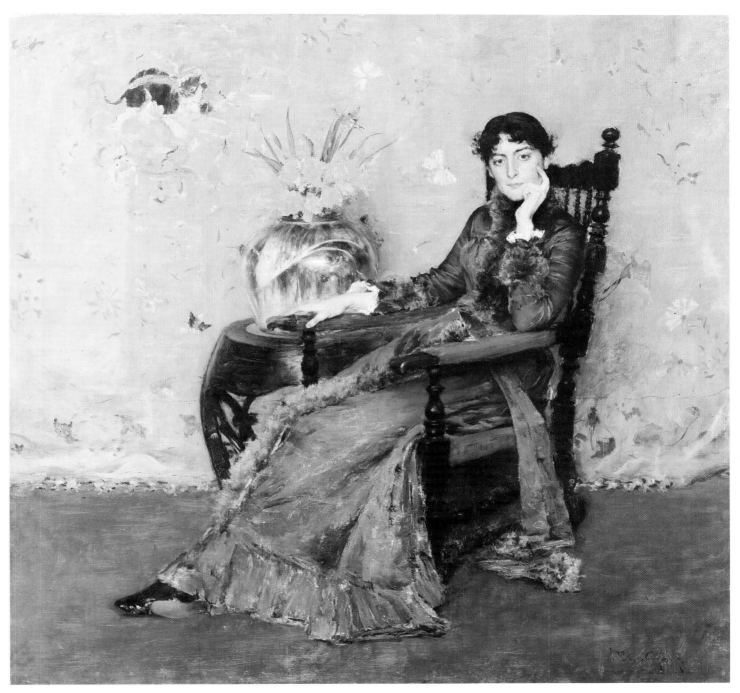

Plate 13 William Merritt Chase, *Miss Dora Wheeler*. Oil on canvas, 158.8 × 165.7 cm (62½ × 65¼ in). 1883.
Cleveland, OH, Cleveland Museum of Art, gift of Mrs Boudinot Keith

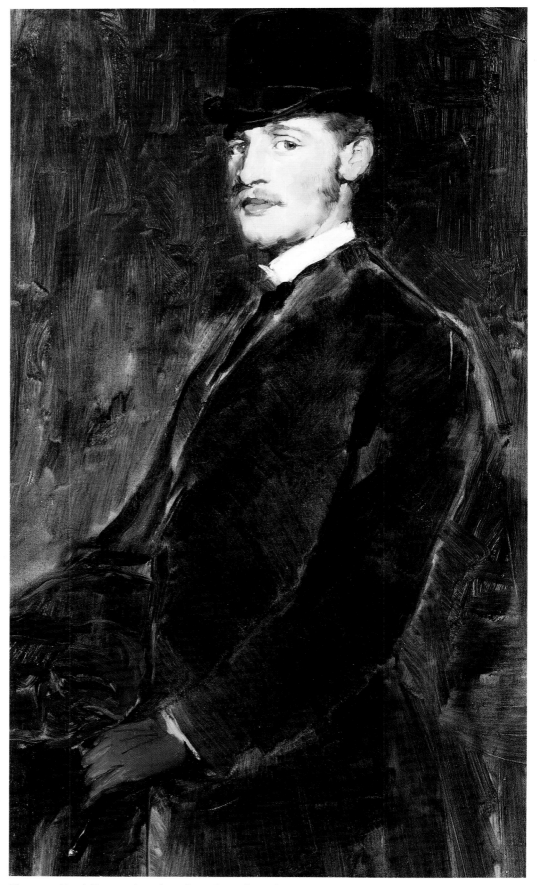

Plate 14 Frank Duveneck, *John White Alexander*. Oil on canvas, 96.7 × 56.1 cm ($38\frac{1}{16} \times 22\frac{1}{16}$ in). 1879. Cincinnati, OH, Cincinnati Art Museum, gift of the artist

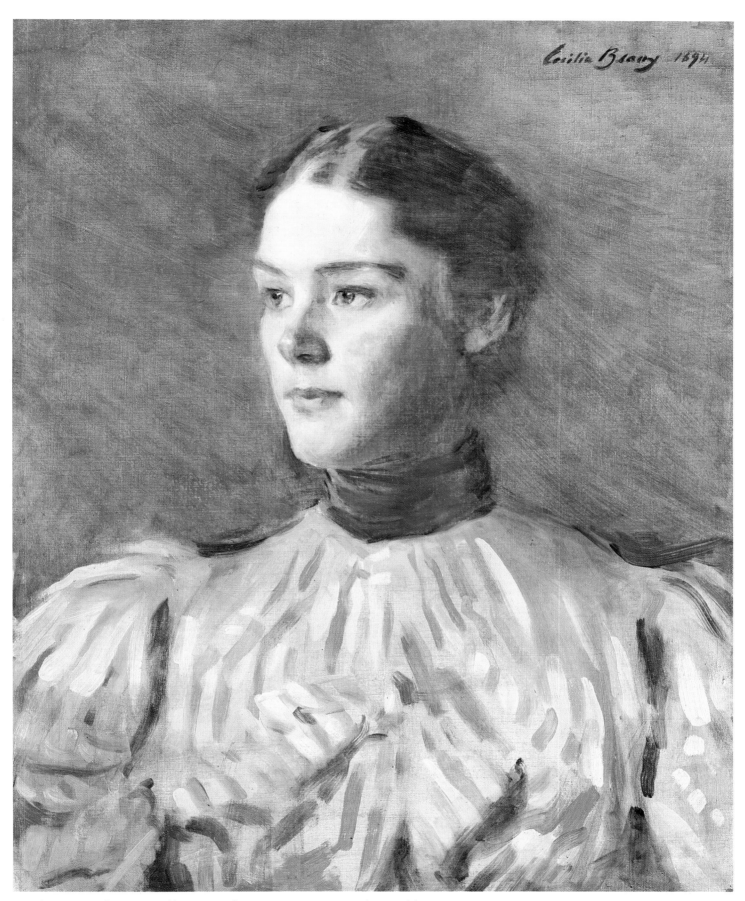

Plate 15 Cecilia Beaux, *Self Portrait*. Oil on canvas, 63.2 × 50.8 cm (24 × 20 in). 1894.
New York, National Academy of Design

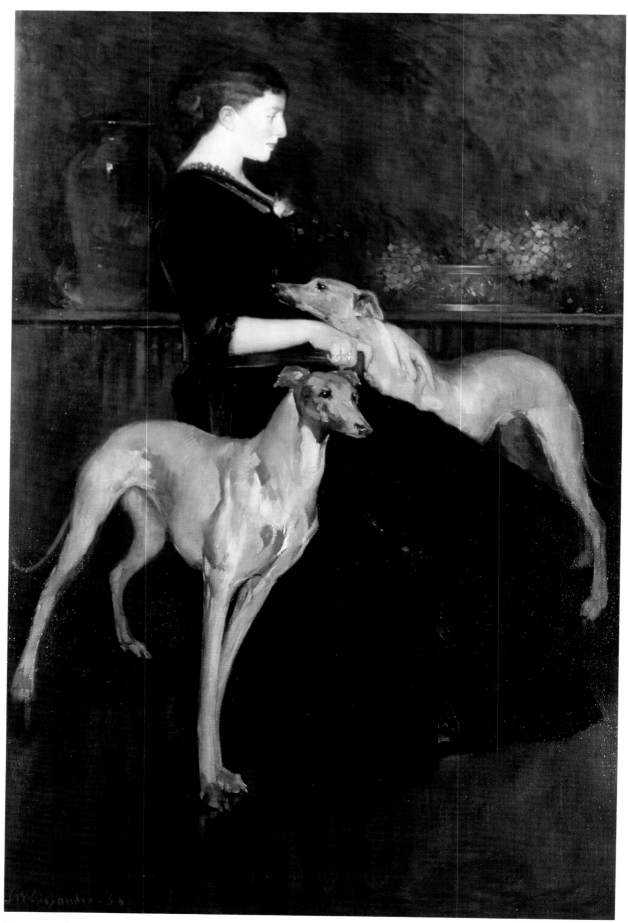

Plate 16 John White Alexander, *Mrs Henry W. Draper*. Oil on canvas, 182.9 × 121.9 cm (72 × 48 in). 1888.
New York, NY, Collection of the New York Public Library, Astor, Lenox, and Tilden Foundations

a dynamic style based on exciting and expressive brushwork, dramatic lighting effects and images of striking realism.

This style of painting is often thought of as the 'Munich School' manner, and no style could have been more fitted to repulse the mid-nineteenth-century's most dramatic challenge to the function of the portrait painter – photography. If the oil portrait now surrendered its primary function of recording a likeness to the new invention, it was still able to offer the unique attractions of the expressive possibilities of paint, and the full exploitation of these qualities is one of the most striking features of the 'Munich' style. Indeed, an important consequence of photography was that it freed portrait painting from its position as a 'service industry' with, at the lowest level, a rather simple and limited function to perform. In addition, however, there was a positive reaction on the part of most American portraitists of stature to the new possibilities which photography provided. Prophetically, the portrait painter S.F.B. Morse (1791–1872), himself so interested in new inventions that he devised the Morse code to accompany the newly-developed telegraph (which he also helped to create), welcomed the photographic pioneer work of Louis Daguerre in these words: 'The daguerre-otype is undoubtedly destined to produce a great *revolution* in art, and we, as artists, should be aware of it and rightly understand its influence.'[44]

At the lower level of the high-street (or sidewalk) portrait studio, there was something of a crisis in America attendant upon the introduction of photographic portraiture, but many artists were swift to respond more fruitfully. Thomas Eakins, for example, used photography in the service of his penetrating portrait studies, in part assisted by his friend in Philadelphia, the great early photographer Eadweard Muybridge.[45] Eakins's precise plotting of composition, scientific approach to the recording of effects of light, and detailed preliminary photographic studies of the sitter's physical details frequently combine to lend his paintings a haunting quality like that of the paintings of the seventeenth-century Dutch artist Jan Vermeer (whom he admired), an effect which seems to have been partly the result of Vermeer's use of the camera obscura.[46] The pictures of both artists are at once hyper-realistic yet faintly, almost disturbingly, surreal, and are similarly pervaded by a quality of deeply meditated stillness (Plate 11, see Figs 24, 26).

Eakins rarely seized on one of the most welcome results of photography: the new freedom of composition which it encouraged. A photographically-literate public could now 'read' portrait compositions in which figures were dramatically cut off by the picture frame, and in which lens distortion might make figures near the viewer loom unexpectedly large; while familiarity with variations in depth of field could encourage the painter to allow figures and objects to move in and out of focus throughout the picture as desired, while remaining comprehensible and, apparently, 'realistic'. By far the most successful portrait painter in exploiting these new possibilities was John Singer Sargent, who happily combined an almost limitless skill in sophisticated composition with a painting technique of breathtaking brilliance.

Eakins and Sargent represent two different but related strands of American life and art in the last quarter of the nineteenth century. In some important ways, Eakins's career was that of a wholly new type of painter, the academic (so familiar today) who, fully employed as an art school director, was free to paint what he

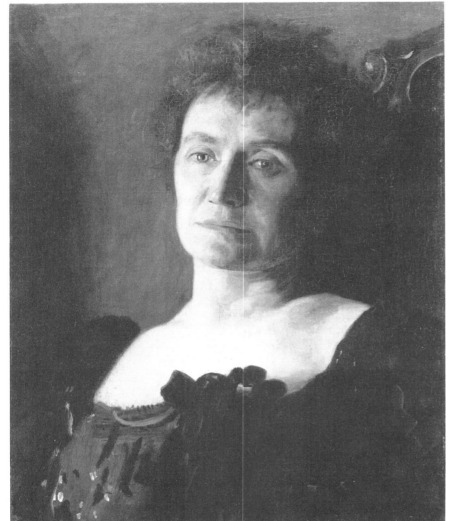

25

25. The Hon. John
Collier, *T. H. Huxley*. Oil
on canvas, 127 × 101.6 cm
(50 × 40 in). 1883.
London, National
Portrait Gallery

26. Thomas
Cowperthwaite Eakins,
*Portrait of Mrs Edith
Mahon*. Oil on canvas,
50.8 × 40.7 cm
(20 × 16 in). 1904.
Northampton, MA,
Smith College Museum of
Art

28. William Morris Hunt,
Miss Ida Mason. Oil on
canvas, 106.7 × 76.8 cm
(42 × 30¼ in). 1878.
Boston, MA, Museum of
Fine Arts. The Hayden
Collection

26

27. Eastman Johnson,
*Portrait of Mr Genio
Scott*. Oil on canvas,
102.2 × 127 cm
(40¼ × 50 in). 1859.
Cleveland, OH, The
Cleveland Museum of
Art. Purchase, Mr and
Mrs William H. Marlatt
Fund

27

28

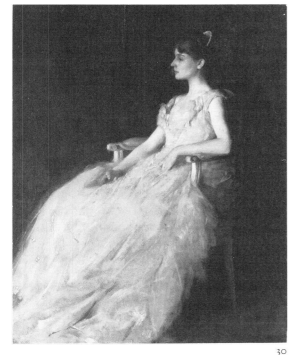

30

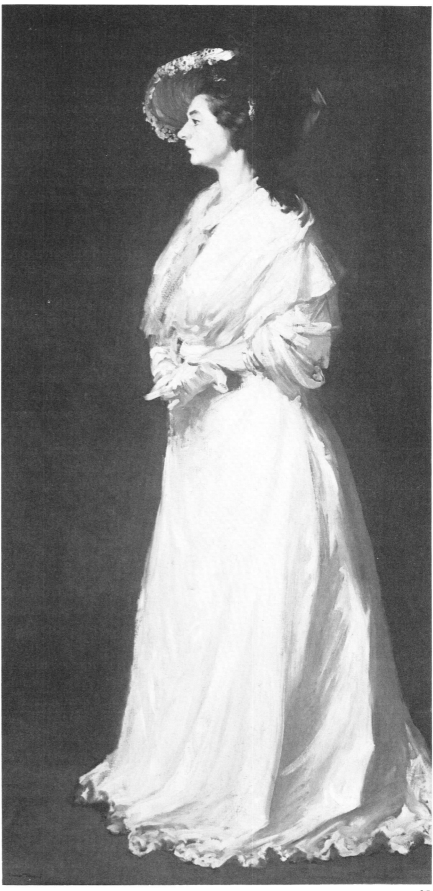

29. Robert Henri, *Young Woman in White*. Oil on canvas, 198.8 × 96.8 cm (78¼ × 38⅛ in). 1904. Washington, DC, National Gallery of Art. Gift of Miss Violet Organ, 1949

30. Thomas Wilmer Dewing, *Lady in Yellow*. Oil on panel, 50 × 40 cm (19¾ × 15¾ in). 1888. Boston, MA, Isabella Stewart Gardner Museum

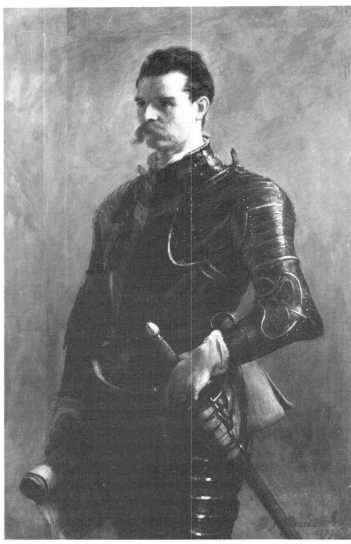

31. John Pettie, *William Black as a Knight of the Seventeenth Century*. Oil on canvas, 128.3 × 80 cm (50½ × 31½ in). 1877. Glasgow, Glasgow Art Gallery

31

wished rather than what economic necessity demanded. As it happened, in common with many contemporaries he chose portraiture as a more exacting artistic challenge, and pursued a special kind of realism directed towards the psychological exploration of the sitter's personality; not many of his portraits were commissioned. Eakins was, in fact, one of the most influential of all American art teachers, and it is revealing to note that many of the leading portraitists of the time whom we have mentioned above were also important teachers, who, by virtue of their employment, were similarly freed from dependence on portrait commissions for their livelihood – Chase, Duveneck, Beaux, Henri and Tarbell among them. Equally, for all the importance to his art of his own experience of European painting, Eakins also represents a new self-confidence and self-reliance in American art. Painters of the next generation, like George Wesley Bellows, 1882–1925 (Plate 17), felt no need to study abroad, finding both their training and ample material for their art within a specifically American way of life. (The work of the Ash Can School is the most famous manifestation of this general tendency.[47])

John Singer Sargent represents, on the other hand, a new international

dimension to American society, itself reflected in the European training of so many nineteenth-century American painters which we have noted. This internationalism was the result of the recent generation of great wealth within American society, and is a phenomenon fully documented in the work of one of its members (and a friend of Sargent's), the novelist Henry James. Sargent was an international 'star', inundated with commissions from clients who moved easily, as Sargent himself did, between America, Britain, France and Italy – and there is surely no portrait painter whose works exude such an atmosphere simply of money.

In addition to his extreme facility with the brush, Sargent was quick to grasp the potential of the visual effects which photography introduced. His compositions often broke with tradition, especially in portrait groups such as *The Daughters of Edward D. Boit* (Fig. 33) and *The Misses Vickers* (Fig. 32). The earlier of these two pictures is an astonishing example of artistic audacity, in leaving so much of the canvas space unfilled. The space, however, is handled so successfully that the tension of the composition is actually increased rather than dispersed. Sargent manipulates, in a wholly pragmatic way for the purposes of the composition, the distinctions between sharp and blurred focus which are customary effects in photography. Thus, for example, the child in the foreground is sharply defined against a carpet which is blurred (Plate 18), and the eye is directed about the picture space by crisp accents of precise impasted paint which plot the positions of the other children. The basic conceit, of painting children in surroundings which dwarf them (here emphasized by the ambiguous shapes of the Chinese vases, at once familiar in shape from any mantlepiece but in fact Brobdignagian[48]), had been used by Van Dyck in his group *The Five Children of Charles I* (Plate 19). It is an especially tactful approach to child portraiture with its inherent dangers of pomposity at one extreme and sentimentality at the other. It is even more remarkable to note the extent to which Sargent took the idea, choosing to paint the four little girls on an enormous canvas that is itself highly unusual in shape, being an exact square measuring $87\frac{5}{8} \times 87\frac{5}{8}$ in (221×221 cm). It is not irrelevant to observe that this shape (though not, of course, the huge size) is usual in early photography but was hitherto almost unknown in portrait painting.[49]

In the later painting, *The Misses Vickers*, the artful randomness of the grouping is more obviously reminiscent of the frozen informality of a camera image, with the figures being distributed widely across the surface of the picture and cut off as they are forced up against the very edges of the frame. A feeling of dramatic intimacy is created that is intensified by the unusually high angle from which the sitters are seen, itself unthinkable in portrait painting before the camera's disruption of traditional rules of pictorial composition. The random inclusiveness of the photographic plate is similarly evoked in the way in which part of a chair is glimpsed before a window in the extreme right background, while a cup and saucer can bee seen on a table to the left. It is indicative of the painting's originality that it had serious difficulty in being accepted by the hanging committee of the Royal Academy when it was sent for exhibition in 1886.[50]

Such tricks as these made Sargent seem very up-to-date but – an important consideration for a society painter – harmlessly so, for such innovations were effortlessly assimilated within the overall effect of his exceedingly glamorous style: indeed, they added to it.

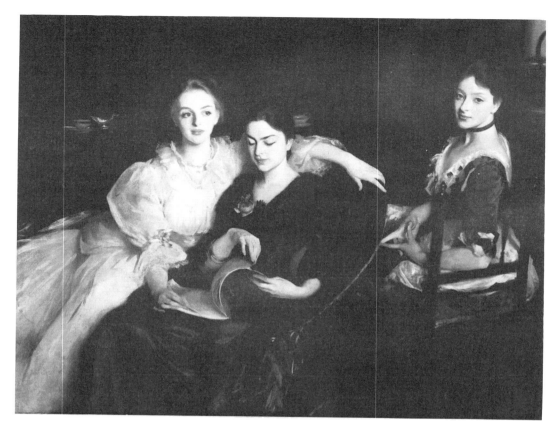

32. John Singer Sargent, *The Misses Vickers*. Oil on canvas, 137.2 × 182.9 cm (54 × 72 in). 1884. Sheffield, Graves Art Gallery

32

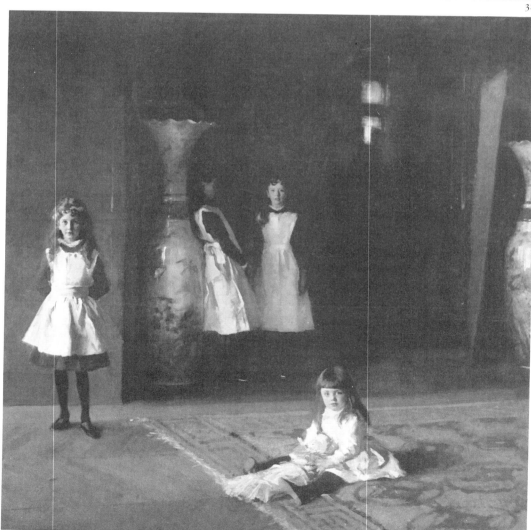

33. John Singer Sargent, *The Daughters of Edward D. Boit*. Oil on canvas, 221 × 221 cm (87 × 87 in). 1882. Boston, MA, Museum of Fine Arts. Gift of Mary Louisa Boit, Florence D. Boit, Jane Hubbard Boit, and Julia Overing Boit, in memory of their father Edward Darley Boit, 1919

Sargent himself lost interest in portraiture towards the end of the first decade of the new century, but in any case the 1914 Great War brought to a close the last great era of society portraiture of which he is so archetypally representative. His fellow-expatriate and near-contemporary J.A.M. Whistler was not interested in the same clientele, but was of greater significance within the context of the late-nineteenth-century aesthetic movement in portrait painting, which diminished the importance of the sitter and exalted the aspirations of the artist.

The outward and visible sign of this inversion of priorities was Whistler's distinctly precious habit of excluding the sitter's name from the titles of his portraits, or placing it in a subsidiary position. *Arrangement in Flesh Color and Black* (Fig. 34), for example, is actually a straightforward portrait, if a very good one, of Théodore Duret, painted in a manner common to other late-nineteenth-century American portraitists, and it might be said that the only innovatory aspect of this picture is its title.

Whistler sometimes appears to be one of those painters whose influence was rather greater than his achievement, and some of the more ambitious portraits are comparatively uncertain in handling and murky in appearance.[51] Although he influenced such portrait-painters as John White Alexander, 1856–1915 (Plate 16), his main importance lies elsewhere and, so far as portrait painting was concerned, Sargent's response to Impressionism, for example, was far more incisive and his contribution more effective. Nonetheless, it was the 'art for art's sake' approach of Whistler that won the day in America, if we take as symptomatic the explicit announcement, at its foundation in 1912, of the National Association of Portrait Painters that the sitter's identity and likeness in a portrait were insignificant in comparison with the creative interests of the artist.[52]

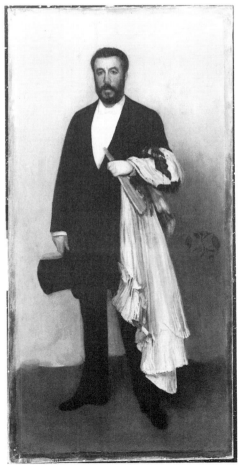

34. James Abbott McNeill Whistler, *Arrangement in Flesh Color and Black: Portrait of Théodore Duret*. Oil on canvas, 194.3 × 90.8 cm (76½ × 35¾ in). 1883. New York, NY, The Metropolitan Museum of Art. Wolfe Fund, 1913

CHAPTER TWO

Poses

35. Raphael, *Baldassare Castiglione*. Oil on canvas, 82 × 67 cm (32¼ × 26⅜ in). *c.* 1514–15. Paris, Louvre

36. Titian, *Man with a Blue Sleeve*. Oil on canvas, 81.2 × 66.3 cm (31¼ × 25⅝ in). *c.* 1511–12. London, National Gallery

37. Rembrandt van Rijn, *Self-portrait at the Age of Thirty Four*. Oil on canvas, 102 × 80 cm (32 × 26 in). 1640. London, National Gallery

38. Hans Holbein the Younger, *Derich Born*. Oil on panel, 60.3 × 45.1 cm (23¾ × 17¾ in). 1533. Windsor Castle, Royal collection.

It has been said that the traditional novel has only three possible endings: fortune, marriage or death. A similar exaggeration in which there would likewise be a grain of truth, might be formulated to describe the limited number of poses which portrait painters have used.

The conservative way in which poses have been employed in portraiture can be demonstrated by the example of John Singer Sargent's portrait *Lady d'Abernon*, painted in 1904 (Plate 20). The sitter is the very image of Edwardian fashionability, yet the pose can be traced back directly to the sixteenth century. Its origins lie in the work of Titian (*c.* 1488–1576) and the adaptation of elements of his style to English portaiture (and especially court portraiture), successively by Hans Holbein (1497/8–1543) in the sixteenth century and Sir Anthony van Dyck (1599–1641) in the seventeenth. The story of the reappearances of this pose over the centuries illustrates the way in which innovations and developments in portrait poses were dependent upon, and often very closely related to, previous models.

Time and again the threads of these developments lead back to a handful of portraits produced in the few decades of the Italian High Renaissance: Raphael's *Angelo Doni* of 1506 (Palazzo Pitti, Florence) and *Baldassare Castiglione* (Fig. 35), Leonardo's *Mona Lisa*, *c.* 1503–4 (Paris, Louvre), and Titian's *Man with a Blue Sleeve* (Fig. 36), *Man with a Glove* (see Fig. 39) and *Tommaso Mosti* of 1520 (Palazzo Pitti, Florence) among them. The poses developed in these portraits were the product of a new and intense fascination with the effective articulation of the human body, in response to an increased demand for purely secular portraits. Religious iconography did not, it now transpired, always provide adequate or appropriate models. A much greater variety of portraiture was now required and ranged from bust-length (which had hitherto been usual) to three-quarter length, seated and full-length portraits (although the latter format took rather longer to be adopted).

For British art, the absorption of these and a few other related sources into the general vocabulary of portraiture was mediated primarily through the work of Holbein and Van Dyck, and it is therefore worth pausing to consider how these poses came to be adopted and transmitted.

When Holbein first came to England from his native Augsburg in 1526, he must already have seen, whether in France or in Italy itself, a number of highly

35

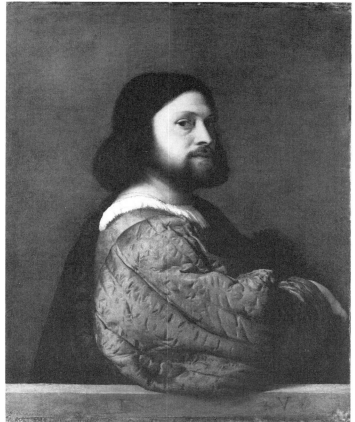

36

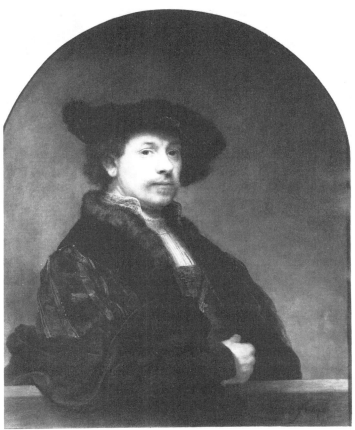

37

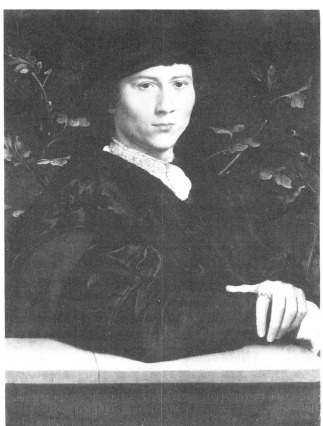

38

39. Titian, *Man with a Glove*. Oil on canvas, 100 × 89 cm (39⅜ × 35 in). *c.* 1523. Paris, Louvre

40. Hans Holbein the Younger, *Henry VIII with Henry VII (the 'Chatsworth Cartoon')*. Black ink and watercolour wash on paper mounted on canvas, 257.8 × 137.2 cm (101½ × 54 in). *c.* 1536–7. London, National Portrait Gallery

41. Sir Anthony van Dyck, *William Laud, Archbishop of Canterbury*. Oil on canvas, 121.6 × 97.2 cm (47⅞ × 38¼ in). *c.* 1635. Cambridge, Fitzwilliam Museum

39

41

40

significant paintings of the Italian High Renaissance. These works, in the original or in the form of copies, included such masterpieces as Leonardo da Vinci's *Mona Lisa* and *Last Supper* (c. 1497), and Raphael's *Baldassare Castiglione*. This is not the place to enter into the controversy surrounding Holbein's possible visits to Italy,[1] but it may be said that the evidence of the influence of Titian's portraits in particular is clear in the work which Holbein produced during his second stay in England, which began in 1532. Holbein had returned to Basle in 1528 after his first visit and, if he did indeed spend some time between 1528 and 1531 in Italy then Mantua, home of the flourishing Gonzaga Court, was a likely destination, as was Ferrara, where the d'Este family also had a remarkable collection of pictures. As Holbein's work after 1531 seems specifically to show the influence of masterpieces that were then in those cities, it is reasonable to suppose that he took the comparatively short journey from Basle to northern Italy at this time when, for such a prolific artist, there is remarkably little documented or surviving work known.[2]

No doubt Holbein intended to bring himself up to date by this Italian journey, and two of the portraits by Titian on which he subsequently drew appear to be *Tommaso Mosti*, which was then in Ferrara, and *Man with a Glove*, then in Mantua, and also *Man with a Blue Sleeve*. It is characteristic of the pattern of portrait developments that *Tommaso Mosti* and *Man with a Glove* may themselves, in turn, be seen as evidence of Titian's own response to the work of Raphael. The former was inspired by Raphael's *Baldassare Castiglione* which was in Mantua by about 1516 (where Titian could have seen it), the latter by Raphael's *Angelo Doni*.[3] It has also been suggested, by way of further indication of the two-way nature of these influences, that Raphael's *Baldassare Castiglione* was itself partly imitative of qualities to be found in the early works of Titian,[4] and in the seventeenth century the same portrait stimulated both Rubens and Rembrandt to copy it. In fact, Rembrandt saw it at the same time as Titian's *Man with a Blue Sleeve,* for both were sold at auction in Amsterdam in 1639,[5] and Rembrandt adapted elements of both pictures to his famous *Self-portrait at the Age of Thirty Four* (Fig. 37).[6]

When we look at Holbein's *Derich Born*, a portrait of a German sitter but painted in England (Fig. 38), it is hard to resist the impression that, a little more than a hundred years before Rembrandt, these same two Italian pictures had exercised a similar fascination on another great northern master.

For the future of English painting, however, one of Holbein's most important adaptations was of Titian's *Man with a Glove* (Fig. 39) to the full-length figure of Henry VII in a great fresco (now lost) that once dominated the Privy Chamber in Henry VIII's Whitehall Palace.[7] A large part of the cartoon for the fresco still survives – the 'Chatsworth Cartoon', a full-scale design executed c.1537 (Fig. 40). The fresco showed the Tudor dynastic line, with portraits of Henry VII, Henry VIII and their Queens, Elizabeth of York and Jane Seymour and was, until its destruction by fire in 1698, one of the most prominent images in London. It was, no doubt, seen in Whitehall Palace by Anthony van Dyck on his first visit to England in 1620–21, and again when, almost exactly one hundred years after Holbein had done the same, he settled in England in 1632.

The influence that Holbein's fresco may have had on Van Dyck's portraits, however, would have been very much less than that of Holbein's own source of

inspiration – the work of Titian. Van Dyck had a regard for Titian amounting to veneration, and the years that he spent in Italy preceding his final return to England had enabled him to study many of the great Venetian's works. Partly as a result of this experience Van Dyck had, by about 1630, developed the pose that ultimately lies behind Sargent's *Lady d'Abernon* (Plate 20), through having seen such portraits by Titian – in addition to those already mentioned – as *Benedetto Varchi*, a portrait which itself has points of similarity to the related full-length pose that Holbein had developed a hundred years before on the basis of his own knowledge of Titian's work. Van Dyck employed this pose on a number of occasions, in varied forms: for example, in *Prince Rupert* of 1631 (Kunsthistorisches Museum, Vienna), and *William Laud, Archbishop of Canterbury* (Fig. 41). Another variation appears in *The Five Children of Charles I* (Plate 19), in the central figure of the young Prince of Wales, the future Charles II.

In Van Dyck's group of the royal children, the height of the Prince of Wales's supported arm in relation to the body gives the pose quite a different effect from that in the Laud portrait, to which it is otherwise quite similar.[8] There is, in fact, a slight awkwardness about the figure of the boy Prince engendered by this pose, which serves to reinforce the amusing way in which the Prince's arm is supported by a dog rather larger than himself. In a similar mingling of formality and humour the usual props of state portraiture – table, ewer, column and drapes – are seen towering over the children. The mixture of the childish solemnity of the sitters with the adult scale of their surroundings strikes exactly the right note of courtly tact.[9] Added wit is given to this Stuart dynastic picture in that the effect of the particular pose used for the Prince of Wales is to recall Holbein's Henry VII in the earlier Tudor fresco (see Fig. 40).

There are circumstantial reasons for supposing that this faint, but distinct, echo was meant to be clearly heard, for Van Dyck's painting was placed in the King's Breakfast Chamber in Whitehall Palace where Holbein's fresco was still to be seen in an adjoining room.[10] In view of Van Dyck's intimate understanding of Titian, it is also interesting to note that Titian's *Man with a Glove*, which has a closely related pose, may have already come into the royal collection by this time.

As Van Dyck had revered Titian, so was Van Dyck himself held in the highest esteem in the eighteenth century, and the two artists were mentioned together in Roger de Piles's assessment of Van Dyck in the *Art of Painting* in 1706:

> If his Performances are not alike perfect, all in the last degree, they carry with them, however, a *Great Character of Spirit, Nobleness, Grace* and *Truth* insomuch that one may say of him, that excepting Titian only *Vandyck* surpasses all the *Painters* that went before him, or have come after him, in Portraits.[11]

To Sir Joshua Reynolds, Van Dyck was 'the first of portrait painters',[12] and his example – or, at least, his reputation as *ne plus ultra* – drove Hogarth, as we have seen, to his own distinctly individual feats of emulation.[13] Van Dyck's pervasive influence, however, in matters of pose and handling, found its finest expression in the portraits of Thomas Gainsborough (1727–88).

Gainsborough's *The Hon. Mrs Thomas Graham* (Fig. 43) clearly derives its pose from portraits by Van Dyck of the kind that we have been examining and is itself of the general type that inspired Sargent's *Lady d'Abernon*. Specifically, as has been shown in a recent study of the influence of Van Dyck upon

42. Sir Anthony van
Dyck, *Catherine
Kirkhoven, Countess of
Chesterfield*. Oil on
canvas, 215.9 × 128.3 cm
(85 × 50½ in). *c.* 1636.
Private collection

43. Thomas
Gainsborough, *The Hon.
Mrs Thomas Graham*.
Oil on canvas,
237.5 × 169.5 cm
(93½ × 66¾ in). *c.* 1777.
Edinburgh, National
Gallery of Scotland

42

44

44. Sir Peter Paul Rubens
(after), *Susanna
Fourment*. Engraving by
James McArdell (as
'Hélène Fourment' by
Van Dyck), 1752.

43

Gainsborough's portraiture, *The Hon. Mrs Thomas Graham* was inspired by Van Dyck's *Countess of Chesterfield* (Fig. 42).[14] It is thought that this Van Dyck portrait was bought by the Earl of Radnor in about 1772, and thus came to Longford Castle, where Gainsborough would have seen it when he executed a group of portraits for the family in 1773.[15]

In Gainsborough's portrait, the Hon. Mrs Graham is wearing a contemporary interpretation of seventeenth-century costume known as 'Vandyke dress', although this particular outfit derived its name from the current misapprehension that Rubens's portrait of his sister-in-law, Susanna Fourment, then in the Walpole collection at Houghton Hall in Norfolk, was a portrait by Van Dyck of Rubens's wife, Hélène (Fig. 44).[16] A number of pictures inspired by this portrait are discussed in the next chapter, but it is important to note here that the fashion for Van Dyck costume, which took a firm hold, began with the portrayal of female sitters in the 1730s.[17] There are not many male portraits that show the sitter both in a pose derived from Van Dyck and in Van Dyck dress before the experiments of Sir Joshua Reynolds (1723–92) in the 1750s, and those attempts were confined to showing children or young men in this manner.[18] Gainsborough was moved to attempt his own Van Dyck costumes only from about 1770, although the influence of Van Dyck, in matters of handling and pose, is evident after his move to Bath from Suffolk in 1759. After 1770, the emulation of his great predecessor became clearer and more frequent and Gainsborough's reinterpretations of Van Dyck poses were now accompanied by reinterpretations of Van Dyck dress. It seems clear that, during his years in Bath (1759–74), as he visited great country houses in the West Country, in Wiltshire, and along the route that lay between Bath and London, it was not only the direct experience of the Van Dyck portraits in these collections that influenced him, but also the fact that he saw in these collections male portraits by his London rival, Reynolds, in which both poses and costumes of Van Dyck were reworked.[19]

Gainsborough's first and most deliberate essay in the use of Van Dyck pose and costume for male portraiture was a portrait of Jonathan Buttall, '*The Blue Boy*' (Plate 21), which made a dramatic impression at the Royal Academy exhibition in 1770: 'Gainsborough is beyond himself in a portrait of a gentleman in the Van Dyke habit' wrote Mary Moser of this picture to J. H. Fuseli.[20] The final impetus for this development may have been that Gainsborough had seen Reynolds's full-length portrait of Jacob Bouverie in Van Dyck dress, painted in 1757 when the sitter was a little boy. It was at the Bouverie home, Longford Castle, and Gainsborough is known to have worked for the Bouverie family by 1770.[21]

The pose of '*The Blue Boy*' (in reverse) was derived from the figure of George Villiers, 2nd Duke of Buckingham, in Van Dyck's double portrait of the two young Villiers boys, a picture which was then at Buckingham House (now Palace) in London (Fig. 45).[22] A drawing by Gainsborough of the head is known, and a copy, half-length, of the two boys was sold in the Swiss art market in 1934 as by Gainsborough.[23]

There is an old story that Gainsborough painted '*The Blue Boy*' and, in 1785, *Mrs Siddons* (Fig. 46), to confute certain precepts, especially concerning colour, that Sir Joshua Reynolds expounded in his eighth *Discourse* to the students of the Royal Academy in 1778.[24] This legend has acquired the dubious status of an 'old chestnut' because, clearly, Gainsborough could not very well have replied to this

45. Sir Anthony van Dyck, *George Villiers, 2nd Duke of Buckingham, and Lord Francis Villiers*. Oil on canvas, 137.2 × 127.7 cm (54 × 50¼ in). 1635. Windsor Castle, Royal collection

45

Discourse in a portrait executed several years earlier. Nevertheless, it is reasonable to suppose that Reynolds had put forward these ideas well before he expressed them in the *Discourse*, and the first reference to the matter in 1820 indeed refers to a 'dispute' among the artists rather than to the relevant *Discourse*. However that may be, there are sufficient other grounds for thinking that 'The Blue Boy' was a deliberate gesture towards Reynolds and his fellow-artists by Gainsborough.

'The Blue Boy' was conceived in terms of professional emulation of Van Dyck who was held, as we have seen, as the touchstone of excellence in portraiture in the eighteenth century; and, in so far as the picture was also directed at Gainsborough's great contemporary, Reynolds, its exhibition in 1770 at the newly-founded Royal Academy seems effectively to have stopped Reynolds in his tracks. The fact is that, while Reynolds had painted some sixteen male sitters in Van Dyck costume up to this date, he painted none for the next six years and only three or four in the rest of his career. His own more timid half-length in Van Dyck costume, *Lord George Seymour Conway* (now in Bucharest), was to be seen in the same exhibition as the full-length '*Blue Boy*', and can hardly have benefited from the comparison. Reynolds did not try his next full-length male portrait in Van Dyck dress until 1776, *Lord Althorp* (Earl Spencer), and it is interesting to note that it was exhibited at the Royal Academy among a whole group of portraits in various costumes – 'hidden' as it were – that made up Reynolds's contribution for that year.[25]

The main precept of Reynolds concerning colour that Gainsborough may have had it in mind to confute in 'The Blue Boy' was that, in order to achieve 'that great effect which we observe in the works of the Venetian painters', cold colours such as blues, greys and greens should be kept out of the 'masses of light in a picture', which should instead 'be always of a warm mellow colour, yellow, red, or a yellowish-white', and that cold colours should be used only to 'support and set off these warm colours in the central masses':

> Let this conduct be reversed: let the light be cold, and the surrounding colours warm, as we often see in the works of the Roman and Florentine painters, and it will be out of the power of art, even in the hands of Rubens or Titian, to make a picture splendid and harmonious.[26]

If he was aware of the new President's opinions by 1770, Gainsborough could hardly have made a more telling riposte than 'The Blue Boy' (so-called, William Jackson recorded in 1798, 'among the painters').[27] Filling the centre of this truly 'splendid and harmonious' picture is the sitter, dressed wholly in blue; and in choosing this colour Gainsborough 'reversed' the colour (to use Reynolds's term), as well as the pose of his model, for Van Dyck's George Villiers is dressed entirely in red. It may be that the rather private nature of Gainsborough's portrait freed him to make a personal 'statement': the sitter, Jonathan Buttall, whose father was a well-to-do ironmonger in Soho, was 'one of the few friends most respected' whom Gainsborough desired in his will should attend his funeral at Kew. Apart from its apparent effect upon Reynolds, 'The Blue Boy' also succeeded in demonstrating that a modern artist of sufficient brilliance could equal Van Dyck. Hogarth had attempted the same, but his idiosyncratic means had multiplied his difficulties. Gainsborough's 'Blue Boy', with the sitter dressed in costume and taking a specific pose from Van Dyck, at once made the comparison more obvious and the attempt more daring. One of Gainsborough's fellow-Foundation Members of the Royal Academy, Francis Hayman, was immediately prepared to announce it 'as fine as a Van Dyck'.[28]

The reasons for the desire of eighteenth-century sitters to be portrayed in Van Dyck costume were several. In the case of old families, the new picture would 'go with' the Van Dyck portraits already on the walls of their houses, and thus set up a sense of elegant 'imitation' that was such a popular mode of wit, defined in literary terms by Dr Johnson in his *Dictionary* of 1755 as:

> A method of translating looser than paraphrase in which modern examples and illustrations are used for ancient, or domestick for foreign.

Again, in his life of Pope, he referred to it as:

> A kind of middle composition between translation and original design, which pleases when the thoughts are unexpectedly applicable, and the parallels lucky.

Another reason was that the portrait thus escaped the evanescence of everyday fashion, something that Reynolds often attempted by portraying his female sitters in flowing drapery of a vaguely classical kind of his own devising. A third reason was that painters of the quality of Reynolds and Gainsborough could supply portraits reminiscent of ancestral splendours to families without ancestors of the right kind to have been portrayed by Van Dyck himself: the then *nouveau riche* Bouverie family was a case in point.[29]

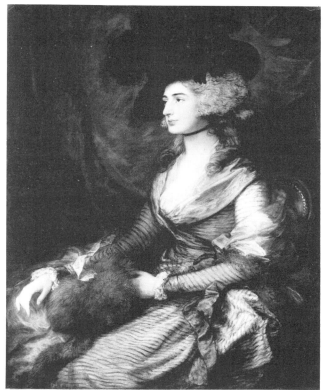

46

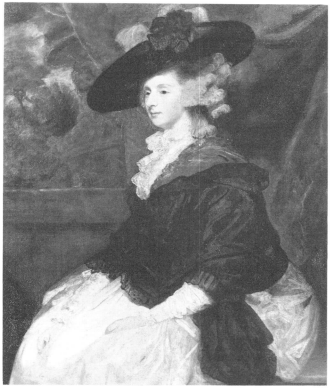

47

Gainsborough's '*Blue Boy*' was itself imitated in a portrait by the American Joseph Wright (1756–93), whose *John Coats Browne* (see Fig. 16) tells us much about the aesthetic temper of the new American Republic, where the affectation of 'Vandyke dress' appears to have been unknown. The pose is clearly enough indebted to '*The Blue Boy*', which Wright had evidently seen during his stay in London as a pupil of Benjamin West, something he could well have done as his mother, the wax-modeller and American spy, Phoebe Wright, was one of Gainsborough's friends. The Van Dyck costume, however, has been replaced by firmly contemporary and down-to-earth clothes with the exception of the plumed hat which is retained. It is an intriguing image, not least because the plainer clothes are accompanied by the introduction of a grand studio setting that is actually more in keeping with a Van Dyck portrait than is Gainsborough's landscape background for the same pose. The portrait offers a revealing contrast with the 'transliterations' of many colonial portraits of the earlier part of the century, when incidental props and elaborate costumes might be foisted on to the sitter wholesale from the mezzotint source of inspiration (see Figs 69, 70, 71). There is a new confidence here, and it is one dependent on a first-hand knowledge of contemporary British and European portraiture that came with travel and study abroad. The sophistication of Joseph Wright, who became rather more than a 'rather trivial painter', as the late Professor Waterhouse described him, is further revealed when we discover the coincidence that his sitter, John Coats Browne, was, like Gainsborough's Jonathan Buttall, the son of a successful ironmonger.[30]

Returning to Gainsborough, we may recall that his *Mrs Siddons* (Fig. 46) was the second portrait that legend associated with '*The Blue Boy*' in a presumed confutation of Reynolds's precepts about colour and composition. Certainly, as

46. Thomas Gainsborough, *Mrs Sarah Siddons*. Oil on canvas, 126.4 × 99.7 cm (49¾ × 39¼ in). 1785. London, National Gallery

47. Sir Joshua Reynolds, *Lady Cornewall*. Oil on canvas, 127 × 101.5 cm (50 × 40 in). *c.* 1786. Washington, DC, National Gallery of Art. Widener collection, 1942

we have seen, 'The Blue Boy', and the implicit reaction of Reynolds to its success, is sufficient evidence that Gainsborough was setting himself up very deliberately in competition with Reynolds, and there were a number of occasions when contemporaries became keenly aware that the rivalry was more or less open. Such a moment arrived in 1782 with the exhibition of their respective portraits in the Royal Academy of the hero of the American War of Independence, Colonel Tarleton (see Fig. 63), which occasioned a newspaper of the day to refer to 'a proud rivalship' between Reynolds and Gainsborough.[31] Gainsborough's *Mrs Siddons* gives further substance to the story that the battle was also joined at the level of aesthetics.

Mrs Siddons was painted in 1785, some years after Reynolds's eighth *Discourse*, and bears a surprisingly accurate (inverse) relation to Reynolds's remarks quoted above on the inadvisability of blue in the main figure: the sitter is dressed in pale blue against a rich red background. Furthermore, in addition to the fact that Mrs Siddons also sat to Reynolds in 1785 for his characteristic picture *Mrs Siddons as The Tragic Muse*, there is the strange coincidence that the unusual pose of Gainsborough's portrait, also showing the sitter in near-profile, was used by Reynolds at about the same time in *Frances, Lady Cornewall* (Fig. 47), a picture for which Reynolds was paid in 1786.

There, however, the resemblance ends, for the portrait of Lady Cornewall is one of Reynolds's worst efforts. The drapery painter here did a particularly bad job, producing a botched version of Van Dyck dress. By way of contrast, it is a striking feature of Gainsborough's *Mrs Siddons* that the sitter is shown in the height of contemporary fashion. Here too, Gainsborough has scored a palpable hit, for the success of the portrait depends upon his handling of this very feature, contemporary fashion, that had posed such problems for the President of the Royal Academy, whose own female portraits of recent years had often shown sitters swathed in indeterminate drapes. A close observer of the time particularly noted 'the new style of the drapery . . . Mrs Siddons's dress is particularly *novelle*, and the fur around her cloak and foxskin muff are most happy imitations of nature'.[32]

If Reynolds attempted his own version of this picture in *Frances, Lady Cornewall*, it was evidently unwise, but it would have been characteristic of his endless willingness to try new ideas. His portraits demonstrate a degree of inventiveness in the matter of trying new poses that is almost bewildering, and gave rise to Gainsborough's famous remark of frustration, 'Damn him! how various he is.'[33] Many of Reynolds's portraits use poses taken from Old Master paintings, as well as from classical sculpture, and this pragmatic eclecticism naturally enough gave rise to charges of plagiarism. It was an accusation that Reynolds was well able to refute by the arguments he put forward in his sixth *Discourse*, which amount to an interpretation of this habit as another form of 'imitation'. His words on the subject apply not only to his own works, but also to such exercises as Gainsborough's '*Blue Boy*' and, indeed, to many of the conscious borrowings of poses by one artist from another that we have been examining:

He, who borrows an idea from an antient, or even from a modern artist not his contemporary, and so accommodates it to his own work, that it makes a part of it, with no seam or join appearing, can hardly be charged with plagiarism: poets practise this

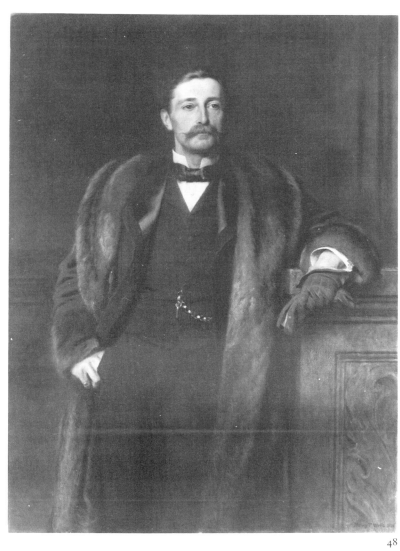

48. Henry Tanworth
Wells, *Sidney, 14th Earl
of Pembroke.*
104 × 83.8 cm (41 × 33 in,
cut down from
60 × 40 in). 1898. Wilton
House, Salisbury,
Wiltshire

48

kind of borrowing, without reserve. But an artist should not be contented with this
only; he should enter into a competition with his original, and endeavour to improve
what he is appropriating to his own work. Such imitation is so far from having
anything in it of the servility of plagiarism, that it is a perpetual exercise of the mind, a
continual invention.[34]

When John Singer Sargent painted *Lady d'Abernon* in 1904, he too was
'imitating' earlier artists, in this case, Reynolds and Gainsborough themselves.
Sargent was an admirer of eighteenth-century English portraiture and can be said
to have entered an 'English phase' in 1900 with his portrait of Lord Dalhousie
(Private collection) which draws inspiration from this source. And, no doubt, the
use of a similar pose by Henry Tanworth Wells (1828–1903) in 1896 (Fig. 48)
owed much to the fact that the picture in question was to hang at the Earl of
Pembroke's house, Wilton, which has one of the greatest of all collections of Van
Dyck portraits. We know that, on more than one occasion, Sargent was asked to
provide portraits that would complement existing ones: his *Marlborough Family*
of 1905 (The Duke of Marlborough), for example, was painted to reflect
Reynolds's *Family of the 4th Duke of Marlborough* of 1778 (The Duke of
Marlborough) and designed to hang opposite it;[35] his *Family of Sir George
Sitwell, Bt,* of 1900 was painted to complement J.S. Copley's ingenious

conversation piece *The Sitwell Children* of 1786, a request that provoked Sargent to exclaim, 'I can never equal that!'[36] It is revealing that, despite the almost restless ingenuity of Reynolds in experimenting with new poses, later portrait painters were content to continue with much the same as before, deriving ultimately from Titian and Van Dyck, to which were added a few poses inspired by classical sculpture. Sargent's *Lady d'Abernon* is easily recognizable as a portrait employing a variation on one of those key poses that we have noted.

Through this brief study of one or two related poses, the pattern of emulation can be seen to repeat itself in the work of successive masters (even when separated by a hundred years), as each master 'imitates', in that creative eighteenth-century sense of the word, the work of an admired predecessor in the idiom of his own day. As Reynolds said of Gainsborough's studying and copying Old Master paintings: 'What he thus learned, he applied to the originals of nature, which he saw with his own eyes; and imitated, not in the manner of those masters, but his own[37]'.

As a direct result of the long shadow cast by Van Dyck over English art, one particular pose derived from Titian in the sixteenth century remained, through successive revivals 'in fashion', as we have seen, until the twentieth. But fashions in poses, something that it is vital to recognise if portraits are to be fully understood, could be much more short-lived. Occasionally, they were so limited to a brief appearance on the stage, and the circumstances that gave rise to them so peculiar, that it is hard to imagine how they came into fashion in the first place. A particularly odd example is that of the pose in Gainsborough's *John Plampin*, a portrait painted in the early 1750s (Fig. 49).

This elaborately relaxed pose derives from a portrait by the great French artist Antoine Watteau (1684–1721), *Antoine de La Roque*, which was engraved by Lépicié in 1734 (Fig. 50).[38] Its first appearance in England was for the figure of the rake in the brothel scene of Hogarth's *The Rake's Progress* (Fig. 51), the engravings of which were published in June 1735. The print after Watteau had, presumably, swiftly found its way into England, where collectors such as Dr Richard Mead were great admirers of Watteau: it had been published at just the time that Hogarth was working on the paintings of *The Rake's Progress*. It has been suggested that the pose was perhaps transmitted to England via a French printed calendar of 1720, which was in turn plagiarized by George Bickham in a vignette in his *Musical Entertainer* of 1737/8.[39] But that does not account for Hogarth's use of the pose in 1734–5, and the likelihood that the Watteau engraving itself was known in England its increased when one considers that Gainsborough's *John Plampin* re-uses the motif of the dog of the Watteau picture – a detail absent from the calendar – and that Plampin, like Watteau's *Antoine de La Roque*, is also disposed on a bank under a tree.

When Gainsborough painted *John Plampin*, the pose had already been used by Francis Hayman (1708–76) in *David Garrick and William Windham of Felbrigg* (Fig. 53) and *The Wapping Landlady* of c. 1742 (Victoria and Albert Museum), and in a portrait painted at about the same time as that of Plampin, and formerly attributed to Gainsborough (Fig. 52).[40] The natural explanation would seem to be that, following Hogarth's use of it in 1734–5, the engraving after Watteau became available for study at the St Martin's Lane Academy, which was started by Hogarth in 1735, where both Hogarth and Hayman were leading figures, and

where the young Gainsborough is generally held to have had some instruction from Hayman.[41]

Hogarth's instinctively parodic turn of mind had seized upon the notion of incapacity present in Watteau's picture. The rake is rendered incapable through drink, an incapacity that extends, by implication, to his dealings with the 'nymphs' that Hogarth substitutes for those visible in the background of Watteau's portrait. Nor is this borrowing from Watteau's portrait entirely gratuitous, for de La Roque's pose is the result of incapacity due to a wound received at the Battle of Malplaquet. It seems, in fact, that Hogarth is almost parodying the general sense of this unusual portrait, which Professor Donald Posner has glossed in the following words:

> In Watteau's picture the spirits – as spirits – seem as real as the sitter. They have no specific allegorical meaning, and they emerge unsuspected from the woods and rocks. They characterize the quality, not of the sitter, but of the place to which he has come to refresh himself. It is as if by his devotion to the muses the old soldier was magically transported to an idyllic, pastoral land.[42]

A further visual reference to this source is surely Hogarth's substitution, for the old soldier's discarded cuirass, of the 'posture woman's' discarded corset. Watteau's picture is itself almost an eccentric portrait, and the curious thing is that such surprising material should have been adapted to an image of English gentlemanly ease such as we see in Gainsborough's *John Plampin*. One of the main reasons that this pose was so rapidly adapted to English portraiture was because the posture conformed to current rules of deportment, which insisted upon a pleasing variation in the arrangement of the limbs. Another reason was that the resulting image was composed of attractive curves and counter-curves that accorded with rococo taste. The fad for this particular pose was short lived, but rules of etiquette and deportment – the importance of gentlemanly 'carriage' – had a profound and controlling effect upon portraits in the seventeenth and eighteenth centuries.[43]

The fact is that many poses of eighteenth-century portraits have little or nothing to do with the individual sitter, who is merely adopting an attitude established by rules of deportment, in a posture that a specialist drapery painter could easily supply for the artist who had painted the face. Hogarth occasionally defied convention, and the strong impression of a modern individuality that some of his portraits convey is the result – for example, *Captain Coram* (see Fig. 4), *William Jones* of 1740 (see Fig. 84) and also *George Arnold* (Fig. 54). These sitters adopt attitudes that are indeed 'natural': but to their contemporaries they would, for very precise reasons, have appeared coarse, even shocking. These self-evidently fine paintings portray sitters who, it is clear, did not care to be portrayed as fine gentlemen – which they were not. George Arnold holds his upturned hat firmly in both hands, themselves not disposed in a sufficiently varied manner to satisfy the rules. Unlike the French sitter in the source for Hogarth's *Captain Coram* (see Fig. 5), Coram does not have his feet at right angles to each other, and each hand clutches an object in far too similar a way for refined taste; and, in an age when wigs were worn, to appear in your own hair, in a portrait, especially one with so splendid a setting as that of *Captain Coram,* was unusual.[44]

When we see a conventional eighteenth-century portrait such as Thomas

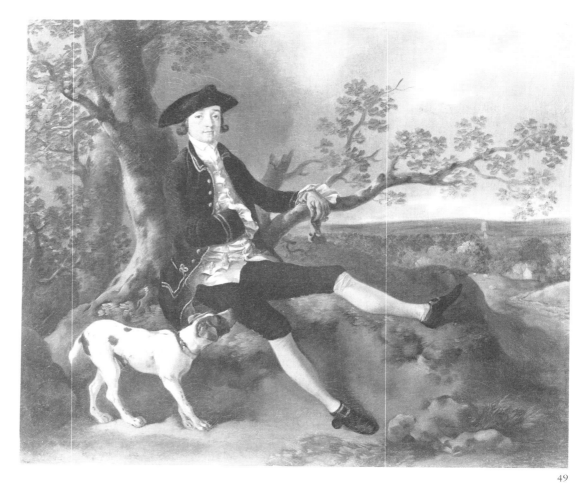

49

49. Thomas
Gainsborough, *John
Plampin*. Oil on canvas,
50 × 60.5 cm
(19¾ × 23¾ in). *c.* 1753–4.
London, National
Gallery

50. Antoine Watteau
(after), *Antoine de La
Roque*. Engraving by
Bernard Lépicié, 1734

51. William Hogarth, *The
Rake's Progress, III: The
Orgy*. Oil on canvas,
62.2 × 74.9 cm
(24½ × 29½ in). 1734.
London, Sir John Soane's
Museum

52. Francis Hayman,
Portrait of a Gentleman.
Oil on canvas,
63.5 × 76.5 cm
(25½ × 30¼ in). *c.* 1750. St
Louis, MO, The Saint
Louis Art Museum

53. Francis Hayman,
*David Garrick and
William Windham of
Felbrigg*. Oil on canvas,
85 × 102 cm (33½ × 40 in).
Private collection

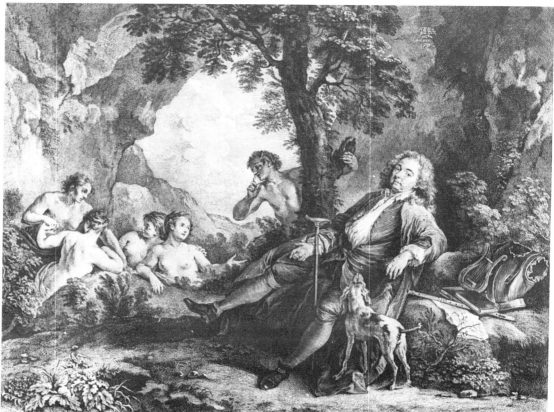

50

51

52

53

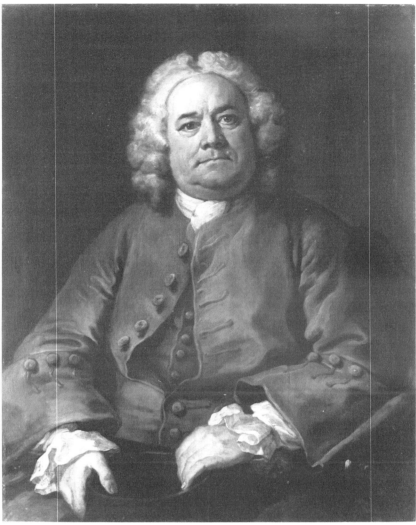

54. William Hogarth,
George Arnold. Oil on
canvas, 91 × 70.8 cm
($35\frac{5}{8} \times 27\frac{7}{8}$ in). *c.* 1740.
Cambridge, Fitzwilliam
Museum

54

Hudson's portrait of a man perhaps to be identified as Charles Douglass (Fig. 56),
it may well strike us that it has a formal, contrived air about it. That is because the
pose is indeed artificial, in almost every respect – however natural it became to the
person trained by rigid rules of behaviour to adopt it. We can see that the sitter's
back is arched (although the shoulders are not thrown *too* far back), the head held
high, the feet set at right angles to each other, the hands 'pleasingly differentiated'
by their varied gestures. As Lord Chesterfield wrote to his godson in 1765: 'Turn
out your right foot, raise your head above your shoulders, walk like a
Gentleman.'[45] Conversely, it was ill-bred to stand with your shoulders slumped,
your feet parallel to each other and taking no care with the position of your arms
and hands. An excellent comparison of these distinctions in deportment is
afforded, as Professor Alastair Smart has shown, by the contrasing figures of the
aristocratic (if impoverished) Earl and the ill-bred (but rich) merchant, and their
respective offspring, in the first scene of Hogarth's *Marriage à-la-Mode*
(Fig. 55).[46]

 The main formulations of these ideas were published in fully-illustrated English
translations. Gérard de Lairesse's *The Art of Painting in all its Branches* appeared
in 1738, and F. Nivelon's *Rudiments of Genteel Behavior* in 1737, the latter with

engravings by L.P. Boitard after designs by the portrait painter Bartholomew Dandridge (1691–c. 1755). Nivelon's book describes the 'the Method of Attaining a Graceful Attitude, and Agreeable Motion, an easy air and a genteel Behaviour', the end being to 'distinguish the polite Gentleman from the rude Rustick', and to acquire, more surprisingly, a stance 'free of affectation'.[47] It can readily be seen how closely Plate I of the second part of Nivelon's book (Fig. 57) corresponds to Hudson's presumed portrait of Douglass (Fig. 56) as a whole and, in various details, to many other eighteenth-century portraits. Although Nivelon's book, we may assume, was partly directed at those ungenteel members of the population who wished to rise in the world, Chesterfield's letters abundantly display the anxiety of a society grandee over these matters – so much so, indeed, that Dr Johnson, a member of a new and more independent intellectual class, could condemn them as teaching 'the morals of a whore and the manners of a dancing-master'.[48] His close friend Reynolds, unusually for a portrait painter, also spoke 'with contempt of those who suppose grace to consist in erect position, turned out toes, or the frippery of modern dress'.[49]

A specific point that often baffles modern viewers is the habit of tucking one hand inside the waistcoat. James Northcote, a pupil of Reynolds, is partly responsible for starting the *canard* that it was a way of the painter's avoiding the

55. William Hogarth, *Marriage à-la-Mode*, I: The Marriage Contract. Oil on canvas, 70 × 91 cm (27½ × 35¾ in). 1743–5. London, National Gallery

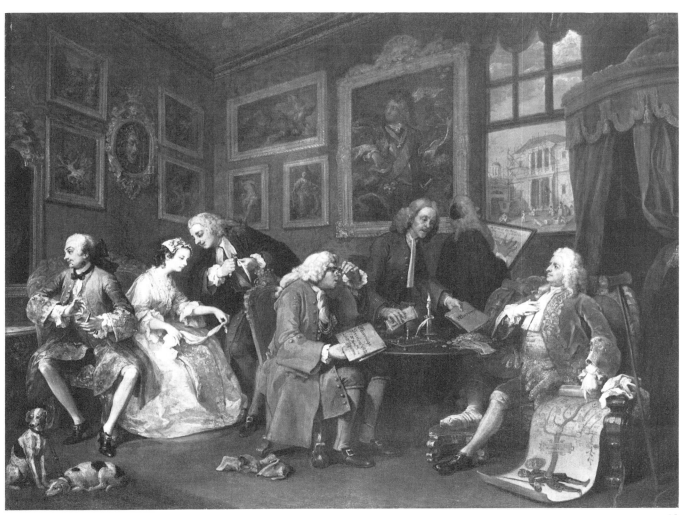

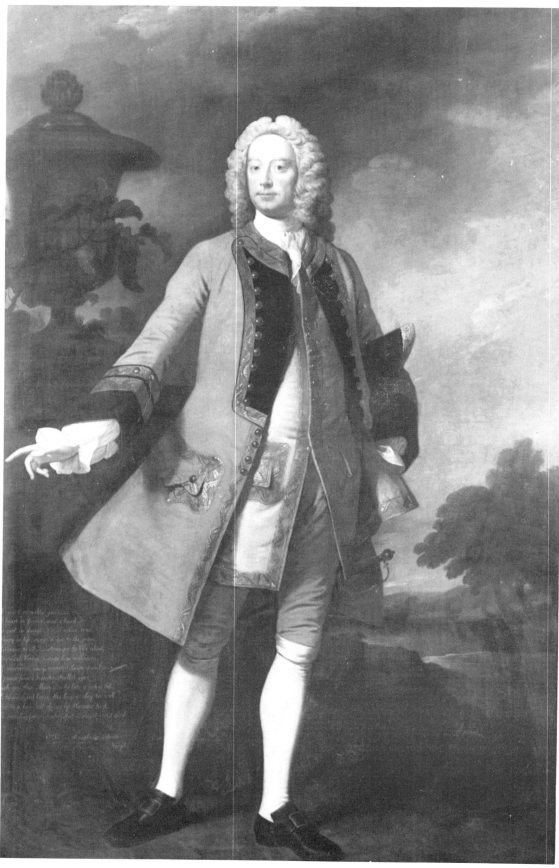

56. Thomas Hudson, *A Gentleman said to be Charles Douglass*. Oil on canvas, 231.1 × 146.2 cm (91 × 57½ in). *c.* 1754–5. Christie's, 21.XI.75 (88)

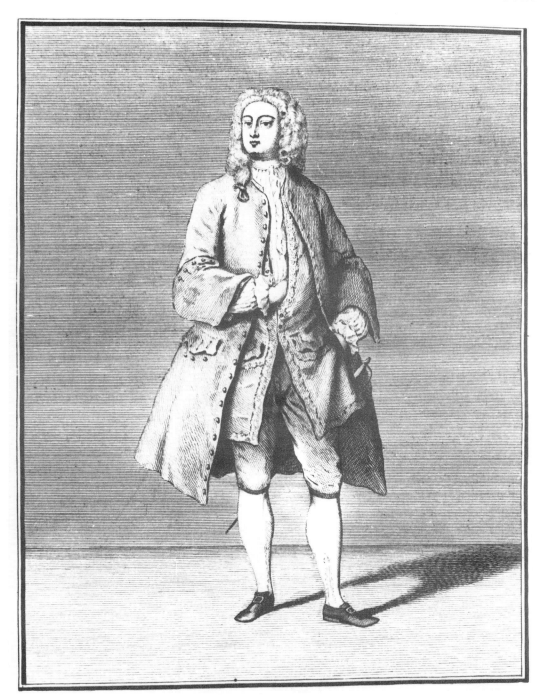

57. Bartholomew
Dandridge (after).
Engraving by L. P. Boitard
for F. Nivelon,
*Rudiments of Genteel
Behavior* (1737), Plate 1

57

difficulty of painting hands.[50] The true explanation of its origin appears to have
been the necessity of keeping one hand warm if a glove had been removed (as
would be the case in order to shake hands) as *John Plampin* (see Fig. 49)
demonstrates. Nevertheless, however functional it may have been to begin with,
the gesture became merely fashionable as a neat way of solving the problem of
disposing your hands differently. It is a point specifically covered by Nivelon in his
advice on how to stand. The passage is worth quoting in full in order to
demonstrate how precise the prescription for gentility could be (Fig. 57):

Standing

The Head erect and turnd as in this figure, will be right, as will the manly Boldness in the Face, temper'd with becoming Modesty; the Lips must be just join'd to keep the Features regular; the Shoulders must fall easy, and be no farther drawn back than to form the Chest full and round, which will preserve the true Proportion of the Body, but if they are too far drawn back, the Chest will appear too prominent, the Arms stiff and lank, and the Back hollow, which will intirely spoil the true Proportion, and therefore must be carefully avoided. The Arms must fall easy, not close to the Sides, and the Bend of the Elbow, at its due Distance, will permit the right Hand to place itself in the Waistcoat easy and genteel, as in this figure is represented; but any rising or falling the Hand from that Place, will make it appear lame, and consequently disagreeable; the Hat shou'd be plac'd easy under the left Arm, and that Wrist must be free and straight, and the Hand support itself above the Sword-hilt; the Sword exactly plac'd as shewn in this Figure, is the only proper and genteel Situation for it; the whole Body must rest on the right Foot, and the right Knee, as also the Back be kept straight, the left leg must be foremost and only bear its own weight, and both Feet must be turn'd outwards, as shown by this Figure, neither more nor less, but exactly.[51]

It may seem surprising that the way one looked should be so governed by precepts of this kind, although a little reflection will show that these rules have merely been superseded by others (and it is not long since young ladies were trained in deportment by having to balance books on their heads). But it is certainly odd to reflect that the very expression of your face in a portrait might be the result of the painter's application of yet another set of rules governed by an even more minute system. Although such an influential work as Charles le Brun's *A Method to Learn to Design the Passions,* a French book first published in 1698 and translated into English with this title in 1701, is of more relevance to history and to subject paintings generally, it can be shown that it exerted a distinct influence on portraiture, although often of the 'elevated' kind practised, for example, by Reynolds in *Lady Sarah Bunbury Sacrificing to the Graces* (Plate 22).[52] These ideas were very much the product of an age when many were led into believing that every aspect of human behaviour could be rationalized.[53]

We have looked at both short- and long-lived poses, and at the effect upon portraiture of contemporary manners in a particular period. Another major, and lasting, influence upon portraiture was that of classical sculpture. Naturally, it was something to which patrons who took the Grand Tour in Europe were increasingly likely to respond, and in the eighteenth century especially it became common for both patrons and artists to visit Italy and study the collections of classical sculpture there. Many classical sculptures became known through engravings and, from its foundation, the Royal Academy had a collection of plaster casts.

The urge to translate classical models into modern form lay at the foundation of the Augustan age in England, which began after the Restoration of Charles II in 1660. The Augustan vision was of England as another Rome as it had appeared in the 'golden age' of Augustus when Virgil and Horace flourished, a time of enlightened and wealthy patronage (although attitudes to Augustus himself were mixed). The English 'Augustan' could see Augustus's proverbial boast, 'I found Rome brick and left it marble', as a profound and wide-reaching cultural metaphor.

58

59

Augustanism is a familiar subject of study in literature[54] but it has been less generally recognized that painters might also be possessed of a similar sensibility, or have worked for a patron of Augustan cast of mind. Such a patron was Anthony Ashley-Cooper, 3rd Earl of Shaftesbury (1671–1713), author of the famous *Characteristics* (1711). Under his encouragement and direction, John Closterman, a technically expert but hitherto unimaginative portrait painter, produced a series of remarkable classicizing portraits, notably, in about 1701, a double portrait of the Earl and his brother (Fig. 59) in which the poses imitate those of the Roman sculpture of the heavenly twins *Castor and Pollux* (Fig. 58).[55] In painting as in literature, much of the success of these witty 'imitations', in which poses from the classical past were adapted to modern portraiture, depended on the recognition of the original by the beholder. Some imitations were particularly apposite: Wright of Derby (1734–97) amusingly adapted the classical Hercules with his club, *The Farnese Hercules* (Fig. 60), to the figure of a young boy leaning on his cricket bat in *The Wood Children* (Fig. 61), while Reynolds, in one of his most brilliant efforts of this sort, adapted the supposed '*Cincinnatus*' (Fig. 63) to his portrait of *Colonel Tarleton* (Fig. 62), using the pose in reverse.[56] Both these 'imitations' are relevant to the activity of the modern sitter: Wright's boy is mock-

58. *Castor and Pollux*. Marble, height 158 cm (62¼ in). Madrid, Prado

59. John Closterman, *Anthony Ashley Cooper, 3rd Earl of Shaftesbury and the Hon. Maurice Cooper*. Oil on canvas, 241 × 170.8 cm (95¾ × 64¼ in). *c.* 1700–1. London, National Portrait Gallery

60. *The Farnese Hercules.*
Marble, height 317 cm
(124¾ in). Naples, Museo
Nazionale

61. Joseph Wright of
Derby, *The Wood
Children.* Oil on canvas,
167.6 × 134.6 cm
(66 × 53 in). 1789. Derby,
Derby Art Gallery

61

heroically seen with a modern 'club' preparing to do battle; Tarleton, like
Cincinnatus, had left home to do battle, and is portrayed after his return from the
American Colonies. In both instances, the words of Dr Johnson are especially apt:
'the thoughts are unexpectedly applicable and the parallels lucky.'

Many adaptations, however, were much vaguer and one sometimes gets the
impression that when (as in Reynolds's studio, for example), customers were
invited to look through portfolios of prints in order to choose a pose, the choice
was a matter purely of whim.[57] Poses taken from the Old Masters and from
classical sculptures were employed by Reynolds and other like-minded artists for
the far more general purpose of 'elevating' portraiture in the direction of the

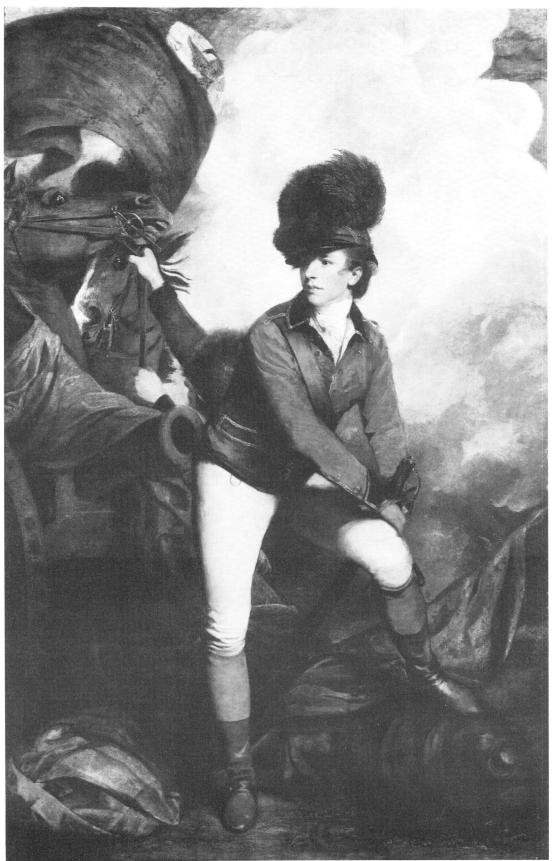

63. *Hermes*?
('*Cincinnatus*'). Marble,
height 154 cm (100 in).
Paris, Louvre

62. Sir Joshua Reynolds,
Colonel Tarleton. Oil on
canvas, 236 × 145.5 cm
(93 × 57¼ in). 1782.
London, National
Gallery

'Great Style' of history painting, and it evidently didn't always matter how far the 'ancient' source corresponded with the modern circumstance. That is true, for example, of one of the more famous of these adaptations, that by Reynolds of the *Apollo Belvedere* (Fig. 64) to *The Hon. Augustus Keppel* in 1753–4 (Fig. 65), an instance where the classical source is not quoted so exactly as in the portrait of Colonel Tarleton. Such would also seem to be the case with the British portrait that appears to have been the first to derive the pose of the sitter from the *Apollo Belvedere*, the Italian-trained Allan Ramsay's *Norman, 22nd Chief of Macleod* (Fig. 66), painted in 1747–8. What may obscure these facts to modern eyes is that both Ramsay and Reynolds were sophisticated artists who, while they may have been drawing on a single, principal source of inspiration, might also subtly vary details of their source in the sitter's pose. For example, some details of the source could be used in reverse – as was the whole figure in Reynolds's *Colonel Tarleton*.

In Ramsay's *Norman, 22nd Chief of Macleod*, the *Apollo Belvedere* is referred to in such a flexible way that, as with Reynolds's portrait of Keppel, it has been questioned whether the *Apollo Belvedere* is indeed the classical source for the pose seen here.[58] It has been proposed in the case of Ramsay's portrait that a more specific reference is perhaps being made to another classical statue (or group of statues), the 'magistrate' type in a full-length toga that occurs in Roman sculpture, thus endowing the sitter with overtones of 'civic virtue'.[59] However, the evident differences between Ramsay's portrait and this obscure source are at least as great as those between the portrait and the famous, and then (as today) widely recognizable, *Apollo*.

The points of similarity are, in fact, more suggestive of the *Apollo* being the principal classical point of reference. For example, the bare legs of the *Apollo* are plainly visible, and form a prominent feature of Ramsay's portrait, the sculptural source here providing the painter with an excellent justification for showing off his sitter's well-turned calves encased in their tight-fitting trews, the set of the lower limbs in relation to the torso evidently recalling (in reverse) those of the *Apollo*. The 'magistrate' type, supposing it, for the sake of argument, to have been recognizable as a source at this time, could not have afforded such an opportunity, for the legs in statues of that type are obscured beneath a toga of office that reaches to the ground. Indeed, it was precisely the proportion of the lower limbs of the *Apollo* that was a principal point of discussion at the time.[60] The set of the head in Ramsay's portrait, both dignified and imperious, in relation to the upper part of the body (still in reverse) again argues in favour of the *Apollo* as the main source for the pose.

Of course, the arms are somewhat differently disposed in Ramsay's portrait, as they are in Reynolds's: Reynolds pointed out that, if the original drapery of the sculpture were removed, the angle of the outstretched arm in relation to the body would have to be softened.[61] That effect, evident in these portraits, may also be partly explicable in terms of the artists' having exploited, for these details, the effect of a differently foreshortened viewpoint of the three-dimensional sculpture. A variety of views of this famous figure were available in books of engravings, a source that Jonathan Richardson referred to in the context of a discussion of the *Apollo* in 1722.[62] It would seem that Ramsay's (like Reynolds's) exploitation of the *Apollo Belvedere* is an occasion on which a vague point is being made, by way of an educated 'conceit', without any specific associational meaning being

intended, other than that which lends the sitter's image a general air of antique poise.

The *Apollo* was, as we have said, readily available for study in engravings, and could probably by this time have been studied in complete, as well as in partial, casts in England. It was also one of the highlights of the Grand Tour.[63] In contrast, there appears to have been no attention paid to the 'magistrate' type of statue during this period, and there would, of course, have been no point in 'imitating', in the Augustan sense, a source that no one could recognize.

It is worth arguing this rather minute point at some length in view of the priority of Ramsay's portrait over Reynolds's, since it was the latter's *The Hon. Augustus Keppel* that received, for very good reasons, the greater acclaim. For, whatever the force of these borrowings, Ramsay's *22nd Chief of Macleod* was a decisive step towards the creation of the 'grand style' in England and, as the late Professor Waterhouse observed, 'it is impossible to escape from the conclusion that the marriage of the Italian grand style to British portraiture was primarily the achievement of Ramsay' and not, as is so often supposed, that of Reynolds.[64] The fact that Ramsay's picture immediately went to a remote Scottish island on completion has obscured the near-certainty of its having been the direct inspiration for Reynolds's own *The Hon. Augustus Keppel* (see Fig. 65) of some six years later – itself such a spectacular and, apparently, original adaptation of the *Apollo Belvedere*. The similarities to Ramsay's picture extend beyond the pose and include the setting, with rocks, trees and seashore; the pattern of foreground and middleground; and the general disposition of tonal variations. Whilst one setting, however, is calm and clear, no doubt suggesting to both artist and sitter the lochs of the Western Isles they both knew, the other is dramatic, recalling Keppel's recent shipwreck.[65] The explanation for Reynolds's familiarity with Ramsay's portrait must lie in the fact that both Ramsay and Reynolds's teacher, Thomas Hudson (1701–79), in whose studio Reynolds was working until 1743, shared the same drapery painter, Joseph van Aken (*c*. 1709–1749), whose guide drawing for Ramsay's portrait of the Chief of Macleod survives (Plate 23).[66]

It is clear that Reynolds, despite having abandoned his apprenticeship with Hudson in 1743, remained in close touch with him, and continued to spend much of his time in London between 1744 and 1749. He could surely have visited the studio of Van Aken, who was still working for both Hudson and Ramsay, and there have seen Ramsay's portrait of the Macleod.[67] Reynolds left for Italy in 1749, where he could study for himself the source of Ramsay's remarkable innovatory portrait, a portrait that, had it not been for the circumstances of Reynolds's early training, could have exerted very little influence upon later portraiture from its fastness on the Isle of Skye. As it was, after the resounding success of Reynolds's *The Hon. Augustus Keppel*, many variations were to be played on the theme.[68]

Support for the above explanation comes from the existence of Hudson's portrait *A Gentleman called Charles Douglass* (see Fig. 56), which not only corresponds to the rules of gentlemanly deportment set out in Nivelon's *Rudiments of Genteel Behavior*, but also, in the matter of pose and setting, to Ramsay's *Norman, 22nd Chief of Macleod*. It therefore seems that Ramsay's picture influenced both Reynolds and Hudson. The similarity extends to the identity of gesture in the right hand of the Hudson and Ramsay figures although

64. *Apollo Belvedere.* Marble, height 224 cm (88¼ in). Vatican Museum

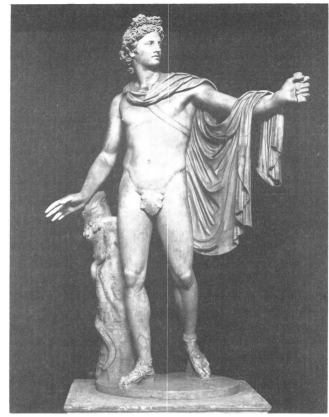

64

65. Sir Joshua Reynolds, *The Hon. Augustus Keppel.* Oil on canvas, 238.8 × 147 cm (94 × 57⅞ in). *c.* 1753–4. Greenwich, National Maritime Museum

66. Allan Ramsay, *Norman, 22nd Chief of Macleod.* Oil on canvas, 223.5 × 137.2 cm (88 × 54 in). 1748. In the collection of Macleod of Macleod, Dunvegan Castle, Isle of Skye

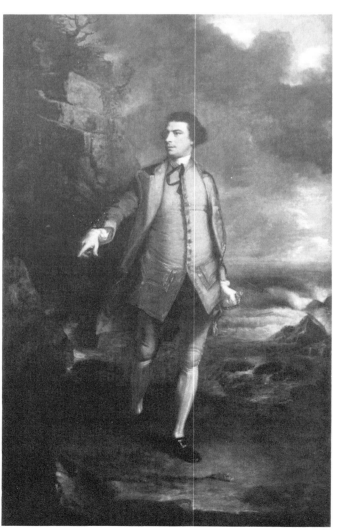

65

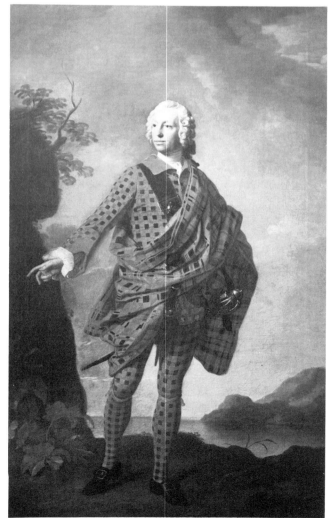

66

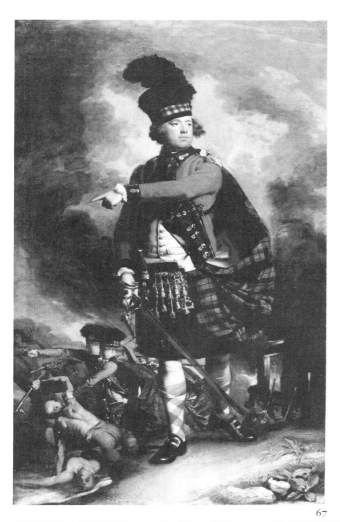

67. John Singleton Copley, *Portrait of Major Hugh Montgomerie, 12th Earl of Eglinton*. Oil on canvas, 240 × 151 cm (94½ × 59¾ in). 1780. Los Angeles, CA, Los Angeles County Museum of Art. Gift of Andrew Norman Foundation and Museum Acquisitions Fund

67a. John Singleton Copley, *Study for Major Hugh Montgomerie, 12th Earl of Eglinton*. Black and white chalk on pink-buff paper, 30.5 × 43.2 cm (12 × 17 in). 1779–80. Owned by Bennett H. Stayman

68. Edward F. Burney, *The Antique School at Old Somerset House*. Pen and wash on paper. 33.6 × 48.9 cm (13¼ × 19¼ in). 1779. London, Royal Academy of Arts

67

67a

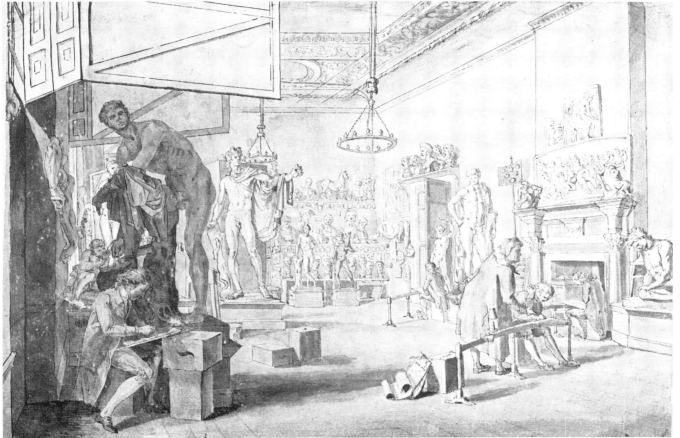

68

the overall effect of Hudson's picture is very different: it lacks the grace of Ramsay's portrait and also, we may add, the drama of Reynolds's *The Hon. Augustus Keppel*.

It is indicative of the powerful influence of contemporary notions of correct deportment that, although the *Apollo Belvedere* provided the inspiration for Ramsay's portrait, the finished picture still corresponds closely to the illustration examined in Nivelon's book of etiquette. The emotive influence of this famous classical statue was, therefore, strictly moderated in the eighteenth century by the most local rules of decorum.[69]

There are examples of Reynolds making references of this kind between his figures and classical sculpture within the painting itself. The attitude of the sitter in *Lady Sarah Bunbury Sacrificing to the Graces* (Plate 22) is the mirror image of that of the central one of the three Graces whose images appear in the top left of the picture. Another example, just as oblique, is to be seen in the portrait of Dr John Ash of 1788 (Birmingham General Hospital) whose pose echoes that of a statue of Benevolence to be seen behind the sitter.[70] It was a device that had been previously employed by Hogarth in, for example, *Charity in the Cellar, c.* 1739 (Private collection), where the central group resembles that of a sculpture of Charity to be seen on a sideboard in the background.[71] In some ways, Reynolds's parodic habit of mind resembled that of Hogarth very closely.

At first sight, Copley's *Major Hugh Montgomerie, later 12th Earl of Eglinton* (Fig. 67) bears only a general resemblance to the Ramsay and Reynolds adaptations of the *Apollo Belvedere* that we have been considering. But the preliminary drawings for the portrait (Fig. 67a) reveal that Copley had this pose in mind at first, and then worked his way towards a variation upon it with the outstretched arm flung back across the body, the resulting effect, it must be said, being a little strained.[72]

It can be seen that the viewpoint and the arrangement of foreground and middleground also owe much to Reynolds's earlier composition. Copley could easily refer, by this date, to the Royal Academy's collection of casts in order to study the classical source of Reynolds's pose, a collection which included copies of such statues as '*Cincinnatus*', *The Farnese Hercules, Mercury* and the *Apollo Belvedere*, as we can see in a drawing of 1779 by Edward F. Burney (Fig. 68).

In the case of Gainsborough's *John Plampin*, we have looked at the way in which a particular pose could become current through the medium of engraving. In the case of the American colonial artists, engravings were perhaps the most important source of inspiration, as many of Copley's own early portraits demonstrate. The Boston painter John Smibert, for example, carried on a brisk business alongside his portraiture in the importation and re-sale of prints, an activity that was evidently usual with portrait painters in England.[73] From his time in Italy, Smibert also possessed copies of European masterpieces including, famously, his own copy of Van Dyck's *Cardinal Bentivoglio* – although it is hard to say whether this much admired copy had any influence upon aspirant colonial painters, other than to increase a general sense of despair at the impossibility of emulating such an example.[74]

Copley's stepfather, Peter Pelham, was an engraver and something of a painter and had a good collection of prints. Copley's range of poses was more extensive and varied than that employed by most colonial American portraits but, as

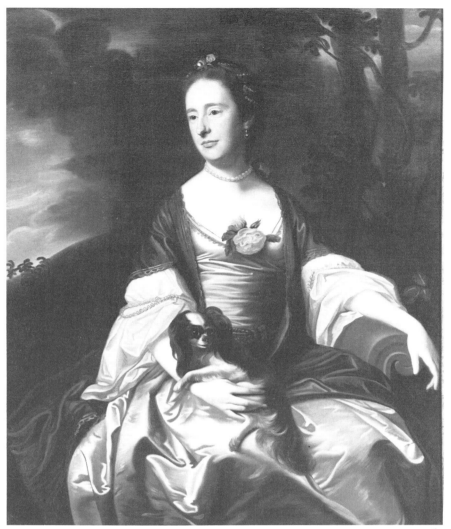

69

69. John Singleton
Copley, *Mrs Jerathmael
Bowers*. Oil on canvas,
126.7 × 101 cm
(48⅞ × 39¾ in). *c.* 1765.
New York, NY, The
Metropolitan Museum of
Art, Rogers Fund, 1915
(15.128)

70. Sir Joshua Reynolds
(after), *Lady Caroline
Russell*. Engraving by
James McArdell, *c.* 1760

71. Sir Peter Lely (after),
Catherine of Braganza.
Engraving, *c.* 1700–5

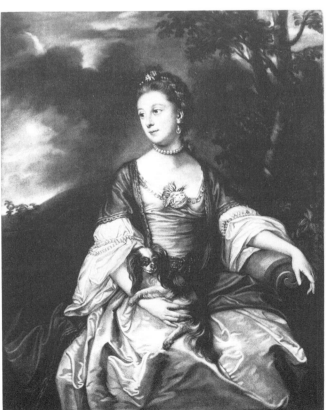

70

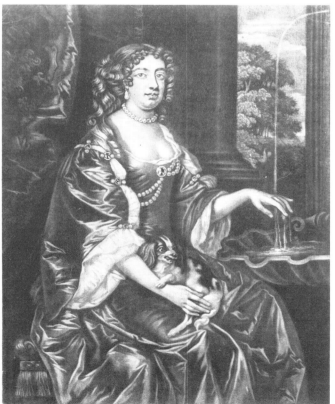

71

Belknap's researches demonstrated, colonial artists had drawn on engraved portraits for their poses for a long time.[75] The use of these poses was dependent on the sitter's willingness to be portrayed in a rather grand manner: some upper-class colonial sitters wished to maintain an image that had some relation to contemporary notions of fashionable posture and gesture in England, enhanced by the use of an elaborate setting and rich drapery. The contrasting image of extreme plainness of other colonial portraits is explicable not only in terms of the dress and setting depicted, but also because the sitters did not care to adopt specifically genteel postures of the kind we have examined, or perhaps knew little about them; and Ralph Earl's *Roger Sherman* (see Fig. 15) may strike us, even today, as almost aggressively inelegant in pose as it is in plain in setting.

Earl's portrait is true both to its sitter and to its period, but the use of engravings as a source for portraits in eighteenth-century America meant that many sitters were depicted in poses and with props that, if they were appropriate to their original sitters, were arbitrarily adopted for colonial sitters. In some cases, especially in the earlier years of the eighteenth century, sitters could find themselves not only in the pose but also dressed up in the habit of an engraving of some thirty years earlier. Even Copley, who strove to find up-to-date sources in contemporary British painting, painted a portrait in 1753 which was based on a mezzotint after Wissing of some fifty years before.[76] When he borrowed from an up-to-date print after Reynolds, as it seemed, Copley was not to know that, following his frequent practice, Reynolds might have based the pose of his own portrait on a mezzotint of an earlier age. Such was the case with Copley's *Mrs Jerathmael Bowers* of about 1763 (Fig. 69), which he based on a mezzotint by McArdell of about 1759 after Reynolds's portrait of Lady Caroline Russell (Fig. 70); for Reynolds's sitter was herself portrayed with certain elements taken from a mezzotint portrait of Catherine of Braganza of about 1705 (Fig. 71).

An interesting feature of this transmission of poses in Colonial America is the number of times that a pose in a portrait painting is shown in reverse to its engraved original. Where that is the case, it also seems that the similarity to the mezzotint source is often greater than when the painted portrait is in the same sense as the print, even down to small details of the drapery. A possible explanation of this phenomenon is that, as one copy only of the mezzotint is likely to have been available for study, artists other than the owner may have copied the print by a tracing method in such a way as to reverse it, and that it was only then squared up for transfer to canvas in the usual way.[77]

When discussing the influence of classical sculpture on portraiture, it is easy to forget that one of the most common forms of portrait, the bust in an oval, is itself derived ultimately from classical forms, especially the *imago clipeata*,[78] and their reinterpretation in the Renaissance. It was a formula that, for unexplained reasons, did not find much favour in the American Colonies, but in England it flourished to an extraordinary degree from at least the time of Lely onward. When Hogarth turned to full-scale portraiture in the late 1730s the bust in a feigned oval had become a very clichéd form indeed and, being at the cheaper end of the scale of charges, it could sometimes seem rather a poor relation in the portrait family.

It is characteristic of Hogarth that he should choose to re-examine and revitalize this rather tired formula. He perceived that the bust in an oval had its origins in the painter's imitation of a sculptural genre, especially the kind of

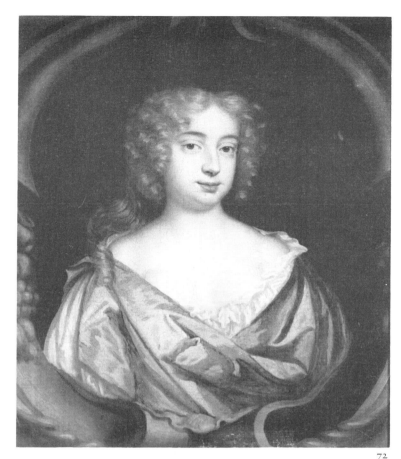

73

72. Mary Beale,
*Elizabeth, Wife of
Christopher Vane, 1st
Lord Barnard*. Oil on
canvas, 73.7 × 61 cm
(29 × 24 in). *c.* 1678. Raby
Castle, Lord Barnard

73. Giovanni da Maiano,
Head of Galba.
Terracotta. *c.* 1521.
Hampton Court Palace,
George II Gateway

72

Renaissance portrait bust of which there are excellent examples on the exterior of
Hampton Court Palace (Fig. 73) while, in Hogarth's day, closely similar examples
were still to be seen on the Holbein Gate in the centre of London.[79] It is the
existence of this sculptural antecedent that explains, for example, the heavily
'sculpted' fruit and swags around the feigned ovals in the work of Mary Beale at
the end of the seventeenth century (Fig. 72). Hogarth evidently decided to revive
the ancient argument about the respective advantages of painting and sculpture, a
controversy that had recently been referred to by the elder Richardson in his
influential and widely-read *Discourse* on connoisseurship of 1719, a book which
Hogarth certainly read:

> It has been much disputed which is the most excellent of the two Arts, Sculpture or
> Painting, and there is a story of its having been left to the determination of a Blindman,
> who gave it in favour of the Latter, being told that what by feeling seem'd to him to be
> Flat, appear'd to the eye as Round as its Competitor Now the great End of both
> these Arts is to give Pleasure, and to convey ideas, and that of the two which best
> answers Those Ends is undoubtedly preferable; And that this is Painting is Evident,
> since it gives us as great a degree of Pleasure, and all the Ideas that Sculpture can, with
> the addition of Others; and this is not only by the help of her Colours A statue
> indeed is seen all round, and this is one great Advantage which 'tis pretended Sculpture
> has, but without reason: if the Figure is Seen on every side, 'tis Wrought on every Side,
> 'tis then as so many several Pictures, and a hundred Views of a Figure may be Painted in
> the time that that Figure is cut in Marble, or cast in Brass.'[80]

This Renaissance question, to judge from the evidence of a number of his
portraits, had been consciously confronted by Van Dyck. His interest in the

74. Sir Anthony van
Dyck, *Triple Portrait of
Charles I*. Oil on canvas,
84.5 × 99.7 cm
(33¼ × 39¼ in). *c.* 1636.
Windsor Castle, Royal
collection

75. Manner of Sir
Anthony van Dyck (after
Van Dyck's *Lords John
and Bernard Stuart*), *Two
Young Men*.
220 × 128 cm
(87 × 50½ in). London,
National Gallery

76. John Michael
Rysbrack, *Henry St John,
1st Viscount Bolingbroke*.
Marble, height 66.1 cm
(26 in). 1737. Borough of
Thamesdown, Lydiard
Mansion

matter can be seen most obviously and fittingly, perhaps, in his triple portrait of Charles I (Fig. 74), which had been designed specifically to enable the great Italian Baroque sculptor Bernini to create a sculptured bust of the king. It may also be seen in a number of double portraits where the painter's capacity to show different aspects of the human figure simultaneously is demonstrated (Fig. 75). In a manner characteristic of the pattern of artistic inspiration, it is clear that Van Dyck had himself studied at least two works of the Italian Renaissance that had been produced at a time when the controversy was alive, Palma Vecchio's *Il Bravo* (Van Dyck's sketch of which survives[81]), and Lorenzo Lotto's *Triple Portrait of a Man*, now in Vienna, but then in the collection of Charles I at Whitehall.

With Jonathan Richardson's rekindling of the question in mind, Hogarth's quixotic attitude to his art would appear to have led him to adopt a characteristically radical approach to the painting of portrait busts. He was doubtless also impressed by the fact that the 1730s had seen a dramatic increase in the quality and number of sculptured portrait busts produced in England, sculptures often recalling the antique (Fig. 76). The quality of these sculptures was such that the diarist George Vertue reckoned that, by 1738, sculpture had made 'greater advances' in Britain even than painting.[82] In addition, it was at this very time that Hogarth was sharing the direction of the St Martin's Lane Academy with the great Huguenot sculptor Louis-François Roubiliac (1705–62), into whose studio the Academy moved in 1741, and no doubt these questions were frequently debated, both there and in the artists' meeting places such as Old Slaughter's Coffee House.[83]

Hogarth's first attempts at the portrait bust in an oval include works where the colour is carefully limited and the lighting on the head deliberately heightened in a manner calculated to recall a sculptured 'original': *Mrs Catherine Edwards* (Fig. 77) and *James Quin* (Tate Gallery), dating from 1739 and about 1740 respectively, are good examples. There followed, at some time towards 1744, a series of matching busts of four members of the James family in which, significantly, the feigned oval is surrounded by a *trompe l'oeil* rusticated wall. The delicacy and refinement of Hogarth's brushwork and colouring in the actual figures in this series, of which *Mrs Anne Lloyd* is an exquisite example (Fig. 78), deliberately point up, of course, the fact that these are paintings, and not sculptures, thus developing Hogarth's tacit argument in favour of painting's superiority. At the same time, the figure is taken to half-length and hands are introduced, an extension of the format that Hogarth explored elsewhere at this time.

Inspired, no doubt, by a renewed examination of the works of his admired Maurice Quentin de La Tour (1704–88) during a visit to Paris in 1743, Hogarth also painted *Mrs Salter* (Plate 24), shortly after his return to England.[84] In his earliest essays in this form, he had restricted his use of colour in favour of effects of light, with marked contrasts evident in sharp transitions from darkest tone to lightest, in imitation of the visual effect of sculpture. In *Mrs Salter,* on the contrary, he seems to dispense with his hard-won skills in the use of dramatic light and shade, in order to demonstrate that the painter can create form and a powerful impression of naturally-lit three-dimensionality almost through the manipulation of colour alone.

The portrait is set in a generally high key: the tones are restricted to middle and high, while the shadows in the drapery are denoted by colour shifts between

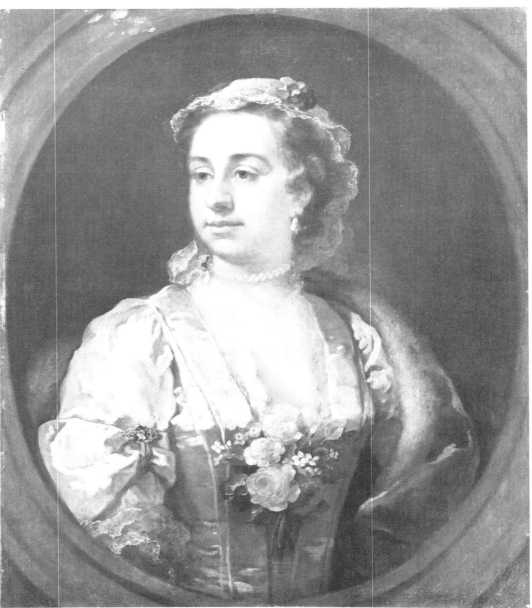

77. William Hogarth,
Mrs Catherine Edwards.
Oil on canvas,
75.5 × 63 cm
(29¾ × 24½ in). 1739.
Geneva, Musée d'Art et
d'Histoire

77

yellow and orange which, with white, form the whole range of colours used in the figure. Behind it, a green drape throws the figure forward by means of a colour opposition that is equivalent in its effect to that usually achieved by a strong tonal contrast.

This dialogue between painter and sculptor today emerges only through a study of Hogarth's pictures, but it is clear that at the end of his life, he was planning to write an essay, 'On the Arts of Painting and Sculpture', that was to be the culmination of a body of work forming a theoretical and practical demonstration of his aesthetic tenets.[85] In his painting, at least, the dialogue was brought to a logical close by a picture that makes a specific point in relation to Roubiliac, and which seems designed to prove the accuracy of Richardson's estimation of the painter's superiority to the sculptor.

Roubiliac had produced a terracotta bust of Hogarth (Fig. 79), together with a

separate terracotta model of Hogarth's dog, in 1740–1.[86] In 1745 Hogarth painted *Self-Portrait with Pug* (Fig. 80), thus recreating the subjects of Roubiliac's separate sculptures upon a single piece of flat canvas. The picture was designed as something of a public manifesto and was explicity used for that purpose in its engraved form as a frontispiece for Hogarth's treatise *The Analysis of Beauty* (1749). *Self-Portrait with Pug* is not, strictly speaking, a self-portrait, but a still-life. It shows a self-portrait propped on three books (significantly labelled Shakespeare, Milton, and Swift), the artist's palette nearby, with a dog sitting in front of it. The self-portrait is, in fact, in the form of a bust painted on an oval canvas that is now seen unframed, the nails attaching the canvas to the stretcher being clearly visible. The complexity of the whole image is such – the dog in the painting is, for example, 'real' in a different sense from his master, who takes on

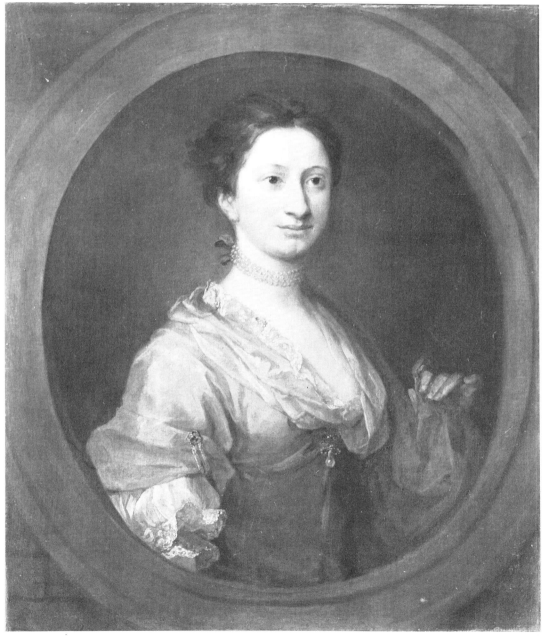

78. William Hogarth, *Mrs Anne Lloyd*. Oil on canvas, 76.2 × 63.5 cm (30 × 25 in). *c.* 1744. Glasgow, The Burrell collection, Glasgow Art Gallery and Museum

78

the appearance of reality only in the form of a painting – that we are made to reflect upon the virtuoso painter's capacity to escape the apparent limitations of his materials (by implication, in contrast with the constraints of sculpture). When he designed this painter's 'answer' to sculpture, it is also possible that Hogarth had in mind the engraving *Catherine Howard, Countess of Arundel* (Fig. 82), issued in the portrait series known as 'Houbraken's Heads' in 1743. Significantly, this print itself uses a strongly sculptural conceit, and the referential material lying about is similar in function to Hogarth's books and palette (in what we understand to be a painter's studio); and the presence of a cupid in *Catherine Howard*, in front of the portrait bust in an oval, is similar to that of the dog in Hogarth's picture.

An intriguing picture by Thomas Frye (1710–62) – a rather obscure artist who may, however, have been closer to Hogarth than has yet been realised – adds further substance to these speculations. Frye's *Portrait of a Man* of 1742 (Fig. 81) is evidently a portrait conceived in terms of a record of a sculptured bust. It is an unusual picture, although it actually corresponds to a type produced in

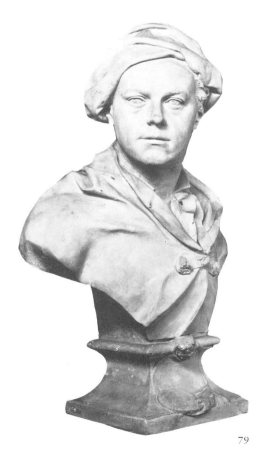

79. Louis-François Roubiliac, *William Hogarth*. Terracotta, with plaster socle, height 71.7 cm (28 in). *c*. 1740–1. London, National Portrait Gallery

79

80. William Hogarth, *Self-portrait with Pug*. Oil on canvas, 90.2 × 69.9 cm (35½ × 27½ in). 1745. London, Tate Gallery

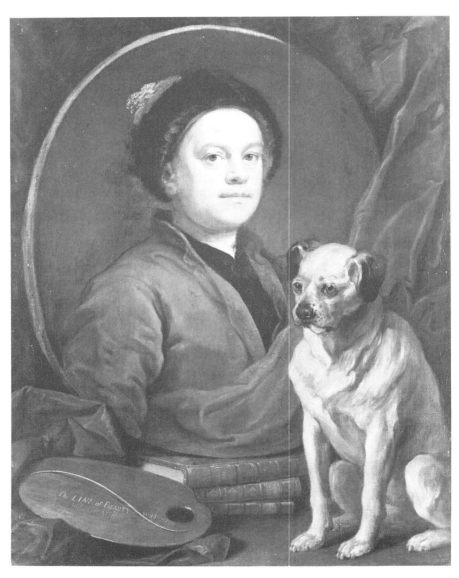

80

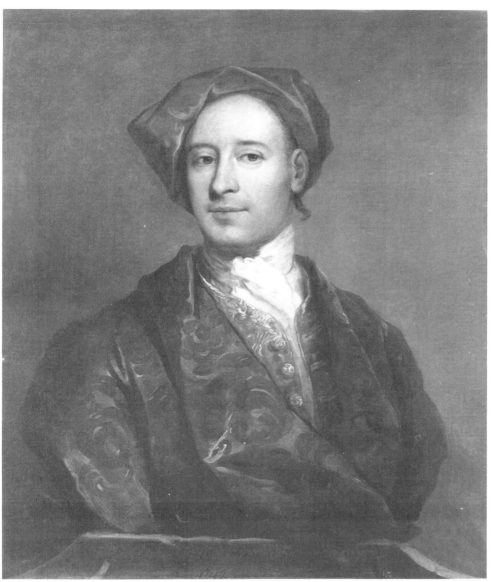

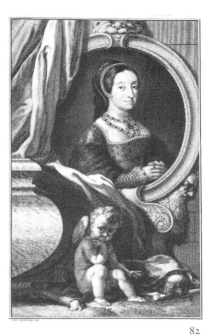

82. Jacobus Houbraken,
*Catherine Howard,
Countess of Arundel.*
Engraving, 1743

81. Thomas Frye, *Portrait
of a Man.* Oil on canvas,
105.9 × 91.4 cm
(42 × 36 in). 1742. Private
collection

81

preparation for engravings, for example, by William Faithorne (1616?–91) in the
late seventeenth century.[87] In this instance, however, there is no reason to suppose
that a sculptured original ever existed, the signature inscribed on the plinth, to
take a key point, being that of the painter – *T. Frye pinxit 1742* – and not of a
sculptor. Yet so close is this painting to contemporary sculpture that it has been
suggested that it merely records a now unknown bust by Roubiliac.[88] Frye seems,
rather, to have been exploring much the same ground as Hogarth, the relationship
between painting and sculpture, at exactly the same time, and with the same
individual sculptor's examples in mind. Hogarth's own paintings evidently
influenced Frye: his *Mr Crispe* of 1746 (Fig. 83), for example, is derived from
Hogarth's *William Jones* of 1740 (Fig. 84).[89] Furthermore an interest in the
polemic between painter and sculptor would have come readily to Frye, a portrait
painter who was also to be deeply involved in the three-dimensional creations of
the Bow porcelain factory which he helped to found in 1744, and for which
Roubiliac himself is believed to have modelled figures some few years later.[90]

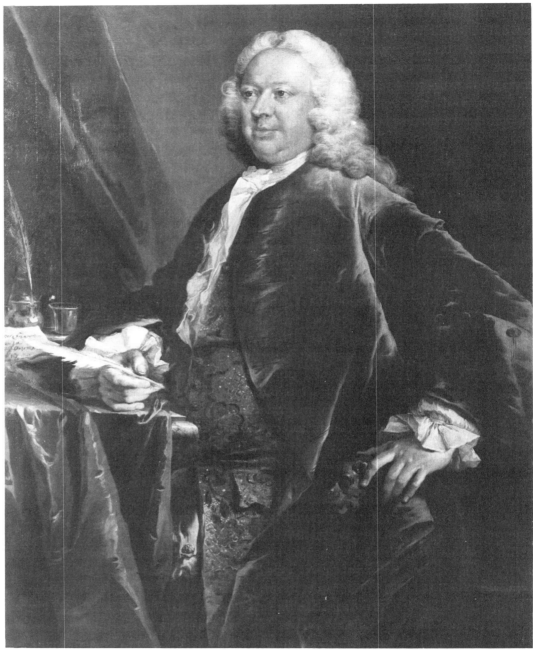

83

With his triumphant demonstration of the painter's art in *Self-Portrait with Pug*
Hogarth's main foray into portraiture came to an end. Of course, his intricate
variations would have had little meaning if the theme on which they were played
had not been well-known and understood; and what we learn from a
consideration of portrait poses is that there was a common language of
portraiture, possessing its own rhetoric of gesture and pattern – of figure, drapery
and props – that afforded the means for effective variety, and a flexible range of
expression from the informal to the grand and stately. The constraints of
nineteenth-century England – or of any society distrustful of rhetorical gesture
of the kind that is so impressive in, for example, Ramsay's *Norman, 22nd Chief of
Macleod* (see Fig. 66) – together with the development of a dismal uniformity of

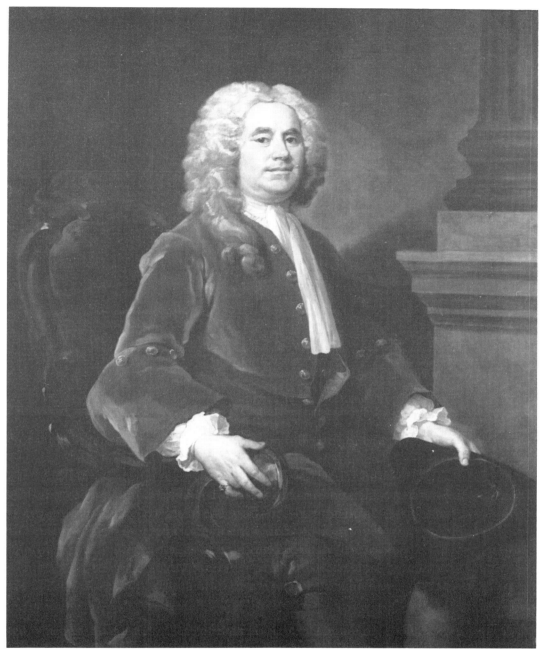

84

black in men's clothes (what Millais called 'the horrible antagonism of modern dress') resulted in the monotony so familiar in much portraiture of the Victorian era. The magnificent portraits painted by Sir Francis Grant (1803–78) during this period are notable exceptions to this general rule (Plate 25).

Notable attempts were made to evade these limitations in the best of nineteenth-century American portraits in the grand manner, particularly through the continental device of distancing the sitter, in his now drab costume, from the viewer, by setting him well back in the picture space, and surrounding him with a glamorously painted interior full of rich colour. Such expedients were limited, but American artists found a more generally enlivening compensation in effects of brilliant brushwork. In addition, as we have seen, by turning back to the

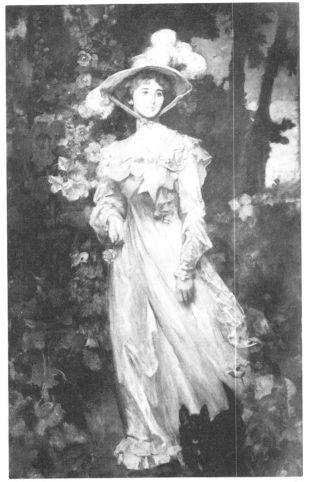

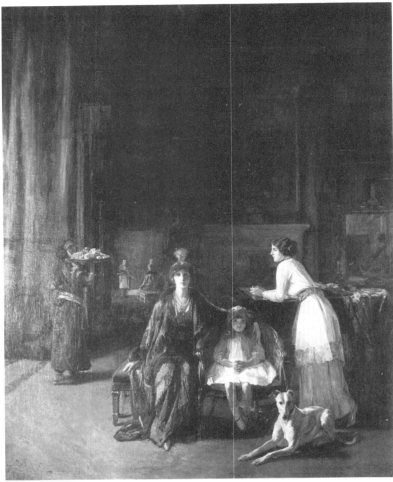

85

86

85. Sir James Jebusa
Shannon, *Lady Henry
Cavendish-Bentinck*. Oil
on canvas,
224.2 × 132.7 cm
(88¼ × 52¼ in). 1898.
Bonhams, 21.VI.84 (50)

86. Sir John Lavery, *Lady
Lavery with her Daughter
and Step-daughter*. Oil on
canvas, 344 × 274 cm
(135¼ × 107⅛ in). 1913.
Dublin, National Gallery
of Ireland

eighteenth century for his inspiration, Sargent was able to reintroduce into grand portraiture some of the expansiveness and variety of pose and gesture that had disappeared. That, and the example of his handling of paint, had a considerable influence even on some of his British contemporaries, so much so that Sir James Jebusa Shannon, 1862–1923 (Fig. 85), who was, in fact, American by birth, Sir John Lavery, 1856–1941 (Fig. 86) and Charles Wellington Furse (1868–1904) were called 'The Slashing School'. But it was a short-lived development, although in terms of Sargent's own career as a portrait painter, portraits such as *Lady d'Abernon* provided a fittingly daring climax. To a great extent, subsequent portraiture in the twentieth century has failed to discover a common language of expression (of which poses form such a vital part), to replace the traditional one that was successful for nearly four hundred years, and which it has chosen to ignore.

CHAPTER THREE

Practice

In the preceding chapters we have noted the collaborative nature of much portrait painting of the past. The use of drapery painters and other assistants to complete large areas of a portrait is an aspect of professional practice that is especially intriguing to the modern mind, conditioned as it is by post-Romantic notions of the value of the unique quality of the creative process. Any distrust contemporaries may have felt was, very reasonably, based on the question of value for money; the more discerning customer could be uneasily aware that he might be palmed off with something less than the genuine article, especially when the painter had a strong selling line in copies of his more successful public portraits. The friend of one of Lely's customers wrote to warn him: 'I have know Sir Peter Leley change an origenall for a coppy, especially to thos that don't understand pictors.'[1] The substitution of a copy for an original – where the price was supposed to be different[2] – is distinct from the question of what constituted the artist's 'own hand'. This question had always been subject to reinterpretation, often according to whether the customer was satisfied or not, but there was usually a mutual assumption that the painter would inevitably employ workshop assistance to a reasonable extent. As Professor Baxandall has shown, the *sua mano* clause of late-mediaeval and Renaissance contracts was a necessarily flexible one, allowing for the natural function of a workshop, and Lely's pledge in the seventeenth century to Sir Richard Newdegate that portraits executed for him were 'from the Beginning to ye end drawne with my owne hands' is probably to be interpreted in the same way.[3]

It is, however, extraordinary to reflect that we continue to identify portraits as being by, say, Allan Ramsay, Sir Joshua Reynolds or Thomas Hudson, when we know for a fact that in a full-length portrait, for example, some eighty per cent or more of the canvas was painted by somebody else, a fact that even the most distinguished modern writers have occasionally found difficult to accept.[4] On other occasions – and, in some ways, more illogically – when we happen to be aware of the regular partnership of two artists, one of whom painted the heads, and the other the drapery and accessories, the modern practice has developed of ascribing pictures to this joint authorship, as with Riley and Closterman in late-seventeenth-century England: the case is different with Waldo and Jewett in nineteenth-century America, for they actually traded under this description and stamped their canvases in this form.[5]

Joint businesses as such were, however, fairly unusual, and it was far more common for a master to adopt the practice either of using assistants within his studio (many of whom were formally apprenticed) or of sending out his heads to be fitted with draperies by a specialist in that line, of whom Joseph van Aken (*c.* 1699–1749) is the most famous. It is nowadays always assumed, whichever of these procedures was followed, that the head was painted before the body, and that appears generally to have been so. We have earlier noted Pepys's record of heads being prepared first in Lely's studio, and examples survive of heads without bodies by both Lely and Kneller (Plate 1, see Fig. 1); but even in Lely's studio it was apparently the case that 'postures' alone might be prepared in advance, on canvas, to await the arrival of the head when a copy or replica of a popular portrait was demanded. The lots in the auction at Lely's studio after his death included such items as '14. halfe lengths outlines' and 'whole length postures No. 8 & 1. and 1. cloth and hand on it', a record which, incidentally, confirms that portraits, or at least the 'postures', could be ordered from Lely's studio by numbers.[6]

More surprising still, as we shall see, is that it was evidently possible for portrait painters to be supplied beforehand with complete bodies by a 'posture' painter, on canvases to which they proceeded to attach heads; and we can also point to a number of portraits where the head was painted on a separate piece of canvas intended to be sewn or stuck into position on a larger canvas bearing the body. Nonetheless, not the least remarkable aspect of this whole business is how very seldom we are actually made to feel aware of the production-line process that may lie behind the elegant, and apparently undisturbed, surface of the portrait.

When J.T. Flexner, in his history of American painting, discussed the often curious itinerant artists of that country, he asserted: 'Popular legend to the contrary, there is no evidence that the itinerants ever brought with them prefabricated bodies to which they added their sitters' heads.'[7] In fact, there is evidence, from the practice of portraiture in seventeenth- and eighteenth-century England, to suggest that they are quite likely to have done just that. Sir J.B. de Medina (1659/60–1710) is documented as having taken ready-made 'postures' on canvases with him when he went to Scotland in 1693.[8] Although usually a competent painter, Medina provides us with examples of the procedure coming seriously unstuck, and in *Thomas Edgar* (Fig. 87) there is every sign of a major misunderstanding between face and drapery painter, for the head has been attached to the body in relation to the wrong shoulder. The posture is a familiar one in Medina's work, and there are other poses similarly repeated in such a way as to form distinct groups, even though the sitters are widely discrete. Although Medina does not apparently make such a bad mistake elsewhere, there is occasionally an uncomfortable relationship between head and body in his portraits.[9]

The order of execution of a portrait was a point specifically referred to by Sir Godfrey Kneller in a revealing remark to Alexander Pope: 'I find he [i.e., Kneller] thinks it absolutely necessary to draw the Face first, which he says can never be set right on the figure of the Drapery and the Posture finished before.'[10] The very fact that Kneller thought it necessary to state what seems to any present-day reader to be the obvious suggests that the reverse of his own practice was common. It is tempting to make an analogy with the British seaside amusement where a hole is provided for the holiday-maker to 'attach' his head to the body, say, of the

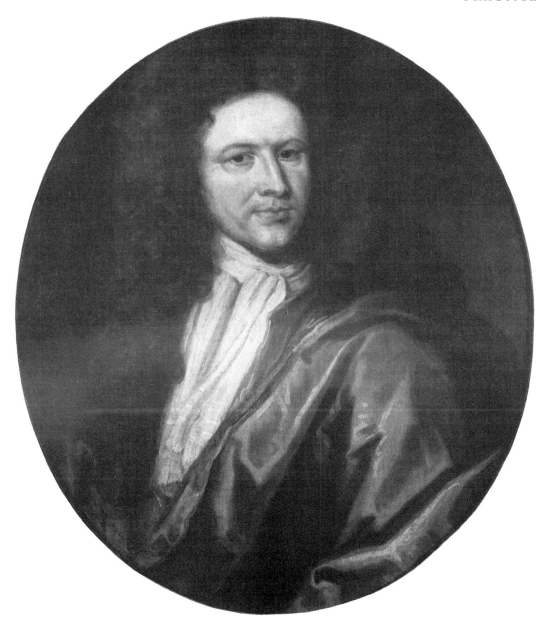

87. Sir John Baptist de Medina, *Thomas Edgar*. Oil on canvas, 77.5 × 64.3 cm (30½ × 25½ in). *c.* 1697. In the collection of the Royal College of Surgeons of Edinburgh.

Princess of Wales, and the idea is close enough even when face and body were painted on the same canvas. Where head and body were painted on separate pieces of canvas the analogy is even closer. The clearest contemporary account of this practice is that of George Vertue in relation to Hamlet Winstanley (1694–1756):

Winstanley travelld about and drew pictures from the life in Oyl Colours. often on small peaces of cloth only the face, pasted them when sent to London on larger Cloths. one two three or more whole family peeces he did on this manner. only did the faces sent them to Town to one Mr. Vanaken. and excellent painter of draprys. he stuck them on large strained Cloths as he pleas'd and made postures and draperys. and so made them compleat pictures. this sort of trade Winstanley persued – a method quite new and extraordinary.[11]

Examples of Winstanley's portraits which show him using this method are not confined to groups, and include *Thomas Patten of Warrington* (Christie's, 24.xi.72 (161)), where the square of canvas containing head and shoulders had suffered bad flaking of the paint surface at its edges, and so revealed the outline of the inserted section when the picture came up for sale in 1972.[12]

Vertue was wrong in calling this 'a method new and extraordinary'. Winstanley had his heads stuck on to the canvas, but other artists before this date had painted heads separately and had them stuck on to, or sewn both in and on to, larger canvases. A striking example from about 1685–6 is *Master Montagu Drake* ascribed to John Vandervaart, 1653–1727 (Plate 26), where the head, hat, bow, wig and the very top of the cravat are together painted on a separate square of canvas. The reasons here for the use of this method are probably similar to those obtaining in Winstanley's case: it was a very practical arrangement when the portrait painter was visiting the sitter's country house rather than having the sitter visit his studio, and avoided the problem of transporting about the country a full-length canvas some eight feet high.

Master Montagu Drake raises some interesting questions, because it was executed at a time when Vandervaart is known to have been in partnership with the portrait painter Willem Wissing (1656–87), under the terms of which agreement Wissing was paid twenty pounds and Vandervaart ten for any one large picture.[13] *Master Montagu Drake* was painted at the same time as another picture, also ascribed to Vandervaart, in which the same boy is shown with a pony and an attendant. It is recognised that the landscape and birds in this latter picture were painted by Francis Barlow (*c.* 1626–1704?), and it appears that the collaborative nature of this picture again extends to the head's having been painted by a hand distinct from that responsible for the drapery and other details. Indeed, close examination reveals that the head of Montagu Drake in this picture is identical in handling and detail with that in the picture of himself alone (Plate 26), and that the head is again painted on a separate piece of canvas sewn into a much larger canvas in an identical fashion, as photographs taken in raking light reveal (Fig. 88). We may go further, and observe that the head of the attendant is painted by an artist with quite a different manner from the portraitist responsible for the heads of Montagu Drake. The quality of the two latter is superior to that of any portraits known to have been painted by Vandervaart during his independent career following the death of Wissing, whose own manner, however, closely corresponds with that of these two heads. If we assume that Vandervaart painted the drapery in both pictures it would seem to be more reasonable to ascribe the authorship of *Master Montagu Drake* (Plate 26) to Wissing and Vandervaart together, while Barlow should be added to the list in the case of *Master Montagu Drake with his Pony and an Attendant*. It is possible that Barlow also supplied accessories of this kind for other Wissing/Vandervaart portraits (he may have painted the dog in *Master Montagu Drake,* for example), although there is no evidence of a formal partnership in which the animal painter was involved.[14] It is known that Wissing occasionally stayed at country houses where he carried out his portraits – for example, Burghley House, Cambridgeshire, where, in fact, he died – and it would seem that, when he painted his heads on separate pieces of canvas, they would have been sent to London for Vandervaart (and sometimes Barlow also) to complete.

88. Willem Wissing (with John Vandervaart), *Master Montagu Drake with his Pony and an Attendant* (detail). Oil on canvas, 158.8 × 236.2 cm (62½ × 93 in) (whole). *c.* 1686. Private collection

Another instance where the drapery painter in London supplied posture and background for heads sent to him from the country was when heads were let into a larger canvas for a group of the Delaval family by a London drapery painter in the middle of the eighteenth century. The heads were painted by the amateur Rhoda Delaval and were sent down to London from the North of England.[15]

This technique of separating the execution of body from head could also be useful for the unexpected purpose of bringing portraits up-to-date by replacing old 'postures' with new, while retaining the heads which preserved the original likeness. William Aikman was employed for this purpose by the Earl of Carlisle in cutting out two Kneller heads, 'expungeing the old posturs', and 'pasteing these two pictures into whole lengths' on which he painted new bodies.[16]

In the eighteenth century, in addition to the example of Winstanley, we can point to no less a figure than Allan Ramsay as an occasional user of this method. His royal portrait group *Queen Charlotte and her Two Eldest Sons,* 1769 (Her Majesty the Queen), has the heads on pieces of canvas attached to a larger whole (the replicas do not), and he also used this method in his double portrait *The Earl and Countess of Wemyss* (Earl of Wemyss and March),[17] and again in *Prince George Augustus of Mecklenburg,* 1768–9 (Her Majesty the Queen).[18] However, Ramsay, in common with most other portrait painters of his day, usually sent his heads out from his studio on the same canvas on which the posture and other details were to be painted by a specialist, or specialists, in those fields. As we have noted, the most famous drapery painter was Joseph van Aken who, since he was employed by a considerable number of portraitists, including Ramsay (until Van Aken's death in 1749), lent a distinct air of similarity to the works of the artists who employed him (a fact noted by observant contemporaries[19]). At times, there is an identity both of costume and of handling not only in portraits by the one artist of different sitters, but also in portraits by various artists of different sitters. A telling example is a group of portraits painted in the 1730s and 40s that follow a particular vogue for 'Vandyke dress' (Figs 89–94). The costume in question derived, as we have seen, from Rubens's portrait of his sister-in-law, a picture

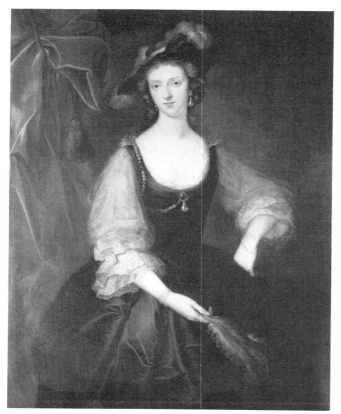

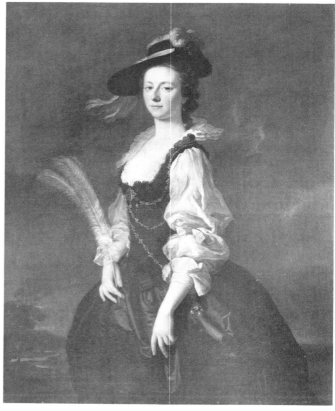

89

90

89. John Robinson,
*Hester Lyttleton, Wife of
John Fitzmaurice*. Oil on
canvas, 122.5 × 98.4 cm
(48¼ × 38¾ in). *c.* 1742–5.
Viscount Cobham,
Hagley Hall

90. Allan Ramsay, *Jane
Hale, Mrs Madan*. Oil on
canvas, 127 × 101.6 cm
(50 × 40 in). 1745.
Viscount Leverhulme

attributed at the time to Van Dyck, and supposed to be of Rubens's wife (see Fig. 44).[20] A study of these pictures reveals just how drapery and face painter might work together.

Ramsay and Hudson were pall-bearers at Van Aken's funeral. It was a rare mark of gratitude to the man responsible to such a great extent for their fashionable success: drapery painters were more usually kept, like mistresses, in comfortable obscurity.[21] The reasons for Van Aken's success were, in the first place, his outstanding skill which benefits, rather than suffers, from close examination (Fig. 95) – unlike that of most drapery painters. Secondly, Van Aken evidently approached the question of fitting posture to head with great care and meticulous planning.

Considerable numbers of drawings associated with Van Aken, and with specific portraits by the artists who employed him, survive. The precise function of these drawings is a matter of some debate, and they have sometimes been seen as studio records of the completed paintings.[22] It seems possible, however, to see them in part as detailed preliminary drawings, worked up from a guide drawing supplied by the artist, at least in the first instance. They would afterwards be used for the painted repetitions of poses and costumes which Van Aken certainly made.[23] The artist's guide drawing might contain colour instructions as, for example, does Hudson's drawing (see Fig. 92) either for his portrait of the Duchess of Montrose (see Fig. 93) or, more probably, Anne Dixie (see Fig. 91). From this drawing Van Aken appears to have made his own detailed plan (Fig. 94) in which he used different coloured chalks; the black apparently indicates those parts to be painted by himself, and representing the posture proper, the red chalk showing the work

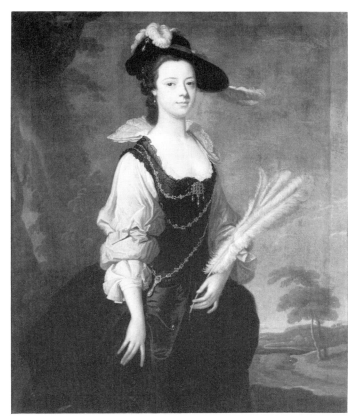

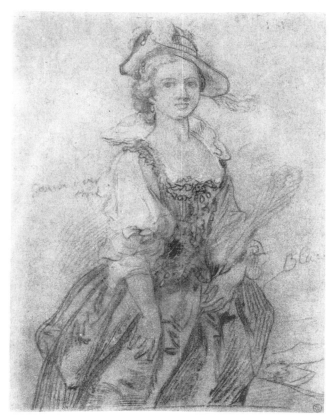

91

92

initially provided by the face painter. Another example of Van Aken's use of this method, which he seems invariably to have employed, is his plan for Ramsay's *Norman, 22nd Chief of Macleod* (Plate 23, see Fig. 66), a drawing that again shows the careful delineation of these distinct areas of responsibility.

In many cases, it is clear that the face painter, naturally enough, corrected or finished off the portrait on its return from the posture man. A number of Lely's pictures appear to show that this was his practice. The famous portrait of a boy formerly identified as Abraham Cowley, *c.* 1658–60 (Dulwich College Picture Gallery), for example, shows signs of reworking in the hair and shoulder area that may well have been intended to smooth over the join between the two parts of the picture. There are clearer examples in Reynolds's work, where Reynolds's tendency to 'finish too much' could lead to his heavy-handed blurring of the sometimes more delicate and accomplished work of the drapery painter: a case in point is the *pentimento* on the left shoulder of Lady Sarah Bunbury in the portrait now in Chicago (Plate 22, Fig. 96).

A consequence of the employment of drapery painters with a practice distinct from that of the portrait painter was that sitters were, as likely as not, to be painted in clothes other than their own – at least, until the nineteenth century. We have noted the vogue for 'Vandyke dress', but the same tendency to dress up specifically for a portrait took other forms. It is not perhaps immediately obvious, for example, that the loose, flowing draperies so familiar in much seventeenth- and eighteenth-century portraiture were themselves a form of 'Loose-Dressing' especially adopted for portraits. A wide variety of costumes were used including Indian gowns, shifts, nightgowns, forms of classical armour or Roman outfits,

91. Thomas Hudson, *Anne Dixie*. Oil on canvas, 123 × 100 cm (48½ × 39½ in). *c.* 1742–5. Sotheby's, 13.XII.72 (108)

92. Thomas Hudson, *Study for Portrait of an Unknown Lady* (here identified as Anne Dixie). Black chalk on grey paper, 30.3 × 22.8 cm (11⅝ × 9 in). *c.* 1742–5. Dublin, National Gallery of Ireland

93. Thomas Hudson,
Lady Lucy Manners,
Duchess of Montrose. Oil
on canvas, 127 × 101.6 cm
(50 × 40 in). *c.* 1742–5.
The Marquis of Graham

94. Joseph van Aken,
Study for Portrait of Lady
Lucy Manners, Duchess
of Montrose. Black, red
and white chalk on blue
paper, 33 × 27.7 cm
(13 × 10⅞ in). *c.* 1742–5.
Edinburgh, National
Galleries of Scotland
(D 2168)

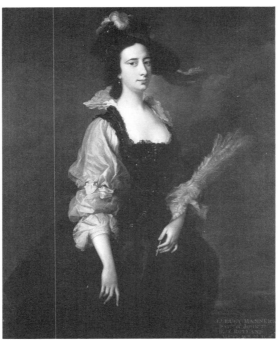
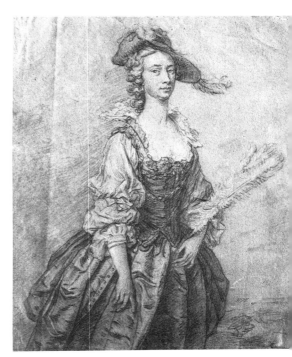

93

and various kinds of adapted oriental attire.[24]

At first sight, it appears rather surprising that, in an age of considerable formality such as that of late-seventeenth-century England, aristocratic sitters should wish to be seen in a state of modified undress. It seems likely, however, that there is some connection here with the very formality and ritual of that society where a great house would usually have a carefully planned sequence of state rooms and an elaborate rigmarole for receiving visitors. This sequence of ante-chamber, drawing room, and so on, culminated in the bedroom or closet, where the sitter might indeed be found, by those privileged to approach so far, in a nightgown or shift – a costume which was to be seen in the increasingly popular *levées* of the period.[25]

Such costumes were not, then, strictly fancy-dress, unlike the Roman outfit, for example, which, like 'Vandyck dress', was worn both for portraits and for that popular entertainment of the time, masquerades.[26] One of the reasons for the use of all these devices in portraiture was undoubtedly the vexed question of the transience of everyday fashions which we have looked at; and for most portrait painters there were also considerable advantages, in terms of convenience, to be gained from 'dressing' their sitters in what were usually nothing other than studio props. In the first place, the sitter did not have to be present when the drapery was painted, and might never physically wear the costume in which he was to be immortalized. He did not even have to send along a suit of clothes to the studio as might otherwise have been the case.[27] Another advantage was that the studio costumes themselves need not even be life-size, as the survival of some costumes of Arthur Devis (*c.* 1711–87) and a lay-figure of Roubiliac's makes clear (Figs 97, 98).

The Devis costumes which survive include another popular type of fancy-dress, Hussar costume, and it is possible to find several different sitters 'dressed' in this way in Devis's work.[28] His lay-figure is actually a doll, and is, no doubt, a type familiar to eighteenth-century portraitists, including Arthur Pond (1701–58),

95. Thomas Hudson,
*Lady Lucy Manners,
Duchess of Montrose*
(detail of drapery by
Joseph van Aken)

95

96. Sir Joshua Reynolds,
*Lady Sarah Bunbury
Sacrificing to the Graces*
(detail of Plate 22)

96

97. Artist's lay-figure, formerly owned by L.-F. Roubiliac. Eighteenth century. The Museum of London

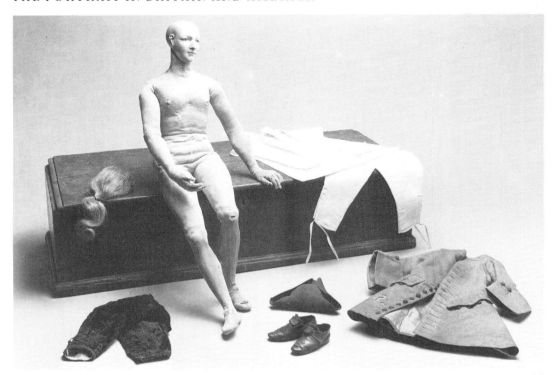

97

98. Lay-figure costumes, formerly belonging to Arthur Devis. Eighteenth century. Preston, Harris Museum and Art Gallery

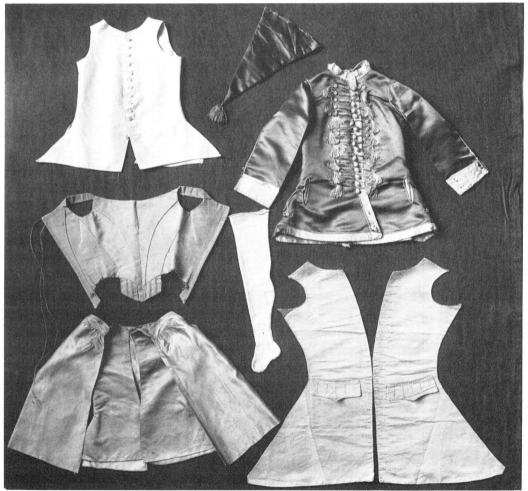

98

who bought a 'little Woman Dol' for no less than £3.14.0. in 1742.[29] In view of the prevalent use of these fully-shaped miniature creatures for completing portraits, it is hardly surprising that not only the figures of Devis, but also those of Francis Hayman, and those in the early portraits of Gainsborough, are so often remarked to be doll-like (see Figs 49, 52, 53). Even where the figure is not so apparently doll-like, the use of a lay-figure can often be presumed, and some portraits appear to betray their use for the purpose of exploring variations in pose. For example, Hudson's *4th Earl of Donegall* (Fig. 99) can readily be conceived of as a variation on the pose of *A Gentleman called Charles Douglass* (see Fig. 56), which we have examined in relation to Ramsay's use of the *Apollo Belvedere*. It would appear that Hudson rotated the body (but not the head) of the lay-figure some thirty degrees to the left, with slight adjustments to the hands. Perhaps Hudson used a device similar to that sold from Hoppner's studio after his death, a circular, baize-covered platform on castors for a lay-figure.

Gainsborough, whose fascination with painting drapery is well-attested, seems to have availed himself of this convenient small-scale arrangement even late in life. It has been observed that the Van Dyck costume of '*The Blue Boy*' reappears in other male portraits of Gainsborough's, notably *Paul Cobb Methuen* of 1776 (Lord Methuen), but the one sitter was a boy and the other a full-grown man, and it is inconceivable that each physically wore the same costume, when the effect could be achieved by the imaginative use of a studio doll.[30] The rather exceptional nature of Gainsborough's attempts at 'Vandyck dress' and poses, from about 1770 on, may have led him to resurrect what was, apparently, his early practice and, although there were still two lay-figures in his studio at his death, there is no reason to suppose that he generally used lay-figures for his portraits proper, in the manner of Devis, at this later period of his career. There is a considerable amount of evidence against it, in fact, including his expert painting of Mrs Siddons's costume which we have discussed.[31]

Lay-figures were not always dolls on which costumes could be fitted but, as we know one of Gainsborough's to have been, brass-jointed, articulated and stylized figures on which drapery could be hung. Holding forth in characteristic vein, James Northcote emphasised his argument on one occasion by 'pointing to a beautiful piece of red drapery which was placed on his lay-figure to be painted from.'[32] To have one's own clothes carefully painted in a portrait, however, could be a distinct attraction, as a letter from an American sitter of Ramsay's in London in 1751 makes clear. His portrait, Peter Manigault tells his mother, was painted by:

> ... one of the best hands in England & is accounted by all judges here, not only an Exceedingly good likeness, but a very good Piece of Painting: the Drapery is all taken from my own Clothes, & the very Flowers in the lace, upon the Hat, are taken from a Hat of my own; I was advised to have it drawn by one Keble, that drew Tom Smith, & several others that went over to Carolina, but upon seeing his Paintings, I found though his Likenesses, (which are the easiest part in doing a Picture) were some of them very good, yet his Paint seemed to be laid on with a Trowel, and looked more like Plaistering than Painting ... You'll also tell me if you think any part of it too gay, the Ruffles are done charmingly, and exactly like the Ruffles I had on when I was drawn, you see my Taste in Dress by the Picture, for everything there, is what I had had the Pleasure of wearing often.[33]

99. Thomas Hudson, *4th Earl of Donegall*. Oil on canvas, 235.6 × 144.2 cm (92¾ × 56¾ in). *c.* 1754–5. Christie's, 24.VII. 80 (21)

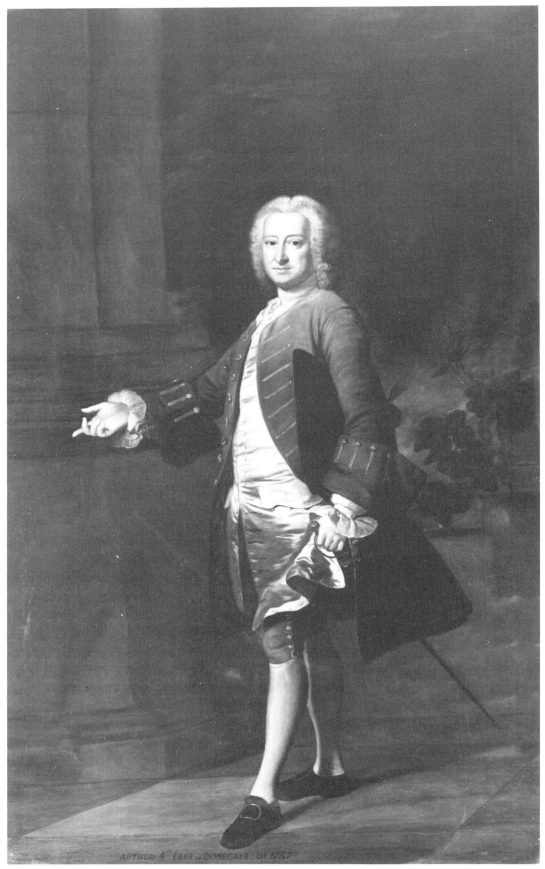

Here the drapery would have been done for Ramsay by a successor to Van Aken (who had died two years before), and it is evident from Ramsay's later portraits that Van Aken was not alone in being astonishingly accomplished in the field of drapery painting, for there are any number of examples of intricate costumes painted freely and with great sureness of touch. Van Aken's independent paintings, and his own drawings, demonstrate his limited capacity to handle the whole human figure with ease; and he was clearly content, therefore, to leave the invention of the portrait design, and especially the head, to the portrait painter, while exercising his rare dexterity in a narrow field. It was a highly profitable business and not, Gainsborough thought, a very taxing occupation, as he wrote to a friend with ambitions to be a painter:

> There is a branch of Painting next in profit to portrait, and quite in your power without any more drawing than I'll answer for your having, which is Drapery and Landskip backgrounds. Perhaps you don't know that whilst a face painter is harassed to death the drapery painter sits and earns five or six hundred a year, and laughs all the while.[34]

No doubt, one of the principal reasons that the drapery painter could sit back and enjoy himself was that his customer was the artist, whom he did not even have to see, and not the sitter, for surely one of the most trying parts of a portrait painter's profession was the need to deal with his customers. Northcote, an entertaining if somewhat embittered conversationalist, saw these difficulties of the portrait painter plainly: '... to succeed in that department of the art a man must not only be able to paint well, but to paint well under certain disadvantages and hindrances. Your sitters, instead of assisting you, are often bent only on their own amusement or self-indulgence, and plague you'[35]

The forced intimacy of painter and sitter meant that the manners and address, the general social skills, of a portrait-painter were of the utmost importance. Even more than is the case with most commercial transactions, the ability to get on with a customer was vital if the sittings were to be bearable, and while the busiest portrait painters might regularly see half a dozen different sitters a day, each sitter, naturally enough, was convinced that his or her portrait was the most important work in hand. Vertue records Kneller's exceptional gifts in this respect:

> ... a pleasant conversation finely entertaining when a Painting, that is always observed that his performance is with so much facility that there is no seeming confinement to sitting (as is usual) that People go away with more sprightliness than they came.[36]

In Britain, the most able artists had at least to assume the appearance of being gentlemen, since they would be patronized by the upper classes, which in turn might lead to work at court. An artist like Van Dyck was not only held in high regard for his exceptional artistic gifts but also because he had the necessary courtliness of manner to enable him to mix comfortably at the highest level of English society. It was a way of life to which Van Dyck was naturally drawn: 'He always went magnificently dress'd, had a numerous and gallant equipage, and kept so noble a table in his apartment, that few princes were more visited, or better serv'd.'[37] Van Dyck was knighted as, after him, was Lely, while Kneller was created baronet. No English painters of any kind were to be so honoured until Sir James Thornhill (1675/6–1734) was knighted in 1720, followed by Sir Joshua Reynolds, the only other in the eighteenth century, in 1769.[38]

As a result of the almost over-eager patronage by the English aristocracy of

foreign portrait painters, their social and financial success often went to their heads. Van Dyck seems always to have retained a natural sense of propriety (and he actually married into the English aristocracy[39]), but lesser men like Lely began to give themselves airs: 'A mighty proud man he is, and full of state', Pepys recorded; while Pope has left a famous account of a visit to the dying Kneller:

> I paid Sir Godfrey Kneller a visit but two days before he died; I think I never saw a scene of so much vanity in my life. He was lying in bed and contemplating the plan he had made of his own monument. He said many gross things in relation to himself and the memory he would leave behind him. He said he would not like to be among the rascals at Westminster. A memorial there would be sufficient and desired me to write an epitaph for it. I did so afterwards and I think it is the worst thing I ever wrote in my life.[40]

Some portrait painters could be unexpectedly brought down to earth with a bump, as the precocious Lawrence discovered in 1769 when his request to Queen Charlotte to enliven her features by talking was viewed as presumption.[41]

A natural relationship, however, usually obtained between portrait painter and sitter, the artistic and professional status of the one matching the social status of the other; and, while that might mean that a great painter like Gainsborough might choose an extraordinarily wide range of sitters, from the son of a Soho ironmonger to the King, there are numerous examples of portrait painters whose clientele was limited to, say, the armed services, the manufacturing classes or the medical and legal professions. Snobbery, on the other hand, was likely to rear its head on either side, especially over such niceties as whether the sitter visited the painter's studio or had him call at one's house (a matter distinct from that of the itinerant artist on visits to country houses). With the grandest painters, the latter distinction was rarely accorded, save to royalty, and Pope remarked on the fact to Lady Mary Wortley Montagu when he told her that Kneller would come to her house 'to draw your face in crayons': '. . . from whence he will transfer it to canvas, so that you need not go sit at his house. This, I must observe, is a manner in which they seldom draw any but crowned heads: and I observe it with secret pride and pleasure.'[42]

Lely apparently considered it beneath his dignity to leave his studio to paint dignitaries of the City of London in 1670 and the commission therefore passed to J. M. Wright (1617–94).[43] At this point Lely had, after all, been Principal Painter to the King since 1661 (with one of those uncertain Stuart pensions of two hundred pounds a year), although he was not to be knighted until 1680, and it is indicative of the importance attached to such niceties of professional status that he should have turned down an important commission on these grounds. There was always the possibility that a customer could offend a successful painter by failing to recognize that the artist might be in a position to pick and choose, and might see a commission as being patronizing rather than patronage. Gainsborough was infuriated to hear one of his sitters refer to him condescendingly as 'that fellow', and immediately struck the brush through the portrait with the challenge, 'Where is that fellow now?'[44]

The precise arrangements for sittings could vary considerably. The customer arriving at Gainsborough's studio, for example, might be surprised to discover that sittings began almost in the dark, using candlelight, a habit recorded by the

painter Ozias Humphry (1742–1810) who knew Gainsborough well:

> Exact resemblance in his portraits . . . was Mr Gainsborough's constant aim, to which he invariably adhered. These pictures, as well as his landscapes, were frequently wrought by candlelight, and generally with great force and likeness. But his painting-room – even by day a kind of darkened twilight – had scarcely any light, and I have seen him, whilst his subjects have been sitting to him, when neither they nor the pictures were scarcely discernible.[45]

It is interesting to note that this method was used for portraiture in sixteenth-century Italy, although it was far more usual for a portrait painter to work, as Lely did, by the full light of a nearby window.[46] (Reynolds's studio, however, cannot have been very well lit, perhaps for reasons of parsimony.[47]) The rest of Humphry's account shows that this candlelight method was employed only as an initial step by Gainsborough, who later admitted more light into the studio in order to finish the portrait in the usual way. It was a system perpetuated by his nephew, Gainsborough Dupont.[48] (It is probable that a similar approach is the explanation of Shaftesbury's record that Closterman used to study his portraits in the dark while they were in progress.[49])

In other respects, too, Gainsborough employed unusual methods to ensure that he captured an accurate likeness which was, he averred, 'the principal beauty and intention of a portrait.'[50] To this end he would loosen larger canvases from their stretchers, having marked the correct position of the head upon the canvas, and then work that area to the side of the frame in order closely to compare it with the sitter's face, an arrangement that also allowed him to move back and forth and compare the two side by side 'both near and at a distance':

> If the canvases were of three-quarter size he did not desire they should be loosened upon the straining frames, but if they were half-lengths or whole-lengths he never failed to paint with the canvas loose, secured by small cords, and brought to the extremity of the frame, and having previously determined and marked with chalk upon what part of the canvas the face was to be painted it was so placed upon the easel as to be close to the subject he was painting; which gave him an opportunity (as he commonly painted standing) of comparing the dimensions and effect of the copy with the original, both near and at a distance. By this method, with incessant study and exertion, he acquired the power of giving the masses and general forms of his models with the utmost exactness. Having thus settled the ground-work of his portraits he let in (of necessity) more light for the finishing of them; but his correct preparation was of the last importance and enabled him to secure the proportions of his features, as well as the general contour of objects, with uncommon truth.[51]

It should be pointed out here that the term 'three-quarter size', which appears to make nonsense of the account, actually refers to a standard size of canvas smaller than that used for a half-length, indicating that it measured approximately three-quarters of a yard, and would be used for a head and shoulders. Canvases, in fact, came in such standard sizes, ready-stretched and, apparently, not only ready-primed but with a 'ground lay' (or 'first lay') on them of lead-white and charcoal, for example (visible in Plate 1).[52] The 'three-quarter' measured 30 × 25 in (76.2 × 63.5 cm) when stretched; other standard sizes were available for half-length portraits (50 × 40 in; 127 × 101.6 cm), full-length portraits (94 × 58 in; 238.7 × 147.3 cm), 'kit-cats' (or 'kit-kats') which showed near-half-length with one or both hands (36 × 28 in; 91.5 × 71.1 cm)[53] and there was even a 'bishop half-

length' which measured 55 × 44 in (139.7 × 111.8 cm), evidently to allow for the
spreading of a pair of lawn sleeves.[54] It explains why Gainsborough had to begin
by undoing the work of the canvas supplier with his half- and full-length canvases.

Other artists used different devices from Gainsborough's, but they were often
equally idiosyncratic, and an account has come down of Reynolds's painting the
4th Duchess of Rutland, who described 'how he would rush forward, and look
closely into her eyes, take her well in, and then go as far back as possible, and look
at the general effect in a distant glass, chiefly making his picture from that.'[55] This
account is confirmed in some ways, and contradicted in others, by that of Lady
Burlington, who lived on well into the nineteenth century, and told Sir Francis
Grant of her sitting to Reynolds:

> He took quite a quantity of exercise when he painted, for he continually walked
> backwards and forwards. His plan was to walk away several feet, then take a long look
> at me and the picture as we stood side by side, then rush up to the portrait and dash at it
> in a kind of fury. I sometimes thought he would make a mistake and paint on me
> instead of the picture.[56]

It is not quite clear exactly how Reynolds used the mirror (or mirrors) in his
studio, but it is known from other sources, including Ozias Humphry, that he did
so. His employment of them for the purpose of recording 'the general effect',
evidently by increasing the distance between painter and sitter, accords with his
attempts to avoid being too confined by the particularities of an individual, and
instead to generalize in a typically Augustan manner. Reynolds's view of the
painter's vocation was similar in some ways to Imlac's view of the poet's task in
Dr Johnson's *Rasselas* (1759): 'The business of a poet is to examine, not the
individual but the species; to remark general properties and large appearances . . .
he must . . . rise to general and transcendental truths.' Of course, the portrait is
not, ostensibly, a very suitable form in which to pursue this high-minded ideal: the
painter might wish to rise, in the words of Dr Johnson (*Prefaces to Shakespeare*),
to 'just representations of general nature', but the sitter would naturally be
anxious that the painter should capture an individual likeness. It was a difficulty
that Reynolds successfully confronted for, as Waterhouse has put it, Reynolds's
portraits 'reveal universal human values beneath an individual human likeness.'[57]

Kneller seems to have used two mirrors in his studio, although the record
appears to suggest that they were needed merely to amuse his sitters by enabling
them to compare their own image with that being created on canvas: 'He had two
looking glasses behind him that they [i.e., the sitters] co[d] see the Life & ye
Pictor.'[58] This form of amusement helped to limit the tedium of sittings, and when
Reynolds, using only one mirror, allowed Dr Beattie to watch the progress of his
portrait, the sitter found that five hours passed quickly enough.[59]

Other arrangements in the studios of portrait painters are better understood. In
Reynolds's studio, for example, the sitter was raised up on a dais, on which a chair
on castors was placed.[60] The effect can be seen in his famous portrait *Mrs Siddons
as the Tragic Muse, c. 1784* (San Marino, Henry E. Huntington Library and Art
Gallery), especially since she is known to have been painted in the attitude she
happened to strike just as she flung herself into Reynolds's throne.[61] Most of
Reynolds's sitters adopt a rather commanding air through being elevated in this
way, and the viewpoint, rather from below, was general enough in traditional

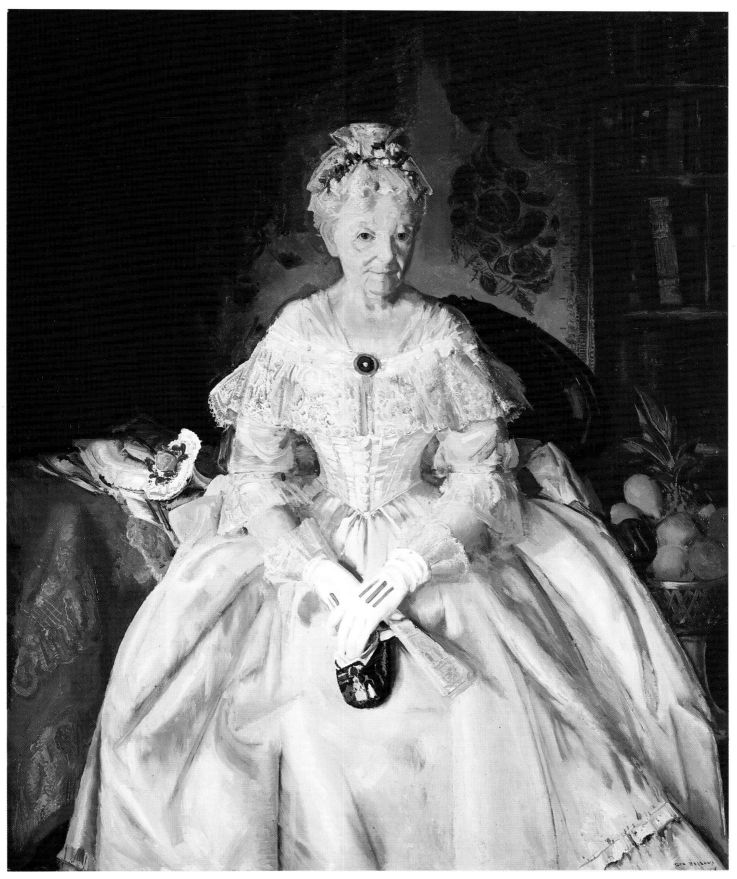

Plate 17　George Wesley Bellows, *Mrs T. in Cream Silk*, No. *1*. Oil on canvas, 134.6 × 111.8 cm (53 × 44 in). 1920.
Minneapolis, Minneapolis Institute of Art

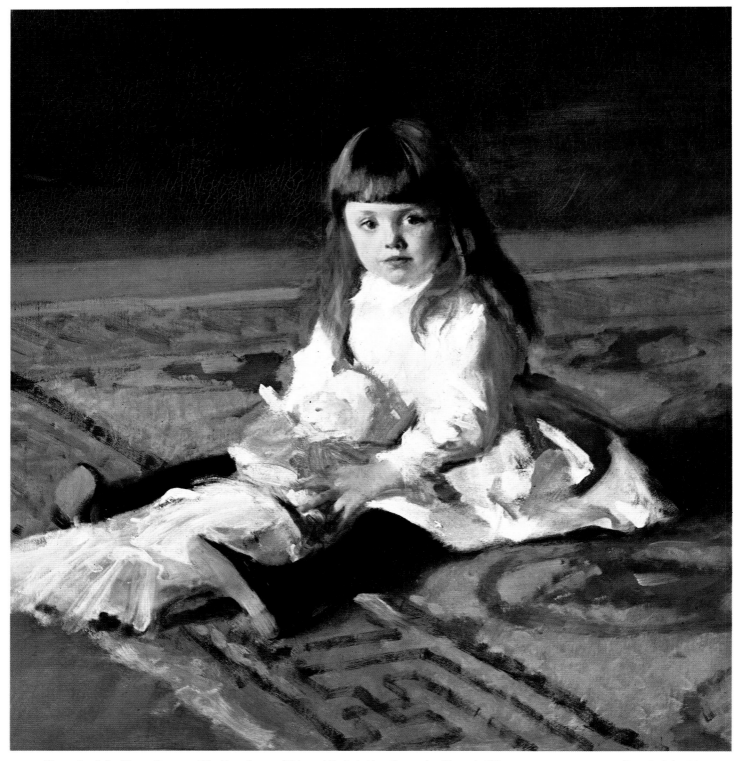

Plate 18 John Singer Sargent, *The Daughters of Edward D. Boit* (detail, see also Fig. 33). Oil on canvas, 221 × 221 cm (87 × 87 in). 1882.
Boston, MA, Museum of Fine Arts

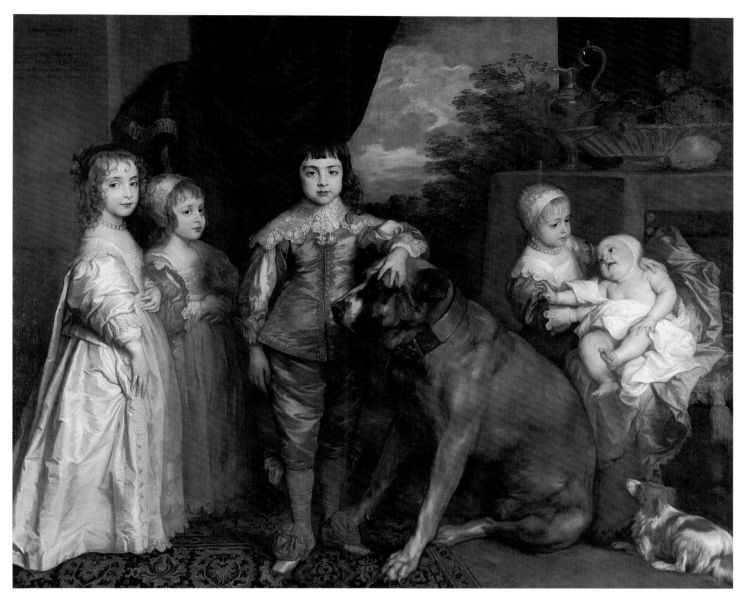

Plate 19 Sir Anthony van Dyck, *The Five Children of Charles I*. Oil on canvas, 163.2 × 198.8 cm (64¼ × 78¼ in). 1637.
Royal Collection, Windsor Castle

Plate 20 John Singer Sargent, *Lady Helen Vincent, Viscountess d'Abernon*. Oil on canvas, 158×108 cm ($62\frac{1}{2} \times 42\frac{1}{2}$ in). 1904.
Birmingham, AL, Birmingham Museum of Art, Museum purchase

Plate 21 Thomas Gainsborough, *'The Blue Boy' (Jonathan Buttall)*. Oil on canvas, 177.8 × 121.9 cm (70 × 48 in). *c.*1770.
San Marino, CA, Henry E. Huntington Library and Art Gallery

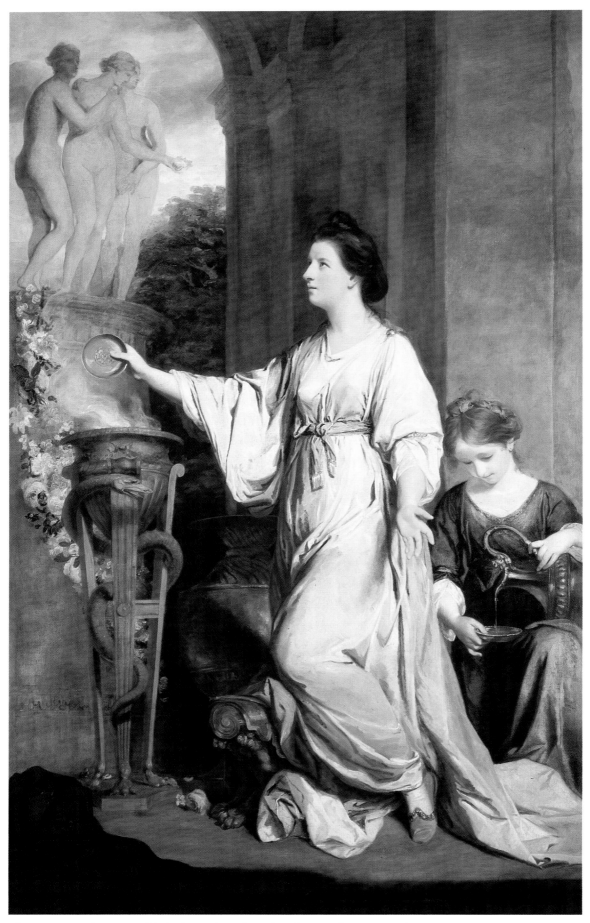

Plate 22 Sir Joshua Reynolds, *Lady Sarah Bunbury Sacrificing to the Graces*. Oil on canvas, 242 × 151.5 cm
(94 × 60 in). 1765. Chicago, The Art Institute of Chicago, W. W. Kimball collection

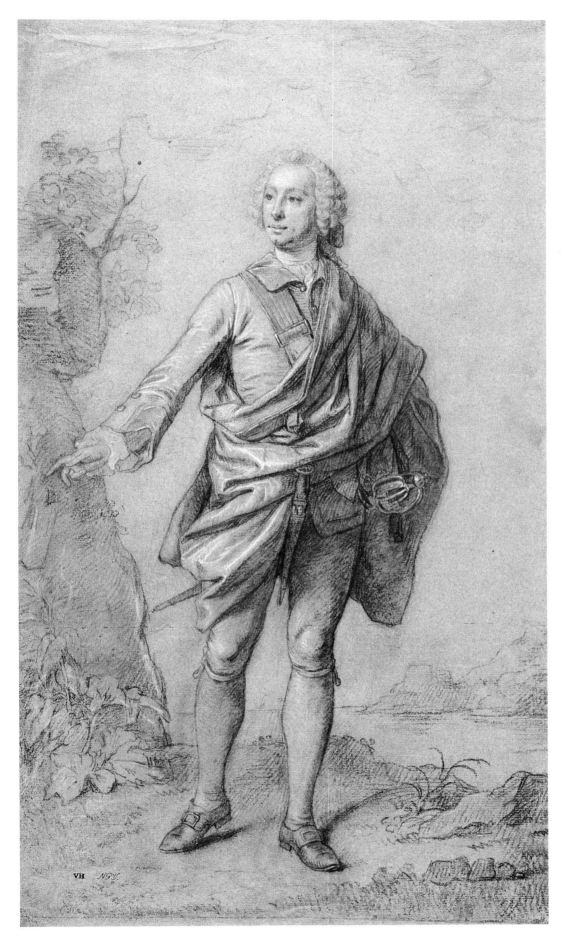

VH NGY

Plate 23 Joseph van Aken, *Study for Allan Ramsay's 'Norman 22nd Chief of Macleod'* (*'A Man Walking by the Sea with a Broadsword'*). Black, red and white chalk on blue paper, 52.1 × 32.1 cm (20½ × 12⅝ in). *c*.1747–8. Edinburgh, National Gallery of Scotland

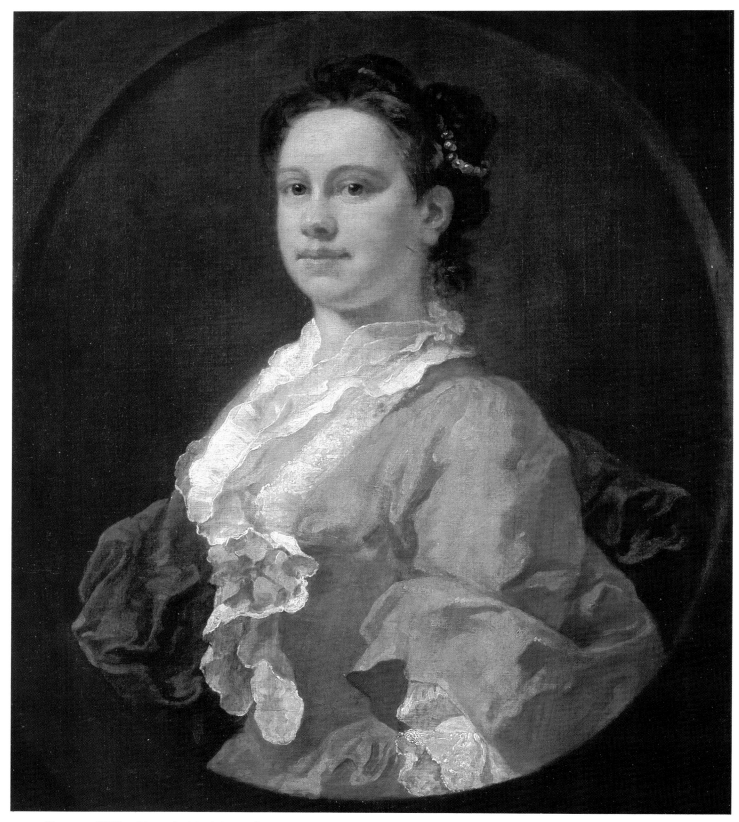

Plate 24 William Hogarth, *Mrs Salter*. Oil on canvas, 76.2 × 63.5 cm (30 × 25 in). 1744.
London, Tate Gallery

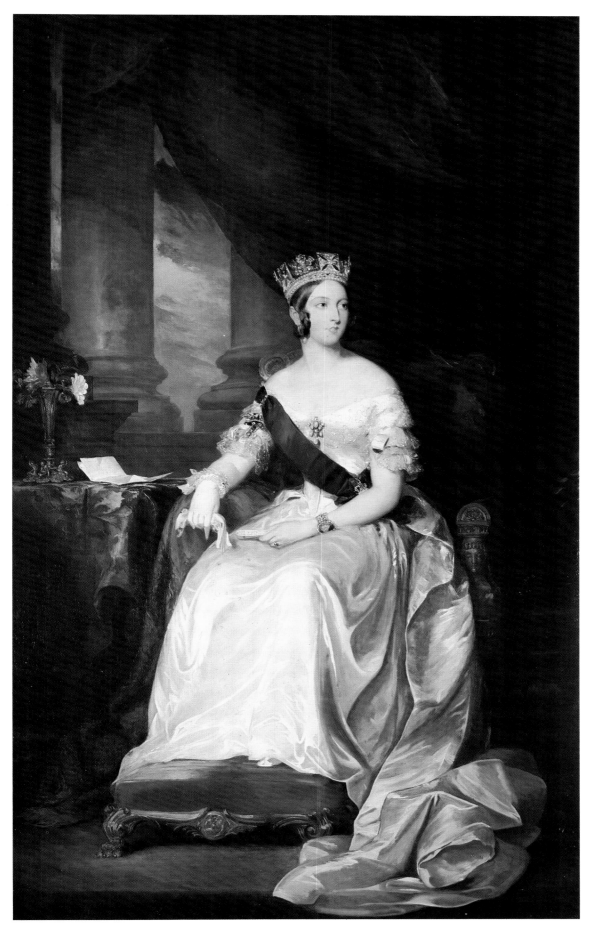

Plate 25 Sir Francis Grant, *Queen Victoria*. Oil on canvas, 243.8 × 147.3 cm (96 × 58 in). 1843.
London, Institute of Directors

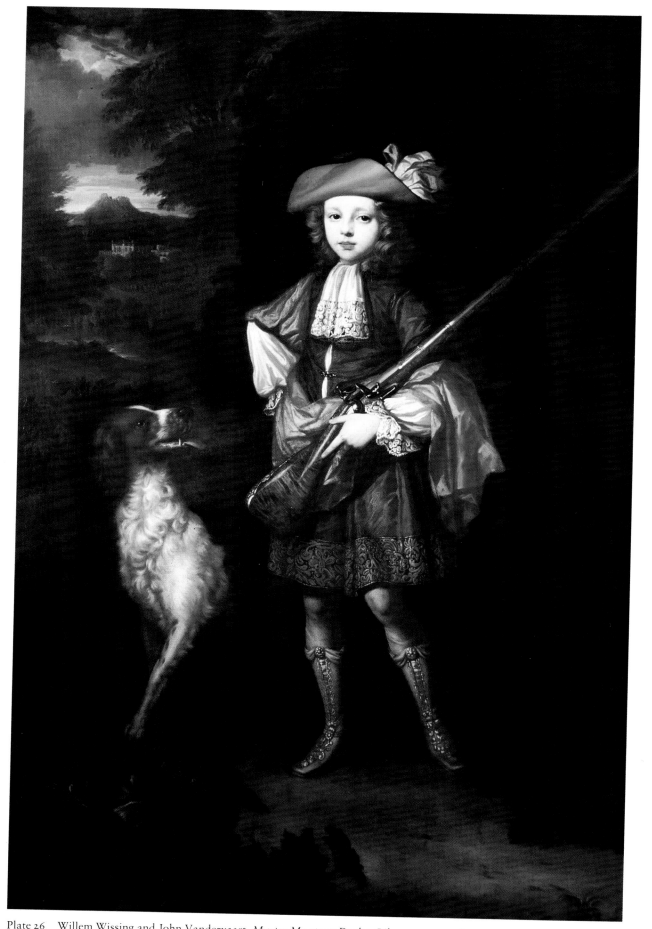

Plate 26 Willem Wissing and John Vandervaart, *Master Montagu Drake*. Oil on canvas, 238.7 × 127 cm (94 × 50 in). *c.*1685–6.
Private collection

Plate 27 James Sant, *The Hon. Julian and the Hon. Lionel Byng*. Oil on canvas, 156 × 108.5 cm (61½ × 42¾ in). 1890.
Wrotham Park collection

Plate 28 Sir William Blake Richmond, *Three Daughters of Dean Liddell ('The Sisters')*. Oil on canvas, 90.2 × 74.9 cm (35½ × 29½ in). Early 1860s. Private collection

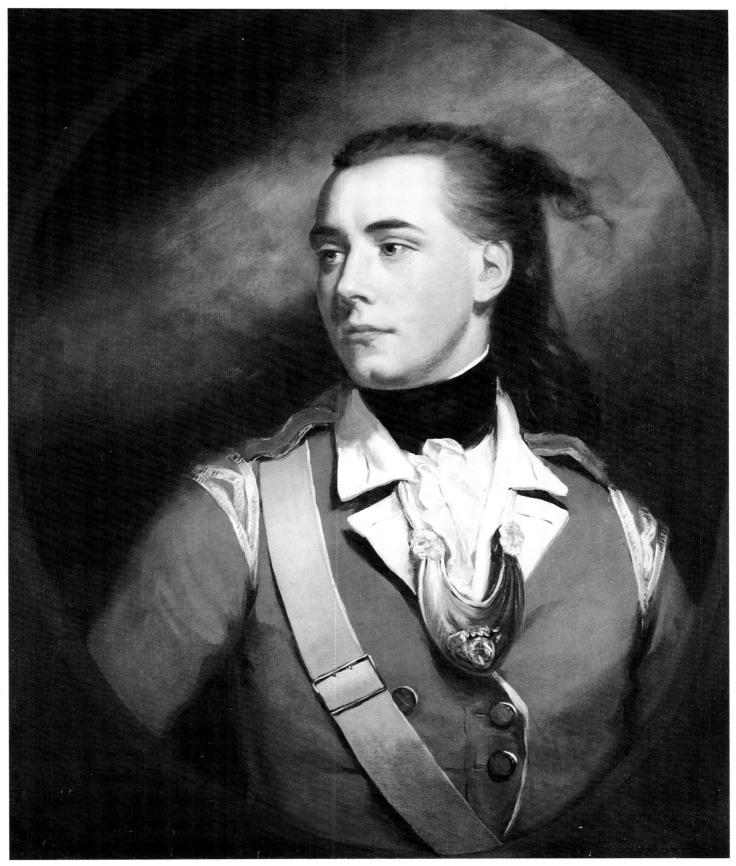

Plate 29 James Northcote, *Lieutenant George Dyer*. Oil on canvas, 75 × 62 cm (29½ × 24½ in).
Anthony Singlehurst

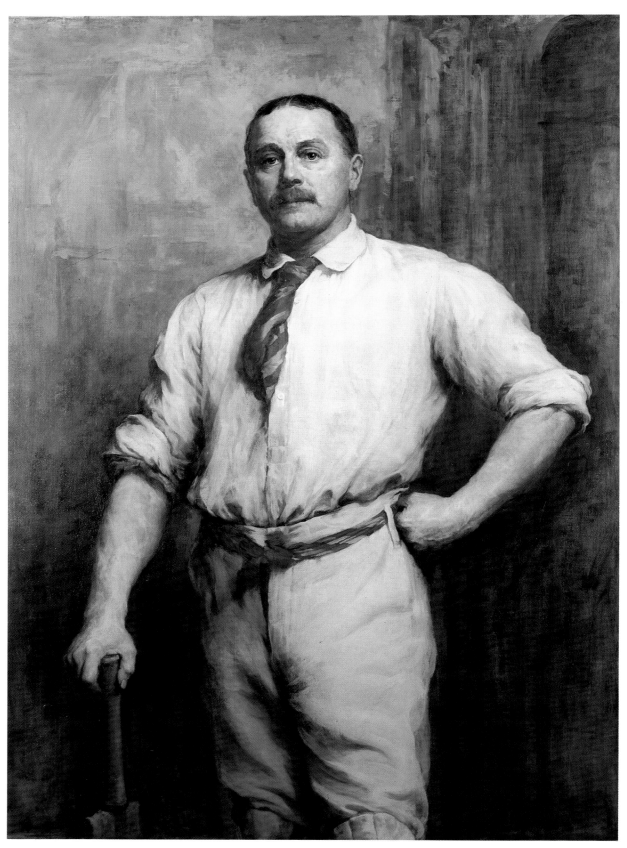

Plate 30 Walter William Ouless, *A. N. Hornby*. Oil on canvas, 142.2 × 104.1 cm (56 × 41 in). 1900.
Lancashire County Cricket Club

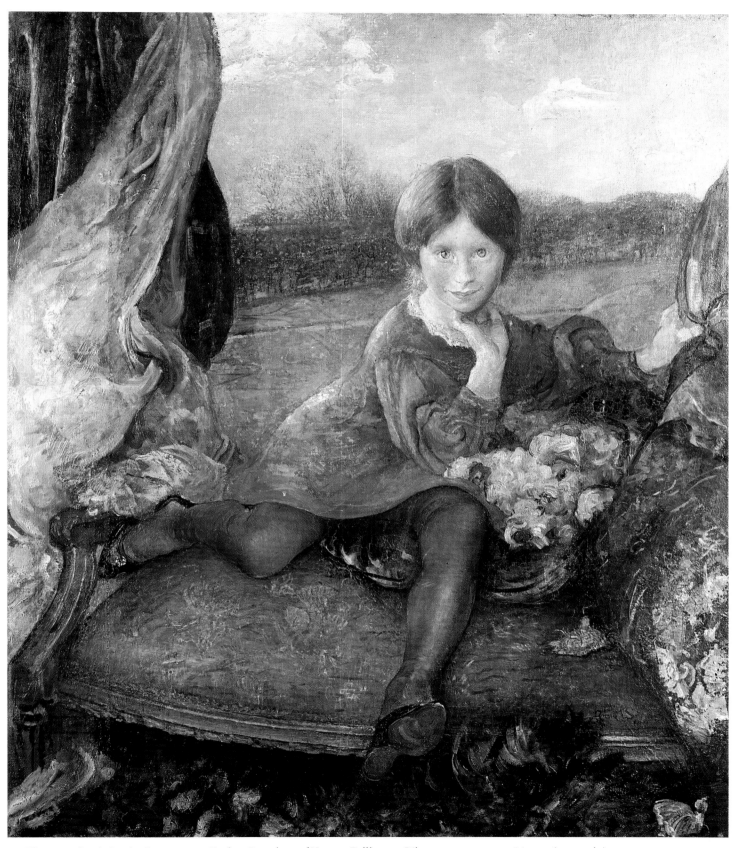

Plate 31 Annie Louisa Swynnerton, *Evelyn, Daughter of Vernon Bellhouse*. Oil on canvas, 101.5 × 86.5 cm (40 × 34 in). 1911.
Private collection

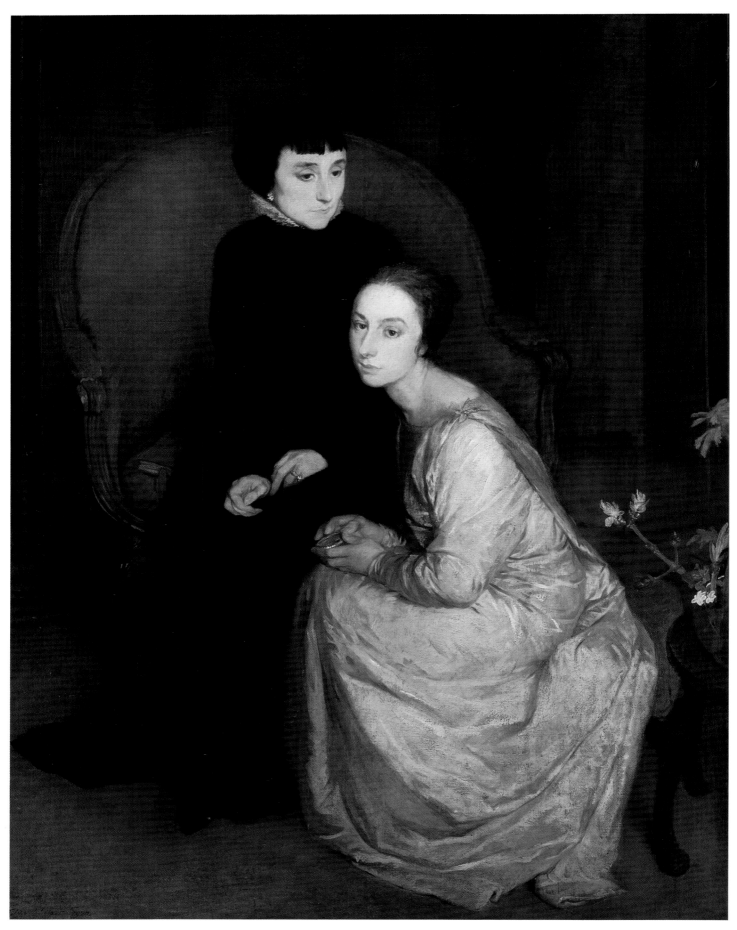

Plate 32 Glyn Philpot, *The Sisters of the Artist*. Oil on canvas, 141 × 110.5 cm (55½ × 43½ in). 1922.
Private collection

portraiture to have accounted for one of the difficulties encountered by John Singer Sargent with *The Misses Vickers* (Fig. 32), when he entered it for exhibition at the Royal Academy in 1886; for in the latter picture the sitters are seen from above, and at rather an acute angle.

We have noted before that sitters would be invited by Reynolds to look through folios of prints on arrival in his studio (including engravings after portraits by himself), in order to find a pose they fancied.[62] His usual method was then to design and paint the portrait directly on the canvas without preliminary drawings.[63] This procedure was not, generally speaking, a handicap, although Reynolds himself felt his lack of training as a draughtsman throughout his career. He was ambitious, however, to work on complex portraits and portrait groups, and there his lack of a systematic preparatory process could be a distinct disadvantage, although it is a lack more noticeable in his attempts at history painting where he may not have had, to the same extent, the compensatory assistance of a highly-trained studio helper. He seems, for example, never even to have used the most basic method of 'squaring-up', which would enable the straightforward transfer of the design of a finished drawing to a larger canvas. It is the employment of this technique, and of a whole series of related stages of preparatory design, that underpins Copley's remarkable capacity to work on large complicated compositions. Many of Copley's careful drawings survive, some of the finished ones squared-up for transfer; and for the great dramatic portrait groups such as *The Siege of Gibraltar* there are also highly-finished oil studies of individual heads that bear brushed-in indications of precisely how they were to be fitted in to the whole interlocking scheme (Fig. 9).[64]

Naturally, the extent to which artists used preliminary drawings varied widely: Gainsborough, for example, evidently painted the head directly on the canvas, using sketches for the purpose of roughing the pose and general design out on paper. Holbein, however, recorded his sitter's face in drawings, and appears thereafter to have painted his portraits of them without further sittings. Finished drawings of the head could play an important part in Kneller's business, too, partly when, as Holbein seems often to have done, he visited his sitters (Pope's letter to Lady Mary Wortley Montagu specifically states that Kneller will be drawing, and not painting, when he visits her).[65] Drawings were also useful to Kneller because, like Holbein, he often needed to produce replicas of his portraits.

In this context, it seems probable that Kneller's encouragement of the publication of engraved prints after his portraits fulfilled the useful function, in addition to increasing his fame, of providing patterns for his customers to choose from when deciding how they wished to be portrayed. Reynolds, as we have seen, was to employ similar means, and his own view of the importance of fine engravings by James McArdell after his works was, apparently, 'By this man, I shall be immortalized.'[66]

In those cases where the face painter and drapery painter were professionally quite independent, the importance of finished drawings was considerable, as we have seen with Hudson and Van Aken. It is with some surprise therefore that we note the lack of any similar drawings in relation to Reynolds's portraits, since Reynolds was a pupil of Hudson and is known to have used drapery painters. However, this difference of procedure may be attributed to the fact that Reynolds did not always employ an outside specialist, but often carefully trained assistants

within his own studio. The most important of these, Giuseppe Marchi (*fl.* 1752–1808), was distinct from Reynolds's occasional pupils, and occupied a permanent position as his chief assistant for some thirty to forty years within the household. Unfortunately, the precise details of this relationship remain obscure. As Waterhouse noted, however, the fact that Reynolds's technical notes on specific pictures are often in Italian suggests that they were intended for the guidance of Marchi, who also seems to have had general charge of the all-important sitter-books.[67] In contrast, Reynolds was noticeably secretive about his technique and business towards his pupils whom he was, after all, supposed to be instructing.[68]

A more self-contained studio business of this kind meant that Reynolds's practice was, in significant respects, unlike that of his master Hudson, by whom, to take a key detail, there are known to have been some one hundred and sixty drawings still in the studio at his death (even though few are now identified).[69] Reynolds's studio was more similar to the traditional continental arrangement such as that of Lely where, the face having been painted, the master might continue by rapidly laying in, from the life, straight on to the canvas, indications of the pose together with the hands and colouring of the drapery: when Dr Beattie sat to Reynolds in 1773, after breakfasting with the artist, he recorded, 'I sat to him five hours, in which time he finished my head, and sketched out the rest of my figure.'[70] Lely, however, like Gainsborough, might also make rough sketches on paper of pose and drapery for the initial approval of the sitter.[71] It was a habit of Lely's great immediate predecessor, Van Dyck: 'Mr Gibson told me Vandyke would take a little piece of blue paper upon a board before him, & look upon the Life & draw his figures & postures all in Suden lines, as angles with black Chalk & heighten with white Chalk.'[72] As Sir Oliver Millar has observed of Lely, 'Drawings play the same role in his practice and methods as in Van Dyck's.'[73] There are no full-size drawings of sitters' heads by Lely, as there are by Kneller, Dahl, Richardson, Ramsay, and Lawrence, for example, although many exquisite small-scale portrait drawings by Lely are known; but whether the artist produced his portrait with the help of preliminary drawings or not, the actual sittings, even to those artists who painted directly on to the canvas, did not have to be either numerous or lengthy. As Reynolds explained to a potential customer in 1777:

> It requires in general three sittings, about an hour and a half each time but if the sitter chooses it the face could be begun and finished in one day. It is divided into separate times for the conveniences of the person who sits. When the face is finished the rest is done without troubling the sitter.[74]

The comparative ease of this process was, of course, the fruit of Reynolds's great experience by this date, and earlier in his career, sittings had sometimes been more laborious; and he was perhaps being disingenuous in this letter, for Dr Beattie, as we have noted, sat for five hours in 1773. Reynolds carefully recorded the sittings in his sitter-books, many of which survive (from 1755 to 1789), as do those of other artists, including Reynolds's great rival, George Romney.[75] From them, it is possible to see just how hard a successful portrait painter might have to work. Although Reynolds, for example, was careful to keep the number of sittings down to about four or, at the most, six a day, in order to leave himself time for other work and to finish his day's work by four o'clock, Lely is known to have had

to fit sitters in early in the morning, making appointments six days in advance, between seven and eight o'clock.[76] Kneller is supposed to have had as many as fourteen sitters in one day which, since the information is said to have come from the artist himself in the course of conversation, is a claim open to several interpretations.[77] Stray remarks of this kind, taken out of context, can be misleading. In the latter case, for example, it is important to recall that Kneller, an amusing and witty companion, was evidently a braggadocio, as extravagant in his conversation as in his way of life. His claim, on this occasion, to have fourteen sitters a day was followed – hastily, one imagines – by the equally improbable assertion, in an attempt to impress the hearer with his professional scrupulosity, that he gave each sitter ten or twelve sittings.[78] There is no evidence that anyone sat to Kneller more than four times, a normal number of sittings. Such evidence as there is concerning Lely's practice on this point indicates a similar number of sittings, as do, for example, Romney's sitter-books.[79]

The length of time a sitter might wait for the completion of the portrait naturally varied and it is not easy to make any generalization about it, but it was certainly reasonable to expect that a portrait might be delivered within a year of the first sitting. Examples of delays are numerous: Gilbert Stuart began his portrait of Stephen Jay in 1783 only for the family to be forced to wait until 1794 for it to be delivered.[80] Not many, however, can have equalled Lawrence's procrastination over his portrait of Lady Mexborough and her baby son. When Lord Mexborough insisted on its delivery, the following exchange took place:

'Well', said Sir Thomas, 'I've been a long time, I'll allow; but I've got well forward with Lady Mexborough: it's the baby wants finishing. Now if Lady Mexborough would kindly bring the baby and give me another sitting, I really will finish.' – 'Well, Sir Thomas,' said Lord Mexborough, 'my wife will be happy to give you another sitting whenever you like, but the baby's in the guards!'[81]

The rewards for the hard-working portrait painter could be very considerable, although here too it is difficult to make generalizations. A number of studies have been made of the income of professional portrait painters, and a mass of detailed information about prices has survived and is readily available.[82] Despite the difficulties involved in comparing these sums with modern-day values it is easy enough to see that the most successful professional portrait painters of the past could become very rich indeed, and to recognize that many lesser artists were able to live in comfort. When Reynolds, a notoriously careful man with money, moved to Leicester Fields in 1760, he did so in the reassuring knowledge that his income was £6,000 a year. In 1759 he could charge one hundred guineas for a full-length, fifty guineas for a half-length and twenty guineas for a portrait 30 × 25 in (76.2 × 63.5 cm); a more run-of-the-mill artist like Arthur Pond (1701–58) could charge £36.15.0, £21.00.00 and twelve or ten guineas respectively in 1750.[83]

Reynolds was working at a time when artists were increasingly free of the restraint and regulation of employment by the apprenticeship system, which was in the process of disintegration; and the eighteenth century witnessed the emergence of the Livery Companies in their modern form of self-perpetuating clubs, more or less given to charitable works, more or less connected with their nominal trades. It is significant in this respect that Reynolds began his career by being formally apprenticed to Hudson, but got himself bought out before his time

(which would usually be seven years), and that he was subsequently 'made free' of the Painter-Stainers' Company in 1784. It then counted as something purely honorary (another honour in addition to those with which, by this time, he was laden), which he celebrated by taking James Boswell to one of the Company's feasts.[84]

The portrait painter might thus be seen as having finally emancipated himself from the taint of 'trade', and it is certainly true that in Britain he might, at the highest level, enjoy an esteem and social acceptability that had only hitherto been accorded to foreigners. But they 'that live to please, must please to live', and portraitists on both sides of the Atlantic remained dependent for the success of their business on their effective capacity to supply the right goods in response to demand. The further emancipation of the portraitist, as of artists generally, was the far more ambivalent one which saw the artist increasingly provided with independence from the demands of society through his employment in full-time academic work. This phenomenon was significant in the case of only a handful of important portrait painters towards the end of our period.

We have also considered the reaction of portrait painters to photography, an invention that may be said to have provided an equally ambivalent freedom. It would be quite wrong to think that portrait painters saw the camera as a threat, although some of them certainly did: James Smetham (1821-89), for example, a man admittedly melancholic by temperament, despaired of competing with photography and abandoned portrait painting; and a number of run-of-the-mill portrait-painting studios in America either changed over to using the camera, or actually painted in oils on top of photographs. Many artists, however, were in sympathy with Samuel Morse's perception that the daguerreotype and its successors were to be understood as offering an opportunity to extend the painter's art rather than providing a substitute for it.

Professor Novak has observed that, in America for example, in addition to Eakins, whose interest in the camera we have noted: 'Mount, Lane, Homer, Page, Healy, Church, Remington, Harnett, Bierstadt all seem to have made some use of the photograph not only as a study but as a model for paintings.'[85]

This attitude to the assistance of science was nothing new for painters: systems of perspective themselves can be seen as an earlier manifestation of the same eagerness to employ any useful means with which to trap reality, and early in the sixteenth century Dürer, for example, showed how an artist might employ optical devices.[86] In the world of portraiture, the daguerreotype was preceded by such machines as the physiognotrace, invented to take profiles by Gilles-Louis Chrétien in 1786. It was taken to America by Charles de Saint-Mémin (1779-1852) when he fled the French Revolution in 1793; and the resulting drawing, with the aid of yet another machine, the panotrace, could also be engraved on copper in the form of a circular, reduced copy. The camera lucida was popular for the purpose of taking portrait drawings of a more elaborate kind in the nineteenth century, while the camera obscura had long been employed by artists. Reynolds's portable example, complete with its original leather fittings like those of the plate photographer's black cloth, and which folds down into the form of a large leather-bound volume, survives in the Science Museum in London.[87]

In the late 1770s, Reynolds and West were caught up in a flurry of excitement over a development of the camera obscura, William Storer's Accurate Delineator

(an example of which is also in the Science Museum) which, had the inventor been able to simplify his equipment (and not gone bankrupt in March, 1785), might well have provided the portrait painter with a short-cut even more useful than the nineteenth-century camera, in that the image of the required object was reproduced in full colour. It was, apparently, the right way round, in an image more powerful than that hitherto available through the camera obscura.

Horace Walpole waxed enthusiastic about Storer's invention in a number of letters (and allowed Storer to make use of his name in publicity): 'Sir Joshua Reynolds and West are gone mad with it, and it will be all their own faults if they do not excell Rubens in light and shade, and all the Flemish masters in truth.'[88] At the time Walpole wrote this report, in 1777, the device had just been invented, and the image produced was confined in size to that of a sheet of paper. Walpole also refers to the difficulty of operation of the Delineator – 'there is a vast deal of machinery and putting together' – and, of fifty produced and sold for ten guineas each, no fewer than forty-six were returned to the inventor for him to simplify if he could.[89] Nothing daunted, Storer set about making it, in effect, even more complicated, turning it into a method for projecting images, with an eye very clearly on the artistic market. In his *Syllabus* of 1782 he announced his modification:

> By the use of *this part* of the DELINEATOR may be represented *on any scale*, single figures, placed in any attitude, or groups of figures so arranged and disposed at pleasure, as to be of great use to painters, and save them much time and study, in the composition of HISTORICAL or FAMILY PICTURES.[90]

In his support he quotes a commendation from Walpole (no doubt written by himself): '... it represents the objects erect, and neither inverted nor transversed; ... it delineates the human face of any size required, and consequently is of the greatest use to portrait painters'[91] Ominously, the optimistic inventor asked for a day's notice before demonstrating this new improved Delineator, and there is no record of his offer having been taken up and, as we have noted above, he is last heard of as a bankrupt. Portrait painters had to wait for their holy grail (or poisoned chalice) to appear in the form of the daguerreotype some fifty-four years later.

Whatever the response of artists to photography in the nineteenth century, in the purely functional role of recording a likeness portrait painting has long since given way to the snapshot (let alone the studio photograph). From the moment photography was perfected, portrait painting, if it did not die, began to waste away. A great tradition has thus been lost. In the past, the best artists of the day, as we have seen, were often engaged in painting portraits, either willingly or reluctantly. It was an occupation that exercised the ingenuity of many of the greatest artists that Britain and America have produced. In variety, inventiveness, and profound human interest, their achievement is now unlikely to be equalled.

Notes

Chapter One

1. R. Strong, *The English Icon* (London and New York, 1969), pp. 45ff.; *The Treasure Houses of Britain, Five Hundred Years of Private Patronage and Art Collecting*, exh. cat. (G. Jackson-Stops, ed.) (National Gallery, Washington, New Haven and London, 1985), (1), (20), (346), and pp. 60 ff. (J. Cornforth).

2. George Vertue, Notebooks, *Walpole Society*, XVIII (1929–30, Vertue, I), XX (1931–2, Vertue, II), XXII (1933–4, Vertue, III), XXIV (1935–6, Vertue, IV), XXVI (1937–8, Vertue, V), XXX (1948–50, Vertue, VI), XXIX (1940–42, index); Vertue, III, p. 161.

3. Jonathan Richardson, *An Essay on the Theory of Painting* (London, 1715), p. 228; quoted in *Sir Peter Lely 1618–80*, exh. cat. (O. Millar) (National Portrait Gallery, London, 1978–9), p. 27.

4. *Imitations of Horace*, ep. II, i, ll. 139–40, 149–50. The text is that in J. Butt (ed.), *The Poems of Alexander Pope, A One-Volume Edition of the Twickenham Text* (reprinted with corrections, London, 1968). The passage is quoted by Millar, *Lely*, p. 15.

5. R. Latham and W. Matthews (eds), *The Diary of Samuel Pepys*, 11 vols (London, 1970–83), vol. 7, p. 102 (18 April 1666).

6. Millar, *Lely*, p. 17, p. 28, n. 33.

7. Millar, *Lely*, p. 28, n. 40. There is now a considerable amount of information in print about scales of charges for portraits, e.g., M. Pointon, 'Portrait-painting as a Business Enterprise in London in the 1780s', *Art History*, 7, no. 2 (June, 1984), pp. 187–205; *Reynolds*, exh. cat. (N. Penny, ed.) (Royal Academy, London, 1986), p. 58; D. Mannings, 'Notes on some eighteenth-century portrait prices in Britain', *British Journal for Eighteenth Century Studies*, VI (1983), pp. 185–96.

8. Cf. J.D. Stewart, *Sir Godfrey Kneller and the English Baroque Portrait* (Oxford, 1983), p. 18.

9. *Ibid.*, p. 2.

10. Vertue, II, p. 123.

11. R. Latham and W. Matthews (eds), *The Diary of Samuel Pepys*, 11 vols (London, 1970–83), vol. 9, p. 284 (21 August 1668).

12. John Dryden, *Preface to* Sylvae, *or the second part of* Poetical Miscellanies (1685). The text is that in J. Sargeaunt (ed.), *The Poems of John Dryden* (Oxford edition, 1913), p. 384, this Preface being chiefly concerned with translations. The passage is referred to in Millar, *Lely*, p. 25.

13. The chief of these paintings is the sole mythological picture known from Van Dyck's time in England, *Cupid and Psyche, c.* 1640 (Her Majesty the Queen).

14. Vertue, III, p. 94.

15. Reynolds's remark on Gainsborough will be found in Sir Joshua Reynolds, *Discourses on Art* (R. Wark, ed.) (New Haven and London, 1975), 'Discourse XIV', p. 251.

16. Pope described Kneller on his death-bed in a letter to Stafford (see Chp. 3, p. 110); for the exact date of Kneller's death see J. D. Stewart, *Sir Godfrey Kneller and the English Baroque Portrait* (Oxford, 1983), p. 78n.

17. William Hogarth, *The Analysis of Beauty* (J. Burke, ed.) (Oxford, 1955); cf. 'The Autobiographical Notes', pp. 201ff., pp. 216–7.

18. William Hogarth, 'The Autobiographical Notes' (J. Burke, ed.), pp. 216–8; taken here from the adapted reading of R. Paulson, *Hogarth, His Life, Art and Times*, 2 vols (New Haven and London, 1971), vol. 1, p. 433.

19. *Ibid.*

20. A separate study of Hogarth's portrait of Coram is that by H. Omberg, *William Hogarth's Portrait of Captain Coram, Studies on Hogarth's Outlook around 1740* (Uppsala, 1974), where some other suggested precedents for this portrait are discussed (pp. 45ff.). Assuming an uncharacteristic literal-mindedness in Hogarth's use of his sources, the author does not accept Antal's

proposition that this engraving after Rigaud was indeed the source, but these counter-arguments do not bear examination. Cf. F. Antal, *Hogarth and His Place in European Art* (London, 1962), pp. 45–6. For details of the engraving by Drevet after Rigaud's portrait of Samuel Bernard, see M. O'Neill, 'Hyacinthe Rigaud's Drawings for his Engravers', *The Burlington Magazine*, CXXV (November, 1984), pp. 674–83.

21. Cf. B. Nicolson, *The Treasures of the Foundling Hospital* (Oxford, 1972).

22. Vertue observed at the time, 'This is another of his efforts to raise his reputation in the portrait way from the life' (Vertue, III, p. 102).

23. Vertue, III, p. 80.

24. *Ibid.*, p. 117.

25. *Ibid.*, p. 123.

26. *Ibid.*, p. 84.

27. Related to his feeling that 'while he was engaged in painting a picture he never knew when to quit it, or leave off', cf. J. Northcote, *The Life of Sir Joshua Reynolds*, 2 vols (2nd edn revised and augmented, London, 1818), vol. 2, pp. 7–8.

28. E.g., Jonathan Richardson, *An Essay on The Theory of Painting* (2nd edn, London, 1725), pp. 21 ff. Reynolds told three different friends that it was to Richardson that he owed his first fondness for painting; cf. *Reynolds*, exh. cat. (N. Penny, ed.) (Royal Academy, London, 1986), p. 18, p. 40, n. 19.

29. 'William Hogarth's "Apology for Painters"' (M. Kitson, ed.), *Walpole Society*, XLI (1966–8), pp. 46–111, p. 94.

30. Sir Joshua Reynolds, *Discourses on Art* (R. Wark, ed.) (New Haven and London, 1975).

31. Hogarth, for example, supplied heads for John Wootton in 1734, cf. O. Millar, 'Notes on the Royal Collection, I: John Wootton, William Hogarth, and Frederick, Prince of Wales', *Burlington Magazine*, CIII (September, 1961), pp. 381–4; *John Wootton 1682–1764*, exh. cat. (Kenwood, 1984), pp. 19–21. In portraiture this collaborative approach has been more generally recognized. A complicated example is *Augustus Hervey taking Leave of his Family* (N. Trust, Ickworth), a picture in which Gravelot, Zoffany and Hayman were all involved; and the picture perhaps also included portraits after Liotard, with a ship by Dominic Serres; cf. *The Treasure Houses of Britain*, exh. cat. (G. Jackson-Stops, ed.) (National Gallery of Art, Washington, 1985), (165).

32. *Reynolds*, exh. cat. (N. Penny, ed.) (Royal Academy, London, 1986), p. 28.

33. The source is Allan Cunningham, *The Lives of the Most Eminent British Painters, Sculptors, and Architects*, 6 vols, (2nd edn London, 1830), but see C.R. Leslie and T. Taylor, *Life and Times of Sir Joshua Reynolds, With Notices of Some of his Contemporaries*, 2 vols (London, 1865), vol. 2, p. 133.

34. Barry's most elaborate example was his decoration of the rooms of the Royal Society of Arts, cf. *James Barry, The Artist as Hero*, exh. cat. (W.L. Pressly) (Tate Gallery, 1985), pp. 79–100. An early and unusual example of 1758 is discussed by Claire Pace, 'Gavin Hamilton's *Wood and Dawkins discovering Palmyra*: The Dilettante as Hero', *Art History*, 4, no. 3 (September, 1981), pp. 271–90.

35. Pelham and Smibert both died in 1751 when Copley was very young. The two knew each other and were business associates. Smibert maintained contact, as a buyer of prints, with the London portrait painter and print publisher Arthur Pond; cf. L. Lippincott, *Selling Art in Georgian London: the Rise of Arthur Pond* (New Haven and London, 1983), pp. 35, 142, 143. W.P. Belknap carried out the first extensive demonstration of the dependence of Colonial artists on imported engravings; cf. W.P. Belknap, Jr, *American Colonial Painting, Materials for a History* (Cambridge, MA, 1959).

36. Cf. J.D. Prown, *John Singleton Copley*, 2 vols (Cambridge, MA, 1966), vol. 1, pl. 163. The letters between sitter and artist are published in (G. Jones, ed.) 'Letters and Papers of John Singleton Copley and Henry Pelham', *Massachusetts Historical Society Collections*, LXXXI (Boston, MA, 1914).

37. Cf. *The American Pupils of Benjamin West*, exh. cat. (D. Evans) (National Gallery, Washington, 1980).

38. Stuart was quite frank about it, declaring, 'I expect to make a fortune by Washington alone.' There are three types, all of which were repeated in replicas, the 'Lansdowne portrait', 1796 (Lord Rosebery, on loan to National Portrait Gallery, Washington), the 'Vaughan portrait', 1795 (National Gallery, Washington), and the 'Athenaeum portrait', 1796 (Boston Museum of Fine Arts, loan, Boston Athenaeum). Cf. J.H. Morgan and M. Fielding, *The Life Portraits of Washington and their Replicas* (Philadelphia, 1931).

39. Cf. *The American Pupils of Benjamin West*, exh. cat. (D. Evans) (National Gallery, Washington, 1980).

40. Cf. W. Blunt, *'England's Michelangelo': a Biography of George Frederick Watts, OM, RA* (London, 1975).

41. It would be only fair to say that, especially in a few private commissions (rather than in portraits for his 'Hall of Fame'), Watts brought off some splendid effects of Venetian colouring, but such moments are infrequent.

42. *The Düsseldorf Academy and the Americans*, exh. cat. (D. F. Hoopes) (Metropolitan Museum of Art, New York, 1970); W.H. Gerdts, 'Natural Aristocrats in a Democracy: 1810–70' and M. Quick, 'Achieving the Nation's Imperial Destiny: 1870–1920' in *American Portraiture in the*

Grand Manner: 1720–1920, exh. cat. (M. Quick), with essays by M. Quick, M. Sadik and W.H. Gerdts (Los Angeles County Museum of Art and National Portrait Gallery, Washington, DC, 1981–2), pp. 27–60, 61–76.

43. Quoted in *Indianapolis Star*, 14 January 1899, p. 9; cf. W.D. Peat, *Chase Centennial Exhibition*, exh. cat. (John Herron Art Museum, Indianopolis, IN, 1949); J. Wilmerding, *American Art* (Harmondsworth, 1976), p. 144.

44. Cf. R. Rudishill, *Mirror Image, The Influence of the Daguerreotype in American Society* (Albuquerque, NM, 1971), p. 57. For the influence of the daguerreotype and of photography on American painting see also B. Novak, *American Painting of the Nineteenth Century. Realism, Idealism, and the American Experience* (New York, 1969); B. Newhall, *The Daguerreotype in America* (revised edn, New York, 1968); J. Wilmerding, *op. cit.*, pp. 71–2 ff.; M. Hoppin, 'W.M. Hunt: Portraits from Photographs', *American Art Journal*, 11 (April, 1979), pp. 44–57.

45. Cf. G. Hendricks, *The Photographs of Thomas Eakins* (New York, 1972); K. MacDonnell, *Eadweard Muybridge, The Man who Invented the Moving Picture* (Boston, MA, 1972). Eakins's master in Paris in the 1860s, Bonnat, used photography to ease the number of sittings.

46. Perhaps surprisingly, this matter has been the subject of some controversy. The classic demonstration is that of Daniel A. Fink, 'Vermeer's Use of the Camera Obscura – A Comparative Study', *Art Bulletin*, LIII, no. 4 (December, 1971), pp. 493–505; John H. Hammond in *The Camera Obscura, A Chronicle* (Bristol, 1981) sounds a more cautious note, but there was evidently, as J. Ayres has put it, 'a certain discretion surrounding the employment of such devices'; cf. J. Ayres, *The Artist's Craft, A History of Tools, Techniques and Materials* (Oxford, 1985), p. 69. See also Chp. 3, pp. 132ff., where Reynolds's camera obscura is mentioned, together with his interest in another optical device that could be of assistance in the studio.

47. The name was given to the circle of painters around Robert Henri, including John Sloan (1871–1951) and George Luks (1867–1933); cf. W.I. Homer, *Robert Henri and His Circle* (Ithaca and London, 1969). These artists had direct links with Eakins through his pupil Thomas Pollock Anshutz (1851–1912) who taught a number of them; while Henri recalled Eakins's *The Gross Clinic*, 1875 (Jefferson Medical College, Philadelphia) as 'the most wonderful painting I had ever seen' (W.T. Homer, *op. cit.*, p. 32).

48. The pots were indeed the size shown and remain in the family of the sitters; cf. R. Ormond, *John Singer Sargent, Paintings, Drawings, Watercolours* (New York and London, 1970), p. 239.

49. The oddness of the shape was noted at the time, e.g., by H. Houssaye, *Revue des deux mondes*, 57 (1 June 1883), pp. 597–627, p. 616; cf. C. Ratcliffe, *Sargent* (Oxford, 1983), p. 75. For another discussion of the implications of this shape, see W.H. Gerdts, 'The Square Format and Proto-Modernism in American Painting', *Arts Magazine*, 50, no. 10 (June, 1976), pp. 70–5. Discussion of the painting generally centres on the evident influence upon the composition of Velásquez's *Las Meninas*.

50. It was only accepted, so the story runs, after Hubert Herkomer (as he then was) threatened to resign from the Hanging Committee if it were not, but see *John Singer Sargent and the Edwardian Age*, exh. cat. (J. Lomax and R. Ormond) (Leeds Art Galleries, National Portrait Gallery, London, and Detroit Institute of Arts, 1979), (16).

51. The result of an extraordinary technique that often included a preliminary step of soaking the canvas in thinned colours.

52. Cf. *American Portraiture in the Grand Manner: 1720–1920*, exh. cat. (M. Quick), (1981–2), pp. 74–5, p. 76n.

Chapter Two

1. It has generally been considered that Holbein went to Italy in about 1519, just before 1526, and at some point between 1528 and 1531. Cf. P. Ganz, 'Hans Holbeins Italienfahrt', *Süddeutsche Monatschefte*, VI (1909), pp. 596–612. The most recent challenge to a number of assumptions concerning this matter is that of J. Rowlands, *Holbein* (Oxford, 1985), pp. 27 ff., who considers that it was possible for Holbein to have seen copies elsewhere (notably in France) of Italian Renaissance paintings the influence of which is evident in Holbein's work.

2. J. Rowlands, for example (*op. cit.*, pp. 75 ff.), has little detail about Holbein's time in Basle following his return from England in mid-1528, a period which lasted until the end of 1531 or early 1532.

3. C. Hope, *Titian* (London, 1980), pp. 62–6. Palma Vecchio (1480?–1528) used a variation on this pose in his *Portrait of a Poet* (London, National Gallery) of about 1515–6.

4. K. Clark, *Rembrandt and the Italian Renaissance* (London, 1966), pp. 123 ff.

5. K. Clark, *op. cit.*, see especially pp. 124–5. Rubens's copy of Raphael's *Baldassare Castiglione* (which shows it before it was cut down) is in the Seilern collection of the Courtauld Institute of Art. It is just possible that Holbein had had a similar opportunity of seeing the two pictures together, for Titian's *Man with a Blue Sleeve* may have been in the Mantuan collection together with Raphael's portrait (the Mantuan

collection having finally been broken up a decade or so before the Amsterdam auction).

6. K. Clark, *Rembrandt and the Italian Renaissance* (London, 1966), p. 124.

7. J. Rowlands, *Holbein* (Oxford, 1985), pp. 224–6; R. Strong, *Holbein and Henry VIII* (London, 1967). Rowlands (*op. cit.*, pp. 114–5) rejects Strong's suggestion that the figures in the fresco flanked a window, particularly because a visitor to Whitehall Palace in 1600 recorded the very inscription to be seen in Van Leemput's 1667 copy of the fresco (destroyed in the Whitehall fire of 1698). Further support for Rowlands's view may perhaps be found in Holbein's miniature of Henry Brandon (Rowlands, cat. M.11), cf. *Holbein and the Court of Henry VIII*, exh. cat. (Queen's Gallery, 1978–9), (85), (86). Not only does the pose here echo that of Henry VII in Holbein's lost fresco, but the boy is seen leaning on an altar or plinth on which there is an inscription. Brandon was the elder son of Charles Brandon (d. 1545), 1st Duke of Suffolk, who at one time had been married to Henry VIII's sister Mary, and the son was given the name of the King who for so long patronized his father. The boy was educated with Henry VIII's son, Edward VI, who was himself to be portrayed (by Scrots) in the pose adopted by his father in the same lost fresco by Holbein. Incidentally, Henry VIII's pose was also derived by Holbein from Titian (cp., e.g., H. Wethey, *The Paintings of Titian*, 3 vols (London, 1969–75), vol. 3, cat. nos 44, 45).

8. The Laud portrait is discussed by M. Jaffé, 'Van Dyck Studies I: The Portrait of Archbishop Laud', *The Burlington Magazine*, CXXIV (October, 1982), pp. 600–607. Professor Jaffé notes the similarity between its pose and that of Van Dyck's *Abbé Scaglia*, 1634/5 (The Viscount Camrose), while Sir Oliver Millar has pointed to the probable development of the latter from Titian's *Benedetto Varchi* in *Van Dyck in England*, exh. cat. (O. Millar) (National Portrait Gallery, London, 1982–3), pp. 58–9. The drawing in Van Dyck's Italian sketch-book after a now-lost portrait by Titian has a detail in which the arm leaning on a column is enclosed at the elbow by a drape, something present only in the *Abbé Scaglia* among the portraits by Van Dyck in which he employs this type of pose (G. Adriani, *Anton van Dyck: Italienische Skizzenbuch* (Vienna, 1940), f. 104v.; Jaffé, Fig. 9.

9. Tact was needed, for the King had disapproved of Van Dyck's earlier group of the three eldest children; cf. Millar, *Van Dyck* (National Portrait Gallery, London, 1982–3), pp. 60–1, 71–2; O. Millar, *The Tudor, Stuart and Early Georgian Pictures in the Collection of Her Majesty the Queen*, 2 vols (London, 1963), (152).

10. The function and disposition of the rooms of Whitehall Palace changed between the Tudor and Stuart periods, but the pictures were within one room or so of each other. The Van Dyck is known to have been in the King's Breakfast Chamber off the Privy Gallery: 'In the breakfast Chamber above the table the Picture of the Kings five children in one peece with a great dogg by. In a blue and carved guilded fram.' Cf. 'Abraham van der Doort's Catalogue of the Collection of Charles I' (O. Millar, ed.), *Walpole Society*, XXXVII (1960), p. 31. Charles I actively collected portraits of his Tudor forebears to add to those already abundantly in Whitehall Palace (e.g., *ibid.*, p. 24) and it may be more than a striking coincidence that this Stuart dynastic portrait group was commissioned from Van Dyck exactly one hundred years after Holbein had painted his prominent affirmation of the establishment of the Tudor dynastic line. The latter was in what became the Privy Chamber but which was presumably, at the time of fresco's painting, either the main ante- or audience-chamber (J. Rowlands, *Holbein* (Oxford, 1985), p. 113). For the disposition of the rooms in Whitehall Palace and changes to them see H. M. Colvin, *The History of the King's Works*, IV, pt. 2 (London, 1982), pp. 302, 302 (n.3), 309 (plan), 311–2, 318. The Brandon portrait (see n. 7) was also in Charles's collection, a gift from Sir Henry Fanshaw (Millar, 'Van der Doort', *op. cit.*, p. 119). Sir Oliver Millar has noted that Van Dyck's 'greate peece' at Whitehall of Charles I and his Queen with their two eldest children was designed in such a way as to echo another Tudor dynastic portrait group by a painter of the Holbein School then also at Whitehall (Millar, *Van Dyck*, National Portrait Gallery, London, 1982–3), pp. 46–7.

11. R. de Piles, *The Art of Painting*, translated from the French by J. Savage (London, 1706), p. 306.

12. Sir Joshua Reynolds, *Discourses on Art* (R. Wark, ed.) (New Haven and London, 1975), 'Discourse VI', p. 109.

13. See Chp. One, p. 14. When painting Archbishop Herring, Hogarth specifically mentioned Van Dyck's portrait of Archbishop Laud; cf. R. Paulson, *Hogarth, His Life, Art and Times*, 2 vols (New Haven and London, 1971), vol. 2, p. 8. The very different responses of Hogarth and Reynolds to the art of Van Dyck are discussed by David Mannings, 'Reynolds, Hogarth and Van Dyck', *The Burlington Magazine*, CXXVI (November, 1984), pp. 689–90.

14. D. Cherry and J. Harris, 'Eighteenth-Century Portraiture and the Seventeenth-Century Past: Gainsborough and Van Dyck', *Art History*, 5, no. 3 (September, 1982), pp. 287–309, p. 304.

15. *Ibid.*, p. 305.

16. 'The Dress of Rubens's wife' is fully discussed, in a section bearing that title, by A. Ribeiro, *The Dress Worn at Masquerades in England 1730 to 1790, and its Relation to Fancy Dress in Portrait-*

ure, Ph.D. (Courtauld Institute of Art, 1975; New York and London, 1984), pp. 144 ff., 356–8.

17. Writing in 1745, Vertue credited the young John Robinson with this innovation: 'Robinson, portrait painter from Bath, but learnt under John Vander Bank ... proposed the Imitation and manner of Vandykes, faces habits &c.' (Vertue, III, pp. 124–5).

18. Important earlier examples include, significantly, a number of portraits by Reynolds's master, Thomas Hudson; cf. J.L. Nevinson, 'Vandyke Dress', *Connoisseur*, CLVII (September–December, 1964), pp. 166–71; M.R. Holmes, 'Some early ideas of period costume', *Northamptonshire Architectural and Archaelogical Society*, LVIII (1954), pp. 13 ff.; Ribeiro, *op. cit.*, pp. 187 ff. Batoni was employing Van Dyck dress, but not Van Dyck poses, in Rome in the 1750s; Angelica Kauffmann picked up the idea there and, e.g., drew West in that guise in Rome in 1763.

19. One of these collections was that of the Bouverie family (Earls of Radnor) at Longford Castle; cf. D. Cherry and J. Harris, 'Eighteenth-Century Portraiture and the Seventeenth-Century Past: Gainsborough and Van Dyck, *Art History* 5, no.3 (September, 1982), p.291.

20. W.T. Whitley, *Thomas Gainsborough* (London, 1915), p. 373.

21. D. Cherry and J. Harris, *loc. cit.*

22. D. Cherry and J. Harris, *ibid.*, p. 298. The influence of Van Dyck's portrait on both Gainsborough and Reynolds in the examples cited was noted by O. Millar, *The Tudor, Stuart and Early Georgian Pictures in the Collection of Her Majesty the Queen*, 2 vols (London, 1963), vol. I, p. 100 n.

23. Kodella sale, Fischer, Lucerne, 29 August–1 September, 1934 (1799) measuring 63 × 76 cm; it is a very odd attribution to have made at that time, if it was not founded on some anterior information. A full-length copy of George Villiers alone was in the Thomas sale, Christie's, 4 February 1927 (bought by Weston for sixty guineas) but the photographic evidence, other than indicating that the picture was not by Van Dyck, does not allow for an attribution to Gainsborough's being confirmed. Gainsborough certainly made copies after Van Dyck, as he did after other Old Masters, including *Lord John and Lord Bernard Stuart* (City Art Museum, St Louis, MO, U.S.A.). Gainsborough's drawing of the head of George Villiers is identified by J. Hayes, *The Drawings of Thomas Gainsborough* (London, 1970), no. 38, and dated to 1760s, its location at present unknown. It is described in an unpublished typescript in the Library of the Mellon Centre for Studies in British Art, that of its owner in about 1910, Henry J. Pfungst, at whose sale it was sold (Christie's 15.vi. 1917

(33)), when bought by Sir George Donaldson, thence to Henry J. Schiewind, Jr, and thereafter evidently in the U.S.A., having been exhibited in Cincinnati Art Museum, 1931 (72, pl. 62); cf. *A Catalogue with Descriptive Notes of a Collection of Drawings and Studies by Thomas Gainsborough, RA, with an Introductory Essay by Arthur B. Chamberlain and Henry J. Pfungst, FSA, with illustrations* (lost), f. 59B, no. 64, and there identified as a study for '*The Blue Boy*' (typescript, Mellon Centre for Studies in British Art).

24. The earliest source of this tale would appear to be J. Young, *Catalogue of Pictures at Grosvenor House* (1820), but see W.T. Whitley, *Thomas Gainsborough* (London, 1915), pp. 374 ff. Cf. Sir Joshua Reynolds, *Discourses on Art* (R. Wark, ed.), especially p. 158.

25. These costume pieces included *Master Crewe as Henry VIII*, *Master Herbert as Bacchus*, and *Omai* (in oriental costume).

26. Sir Joshua Reynolds, *Discourses on Art* (R. Wark, ed.), 'Discourse VII', p. 158.

27. William Jackson 'of Exeter', *The Four Ages, Together with Essays on Various Subjects* (London, 1798), p. 155.

28. Cf. W.T. Whitley, *Thomas Gainsborough* (London, 1915), p. 373.

29. D. Cherry and J. Harris, 'Eighteenth-Century Portraiture and the Seventeenth-Century Past: Gainsborough and Van Dyck, *Art History*, 5, no. 3 (September, 1982), pp. 304–5 ff.

30. John Coats Browne's life is noted in *American Portraiture in the Grand Manner: 1720–1920*, exh. cat. (M. Quick) (Los Angeles County Museum of Art, National Portrait Gallery, Washington, DC, 1981–2), p. 120, where the picture is illustrated in colour, p. 121. E.K. Waterhouse's comment on Wright (who was Hoppner's brother-in-law) is to be found in his *The Dictionary of British 18th Century Painters in Oils and Crayons* (Woodbridge, 1981), p. 429 (caption to his illustration of an early portrait by Wright). Jonathan Buttall, Sr, lived and carried on his 'extensive' ironmongering business at 31 Greek Street, Soho (on the corner of King Street) from 1728 until his death in 1768. His son, the subject of Gainsborough's portrait, carried on the business until 1796 when his effects, together with 'capital pictures and drawings by Gainsborough', were sold by Sharpe and Cox (he himself died towards the end of 1805 at his home in Oxford Street).

31. *Morning Chronicle*, cf. W.T. Whitley, *Thomas Gainsborough* (London, 1915), p. 184. Gainsborough certainly criticized Reynolds's Fourth Discourse: 'Sir Joshua either forgets, or does not chuse to see that his Instruction is all adapted to form the History Painter, which he must know there is no call for in this country.' M. Woodall, *The Letters of Thomas Gainsborough* (London,

1961), p. 95. The letter contains further perceptive observations by Gainsborough on painting, especially portraits, in the light of Reynolds's theories.

32. Cf. W. T. Whitley, *op. cit.*, p. 236.

33. Apparently uttered while looking at Reynolds's pictures at an exhibition, cf. C. R. Leslie and T. Taylor, *Life and Times of Sir Joshua Reynolds, with Notices of Some of his Contemporaries*, 2 vols (London, 1865), vol. 2, p. 83.

34. Sir Joshua Reynolds, *Discourses on Art* (R. Wark, ed.), 'Discourse VIII', p. 107.

35. Cf. *The Treasure Houses of Britain*, exh. cat. (G. Jackson-Stops, ed.) (National Gallery, Washington, New Haven and London, 1985), (570), pp. 640–2.

36. A full and entertaining account of the painting of this portrait is given by one of the sitters, Sir Osbert Sitwell, Bt, *Left Hand Right Hand!* (London, 1945), especially pp. 215–33. Copley's and Sargent's portrait groups of the Sitwell family are in the collection of Reresby Sitwell, Esq., Renishaw Hall.

37. Sir Joshua Reynolds, *Discourses on Art* (R. Wark, ed.), 'Discourse XIV', p. 253.

38. Cf. Brian Allen, *Francis Hayman and the English Rococo*, Ph.D. (Courtauld Institute of Art, 1984), pp. 181 ff., for a full discussion of this pose in its various forms.

39. These aspects of the introduction of this pose into English art are discussed by H. Potterton, *Reynolds and Gainsborough* (National Gallery, London, 1976), pp. 13–16.

40. B. Allen, *loc. cit.*

41. The basic study of this milieu is that of M. Girouard, 'Coffee at Slaughters: English Art and the Rococo, I', *Country Life* (13 January 1966), pp. 58–61; 'Hogarth and His Friends: English Art and the Rococo, II', *Country Life* (27 January 1966), pp. 188–90.

42. D. Posner, *Antoine Watteau* (London, 1984), p. 255.

43. Cf. A. Smart, 'Dramatic Gesture and Expression in the Age of Hogarth and Reynolds', *Apollo*, LXXXII, 42 (August, 1965), pp. 90–97; H. A. Hammelmann, 'A Georgian Guide to Deportment', *Country Life* (16 May 1968), pp. 1272–3; D. Mannings 'A Well-Mannered Portrait by Highmore', *Connoisseur*, CLXXXIX (June, 1975), pp. 116–9.

44. It is hard to draw any general rules on the question of a sitter's being portrayed, in an age of wigs, in his own hair, but it was usual, if at all, only when the sitter was shown *all' antico*, or where there was some definite suggestion intended of that kind of classical timelessness. For the French source of this portrait see Chp. One, note 20.

45. Earl of Carnarvon (ed.), *Letters of Philip Dormer Stanhope, Fourth Earl of Chesterfield to his Godson and Successor* (Oxford, 1890), p. 263,

quoted by D. Mannings, *op. cit.*, p. 119.

46. A. Smart, *op. cit.*, p. 95.

47. F. Nivelon, *Rudiments of Genteel Behavior, An Introduction to the Method of Attaining a Graceful Attitude, an Agreeable Motion, an easy air and a genteel Behaviour* (sic) (1737). The first part of the book (which is unpaginated) deals with women, the second part with men.

48. Quoted by Boswell in his life of Johnson, first published in London in 1791. The reference is to be found in the London edition of 1824 in four volumes, vol. 1, p. 230.

49. J. Northcote, *The Life of Sir Joshua Reynolds*, 2 vols (London, 1818), vol. 1, p. 297 (quoting Dr Beattie's diary for 15 August 1773).

50. *Ibid.*, vol. 1, p. 23.

51. F. Nivelon, *op. cit.*

52. Cf. A. Smart, 'Dramatic Gesture and Expression in the Age of Hogarth and Reynolds', *Apollo*, LXXXII, 42 (August, 1965), figs. 4, 5. It is interesting to note that William Jackson considered the subject of the painting misconceived, as Lady Sarah should only have sacrificed to the Graces had she been ugly, cf. *The Four Ages* (London, 1798), pp. 172–3. There is a remote source for the title in Plato's advice to Diogenes, but also see *Reynolds*, exh. cat. (N. Penny, ed.) (Royal Academy, London, 1986), pp. 224–5.

53. D. Mannings, 'A well-Mannered Portrait by Highmore,' *Connoisseur*, CLXXXIX (June 1975), p. 113 (n. 3).

54. Recent studies include: F. Stack, *Pope and Horace: Studies in Imitation* (Cambridge, 1986); H. Erskine-Hill, *The Augustan Idea in English Literature* (Princeton, 1982); H. D. Weinbrot, *Alexander Pope and the Traditions of Formal Verse Satire* (London, 1983); *ibid.*, *Augustus Caesar in Augustan England: the Decline of a Classical Norm* (Princeton, 1977). Among many articles on the subject may be mentioned Patrick Cruttwell, 'Alexander Pope and the Augustan World', *Centennial Review*, x, no. 1 (Winter, 1966), pp. 13–36 (see especially p. 19).

55. The point was made by Dr Alex Potts to M. Rogers and noted by him in his 'John and John Baptist Closterman: a Catalogue of their Works', *Walpole Society*, XLIX (1983), pp. 224–79; cf. F. Haskell and N. Penny, *Taste and the Antique: The Lure of Classical Sculpture 1500–1900* (New Haven and London, 1981; 2nd printing with corrections, 1982), pp. 173–5 (*Castor and Pollux*). Philosophically speaking, of course, Shaftesbury followed the usual line of considering portraiture to be below the salt, *2nd 'Characters' or the language of forms* (B. Rand, ed.) (Cambridge, 1914), pp. 134–5. See also Edgar Wind, 'Shaftesbury as a Patron of Art', *Journal of the Warburg and Courtauld Institutes*, II (1938), pp. 185–8; reprinted *Hume and the Heroic Portrait, Studies in Eighteenth-Century Imagery* (Jaynie Anderson, ed.)

(Oxford, 1986), pp. 64–8, and see also the title essay in that volume. It is important to remember that an Augustan cast of mind could embrace both Whig and Tory, and Pope, to take the example of a high Tory poet, derived many of the notions of his *Essay on Man* from the Whig Shaftesbury (notions which admittedly, in his other poems, he generally scorned).

56. Cf. R. Simon and A. Smart, *The Art of Cricket* (London, 1983), p. 24; the statue of Hermes (?) was then supposed to represent Cincinnatus, cf. F. Haskell and N. Penny, *op. cit.*, pp. 182–4 ('*Cincinnatus*'), 229–32 (*Hercules*); *Reynolds*, exh. cat. (N. Penny, ed.) (Royal Academy, London, 1986), pp. 300–1. The pioneering article in this field is Edgar Wind, 'Borrowed Attitudes in Reynolds and Hogarth', *Journal of the Warburg and Courtauld Institutes*, II (1938), pp. 182–5, reprinted in *Hume and the Heroic Portrait*, pp. 69–73.

57. Cf. J. Northcote, *The Life of Sir Joshua Reynolds*, 2 vols (London, 1818), vol. 1, p. 83.

58. Reynolds's use of the pose has been questioned by N. Penny (ed.), *Reynolds*, exh. cat. (Royal Academy, London, 1986), p. 22, but affirmed in the same catalogue by D. Mannings, pp. 181–2. For a perceptive discussion of the use of the pose by Benjamin West, in relation both to his viewing of the statue in Rome and to his adaptations of it in history and portraiture, see Ann Uhry Abrams, *The Valiant Hero: Benjamin West and Grand-Style History Painting* (Washington, DC, 1985), pp. 75–80, 95–7; the latter reference is to a comparison of West's *General Monckton* of c. 1764 with Reynolds's *Keppel* that makes their common source in the *Apollo Belvedere* very clear. West drew the *Apollo Belvedere*, c. 1760–2 (Friends Library, Swarthmore College, PA).

59. D. Solkin in a paper at the International Symposium that accompanied the Reynolds exhibition, held at the Royal Academy on 22 February 1986 (the papers are to be published, although excluding that by Dr Solkin).

60. E.g., Sir Joshua Reynolds, *Discourses on Art* (R. Wark, ed.), 'Discourse x', pp. 179–80; F. Algarotti, *An Essay on Painting Written in Italian* (London, 1764), p. 42; J. Burke (ed.), W. Hogarth, *The Analysis of Beauty* (Oxford, 1955), p. 104.

61. Sir Joshua Reynolds, *Discourses on Art* (R. Wark, ed.), 'Discourse x', p. 184.

62. J. Richardson, *An Account of some of the Statues, Bas-reliefs, Drawings and Pictures in Italy* (London, 1722), pp. 275–6; cf., e.g., Joachim von Sandrart (as Joachim de Sandrart), *Sculpturae Veteris Admiranda* (Nuremberg, 1680); G.B. Cavalieri, *Antiquarum Statuarum Urbis Romae Quae in publicis privatisque locis visuntur ... parte terza* (Rome, 1584), where the statue (pl. 6) is seen in reverse, and the head in

profile; G. Porro, *Statue antiche che sono poste in diversi luoghi nella Città di Roma* (Venice, 1576); Bowles's *Proportions of the Human Body, measured from the most beautiful antique statues; by Monsieur Audran ... Done from the originals engraved at Paris* was already in a late edition in London in 1785, and was in its 12th edition by 1790; it was after G. Audran, *Les Proportions du corps humain*, &c. (Paris, 1683), where five different illustrations of the *Apollo* can be found. Cf. F. Haskell and N. Penny, *Taste and the Antique: the Lure of Classical Sculpture 1500–1900* (New Haven and London, 1981; 2nd printing with corrections, 1982), pp. 148–50.

63. F. Haskell and N. Penny, *loc. cit.*

64. Cf. E.K. Waterhouse, *Painting in Britain 1530 to 1790* (Harmondsworth, 1953; 4th edn, 1978), pp. 203–4.

65. J. Northcote, *The Life of Sir Joshua Reynolds*, 2 vols (London, 1818), vol. 1, p. 64.

66. The Van Aken drawing is in the National Gallery of Scotland, reg. no. 2163.

67. I am most grateful to Emeritus Professor Alastair Smart for discussing this particular point with me.

68. See note 58.

69. For further ramifications of the use of this pose, especially by Thomas Hudson and the influence upon him of Reynolds, see R. Simon and A. Smart, *The Art of Cricket* (London, 1983), p. 25.

70. Illustrated in *Reynolds*, exh. cat. (N. Penny, ed.) (Royal Academy, London, 1986), p. 144.

71. Illustrated in *Hogarth*, exh. cat. (L. Gowing) (Tate Gallery, London, 1971–2), (87).

72. J.D. Prown, *John Singleton Copley*, 2 vols (Cambridge, MA, 1966), vol. 2, figs. 390, 390a. The use of the tartan plaid is again used here, as in Ramsay's *Macleod*, with a suggestion of an antique cloak, an effect developed further, as Francis Russell has observed, by Batoni in his portrait of Col. William Gordon of 1766 (National Trust for Scotland, Fyvie Castle) where, in addition, the sitter's stockings have been rolled down in imitation of antique buskins; cf. *The Treasure Houses of Britain*, exh. cat. (G. Jackson-Stops, ed.) (1985), (176), p. 257.

73. Cf. L. Lippincott, *Selling Art in Georgian London: the Rise of Arthur Pond* (New Haven and London, 1983) (references to Smibert's print-buying, pp. 35, 142, 143).

74. Cf. H.W. Foote, *John Smibert, Painter* (Cambridge, MA, 1950, reprinted New York, 1969). Smibert's close contemporary, Jonathan Richardson, Jr, observed of Van Dyck's *Cardinal Bentivoglio* 'I never saw anything like it'. Smibert also owned casts after antique statues (complete with fig leaves) which were seen in his house by both C.W. Peale and J.S. Copley and which remained in his house for over thirty years after his death. The collection was a major reason for Trumbull's taking his house; cf. *ibid.*,

pp. 121–2, 125–6.

75. W.P. Belknap, Jr, *American Colonial Painting: Materials for a History* (Cambridge, MA, 1959). See also L. Park, 'An Account of Joseph Badger, and a Descriptive List of his Work', *Massachusetts Historical Society Proceedings*, 51 (December, 1917), pp. 158–201.

76. W.P. Belknap, *op. cit.*, pls XX, 16, 16A.

77. The question of the reversal of sources has not been thoroughly studied, but cf., e.g., H. Hibbard, *Bernini* (Harmondsworth, 1965), pp. 174, 191, pls 96–99, pp. 202 ff.; J.D. Stewart, *Sir Godfrey Kneller and the English Baroque Portrait* (Oxford, 1983), p. 152. In a rather different context, Rembrandt's use of mirrors to diversify the compositional possibilities of studio maquette groups has been demonstrated by Nigel Konstam, 'Rembrandt's use of models and mirrors', *Burlington Magazine*, CXIX (February, 1977), pp. 94–8. For various methods of copying which, it would seem, could easily lead to reversal of the original when it was not necessary to reproduce the original image in the same sense, see M.K. Talley, *Portrait Painting in England, Studies in the Technical Literature before 1700* (London, 1981), pp. 199, 339. Mary Beale (1632/3–99) specifically used a mirror to reverse a portrait composition of Lely's (Talley, *op. cit.*, p. 292). For the use of mirrors in the portrait studio see p. 112. For examples of American Colonial portraits where the reversal of poses is evident, see W.P. Belknap, *op. cit.*, especially pls XI–XLVI.

78. J.D. Stewart, *op. cit.*, p. 37, pl. 20b.

79. At least two of these latter heads survive: cf. Royal Commission on Historical Monuments, *Middlesex* (London, 1937), p. 52a, pl. 77 (Hanworth Park), pls 76–7 (Hampton Court).

80. J. Richardson, *A Discourse on the Dignity, Certainty, Pleasure and Advantage, of the Science of a Connoisseur* (London, 1719), pp. 23 ff.

81. G. Adriani, *Anton van Dyck: Italienische Skizzenbuch* (Vienna, 1940), f.65 v. Richardson, incidentally, is known to have copied Van Dyck's triple portrait of Charles I.

82. Vertue, III, p. 85.

83. Cf. M. Girouard, *op. cit.*, (see note 41), II, p. 189.

84. For Hogarth's journey to France in June 1743, see R. Paulson, *Hogarth, His Life, Art and Times*, 2 vols (New Haven and London, 1971), vol. 2, pp. 5 ff. His certain knowledge of French has been revealed by J.A. Dussinger, 'William Hogarth's translation of Watelet on "Grace"', *The Burlington Magazine*, CXXV (November, 1984), pp. 689–94, while the similarity of aspects of his aesthetic thought to a (separately evolved) strain of French thinking is discussed by J. Dobai, 'William Hogarth and Antoine Parent', *Journal of the Warburg and Courtauld Institutes*, XXXI (1968), pp. 336–82.

85. 'Hogarth's "Apology for Painters"' (M. Kitson, ed.), *Walpole Society*, XLI (1966–8), pp. 46–111, p. 78. The phrase appears in a draft title on BM Add. MS 27, 993 (I), f.3 v. It would appear that the synopsis on (II), f.1 r. and v. amplifies this plan, i.e., that the former phrase is to be understood as being a draft towards 'Of the State of the Arts of Painting Sculture & Engraving and likewise of the Artists in the King(dom)' (II, f.1 r.). (I), f.3 v. shows that the work was intended to be completed by 'A short explanation of (all) Mr. Hogarth's prints (and pictures) written by himself'. There is nothing in the 'Apology for Painters' that touches on the respective merits of painting and sculpture: Hogarth did not get as far in his notes as discussing sculpture at all. For further evidence of Hogarth's increasing interest in aesthetics, see also J.A. Dussinger, *art. cit.*, and previous note.

86. The terracotta of the pug (Trump) has disappeared, but copies of the porcelain figure after it survive; cf. J.V.G. Mallett, 'Hogarth's pug in porcelain', *Victoria and Albert Museum Bulletin*, vol. 3, no. 2 (April, 1967), pp. 45–54.

87. *Sir Edmund King*, watercolour and body colour over red and black chalk (British Museum), is a typical Faithorne working image for the purposes of engraving, a method referred to by Pepys: 'Called at Faythornes to buy some prints for my wife to draw by this winter; and here did see my Lady Castlemaynes picture, done by him from Lillys, in red chalk and other colours, by which he hath cut it in copper to be printed'; R. Latham and W. Matthews (eds), *The Diary of Samuel Pepys*, 11 vols (London, 1970–83), vol. 7, p. 359 (7 November 1666).

88. Cf. C. Hussey, *Country Life* (24 August 1951), p. 577 (letter); E. Esdaile and H.P. Cunard, *Country Life* (14 September 1951), pp. 821–2 (letters).

89. Frye's *Mr Crispe* was with Messrs Agnew in 1984 in their exhibition *The Heroic Age*, 6 June–3 August, 1984 (9).

90. E. Esdaile, *loc. cit.* For further information on Frye, see *Irish Portraits 1660–1860*, exh. cat. (National Gallery of Ireland, Dublin, Ulster Museum, Belfast, and National Portrait Gallery, London, 1969–70), (37). Frye's implicit connections with Hogarth include his painting a portrait of Hogarth's friend the entertainer Richard Leveridge (1679–1758) (Court House, Warwick), a portrait reportedly painted in 1760 (which would make it posthumous). On Captain Coram's death, Leveridge assumed his pension, having fallen on hard times. See also R. Simon, 'Hogarth and the Popular Theatre', *Renaissance and Modern Studies*, XXII (1978), pp. 13–25, pp. 22–3.

Chapter Three

1. Quoted in *Sir Peter Lely 1618–80*, exh. cat. (O. Millar) (National Portrait Gallery, London, 1978–9), p. 17.

2. J. D. Stewart, *Sir Godfrey Kneller and the English Baroque Portrait* (Oxford, 1983), pp. 83, 187–96.

3. M. Baxandall, *Painting and Experience in Fifteenth Century Italy* (Oxford, 1972; reprinted 1976, etc.); Millar, *Lely, loc. cit.*

4. E.g., R. Edwards (letter), 'Van Aken and Ramsay', *Apollo*, LXXX (July, 1964), p. 76; *Thomas Hudson*, exh. cat. (Kenwood, 1979), (28). Yet the point was made by Hogarth at the time: 'if one of these people (i.e., portrait painters) is industrious in this kind of manufacture he cannot fail of getting a fortune nine parts in ten of such picture (and perhaps the best ...) is the work of the drapery man ... and all the reputation is engrossed by the fizmonger' ('Apology for Painters' (M. Kitson, ed.) (1966–8), pp. 100–1). Hogarth in fact made a satirical picture on the subject, *Van Aken's Funeral Train* (cf. J. Northcote, *The Life of Sir Joshua Reynolds*, 2 vols (London, 1818), vol. 1, p. 16), which has, alas, been lost.

5. Cf. Frederic F. Sherman, 'Samuel L. Waldo and William Jewett, Portrait Painters', *Art in America*, XVIII (February, 1930), pp. 81–6.

6. Cf. Millar, *Lely*, p. 17 (n. 33); see also *The Burlington Magazine* (editorial) LXXXIII (August, 1943), pp. 185–91.

7. J. T. Flexner, *History of American Painting*, 3 vols (1947, 1954, 1962, reprinted New York, 1969, 1969, 1970 respectively), vol. 2, p. 210.

8. J. Fleming, 'Sir John Medina and his Postures' *Connoisseur*, CXXXXVIII (November, 1961), pp. 22–5, e.g., '... in the meantime he is to doe the drapery work for some to take alongst with him, so that ther will be little to doe except to add a head and neck'; '... If there be any men who want their pictors they could be quite finished here (except the face).'

9. Cf. D. Mannings, 'Sir John Medina's Portraits of the Surgeons of Edinburgh', *Medical History*, 23 (1979), pp. 176–90, fig. 16.

10. Cited by J. D. Stewart, *Sir Godfrey Kneller and the English Baroque Portrait* (Oxford, 1983), pp. 82–3.

11. Vertue, III, p. 91.

12. Another example is that of *The Blackburne Family* of 1741, formerly at Hale Hall, cited by E. K. Waterhouse, *Dictionary*, p. 419. Holbein, albeit for rather different reasons of precision, nonetheless employed a similar technique in the 'Chatsworth Cartoon' (see Fig. 40) where the head of Henry VIII is on a separate piece of paper pasted on to the whole.

13. See J. D. Stewart, *Sir Godfrey Kneller and the English Baroque Portrait* (Oxford, 1983), pp.

14. Little is known of Francis Barlow's life, but cf. Vertue, II, pp. 135–6. Attributions to him of portrait groups have, on occasion, proved misguided, and subsequent research has revealed his responsibility solely for dogs, fowl and landscape in such pictures. The attribution to him here of these details is on stylistic grounds. Cf. also E. K. Waterhouse, *Painting in Britain* (1978), pp. 118–21.

15. Cf. L. Lippincott, *Selling Art in Georgian London: the Rise of Arthur Pond* (New Haven and London, 1983), p. 65 (n. 38); but see also M. K. Talley, *Portrait Painting in England: Studies in the Technical Literature before 1700* (London, 1981), p. 348. Contemporary references to the practice can also be found in A. Rouquet, *The Present State of the Arts in England* (London, 1755; reprinted with an introduction by R. Lightbown, 1970), e.g., p. 45.

16. Cf. J. D. Stewart, *Sir Godfrey Kneller and the English Baroque Portrait* (Oxford, 1983), p. 190.

17. I am most grateful to Emeritus Professor Alastair Smart for this information.

18. Cf. O. Millar, *The Later Georgian Pictures in the Collection of her Majesty the Queen*, 2 vols (London, 1969), (1000). The drapery painter involved here may have been George Roth (*fl. c.* 1742–78), who was employed by Hudson, Ramsay and Reynolds.

19. Vertue, III, p. 117.

20. Cf. A. Ribeiro, *The Dress Worn at Masquerades in England 1730 to 1790, and its Relation to Fancy Dress in Portraiture*, Ph.D. (Courtauld Institute of Art, 1975, New York and London, 1984), pp. 144 ff., 356–8.

21. Hogarth said of these 'painter taylors': 'being together with their constant companion a layman (they) are conceald in upper rooms their name scarsly know to any one but the employer'; 'Apology for Painters' (M. Kitson, ed.) (1966–8), p. 98.

22. *Hudson*, exh. cat. (Kenwood, London, 1979), (31).

23. *Paintings and Drawings by Allan Ramsay 1713–1784*, exh. cat. (Alastair Smart) (Royal Academy, 1964), (9), (141).

24. Cf. Millar, *Lely*, pp. 17–18; D. de Marly, 'The Establishment of Roman Dress in Seventeenth-Century Portraiture', *The Burlington Magazine*, CXVII (July, 1975), pp. 443–51.

25. See, for example, the levée (fourth) scene in Hogarth's *Marriage à-la-Mode*, 1743 (National Gallery, London).

26. Cf. A. Ribeiro, *The Dress worn at Masquerades in England 1730 to 1790, and its Relation to Fancy Dress in Portraiture*, Ph.D. (Courtauld Institute of Art, 1975; New York and London, 1984).

27. Cf. *Reynolds*, exh. cat. (N. Penny, ed.) (Royal Academy, London, 1986), pp. 59–60.

188–9 nn., p. 40 n.; Vertue, III, p. 32.

28. Cf. A. Ribeiro, *op. cit.*, pp. 402 ff.

29. L. Lippincott, *Selling Art in Georgian London: the Rise of Arthur Pond* (New Haven and London, 1983), p. 88. For much useful information on lay figures, and on studio practice generally, see J. Ayres, *The Artist's Craft, A History of Tools, Techniques and Materials* (Oxford, 1985).

30. The costume is discussed by D. Cherry and J. Harris, 'Eighteenth-Century Portraiture and the Seventeenth-Century Past: Gainsborough and Van Dyck', *Art History*, 5, no. 3 (September, 1982), p. 299. The indispensability of the lay-figure to the drapery painter was noted by Hogarth (see note 21).

31. *The Mall* of 1783 (Frick collection, New York), however, is known to have been composed using such figures or maquettes; cf. William Jackson, *The Four Ages* (London, 1798), p. 167. Dandridge evidently used maquettes to arrange his conversation pieces (Vertue, III, p. 39), and, as explained in Chp. Two, note 77, Rembrandt is now recognized to have worked with them in combination with mirrors; see note 55.

32. E. Fletcher (ed.), *Conversations of James Northcote RA with James Ward on Art and Artists* (London, 1901), p. 102.

33. Quoted by A.W. Rutledge, 'Portraits of American Interest in British Collections', *Connoisseur*, CXLI (May, 1958), pp. 266–70, p. 267.

34. Quoted by W.T. Whitley, *Thomas Gainsborough* (London, 1915), p. 389.

35. E. Fletcher (ed.), *Conversations of James Northcote RA with James Ward on Art and Artists* (London, 1901), p. 102., p. 35.

36. Vertue, II, p. 122.

37. R. de Piles, *The Art of Painting*, translated from the French by J. Savage (London, 1706).

38. Nathaniel Dance's elevation to a baronetcy in 1800 does not count here, as he retired from painting in 1782, and the distinction was unrelated to that part of his life.

39. In 1639 he married a lady-in-waiting to the Queen, Mary Ruthven, grand-daughter of the Earl of Gowrie.

40. The reference to Lely is in R. Latham and W. Matthews (eds), *The Diary of Samuel Pepys*, 11 vols (London, 1970–83), vol. 8, p. 129 (25 March 1667). Pope's account is to be found in G. Sherburn (ed.), *The Correspondence of Alexander Pope*, 5 vols (Oxford, 1956), vol. 2 (1719–28), p. 22. Pope had especial cause to regret his epitaph when Lady Kneller subsequently tried to move the monument to Pope's father in Twickenham church in order to make room for her own.

41. Cf. M. Levey, *A Royal Subject: Portraits of Queen Charlotte* (National Gallery, London, 1977), p. 16.

42. Pope was able to make this arrangement because of his personal relationship with Kneller, and because it was he who wanted Lady Mary to sit to Kneller; cf. J.D. Stewart, *Sir Godfrey Kneller and the English Baroque Portrait* (Oxford, 1983), p. 151.

43. E.K. Waterhouse, *Painting in Britian*, 4th edition (1978), pp. 108–9.

44. Mrs Arthur Bell (N. D'Anvers), *Thomas Gainsborough, A Record of his Life and Works* (London, 1897), p. 119.

45. W.T. Whitley, *Thomas Gainsborough* (London, 1915), p. 391, and see J. Agnew, *Report on the Papers of Ozias Humphry RA (1743–1810) in the custody of the Royal Academy of Arts*, &c. (Royal Commission on Historical Manuscripts, London, 1972).

46. Cf. J. Bury, 'The use of candle-light for portrait-painting in sixteenth-century Italy', *The Burlington Magazine*, CXIX (June, 1977), pp. 434–7; Millar, *Lely*, p. 17. A diagram of Lely's studio by James Gandy is reproduced by M.K. Talley, *Portrait Painting in England: Studies in the Technical Literature before 1700* (London, 1981), fig. 33.

47. There was, rather surprisingly, only one window high up (9 ft 4 in from the ground) in an octagonal room of 20 × 16 ft, cf. J. Northcote, *The Life of Sir Joshua Reynolds*, 2 vols (2nd edn revised and augmented, London, 1818), vol. 1, pp. 102–3.

48. W.T. Whitley, *Thomas Gainsborough* (London, 1915), pp. 395–6.

49. Cf. B. Rand (ed.), Anthony Ashley-Cooper, 3rd Earl of Shaftesbury, *2nd Characteristics or the Language of Forms* (Cambridge, 1914), p. 132, cited by M. Rogers in his catalogue of Closterman's works (see Chp. Two, note 55) where, however, it is suggested that this practice was the result of the painter's enthusiasm.

50. In a letter to Lord Dartmouth, quoted by W.T. Whitley, *Thomas Gainsborough* (London, 1915), p. 76.

51. *Ibid.*, p. 392 (Ozias Humphry).

52. See D. Bamford and A. Roy, 'Hogarth's "Marriage à-la-Mode"', *National Gallery Technical Bulletin*, vol. 6 (1982), pp. 45–67; M.K. Talley, *Portrait Painting in England, Studies in the Technical Literature before 1700* (London, 1981).

53. This canvas size had a long history (it is that, for example, of Raphael's *Baldassare Castiglione*) although the name was taken from Christopher Cat, owner of the dining rooms where the Kit Kat Club met in Kneller's day, cf. J.D. Stewart, *Sir Godfrey Kneller and the English Baroque Portrait* (Oxford, 1983), especially pp. 65–8.

54. E.K. Waterhouse, *Reynolds* (London and New York, 1973), p. 39; M.K. Talley (*Reynolds*, exh. cat., London, 1986, p. 58) gives the dimensions of this type as 55 × 45 in (139.7 × 114.3 cm).

55. Augustus Hare, *Story of My Life*, 6 vols (London, 1896–1900), vol. 6, p. 501. Lady Diana

Cooper recalled J.J. Shannon's using a mirror when she was sitting for her portrait as a child, cf. *Society Portraits 1850–1939*, exh. cat. (Colnaghi, 1986), (62). Rembrandt's use of mirrors has been referred to in Chp. Two, note 77, and Reynolds appears to have used them to diversify his image in a similar manner in his painting of Isabella Gordon's head in multiple form, 'Angels' Heads', 1786 (Tate Gallery), and in his *Nativity* window for New College, Oxford (1777–80); the procedure in the latter case is described by the Revd W. Mason in William Cotton (ed.), *Sir Joshua Reynolds' Notes and Observations on Pictures* (London, 1859), p. 58. For an extraordinary interpretation of Velásquez's *Las Meniñas*, in which the painting is considered to be conceived as if seen in a mirror, see G. Kubler, 'The "Mirror" in Las Meniñas', *Art Bulletin*, LXVII, no. 2 (June, 1985), p. 316. This interpretation perhaps gains some weight if the habitual use of studio mirrors by painters is taken into account.

56. W.P. Frith, *My Autobiography and Reminiscences*, vol. 3 (1888), p. 124, quoted by D. Hudson, *Sir Joshua Reynolds, a personal study* (London, 1958), p. 75.

57. E.K. Waterhouse, *Reynolds* (London and New York, 1973), p. 9.

58. *Memorandum Book* of Ozias Humphry, BM Add. MS 22, 950, f.35 r. quoted by J.D. Stewart, *Sir Godfrey Kneller and the English Baroque Portrait* (Oxford, 1983), p. 30. The manuscript contains a transcription of technical notes, partly in diary form, of 1673–99. See also M.K. Talley, *Portrait Painting in England: Studies in the Technical Literature before 1700* (London, 1981), pp. 306 ff., where this manuscript is discussed in detail, and the technical notes attributed to William Gandy (*c.* 1655–1729) (the dates for the entries in Stewart's account are slightly wrong).

59. J. Northcote, *The Life of Sir Joshua Reynolds*, 2 vols (London, 1818), vol. 1, p. 299 (Dr Beattie's diary for 16 August 1773).

60. *Reynolds*, exh. cat. (N. Penny, ed.) (Royal Academy, London, 1986), (163), p. 58.

61. But see *Reynolds*, exh. cat. (151), pp. 324–5. William Jackson (*The Four Ages*, 1798, p. 171) considered that 'the sublimity of this picture is much abated by the abominable chair'.

62. Cf. *Reynolds*, op. cit., p. 61. Arthur Pond had prints after his own portraits and others on the walls of his house for sitters to inspect, cf. L. Lippincott, *Selling Art in Georgian London: the Rise of Arthur Pond* (New Haven and London, 1983). Mary O'Neill (see Chp. One, note 20) has suggested that such also was Rigaud's practice.

63. The main discussions of Reynolds's technique are H. Buttery, in D. Hudson, *Sir Joshua Reynolds, a personal study* (London, 1958), pp. 248–50, and M.K. Talley, *Reynolds*, exh. cat., London,

1986, pp. 66—7; but see also the Revd W. Mason in W. Cotton (ed.), *Sir Joshua Reynolds' Notes and Observations on Pictures* (London, 1859).

64. Copley's methods are discussed by J.D. Prown, *John Singleton Copley*, 2 vols (Cambridge, MA, 1966).

65. Cf. J.D. Stewart, *Sir Godfrey Kneller and the English Baroque Portrait* (Oxford, 1983), p. 151: 'to draw your face in crayons ... from whence he will transfer it to canvas'. The practice of a French contemporary of Kneller's is described in M.N. Rosenfeld, *Largillière and the Eighteenth-Century Portrait*, exh. cat. (Montreal Museum of Fine Arts, 1981), pp. 196–219.

66. Cf. E.K. Waterhouse, *Reynolds* (London and New York, 1973), p. 20.

67. Cf. E.K. Waterhouse, *Reynolds* (London and New York, 1973), p. 41. The extent of Reynolds's employment of drapery painters is still unclear, but it is certain that he did employ them, e.g., Peter Toms (*fl. c.* 1748–77); marked similarities can be discerned between draperies in paintings by Reynolds and Francis Cotes for whom Toms also worked. On the whole, it is probably best not to underestimate the extent to which assistants or specialists were employed by Reynolds for the painting of drapery. Marchi's individual paintings (e.g., in the National Museum of Wales, Cardiff) reveal him, interestingly, to have been very good at faces, while the structure of his draperies and of the body underneath is rather flabby, and the hands are poor. There are portraits by Reynolds where these weaker features can be seen, e.g., *Mrs Sarah Otway and her Daughter Jane* (Colnaghi, *The British Face*, 1986, (28)). Marchi reveals himself elsewhere, however, to have been a most skilful copyist (e.g., Christie's, 11.v. 28 (66)). Reynolds's sitter-book for 1755 has been transcribed and published by E.K. Waterhouse, *Walpole Society*, XLI (1966–8), pp. 112–64, with photographic illustrations of two pages from it.

68. J. Northcote, *The Life of Sir Joshua Reynolds* 2 vols (London, 1818), vol. 2, p. 21.

69. Cf. *Hudson*, exh. cat. (Kenwood, London, 1979), (13).

70. Millar, *Lely*, p. 17; when Dr Beattie sat to Reynolds in 1773, after breakfasting with the artist, he recorded, 'I sat to him five hours, in which time he finished my head and sketched out the rest of my figure'. J. Northcote, *op. cit*, vol. 1, p. 299.

71. Millar, *Lely* (162).

72. Cf. M.K. Talley, *Portrait Painting in England: Studies in the Technical Literature before 1700* (London, 1981), p. 320.

73. Millar, *Lely* (62).

74. Letter to Daniel Daulby, 9 September 1777, F.W. Hilles (ed.), *The Letters of Sir Joshua Reynolds* (Cambridge, 1929), p. 56.

75. Cf. H. Ward and W. Roberts, *Romney, A*

Biographical and Critical Essay, 2 vols (London and New York, 1904). Over nine-thousand sittings are recorded in Romney's house, 32 Cavendish Square, which he rented from 1775, i.e., over an active period of some twenty years. In 1783 alone, Romney had five-hundred-and-ninety-three sittings; cf. M. Pointon, 'Portrait-Painting as a Business Enterprise in London in the 1780s', *Art History*, 7, no. 2 (June, 1984), p. 187.

76. Millar, *Lely*, pp. 15, 17.

77. Cf. J.D. Stewart, *Sir Godfrey Kneller and the English Baroque Portrait* (Oxford, 1983), p. 151; the source is BM Add. MS 22,950, f. 39r (cf. note 58).

78. Three sitters a day was considered usual in the middle of the eighteenth century; cf. M.K. Talley and K. Groen, 'Thomas Bardwell and His Practise of Painting: a Comparative Investigation between Described and Actual Painting Technique', *Studies in Conservation*, 20, no. 2 (1975), pp. 44–107.

79. Cf. J.D. Stewart, *loc. cit.*

80. The portrait was sold at Christie's, New York, 25 January 1986.

81. The story is told by Augustus Hare, *Story of My Life*, 6 vols (London, 1896–1900), vol. 6, p. 360.

82. Cf. Chp. One, note 7.

83. E.K. Waterhouse, *Reynolds* (London and New York, 1973), p. 40; L. Lippincott, *Selling Art in Georgian London: the Rise of Arthur Pond* (New Haven and London, 1983), p. 77.

84. D. Hudson, *Sir Joshua Reynolds* (London, 1958), p. 15.

85. B. Novak, *American Painting of the Nineteenth Century. Realism, Idealism, and the American Experience* (New York, 1969), pp. 198–9.

86. Cf. J. Ayres, *The Artist's Craft, A History of Tools, Techniques and Materials* (Oxford, 1985), John H. Hammond, *The Camera Obscura, A Chronicle* (Bristol, 1981).

87. I am most grateful to Ms Jane Wess and members of the staff of the Science Museum, London, for enabling me to study this device, together with other optical instruments, including the Accurate Delineator discussed below. Reynolds's camera obscura is illustrated by J. Ayres, *op. cit.*, p. 64.

88. H. Walpole, *Correspondence* (W.S. Lewis *et al.*, eds), 47 vols (London and New Haven, 1937–83), vol. 28, pp. 32 ff. I am grateful to my colleague Martin Postle for drawing my attention to this device. See also *ibid.*, vol. 29, pp. 370–1, vol. 39, p. 293. J. Hammond, *The Camera Obscura, A Chronicle* (Bristol, 1981), pp. 78–9, discusses the design of this invention.

89. Cf. *Storer's* Syllabus, *to a course of* Optical Experiments, *on the Syllepsis Optica, or the new optical principles of the* Royal Delineator analysed (London, 1782), pp. 50 ff. The Patent Office Library copy has manuscript emendations that suggest it may have been the inventor's own copy (e.g., one of 1 January 1784 on p. 86). The patent for the original form of the Delineator, progression number 1183, had been obtained in 1778.

90. *Ibid.*, p. 55.

91. *Ibid.*, pp. 19–21.

Biographical Dictionary of Portrait Painters in Britain and America 1680-1914

LIST OF ABBREVIATIONS AND SYMBOLS

NOTE: *Standard abbreviations for American States, have been adopted. The absence of such an abbreviation indicates that the reference is to a place outside the U.S.A.; thus, Cambridge refers to Cambridge, England, while Cambridge, MA, indicates Cambridge, Massachusetts; a reference to Paris, for example, indicates the capital of France, not Paris, Texas.*

Abbreviations for the United States

Alabama	AL	Iowa	IA	New Jersey	NJ	Texas	TX
Alaska	AK	Kansas	KS	New Mexico	NM	Utah	UT
Arizona	AZ	Kentucky	KY	New York	NY	Vermont	VT
Arkansas	AR	Louisiana	LA	North Carolina	NC	Virginia	VA
California	CA	Maine	ME	North Dakota	ND	Washington (State)	WA
Colorado	CO	Maryland	MD	Ohio	OH	West Virginia	WV
Connecticut	CT	Massachusetts	MA	Oklahoma	OK	Wisconsin	WI
Delaware	DE	Michigan	MI	Oregon	OR	Wyoming	WY
Florida	FL	Minnesota	MN	Pennsylvania	PA	Dist. of Columbia (e.g. Washington, DC)	DC
Georgia	GA	Mississippi	MS	Rhode Island	RI		
Hawaii	HI	Missouri	MO	South Carolina	SC	Puerto Rico	PR
Illinois	IL	Montana	MT	South Dakota	SD		
Indiana	IN	New Hampshire	NH	Tennessee	TN	Virgin Islands	VI

* An asterisk next to a name indicates an artist for whom a separate entry will be found.

\# A hatch symbol next to a bibliographical reference indicates that the work referred to includes a catalogue or check-list of the artist's work.

Acad.	Academy/Académie.
AFA	Academy of Fine Arts.
AG	Art Gallery.
ANA	Associate of the National Academy of Design, New York, NY.
ARA	Associate of the Royal Academy of Arts, London.
Archer	Mildred Archer, *India and British Portraiture 1770–1825* (London, 1979).
ARSA	Associate of the Royal Scottish Academy of Arts, Edinburgh.
Assoc.	Association.
b.	born.
Baigell	Matthew Baigell, *Dictionary of American Art* (London, 1980).
Baltimore Mus. of Art Cat.	S. K. Johnston, *American Paintings 1750–1900 from the Collection of the Baltimore Museum of Art* (Baltimore, MD, 1983).
Belknap	Waldron Phoenix Belknap, Jr, *American Colonial Painting, Materials for a History* (Cambridge, MA, 1959).
Bénézit	E. Bénézit, *Dictionnaire critique et documentaire des Peintres, Sculpteurs, Dessinateurs et Graveurs de tous les temps et de tous les pays . . .* 10 vols (new edn revised and corrected, Paris, 1976).

BM — British Museum.

Boston MFA Cat. — *American Paintings in the Museum of Fine Arts, Boston*, 2 vols (Boston, MA, 1969).

Bryan — G. C. Williamson (ed.), *Bryan's Dictionary of Painters and Engravers*, 5 vols (new edn revised and enlarged, London, 1904).

CAG — City Art Gallery.

Cat. — Catalogue.

Co. — County.

Coll. — College.

Colln — Collection.

Crookshank and Glin — Anne Crookshank and the Knight of Glin, *The Painters of Ireland, c. 1660–1920* (London, 1978).

d. — died.

DOE — Department of the Environment (U.K.).

EKW — Ellis Waterhouse, *The Dictionary of British 18th Century Painters in oils and crayons* (Woodbridge, 1981).

EKW, *Painting in* — Ellis Waterhouse, *Painting in Britain 1530 to 1790* (4th edn Harmondsworth, 1978).

exh. cat. — exhibition catalogue.

FAM — Fine Arts Museum.

Flexner — James Thomas Flexner, *History of American Painting*, 3 vols (1947, 1954, 1962, reprinted New York 1969, 1969, 1970).

Fogg — Fogg Art Museum, Cambridge, MA.

Foskett — Daphne Foskett, *A Dictionary of British Miniature Painters*, 2 vols (London, 1972).

G & W — George C. Groce and David H. Wallace, *The New-York Historical Society's Dictionary of Artists in America 1564–1860* (New Haven and London, 1957).

Graves — Algernon Graves, *The Royal Academy of Arts: A Complete Dictionary of Contributors and their Work from its Foundation in 1769 to 1904*, 8 vols (London, 1905); 4 vols (reprinted Wakefield and Bath, 1970); *Royal Academy Exhibitors 1905–1970: a Dictionary of Artists and their Work in the Summer Exhibition of the Royal Academy of Arts*, 5 vols (Wakefield, 1973).

Hall, *Artists of Cumbria* — Marshall Hall, *The Artists of Cumbria, An Illustrated Dictionary of Cumberland, Westmorland, North Lancashire and North West Yorkshire Painters, Sculptors, Draughtsmen and Engravers Born Between 1615 and 1900* (Newcastle-upon-Tyne, 1974).

Hall, *Artists of Northumbria* — Marshall Hall, *The Artists of Northumbria, An Illustrated Dictionary of Northumberland, Newcastle upon Tyne, Durham and North East Yorkshire Painters, Sculptors, Draughtsmen and Engravers Born Between 1625 and 1900* (Newcastle-upon-Tyne, 1973); 2nd edn revised and enlarged (1982).

Hammelmann — Hanns Hammelmann, edited and completed by T.S.R. Boase, *Book Illustrators in Eighteenth-Century England* (New Haven and London, 1975), pp. 79–86.

Hist. Soc. of PA — Historical Society of Pennsylvania, Philadelphia, PA.

Hist. Soc. — Historical Society.

HMQ — Collection of Her Majesty the Queen.

Inst. — Institute/Institution.

Inst. of Directors — Institute of Directors, London.

Irwin — David and Francina Irwin, *Scottish Painters at Home and Abroad 1700–1900* (London, 1975).

Lib. — Library.

Lippincott — Louise Lippincott, *Selling Art in Georgian London: the Rise of Arthur Pond* (New Haven and London, 1983).

Mallalieu — H.L. Mallalieu, *The Dictionary of British Watercolour Artists up to 1920*, 2 vols (Woodbridge, 1976).

MCC — Marylebone Cricket Club, London.

Met. Mus. Cat., III — Doreen Bolger Burke (ed.), Kathleen Luhrs, *American Paintings in the Metropolitan Museum of Art, Volume III, A Catalogue of Works by Artists Born between 1846 and 1864* (New York, 1980).

Met. Mus., NYC — Metropolitan Museum of Art, New York, NY.

MFA — Museum of Fine Art.

S. & K. Morris — Sidney Morris and Kathleen Morris, *A Catalogue of Birmingham and West Midlands Painters of the Nineteenth Century* (Stratford-upon-Avon, 1974).

NA — Member of the National Academy of Design, New York, NY.

NAD — National Academy of Design, New York, NY.

Nat. Marit. Mus. — National Maritime Museum, Greenwich.

NG — National Gallery, London.

NGI — National Gallery of Ireland, Dublin.

NGS — National Gallery of Scotland, Edinburgh.

NG Washington — National Gallery, Washington, DC.

NMW — National Museum of Wales, Cardiff.

NPG — National Portrait Gallery, London.

NPG Washington — National Portrait Gallery, Washington, DC.

NPGI — National Portrait Gallery of Ireland, Dublin.

N. Trust — The National Trust for Places of Historic Interest or Outstanding Natural Beauty (England and Wales).

N.-Y. Hist. Soc. — The New-York Historical Society.

NYC — New York, NY.

PAFA — Pennsylvania Academy of Fine Arts.

PRA — President of the Royal Academy of Arts.

PRHA — President of the Royal Hibernian Academy of Arts.

PRSA — President of the Royal Scottish Academy of Arts.

Quick — *American Portraiture in the Grand Manner: 1720–1920*, exh. cat. (M. Quick) (Los Angeles County Museum of Art and National Portrait Gallery, Washington, DC, 1981–2), with essays by M. Quick, M. Sadik and W.H. Gerdts.

RA — The Royal Academy of Arts, London, or Royal Academician.

Redgrave — Samuel Redgrave, *A Dictionary of Artists of the English School: Painters, Sculptors, Architects, Engravers and Ornamentists: with Notices of their Lives and Work* (London, 1873, new edn revised to date London, 1878).

RHA — Royal Hibernian Academy, Dublin, or Royal Hibernian Academician.

RSA — The Royal Scottish Academy of Arts, Edinburgh, or Royal Scottish Academician.

SA — Member of the Scottish Academy (i.e., prior to its becoming the Royal Scottish Academy in 1839).

SNPG — Scottish National Portrait Gallery, Edinburgh.

Soc. — Society.

J.D. Stewart — J. Douglas Stewart, *Sir Godfrey Kneller and the English Baroque Portrait* (Oxford, 1983).

Strickland — Walter George Strickland, *A Dictionary of Irish Artists*, 2 vols (Dublin and London, 1913, reprinted Shannon, 1969).

Tate — Tate Gallery, London.

Th.-B. — Ulrich Thieme and Felix Becker, *Allgemeine Lexikon der bildenden Künstler, von der Antike bis zu Gegenwart*, 37 vols (Leipzig, 1907–50).

Univ. — University.

Vertue, III — George Vertue, Notebooks (III), *Walpole Society*, XXII (1933–4).

V & A — Victoria and Albert Museum, London.

VMI — Virginia Military Institute.

Walker AG Cat. — *Walker Art Gallery, Liverpool: Merseyside Painters, People and Places, Catalogue of Oil Paintings*, 2 vols (1978).

Waters — Grant M. Waters, *Dictionary of British Artists Working, 1900–1950*, 2 vols (Eastbourne, 1975, n.d., respectively).

Whitley II — W.T. Whitley, *Art in England 1800–1837*, 2 vols (Cambridge 1928, 1930, reprinted New York, 1973), vol. 2.

Wood — Christopher Wood, *The Dictionary of Victorian Painters*, 2nd edn (Woodbridge, 1978).

Yale — Yale Center for British Art, New Haven, CT.

Yale Univ. — Yale University Art Gallery or collection.

Biographical Dictionary

Abbott, Lemuel Francis *c.* 1760–1802
b. Leicestershire, d. London; in London 1784; initially self-taught, but then had some teaching from *Hayman; usually male sitters, often naval officers in half- and full-length, including well-known images of Admiral Lord Nelson; a few double portraits are known, one of an early 'Goffer' and caddy; he had a successful practice, but went mad 1798.

LOCATIONS: NPG; Tate.

LITERATURE: A. C. Sewter, *Connoisseur*, CXXXV (April, 1955), pp. 178–83.

Adolph, Joseph Anton 1729–*c.* 1765
b. Mikulov (Czechoslovakia); studied in Vienna; in London by *c.* 1750/1; diluted late Baroque style, with thin handling and stiff figures, but he could work on a large scale; still in England 1765 and may then have returned to Vienna or Czechoslovakia.

LOCATIONS: Castle Mus., Norwich; Lord Cranworth; Marquess of Lothian.

LITERATURE: EKW.

Aikman, William 1682–1731
b. Cairney, Forfar, d. London; pupil and assistant of *Medina; in Rome *c.* 1707 for three years, returning to work in Edinburgh in 1711 or 1712, then London from 1723. Usually a fluent, if repetitious painter; busts in feigned oval are common, but also half- and full-lengths and groups, sometimes in landscape.

LOCATIONS: SNPG; Univ. of Edinburgh; many private Scottish collections.

LITERATURE: EKW.

Alcock, Edward *fl.* 1757–1778
Itinerant; mainly small-scale portraits, usually full-length; recorded in Birmingham, Bath, Bristol and London (1778); also miniaturist and genre painter; interested in Rembrandt and executed oil studies in that manner, but his finished portraits are wholly conventional, not unlike those of *Devis but with more elaborate settings.

LOCATIONS: NPG; Lord Neidpath.

Alexander, Cosmo 1724–72
b.(?)Aberdeen, d. Edinburgh; son and pupil of *John A.; a Jacobite, in Rome from 1745, returning in 1754; worked in Aberdeenshire, then Holland 1763–4, and tried America from 1768–71, including Newport RI; first teacher of *Stuart who was with him when he went back to Edinburgh in 1771. Flat, provincial style, which became a little more fluent later, but always staid; attempted most types of portrait.

LOCATIONS: Chicago Art Inst.; Fogg; SNPG; NGS.

Alexander, Francis 1800–81
b. Killingly, CT, d. Florence; studied with Alexander Robertson in NYC *c.* 1820; introduced by a *Trumbull letter to *Stuart, he went to Boston *c.* 1827, where he was very successful; painted Charles Dickens (1842), Daniel Webster, etc.; in 1853 settled in Florence giving up painting for collecting and dealing, on the grounds that 'a few *soldi*' would buy him better pictures than any he could produce. He experimented with the earliest portrait lithographs in America; also painted genre and still-life.

LOCATIONS: Boston MFA; Harvard; Morristown Lib., Morristown, NJ; NG Washington.

LITERATURE: C. W. Pierce, *Old-Time New England*, XLIV (October–December, 1953), pp. 29–46.

Alexander, John *c.* 1690–*c.* 1757

b. Scotland; father of *Cosmo A.; in London 1710, then Italy from 1714, returning by 1721; based in Edinburgh from 1729, a Jacobite, he was in Italy again after 1745 and back by 1752; fluent but provincial and rather linear style, more sophisticated for its time than that of his son Cosmo A.'s ever was, apparently influenced by French painting, and with marked characterization of features; often busts in oval.

LOCATIONS: SNPG; Scottish private collections.

100

100. Francis Alexander, *Charles Dickens.* Oil on canvas, 111.7 × 90.2 cm (44 × 35½ in). 1842. Boston, MA, Museum of Fine Arts. Gift of the Estate of Mrs James T. Fields

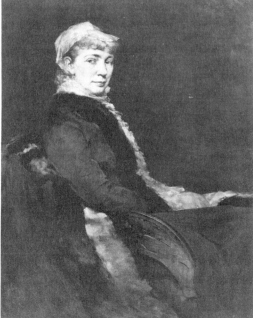

101

101. John White Alexander, *Mrs Samuel Tilton (Helen Reed).* Oil on canvas, 116.8 × 86.3 cm (46 × 34 in). *c.* 1880. Boston, MA, Museum of Fine Arts. Gift of Mrs William Rodman Fay, grand-daughter of the sitter

Alexander, John White NA 1856–1915

b. Allegheny City, PA, d. NYC; began as an illustrator; from 1877 studied in Europe including Munich, and became associated with *Duveneck; back in NYC 1881. Highly successful, with many prominent sitters painted in 'Munich' manner. Went to Paris 1890 where he was the friend of *Whistler and Rodin; from 1893 sensationally successful with new style based on line and flat areas of colour derived from Art Nouveau and *Whistler. Returned to NYC 1901, when his portrait style became more traditional. President of NA 1909. (See Plate 16)

LOCATIONS: New York Public Lib.; Los Angeles Co. Mus. of Art; Boston MFA.

LITERATURE: *John White Alexander (1856–1915),* exh. cat. (Nat. Colln of Fine Arts, Washington, DC, 1977); *John White Alexander, 1856–1915, Fin-de-Siècle American,* exh. cat. (Graham Gall, New York, 1980).

Allan, David 1744–96

b. Alloa, d. nr Edinburgh; also genre and history painter; known as 'the Scottish Hogarth'; patronized by the Cathcart family, went to Rome and Naples 1767–77; studied with *Gavin Hamilton in Rome; in London 1777–80, then settled in Edinburgh. He specialized in groups in open-air settings, with, e.g., guns, dogs, toys or cricketing accessories, often including a view of the sitters' house and park. There remains a faint and refreshing air of naivety in his paintings.

LOCATIONS: SNPG; The Earl Cathcart; Yale.

LITERATURE: T. Crouther Gordon, *David Allan* (Alloa, 1951); *The Indefatigable Mr Allan,* exh. cat. (Scottish Arts Council, 1973).

Allen, George *fl.* 1712–(?)55

Possibly a pupil of *Kneller; a member of St Martin's Lane Academy; a few pictures in the Kneller manner are known, e.g., s. & d. 1712 and 1731, the latter in a more 'up-to-date' style; published *Some Occasional Thoughts on Genius . . . Observations in the Art of Painting* (London, 1750). Worked for Duke of Kent at Wrest Park.

LOCATION: DOE, Wrest Park, Beds.

LITERATURE: *Times Literary Supplement* (26 June 1937), letter.

Allen, Joseph 1764–1839

b. Birmingham, d. Erdington; RA Schools 1787; based in Wrexham from 1798; founding member of Liverpool Academy, 1810; had a good practice among the industrial and

merchant classes in and around Liverpool and Manchester; an inventive and accomplished artist whose groups are reminiscent of *Beach; his later works are more obviously fashionable, with an air of *Lawrence.

LOCATIONS: Manchester CAG; Walker AG, Liverpool.

LITERATURE: Manchester CAG Cat. (1976); EKW; Walker AG Cat.

Alleyne, Francis *fl.* 1774–90

Itinerant, visiting country houses in South East England; small-scale, often oval panels; smooth detailed technique, varied colour, poses and props. Sets of eight or ten family portraits are known, each picture inscribed on reverse. The legs, if shown, are attenuated.

LOCATIONS: Mellon Colln; MCC, London.

Allston, Washington 1779–1843

b. Waccanaw, SC, d. Cambridge, MA; spent childhood in RI; studied at Harvard; went to England with miniaturist Malbone, 1801, and studied RA Schools and with *West; with *Vanderlyn in France in 1804, when he was influenced by neo-Classicism and began to use the clarity of form and richness of colour typical of his mature work. He then visited Italy; back in the U.S.A. 1808, where he married. *Morse was his pupil and he came to England with him in 1811; candidate for ARA, 1814, returning to U.S. A. finally in 1818. A very gifted painter, his portraits are more disciplined and penetrating than his histories, but are fewer in number. (See Chp. One, Fig. 19)

LOCATIONS: Boston MFA; Cleveland Mus. of Art, OH; NPG; FAM San Francisco.

LITERATURE: # E.P. Richardson, *Washington Allston: A Study of the Romantic Artist in America* (Chicago, 1948); '*A Man of Genius*': *The Art of Washington Allston (1779–1843)*, exh. cat. (Boston MFA, 1979); Whitley, II, 1.

Amans, Jacques 1801–88

Belgian; d. Paris; working in New Orleans in 1840s and 1850s; exhibited Paris Salon 1831–7; always accomplished, sometimes powerful painter, influenced by Dutch and Flemish seventeenth-century portraiture.

LOCATION: Brooklyn Mus.

LITERATURE: I.M. Cline, *Art and Artists in New Orleans during the Last Century* (New Orleans, 1922).

Ames, Ezra 1768–1836

b. Framingham, MA, d. Albany, NY; also a sign painter, miniaturist, landscape painter, and banker; worked in Worcester, MA, from

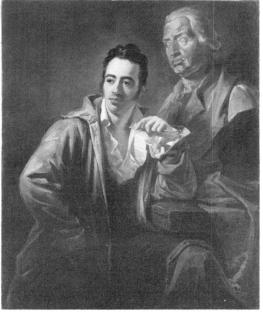

102. Joseph Allen, *George Bullock with his Bust of Henry Blundell*. Oil on canvas, 127 × 100.5 cm (50 × 39½ in). *c.* 1804. Liverpool, Walker Art Gallery

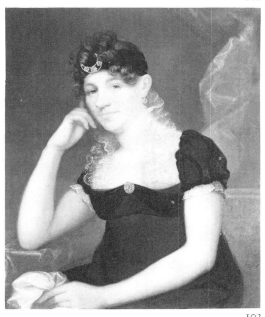

103. Ezra Ames, *Maria Gansevoort Melville*. Oil on panel, 76.2 × 59.2 cm (30 × 23½ in). *c.* 1815. Washington, DC, National Gallery of Art, Andrew W. Mellon collection

1790, then settled in Albany. His various activities are characteristic of many American artists in this period, and his frequent use of wooden supports instead of canvas is not unusual, using standard canvas measurements, e.g., 30 × 25 in (76.2 × 63.5 cm); portraits usually show a habitual back-lighting effect, but he experimented freely with a wide range of poses and settings in an eclectic way. His son, Julius Rubens A. (1801–50), was a miniaturist.

LOCATIONS: NG Washington; Newark Mus., NJ; N.-Y. Hist. Soc.; Brooklyn Mus.

LITERATURE: T. Bolton and I. Cortelyou, *Ezra Ames of Albany* (New York, 1955).

Ames, Joseph Alexander NA 1816–72
b. Roxbury, MO; working in Boston 1841–7, then in Italy where he painted Pope Pius IX (1848); returned to Boston; in Baltimore, MD, 1870, and then NYC until his death; smoothly-modelled, unarticulated half-lengths are typical, but his style is sometimes more painterly. Apparently influenced by *Allston, whose portrait he painted (*c.* 1840, private colln). He was an interesting landscape painter. ANA 1869, NA 1870.
LOCATION: Met. Mus., NYC.
LITERATURE: G & W.

Amigoni, Jacopo 1675–1752
b. (?) Naples, but Venetian; d. Madrid; working in England 1729–39, where he soon had to turn to portraits instead of the histories and decorative schemes for which he had been trained. He could work effortlessly on a large scale, in full-lengths and groups, in a decorative late-Baroque manner; patronized by the royal family. Returned to Venice 1739; court painter in Spain from 1747. Often appears as 'Amiconi'.
LOCATIONS: Mellon Colln; Graves AG, Sheffield; DOE, Wrest Park, Beds.; Lord Barnard.
LITERATURE: EKW.

Anderson, Charles Goldsborough 1865–1936
b. Tynemouth, Northumberland; d. Rustington, Sussex; based in London, and then Sussex; a bright fluent style; painted ovals, full lengths and groups.
LOCATIONS: Balliol College, Oxford; Lord Scarsdale.
LITERATURE: Waters.

Andrews, John *fl.* 1824–70
London painter; had a thriving practice, producing half-lengths and seated portraits, especially of the professional classes and their children; painted Giuseppe Mazzini 1852 (Earl of Rosebery); pleasant subdued manner.
LOCATIONS: NPG; Royal Coll. of Physicians; Earl of Rosebery.

Angeli, Baron Heinrich von 1840–1925
b. Sopron, Ödenburg, Austria; studied in Vienna and Düsseldorf; Munich 1859–62, then Vienna; became a European court portraitist after abandoning histories, under influence of Makart; exh. RA 1874–80; painted Queen Victoria 1883 and, e.g., Stanley the explorer.
LOCATION: HMQ.
LITERATURE: Bénézit.

Archer, James RSA 1823–1904
b. Edinburgh, d. Haslemere; studied at Trustees' Acad.; his best portraits are penetrating studies of character; also painted many histories, sentimental genre, landscapes and, early in his career, chalk portraits; from 1862 based in London; somewhat influenced by the Pre-Raphaelites; had a successful line in historical dress for children's portraits. One of the better Scottish painters independent of the Glasgow School.
LOCATIONS: RSA; Manchester CAG; Dept. of State, Washington, DC.

Arrowsmith, Thomas 1772–*c.* 1829
b. London; RA Schools 1789; worked in Liverpool and Manchester; deaf and dumb; was also a miniaturist; he continued into the age of Lawrence and the Regency a sober eighteenth-century style; was capable of working effectively on life-size full-lengths, sometimes in landscape.
LOCATIONS: Walker AG, Liverpool; Royal Artillery Inst., Woolwich.
LITERATURE: EKW.

Artaud, William 1763–1823
b. & d. London; precocious artist, and attended RA Schools from 1778; went to Rome 1796–9; also a history painter; made annual portrait tours of the Midlands; a pleasant portraitist in a rather rich *Raeburn manner, and a fine draughtsman.
LOCATION: City of Leicester AG.
LITERATURE: A. C. Sewter, Ph.D. (Manchester University, 1952); EKW.

Ashby, Harry *fl.* 1794–*c.* 1836
Not to be confused with Henry Ashby (1744–1818), who worked on inscriptions for prints and banknotes, or H.P. Ashby, exhibited RA 1835–65, who was a landscape painter, but who may have been related to this painter as both lived in Mitcham, Surrey; the subject of this entry sent portraits to RA 1794–1836; his *John Walker*, a portrait of this 'elocutionist', was exhibited RA 1802 (149) (NPG); painted groups and seated portraits in an accomplished manner, not unlike that of *Owen; worked in London with a middle-class and clerical clientele, moving to Mitcham, Surrey, *c.* 1816.
LOCATION: NPG.
LITERATURE: Graves; Redgrave.

Astley, John 1724–87

b. Shropshire, d. Dukinfield (his estate in Cheshire) pupil of *Hudson in early 1740s; *Gainsborough's landlord at Schomberg House, Pall Mall; in Rome and Florence from 1747 to mid-1750s, where he knew and perhaps drew the young *Reynolds; developed a polished continental style; worked successfully in Dublin 1756–9. A competent painter who could produce complex large-scale groups, he married a rich widow, and largely gave up painting after her death in 1762.

LOCATIONS: Ulster Mus., Belfast; N. Trust, Lyme Park; Lewis Walpole Library, Farmington, CT.

LITERATURE: Mary Webster, *Connoisseur*, CLXXII (December, 1969), pp. 256–61; Strickland.

Atkins, James 1799–1833

b. Belfast, where taught by Fabbrini; Italy 1819, and was still in Rome 1831; went to Constantinople at the end of 1832 and died in Malta of consumption on his way home; exhibited RA 1831–3 but working professionally by 1824; a competent painter, notably of doe-eyed women and children, thus foreshadowing a popular Victorian type of portraiture; but he made good individual characterizations and could work on a very large scale.

LOCATION: Christie's, 27.vi.80 (161).

LITERATURE: Strickland.

Audubon, John James 1785–1851

b. Haiti, d. NYC; best known for his *Birds of America* (1827–38), he was also an accomplished portrait painter, especially early on; led a peripatetic life; first went to U.S. in 1803 before leaving for France where he was taught drawing by J.-L. David; travelled extensively in U.S. and Canada from 1806; in NYC 1824, and worked in Pennsylvania and the south before going to England 1826; in U.S. again 1829–39. His portrait style is severe and unadorned, a mixture of native American restraint and the influence of David; the result can be compelling.

LOCATIONS: Nelson Atkins Art Mus., Kansas City; Mellon Colln.

LITERATURE: B. Adams, *John James Audubon: a Biography* (NY, 1966); A. Ford, *John James Audubon*, University of Oklahoma Press (Norman, 1964).

Baccani, Attilio fl. 1859–c.1896

Italian (Florentine ?), based in London; usually large-scale portraits in continental manner; evidently had a good society practice; last portrait s. & d. 1896. Miss Italia B. fl. 1885–c. 1906, also a painter, was presumably his daughter.

LOCATIONS: Inst. of Directors; University of London; Phillips, London, 12.xii.77(5).

Backer, John James, see **Baker, John James**

Bacon, John Henry Frederick ARA 1868–1914

b. & d. ? London, and based in London; his genre pictures are more than usually sentimental, but his portraits are telling, confident characterizations, with unusual poses, on the scale of life and with groups, e.g., *Coronation of King George V and Queen Mary* (HMQ).

LOCATIONS: HMQ; Tate; Guildhall, London; Walker AG, Liverpool.

Badger, Joseph 1708–65

b. Charleston, MA, d. Boston; in Cambridge, MA, 1731–3, then Boston; trained as glazier, house- and sign-painter. His manner is naive and linear; in the early 1750s, between *Smibert (whom he must have known) and *Copley, he was the most important painter in Boston. (See Chp. One, Fig. 12)

LOCATIONS: Bowdoin Coll., ME; Detroit Inst.; Met. Mus., NYC; Worcester Art Mus.; NG Washington; Yale Univ.

LITERATURE: L. Park, *Proceedings of the Massachusetts Historical Society*, LI (December, 1917), pp. 158–201.

Baker, George Augustus, Jr NA 1821–80

b. NYC, and remained there save for a visit to Italy c. 1846; a soft, flattering style, occasionally sentimental but very accomplished, and especially good with women and children; was also a miniaturist.

LOCATIONS: Los Angeles Co. Mus.; Yale Univ.

LITERATURE: G & W.

Baker, John James, 'Old' fl. c. 1685–1725

(also as 'Backer', 'Bakker' or Barker'); an assistant of *Kneller until 1712, and a collaborator with Sir James Thornhill; a drapery and accessory painter, but good separate portraits by him are known, including *Lt Col. Samuel Shute, Governor of Massachusetts*, painted c. 1715 (Sabin, 1976, no. 16); one of the first teachers of the diarist George Vertue. His son of the same name was a flower painter.

LOCATION: Kingston, Ontario.

104. Thomas Barker 'of Bath', *Priscilla Jones (the Artist's Wife)*. Oil on canvas, 76.2 × 63.5 cm (30 × 25 in). *c.* 1796. Bath, Holburne of Menstrie Museum

LITERATURE: J.D. Stewart, pp. 38n, 41n.; Sabin, exh. cat. (1976), no. 16.

Ballantyne, John RSA 1815–97

Studied in Edinburgh and later taught there at the Trustees' Academy but mainly based in London from 1832; best known for his series of portraits of contemporary artists in their studios; official biographer of David Roberts RA; also painted histories and genre. RSA 1845. He was a member of a family of painters of this name, and spent a lot of time on the Continent.

LOCATIONS: NPG; SNPG.

Barber, Thomas, 'of Nottingham' 1768–1843

Nottingham artist; rather linear, provincial style; occasionally interesting, e.g., *Two Park Keepers at Wollaton, Notts* (colln Lord Middleton); generally better with women; he had a wide practice in the Midlands and North of England, where most of his pictures remain.

LOCATIONS: N. Trust, Hardwick Hall; Lord Middleton; Earl of Lichfield.

Barclay, John Maclaren RSA 1811–86

b. Perth, d. Edinburgh; worked in Perth and Edinburgh; also painted genre; large-scale full-lengths and groups; occasionally used free impasted handling, the paint applied very thickly, but his usual manner is highly finished.

LOCATIONS: RSA; many private Scottish collections.

Bardwell, Thomas 1704–67

b. East Anglia, d. Norwich; *c.* 1728 settled at Bungay; began as a decorative and landscape painter, then conversation pieces *c.* 1736, and large-scale portraits *c.* 1741; prolific, much patronized by the aristocracy all over England, and in Scotland (1752/3); highly eclectic, with a variety of sizes, poses and styles, including large canvases; the full-lengths usually reveal attenuated anatomy; his half-length figures are much more secure. He was based in Norwich from *c.* 1759. Published the *Practice of Painting and Perspective made Easy* (1756). His techniques have been scientifically examined.

LOCATIONS: Castle Mus., Norwich; Ashmolean Mus., Oxford.

LITERATURE: #M.K. Talley, *Walpole Society*, XLVI (1976–8), pp. 91–163.

Barker, Thomas, 'of Bath' 1769–1847

b. nr Pontypool, d. Bath, where his family

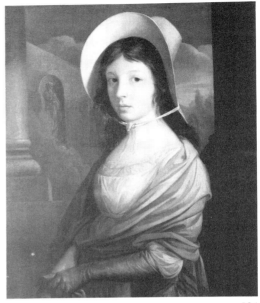

104

moved *c.* 1782, and where he lived thereafter; partly self-taught, although his father was an animal painter, and his work exhibits some typical features of the autodidact; he went to Italy *c.* 1792–5 under the patronage of a Bath coach-builder, Charles Spackman. A talented, eccentric painter but very successful, he could work on a large scale, with half- and full-lengths and groups; also painted landscapes and rustic genre. Some portraits have a bright linear intensity, others solid virtues of a *Raeburn kind. He was much given to self-portraiture in imitation of Old Masters (he had worked as a copyist). His son was *Thomas Jones B., and his brother Benjamin B. (1776–1838) did a few portraits but mainly landscape. The vast fresco in his Bath house survives.

LOCATIONS: Holburne of Menstrie Mus., Victoria AG, Bath; Tate; Yale.

LITERATURE: M. Holbrook, *Apollo*, XCVII (November, 1973), pp. 375–384; EKW.

Barker, Thomas Jones 1815–82

b. & d. Bath; son of *Thomas Barker of Bath; at nineteen, studied under Horace Vernet in Paris; painted landscapes, animals, still life and genre, thus suited to portraying shooting parties and the like, but he also did good straightforward half- and three-quarter lengths in studio settings.

LOCATIONS: NPG; Leeds CAG; Duke of Wellington.

Barraud, Henry 1811–74

Worked in London, often collaborating with his brother William B., 1810–50, a sporting

painter; also painted historical genre and animals, and was a photographer; specialized in large groups often based on his own group photographs, e.g, *The Lobby of the House of Commons*, 1872 (Palace of Westminster); a few single portraits are known; minutely detailed, lifeless style. His son Francis (*fl.* 1878–1924) mainly painted genre.

LOCATIONS: Nat. Army Mus.; Royal Coll. of Surgeons; MCC.

Barron, Hugh 1747–91

b. & d. London. Pupil of *Reynolds *c.* 1764–6. Precocious artist and musician; partly gave up painting for music in 1770s. Conversation pieces and individual portraits. Style indebted to Reynolds but lighter and more deft; use of middle hues, pinks, blues, greys; some influence of *Zoffany. Exhibited at RA until 1786.

LOCATIONS: Tate; Corcoran Gallery of Art, Washington, DC.

Barry, James 1741–1806

b. Cork, d. London; self-taught; in Dublin 1763; patronized by Edmund Burke who got him to London 1764, when he met *Reynolds; financed by Burke, from 1765–1771 he was in Paris and Rome; exhibited RA 1771–6 but he was angered by adverse criticism and ceased exhibiting; Professor of Painting from 1782 at RA but his remarkably difficult disposition led to his expulsion 1799; struggled for most of his life with histories and disliked portraiture, at which, however, he excelled, using striking, often extreme poses, with startling likenesses, and at his most original when combining portraiture with history painting. (See Chp. One, Fig. 8)

LOCATIONS: NPG; Victoria AG, Bath; Crawford Municipal AG, Cork, Ireland; Royal Society of Arts.

LITERATURE: # William L. Pressly, *The Life and Art of James Barry* (New Haven and London, 1981).

Beach, Thomas 1738–1806

b. Milton Abbas, d. Dorchester; pupil of *Reynolds 1760–2; based in Bath, sometimes itinerant in summer, visiting country houses in the West Country; painted in feigned ovals, also half- and full-lengths, and large-scale family groups; noted in his time for strong likenesses; vigorous, even brisk, handling which sometimes shows signs of haste, with a high 'fresh-air' colouring to the flesh, and strong yellows and blues; his pictures often display unaffected informality. After 1800 he retired from painting to live in Dorchester.

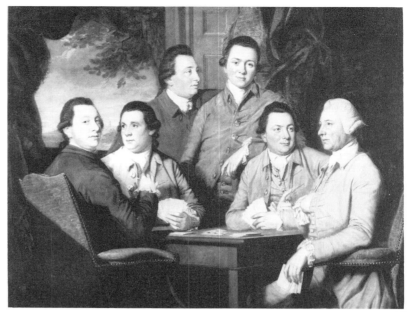

105

LOCATIONS: NPG; Bristol Univ.; Holburne of Menstrie Mus., Victoria AG, Bath; Getty Mus., Malibu.

LITERATURE: # Elise S. Beach, *Thomas Beach, A Dorset Portrait Painter, Favourite Pupil of Sir Joshua Reynolds* (London, 1934).

Beale, Mary 1632/3–99

b. Barrow, Suffolk, d. London; née Cradock; also a miniaturist; style indebted to *Lely*; often busts in feigned ovals of heavily-sculpted fruit, flowers and swags, sometimes with lettering and signature; good, distinct likenesses with the eyes rather like almond-shaped slits. Her son, Charles B. (1660–*c.* 1714 or 1726) is best known as the author of a series of remarkable portrait drawings and studies (British Mus.): his portrait style is similar to his mother's, often using plainer feigned ovals. (See Chp. Two, Fig. 72)

LOCATIONS: NPG; Fitzwilliam Mus., Cambridge; V & A.

LITERATURE: *The Excellent Mrs Mary Beale*, exh. cat. (Geffrye Mus., London, 1975).

Beard, James Henry NA 1811–93

b. Buffalo, NY, d. Flushing; moved as child to Painesville, OH; itinerant early on, e.g., Pittsburgh, Cincinnati, Louisville and New Orleans; based Cincinnati from 1830 but did some work in NYC and KY; settled NYC 1870 and turned to painting anthropomorphic animals; painted several U.S. presidents. NA 1872.

LOCATIONS: Cincinnati Art Mus.; City Hall, Charleston, SC.

LITERATURE: *Art Journal* (1975), pp. 366–8.

105. Thomas Beach, *The Hand that was not Called*. Oil on canvas, 146 × 189.2 cm (57½ × 74½ in). 1775. Houston, Texas. Sarah Campbell Blaffer Foundation

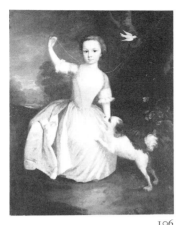

106. George Beare, *Lady with a Canary*. Oil on canvas, 74 × 61.5 cm (29¼ × 24¼ in). 1748. Sotheby's, 21.XII.83 (22)

Beare, George *fl.* 1738–49
d. nr Andover; active in Salisbury, but probably trained in London; his works are sometimes confused with those of *Hogarth, but his handling is flatter and less interesting, and the colours less attractive; he enjoyed playing compositional tricks with, e.g., elaborate twisted poses; a vigorous and original talent, apparently confined to a flourishing provincial business; known works are dated between 1741 and 1749.
LOCATIONS: NPG; Guildhall, Salisbury; Tate; Yale; Corpus Christi College, Cambridge.
LITERATURE: N. Surry, *Burlington Magazine*, CXXVIII (October, 1986), pp. 745–9.

Beaux, Cecilia 1863–1942
b. Philadelphia, d. Gloucester, MA; studied under *Eakins at Pennsylvania AFA and with William Sartain, and in 1888–9 Paris, Acad.

107. James Carroll Beckwith, *William Walton*. Oil on canvas, 121.6 × 72.1 cm (47⅞ × 28⅜ in). 1886. New York, NY, Century Association

Julian, also under Colarossi and Constant; visited England and Italy; taught at Pennsylvania AFA 1895–1915. Also worked in Boston and NYC, established as a leading society portrait painter by 1890. Clearly influenced by *Sargent, whom she knew, the influence was chiefly restricted to fluent handling: her figures tend to be isolated in the picture space in a more traditional manner. Official portraitist in World War I; her work became more obviously 'official' and traditional after *c.* 1905. ANA 1894, NA 1902. (See Plate 15)
LOCATIONS: Philadelphia MFA; Pennsylvania AFA; NPG Washington; Jeu de Paume, Paris.
LITERATURE: *Cecilia Beaux: Portrait of an Artist*, exh. cat. (Pennsylvania AFA, Philadelphia, 1974).

Beckwith, James Carroll 1852–1917
b. Hannibal, MO, committed suicide; trained in Paris under Carolus-Duran; shared a studio with *Sargent (who retouched some of his works after his suicide to make them saleable); associated with *Chase in teaching at Art Students' League. The influence of photography is apparent in his portraits, notably in *William Walton* (Century Assoc., NYC) (the sitter also committed suicide, in 1915), but many, especially the male portraits, are formal studio pieces, seated or three-quarter length.
LOCATION: Century Assoc., NYC.

Beechey, Sir William RA 1753–1839
b. Burford, Oxfordshire, d. London; RA Schools from 1774; taught by *Zoffany, early works small-scale full-lengths, *c.* 1776–86; in Norwich 1782–7, started large-scale, then London; portrait painter to Queen Charlotte 1793; painted royal princesses, and the important (and very large) *The King Reviewing the Dragoons* in 1797–8; knighted 1798. Rather than competing with *Lawrence, he was a rival to *Hoppner; not flattering to women and his portraits of them are rather unsatisfactory; his children are slightly twee, after the Reynolds pattern, but in fresh, lively colours; combined portraiture with fancy pictures very successfully.
LOCATIONS: HMQ; Tate; Detroit Inst. Yale.
LITERATURE: W. Roberts, *Sir William Beechey, RA* (London, 1907).

Bell, John Zephaniah RSA 1794–1883
b. Dundee; studied RA Schools, and in Paris with Baron Gros; also a history painter. His portraits are informed by a thorough study of

Renaissance portrait styles, and also show a mediaevalizing taste which he may have acquired in Paris; his work of the late 1820s thus appears startlingly like some later Victorian portraiture. Some of his portraits are of exceptional quality and interest, and are taut, dramatic compositions.

LOCATIONS: Dundee CAG; Earl of Airlie; Mellon Colln.

Bell, William 1735–1804

b. & d. Newcastle-upon-Tyne; his was the first name enrolled in RA Schools in 1769 when aged thirty-four; Gold Medal for history painting 1771; worked as limner and art teacher for Delaval family c. 1770–5; after 1776 based in Newcastle, and a friend of Thomas Bewick whom he painted in the manner of Rembrandt; subsisted giving drawing lessons; full-lengths and groups are known; rather a wooden style; it has been suggested that he died 1806 (EKW).

LOCATIONS: Christie's, 23.xi.73 (158), 25.xi.60 (88); Seaton Delaval; Mr and Mrs Anthony Jarvis, Doddington Hall, Lincs.

LITERATURE: EKW; Hall, *Artists of Northumbria*.

Belle, Alexis Simon 1674–1734

b. & d. Paris; pupil of de Troy (Acad. 1703); in England painted handsome portraits often in feigned sculptured ovals; painted the Old Pretender 1717, and had Scottish patronage.

LOCATIONS: NPG; St John's Coll., Cambridge.

Bellows, George Wesley NA 1882–1925

b. Columbus, d. NYC; 1904–9 studied NY School of Art under *Chase; strongly influenced by his teacher *Henri; NA 1913, and exhibited in Armory Show where he was fascinated by the Europeans, e.g., Cubists, but continued in his own direction. Best known for his paintings of boxing matches, his numerous portraits provided an important focus for his prodigious but sometimes wayward talent; in them artfully simple compositions are executed with rich, brilliant brushwork and subtle colour; few were the result of commissions. Also a superb lithographer and illustrator. (See Plate 17)

LOCATIONS: Carnegie Inst., Pittsburgh; Chicago Art Inst.; Dallas MFA; Minneapolis Inst.; NG Washington; Columbus Mus. of Art, OH.

LITERATURE: C.H. Morgan, *George Bellows: Painter of America* (New York, 1965); *George Wesley Bellows: Paintings, Drawings and Prints*, exh. cat. (Columbus Mus. of Art, 1979).

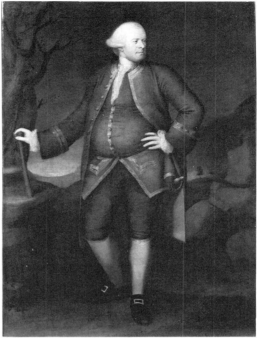

108

108. Henry Benbridge, *Pascal Paoli*. Oil on canvas, 215.9 × 127 cm (85 × 50 in). 1768. San Francisco, CA, The Fine Arts Museums of San Francisco. Gift of Mr and Mrs John D. Rockefeller 3rd

Bellucci, Giovanni Battista *fl.* 1700–39

Venetian; son or nephew of Baroque decorative painter Antonio B. (1654–1726), whom he accompanied to England 1716; a limited artist who had some success in Scotland; feigned ovals are common.

LOCATIONS: Lord Binning; Col. Stirling of Keir.

LITERATURE: EKW.

Benbridge, Henry 1743–1812

b. & d. Philadelphia; had some instruction from *Wollaston 1758; in Rome from 1764 and studied perhaps with Mengs and, more probably, with Batoni; in 1768 was commissioned by James Boswell to paint Pascal Paoli, being sent to Corsica for that purpose; the picture was exhibited at Soc. of Artists in London 1769 and Benbridge arrived there in December of that year; became associated with his distant relation *West, and exhibited portrait of Franklin at RA in 1770, when he returned to Philadelphia; moved to Charleston, SC, 1771 where he became the leading portraitist in succession to Theüs; apparently largely retired from painting c. 1790, but gave some instruction to the young *Sully 1799. His style is highly polished, using chiaroscuro, and 'continental' in the Batoni manner; ovals, three-quarter and full-lengths, conversation pieces and groups, often with thoroughly un-American studio accessories; was also a miniaturist.

LOCATIONS: Carnegie Inst., Pittsburgh; NG Canada; Art Mus., Princeton Univ. (loan); NG, NPG, Washington; Amherst College.

109. Frank Weston Benson, *Portrait in White*. Oil on canvas, 122.2 × 97 cm (48⅛ × 38¼ in). 1889. Washington, DC, National Gallery of Art. Gift of Sylvia Benson Lawson

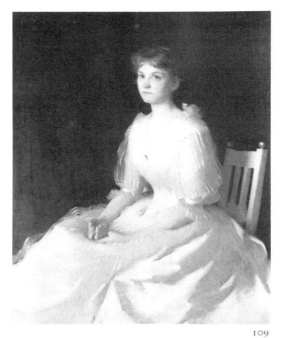

109

LITERATURE: *Henry Benbridge (1743–1812): American Portrait Painter*, exh. cat. (NPG, Washington, 1971).

Benson, Frank Weston NA 1862–1951

b. Salem, MA, d. Boston, MA; studied at Boston MFA School, and in 1883 went with his friend *Tarbell to Acad. Julian, Paris, under Boulanger and Lefebvre; studio with Tarbell, Boston 1886; taught Boston MFA School 1889–1912; NA 1908; member of The Ten; strongly influenced by French Impressionism, but he could turn this style on and off, and his commissioned portraits tend to be traditional, although painted with an exquisite touch. He could use Impressionism to great effect, as in his masterpiece *The Artist's Daughters*, 1907 (Worcester Art. Mus.); he was, finally, rather eclectic. In his fifties he turned to sporting subjects, particularly duck-shooting.

LOCATIONS: Worcester Art Mus., Worcester, MA; Detroit Art Inst.

LITERATURE: *Frank W. Benson, Edmund C. Tarbell*, exh. cat. (Boston MFA, 1938); *Frank W. Benson 1862–1951*, exh. cat. (William A. Farnsworth Lib. and Art Mus., Rockland, ME, 1973).

Berridge, John 1740–c. 1805

b. Lincolnshire; pupil of *Reynolds 1766–8, RA Schools 1796; early works similar to those of Reynolds and *Cotes; his later work is plainer and less inventive, and of lower quality; s. & d. portrait of J.F. Nollekens (1805) was sold in London in 1928.

LOCATIONS: White's Club, London (loan); Sotheby Parke-Bernet, NYC, 30.v.79 (261, 262).

LITERATURE: EKW.

Betts, Louis NA 1873–1961

b. Little Rock, AR., d. Bronxville, NY; studied with his father, then in Chicago, Pennsylvania AFA and with *Chase, NYC; in Spain and Netherlands 1903–5 when he studied Velásquez and Hals who influenced his impressive early portraits, i.e., those until c. 1910; settled NYC; became a fashionable, lightweight society painter.

LOCATIONS: Toledo Mus.; NAD.

Bigg, William Redmore RA 1755–1828

d. London; pupil of *Penny; RA Schools 1778; small full-lengths, conversation pieces and feigned ovals, thus following Penny's own early output, but the style brought up-to-date and influenced by *Zoffany; also rustic genre (for which he is best known).

LOCATIONS: Christie's, 27.vi.80 (117); P.C. Smythe, Esq.

Bingham, George Caleb 1811–79

b. Augusta County, VA, d. Kansas City, MO; he grew up in Franklin, MO; although best known as 'the Missouri Artist', who specialised in haunting images of American life, he painted more portraits than anything else; began portraits 1833, studied Pennsylvania AFA 1838, in Washington 1840–4, then St Louis 1845; went to Düsseldorf 1856–8, and in 1859 settled in St Louis, and turned increasingly to portraiture and to politics. Later portraits are decidedly European in character.

LOCATIONS: St Louis Mus., Missouri Hist. Soc., St Louis, MO; Nelson Atkins Art Mus., Kansas City, NPG Washington.

LITERATURE: # M.E. Bloch, *George Caleb Bingham*, & c., 2 vols (Berkeley, Los Angeles, 1967).

Birley, Sir Oswald Hornby Joseph 1880–1952

b. Auckland, NZ; after Cambridge University, trained in Dresden, Paris and the St John's Wood School of Art; based in London; fashionable society portraitist, who developed a flashy superficial style which is actually of little painterly interest; represented in many English country houses.

LOCATION: NPG.

LITERATURE: Waters.

Black, Mary 1737–1814

Daughter of London painter Thomas Black, ARA (*fl.* 1738–77), who had been assistant of *Pond and *Ramsay and was elected ARA shortly after 1768; a copyist (e.g., *Revd Jeremiah Willes,* after Dance, 1785, Soc. of Antiq., London) and a teacher, but worked independently as a good portraitist somewhat in the manner of *Hudson or *Dance; full-lengths and seated.

LOCATIONS: Earl of Dunraven; Royal Coll. of Physicians.

LITERATURE: Lippincott; EKW.

Blackburn, Joseph *fl.* 1752–78

Presumably b. Britain, recorded in Bermuda 1752 and 1753; may have travelled there from England on commission; Boston until 1760, visiting Newport RI 1754, and Salem, MA; from 1760 worked in Portsmouth, NH, then Boston until 1763; may have been similarly itinerant on his return to England, unless he settled in South Wales where a number of portraits are known. His introduction of fashionable poses had considerable impact in Boston, notable on the young *Copley; his own handling of the figure is sometimes uncertain. By 1773 in South Wales, recorded there again 1777; had some patronage from Loyalists, e.g., *Col. Dawdeswell,* 1776, which has wigwams in the background (Sotheby's, 17.iii.71 (68)); retained a rather linear style to the end. Only two full-lengths known; usually three-quarter length. (See Chp. One, Fig. 11)

LOCATIONS: Boston MFA; MFA Springfield, MA; Detroit Inst.

LITERATURE: # L. Park, *Joseph Blackburn, A Colonial Portrait Painter, with a Descriptive List of his Works* (Worcester, MA, 1923); # J.H. Morgan and H.W. Foote, *An Extension of Lawrence Park, Descriptive List of the Work of Joseph Blackburn* (Worcester, MA, 1937).

Boadle, William Barnes 1840–1916

b. Belfast, d. Birkenhead; lived in Liverpool; 1871 Slade School under Poynter; became leading portrait painter in Liverpool.

LOCATION: Walker AG, Liverpool.

LITERATURE: Walker AG Cat.

Bogle, James NA *c.* 1817–73

b. Georgetown, SC, d. Brooklyn, NY; twin brother of Robert B.; in 1836, James is known to have been a pupil of *Morse in NYC; by 1840, the brothers were working together in Charleston SC; 1842 in Baltimore and 1843 in Charleston again; in that year James moved to NYC where he remained, save for a period in Charleston 1849. NA 1861. His brother Robert (*c.* 1817–?) married an heiress 1845; Robert is known to have worked as a portraitist, e.g., 1860, in Georgetown, DC and Charleston, SC, and to have been in Italy in 1848; but apart from the fact that he was rich, little is known of him after his collaboration with his brother James.

LOCATION: Gibbes AG, Charleston, SC.

LITERATURE: G & W.

Bowen, Edward ANA 1822–70

b. & d. Baltimore, MD; taught by local portraitist, Thomas Coke Ruckle (1811–91), then *c.* 1846–9 studied in Europe, notably with Couture in Paris; Baltimore 1850–2, then Philadelphia 1854–60, finally Baltimore 1868; also worked in crayon and genre and still-life.

LOCATION: Baltimore Mus. of Art.

LITERATURE: Baltimore Mus. of Art Cat.

Bowman, James 1793–1842

b. Alleghany Co., d. Rochester, NY; grew up in Mercer Co., PA; had little formal instruction, but *c.* 1822 went to London, Paris and Rome, returning to Pittsburgh 1829. Thereafter itinerant, opening a studio in Rochester, NY, 1841. He had some distinguished sitters, including Lafayette and Fenimore Cooper, but these portraits have vanished, together with most of his work. Taught *George Whiting Flagg.

LOCATION: State Hist. Soc. of Wisconsin.

LITERATURE: G & W.

Boxall, Sir William RA 1800–79

Based in London; studied RA Schools and in Italy; also landscape and religious painter; RA 1863 and Director of NG 1865–74; knighted 1867; a friend of Maclise, whom he painted; painted *J.M. Whistler when Whistler was fourteen (Univ. of Glasgow); high Victorian style occasionally tempered by expressive brushwork; sitters usually in law, the services and academic world.

LOCATIONS: Inner Temple; Univ. of Glasgow.

Boyle, Ferdinand Thomas Lee
ANA 1820–1906

b. Ringwood, England, d. Brooklyn, NY; in America as a child; pupil of *Inman, spent early career NYC, then St Louis, MO, from 1855; NYC 1866 and became Professor of Art, Brooklyn Inst.; painted Lincoln and Dickens. ANA 1849.

LOCATIONS: Union League Club, NYC.

LITERATURE: G & W.

110. William Bradley, *George Fraser with a Golf Club*. Oil on canvas, 111.8 × 91.5 cm (44 × 36 in). 1830. Manchester, City Art Gallery

111. Charles Bridges, *Augustine Moore*. Oil on canvas, 124.7 × 102 cm (49⅛ × 40⅛ in). c. 1735–43. The Colonial Williamsburg Foundation, Williamsburg, VA

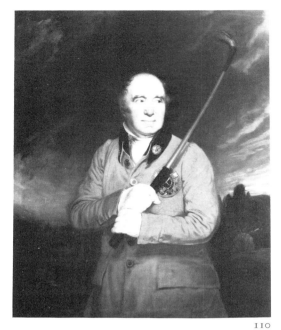

110

111

Bradley, William 1801–57

b. and worked in Manchester; a very good painter, whose work is evidence of the strength of English provincial society as a source of patronage after the Industrial Revolution. The influence of *Lawrence is present in his work to a limited extent; his manner is forthright, often showing the head in close-up, with an excellent sense of structure, but full-lengths are rather stilted.

LOCATIONS: Manchester CAG; Eton Coll.

LITERATURE: Manchester CAG Cat. (1976).

Bramley, Frank RA 1857–1915

b. Sibsey, Lincs., d. Chalford Hill, Gloucs.; studied Lincoln School of Art and in Antwerp; member of the Newlyn School, using powerful colours; influenced by the social realism of Millet and Courbet; founding member of New English Art Club; painted portraits especially after 1897, and blurred the distinction between genre and portraiture. ARA 1893, RA 1911.

LOCATION: NPG.

LITERATURE: Waters.

Breda, Carl Fredrik von 1759–1818

b. & d. Stockholm, where he was trained; in London 1787–96 where influenced by *Reynolds and *Beechey; his work is usually adequate but not very interesting. Worked in Birmingham 1792–3 on portraits of the Lunar Society. Sometimes worked on panel using standard canvas size such as 50 × 40 in (127 × 101.6 cm).

LOCATION: NPG.

LITERATURE: EKW.

Breun, John Ernest 1862–1921

b. and worked in London, son of John Needham B., Duc de Vitry; studied South Kensington and RA Schools 1881–84; had a flourishing business in upper-class society; typical late-Victorian/Edwardian manner, and could work on very large scale; enlivened his work through expressive brushwork.

LOCATION: N. Trust, Dunham Massey.

Bridges, Charles fl. 1670–1747

b & d. Barton Seagrave, Northamptonshire; of a good family; active as agent for SPCK from its foundation in 1699 until 1713, but remained in touch thereafter; one English portrait recorded (engraved 1733). By May, 1735, recently arrived in Williamsburg, VA, with son and two daughters and recommendations to Lt-Governor, etc.; by December 1735 had painted members of the Byrd family of Westover, and thereafter generally successful as the first professional portraitist in VA about whom any details are known. Evidently left for England 1744–5. No English works survive.

LOCATIONS: Colonial Williamsburg; Clarke County Hist. Assoc., VA; Met. Mus., NYC; Yale Univ.; Coll. of William and Mary, Williamsburg, VA.

LITERATURE: H. W. Foote, *Virginia Magazine of History and Biography*, 60 (January, 1952), pp. 1–55; G. Hood, *Charles Bridges and William Dering . . .* (Williamsburg, VA, 1978)

Bridges, John *fl.* 1818–54

Perhaps brother of landscape painter James B. (*fl.* 1819–53). Worked in Oxford in a provincial style; also a good genre painter, and some of his portrait groups have charming details of mid-nineteenth-century domestic life; also painted single portraits of academics and soldiers, full- and three-quarter length.

LOCATION: Oriel Coll., Oxford.

LITERATURE: Wood.

Briggs, Henry Perronet RA 1781–1844

b. Walworth, d. London; worked in London; also painted histories; RA Schools 1811; solely portraits after 1835. A lively and inventive artist best known for a number of portraits of the Duke of Wellington; particularly successful with seated figures of judges and statesmen. Executed some unusual portrait commissions for specific occasions, on a very large scale. Copied paintings by *Reynolds.

LOCATIONS: Duke of Wellington; Nat. Marit. Mus.; Middle Temple; NPG; The Burghley House Colln.

Briggs, William Keighley *fl.* 1847–60

Evidently a Yorkshire artist who worked in Leeds and London; perhaps working by 1842; his few known works are accomplished and charming. Exhibited RA 1849–60.

LOCATION: Leeds City AG.

Bright, Beatrice 1861–1940

b. London, and worked there; pupil of *Cope; exh. RA and Paris Salon; apparently never worked on very large scale; worthy but dull.

LOCATION: Inner Temple; Elton Hall; NPG.

Brigstocke, Thomas 1809–81

London portraitist; studied Sass's, RA Schools, and under *H.P. Briggs and *J.P. Knight; exhibited RA from 1842; studied for eight years in Paris, Florence, Rome and Naples; in Egypt 1847 for sixteen months. Accomplished large-scale full-lengths.

LOCATIONS: NPG; Oriental Club; St Cuthbert's Coll., Ushaw.

LITERATURE: Bryan.

Brocky, Charles 1807–55

b. Hungary; arrived London after impoverished period in Vienna; finally very successful; generally slight, sketchy performances; many portrait drawings; also worked as an illustrator and painted classical subjects.

112. Henry Perronet Briggs, *Lord Encumbe bowing to the Earl of Eldon at the Installation of the Duke of Wellington as Chancellor, 1834. c.* 1835. Stratfield Saye, The Duke of Wellington

112

LOCATION: NPG.

LITERATURE: N. Wilkinson, *Sketch of the Life of Charles Brocky the Artist* (London, 1870).

Brompton, Richard *c.* 1734–83

d. St Petersburg: taught by *Benjamin Wilson; Rome 1757, pupil of Mengs 1758; returned from Italy to London 1765. Painted *Edward Duke of York and his friends in a Landscape* (six versions, one for each sitter) in Padua 1764, and thereafter enjoyed royal and aristocratic patronage; most types of portrait, often with landscape or more unusual setting; the huge Dawkins family group (Over Norton Hall) is some nineteen feet wide. Imprisoned for debt 1780 but summoned to Russia as court painter. Individual portraits are often powerfully conceived.

LOCATIONS: HMQ; NPG; Manchester CAG; Nat. Maritime Mus.

LITERATURE: EKW.

Brooks, Frank 1854–1937

b. Salisbury, d. Lyndhurst, Hants.; also landscape and watercolour artist; studied Salisbury and London and exhibited RA from 1880; made two visits to India, 1888 and 1892, painting Indian princes and figures of the Raj; 1896 returned to London. Half-lengths are common, often with an unarticulated front-on view, with body parallel to picture plane. His father and brother, both Henry B., were local Salisbury painters of genre.

LOCATIONS: NPG; Southampton AG; Royal Soc. of Musicians.

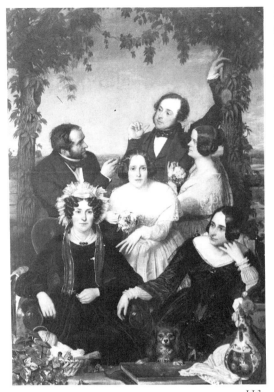

113

Brooks, Henry Jamyn 1865–1925

London portraitist; second name sometimes erroneously given as Jermyn; specialized in large portrait groups, cleverly articulated, e.g., *Court of Examiners of the Royal College of Surgeons* (1894).

LOCATIONS: NPG; Royal Coll. of Surgeons.

Brough, Robert ARSA 1872–1905

b. Invergordon, d. nr Sheffield; studied Aberdeen and Paris under Constant; influenced by French contemporaries and by *Whistler; Edinburgh 1893; returned to Aberdeen 1894 and worked there and in London. Accomplished painter, usually full-length, especially frothy women; his theatrical portraits are high camp. Died of injuries from a railway accident.

LOCATIONS: Garrick Club; NPG; SNPG; Hopetoun House and other private Scottish collections.

Brown, Ford Madox 1821–93

b. Calais, d. London; studied Bruges and Ghent, and Antwerp under Baron Wappers, 1837–9; in Paris 1840–4; Rome 1845–6. Although best known for his genre subjects, *Work* and *The Last of England*, painted under the influence of the Pre-Raphaelites, early works include a number of impressive portraits. The groups are oddly but successfully arranged, although the handling is rather ineffectual on close examination; in the few later portraits this weakness largely disappeared.

LOCATIONS: NPG; Manchester CAG; Birmingham CAG; Fogg.

LITERATURE: # F.M. Hueffer, *Ford Madox Brown*, & c. (London, 1896).

Brown, Henry Harris 1864–1948

b. Northamptonshire, d. (?) London; trained in Paris with Bouguereau; in London 1891; had wide range of patronage. Some works are heavily impasted. Exhibited large number of portraits RA 1889–1904; also worked in U.S.A. and Canada.

LOCATIONS: Inner Temple, London; Jeu de Paume, Paris; Museo Horne, Florence.

Brown, Mather Byles 1761–1831

b. Boston, MA, d. London; studied with *Stuart; practised in MA before going to London 1781 where he became a pupil of *West; RA Schools 1782; his natural gifts led to early success, but he failed repeatedly to be elected RA, the attempt ending 1795; from then on his business declined, partly the result of an unhappy interest in theories about painting, and his works after 1800 became more linear, clumsy and, finally, extraordinarily weak; he began to move about England in search of commissions, from Bucks to Bath, to Liverpool and Manchester, finally London 1824; at the peak of his career, *c.* 1785–95, he painted some royal portraits, his style apparently influenced by *Copley.

LOCATIONS: Boston MFA; Detroit Inst.; NG Washington; NPG; SNPG; HMQ.

LITERATURE: #D. Evans, *Mather Brown, Early American Artist in England* (Middletown, CT, 1982).

Brown, William Garl 1823–94

b. Leicester, England, d. Buffalo, NY; son of landscape and genre painter, William G.B., who emigrated 1837; they shared portrait studio Brooklyn 1842; he settled Richmond, VA, *c.* 1846; painted *Zachary Taylor*, 1847 (Corcoran Gall., NYC) and exhibited portraits of other Mexican War heroes, SC 1850s; NYC 1856–65 but also worked NC and VA; Richmond from *c.* 1880. A rugged, individual style.

LOCATIONS: Corcoran Gall., NYC; Univ. of North Carolina; VMI.

LITERATURE: G & W.

Buckner, Richard *fl.* 1820–79

b. Chichester; based in London for most of his

life; in Rome 1820–40; women often sentimentally treated, rather soulful with cow eyes, in typical Victorian manner, but occasionally more lively; usually better with men but even they are soulful; prolific and successful society painter in England and Scotland. Exhibited RA 1850–65. Also genre.

LOCATIONS: N.Trust, Anglesey Abbey, Saltram; Edmund Brudenell, Esq.

LITERATURE: Th.-B.

Bunker, Dennis Miller 1861–90

b. & d. NYC; studied NA from 1878 and at Art Students' League under *Chase; Paris 1882, a pupil of Gérôme; well-established in Boston 1885; spent successive summers with A. H. Thayer and *Sargent and also admired *Vinton; immensely promising, by the time of his early death from influenza he had already absorbed most of the vital stylistic tendencies of American portrait painting of the period, and had considerable influence on, e.g., *Tarbell and Paxton.

LOCATION: Boston MFA.

Bush, Joseph Henry 1794–1865

b. Frankfort, KY, d. Lexington, KY; after *Jouett the most important KY artist; Philadelphia c. 1810, two years with *Sully; then returned to KY where he remained, working in Frankfort, Lexington, and Louisville; had flourishing practice among Louisiana and Mississippi planters.

LOCATION: Locust Grove, Louisville.

LITERATURE: G & W.

Byng, Robert fl. 1697–1720

Probably (EKW) elder brother to Edward B. (c. 1676–1753) who was one of *Kneller's chief assistants and drapery painters; it is likely that some portraits are wrongly ascribed between the brothers; Robert B.'s portraits are characterized by a jumble of colours, props and costumes, the different parts of the body being uncertainly related to each other. Perhaps born c. 1645 or c. 1649.

LOCATION: Bodleian Lib., Oxford

LITERATURE: EKW; J.D. Stewart, p. 1n, ff.; Colnaghi, *The English Face* (1986), no. 9.

Caddick, William 1719/20–94;
Richard 1748–1831;
William, Jr 1756–84

Liverpool painters, about whose work there is some confusion. The most accomplished appears to be Richard, author of *The Caddick Family*, c. 1788 (Walker AG, Liverpool), a conversation piece painted in a sophisticated

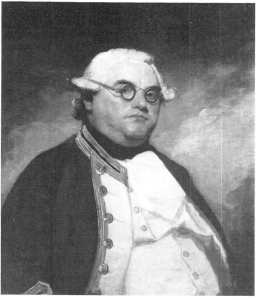

114

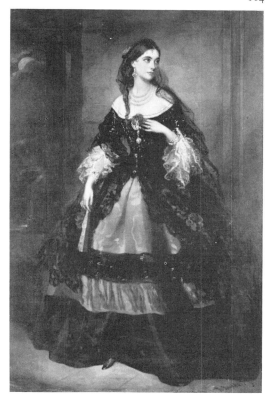

115

114. Mather Byles Brown, *Admiral Peter Rainier*. Oil on canvas, 76.2 × 63.5 cm (30 × 25 in). c. 1783–7. Boston, MA, Museum of Fine Arts. Henry Lillie Pierce Residuary Fund.

115. Richard Buckner, *Adeline, 7th Countess of Cardigan*. Oil on canvas, 119.4 × 78.7 cm (47 × 31 in). c. 1860. The property of Edmund Brudenell, Esq.

style akin to that of a contemporary such as *Walton; similar in style is *John Wood of Brownhills* (Henley Hall). William Sr's manner is harsh and provincial, e.g., *Joseph Brooks* (Walker AG). He was a friend of *Stubbs (who painted a member of his wife's family). The work of William Jr remains wholly obscure.

LOCATION: Walker AG, Liverpool.

LITERATURE: Walker AG Cat.

116. Richard Caddick, *The Caddick Family*. Oil on canvas, 74 × 100 cm (29⅛ × 39⅜ in). *c.* 1788. Liverpool, Walker Art Gallery

117. Margaret Sarah Carpenter, *Mrs John Marshall and her Child*. 127 × 99.7 cm (50 × 39½ in). 1838. Leeds, City Art Gallery

118. Adriaen Carpentiers, *A Lady in Divan Club Costume (in disarray)*. Oil on canvas, 74 × 61 cm (29⅛ × 24 in). *c.* 1739. West Wycombe Park, Sir Francis Dashwood, Bt

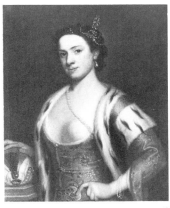

118

Calkin, Lance 1859–1936

b. & d. London; studied Royal Coll. of Art, RA and Slade Schools; unoriginal but very competent with wide-ranging commissions, sitters including King Edward VII, King George V, and Scott of the Antarctic.

LOCATIONS: NPG; HMQ.

Canziani, Louisa, see Starr-Canziani

Carpenter, Francis Bicknell ANA 1830–1900

b. Homer, NY, d. NYC; went to NYC 1852; painted President Millard Fillmore (City Hall,

NYC) and *Lincoln Reading the Emancipation Proclamation* (Capitol); used many studio props, whether in ovals, half- or full-lengths, and the effect is often cluttered; he was a frequent exhibitor at East Coast Institutions.

LOCATIONS: NG and Capitol, Washington, DC; City Hall, NYC; Yale Univ.

LITERATURE: G & W; Th-B.

Carpenter, Margaret Sarah 1793–1872

b. Salisbury, d. London; née Geddes; early on copied pictures at Longford Castle; in London 1814 and soon successful; fluent appealing style; rather better with male sitters – her women tend to simper. Executed a large number of Eton leaving portraits. 1817 married the Keeper of Prints and Drawings at BM. Her son William C., 1818–99, also did some portraits; he went to Boston, MA, 1862, and had been to India 1855.

LOCATIONS: Eton Coll.; NPG.

LITERATURE: Wood.

Carpentiers, Adriaen *fl.* 1739–78

Flemish, d. London; itinerant to some extent, e.g., was in both Buckinghamshire and Kent 1739, Bath 1743, Oxford 1745, East Anglia in 1750s. Patronized by Sir Francis Dashwood of West Wycombe, whom he painted in a number of supposedly amusing guises, and for whom he painted other members of the Divan Club in their costume. Smooth finished style, based on *Kneller system of modelling, with a weakness of structure evident in three-quarter views. Later works are more individual and develop an informality like that of *Highmore's portraits.

LOCATIONS: Sir Francis Dashwood, Bt; NPG; Yale.

LITERATURE: EKW.

Chalmers, Sir George, Bt *c.* 1720–91

b. Edinburgh, d. London; made dubious claim to baronetcy *c.* 1764; married *C. Alexander's daughter 1768; trained as heraldic artist; prolific, apparently self-taught as portraitist, with eclectic, chameleon-like variety of poses and styles, ranging from sophisticated and softly-modelled to a stark heraldic linearity that often appears primitive.

LOCATIONS: NPG; HMG (Chequers).

Chalmers, George Paul RSA 1833–78

Scottish, a pupil at Trustees' Acad. 1853 under *R. Scott Lauder who influenced him; dour, often small portraits in heavy chiaroscuro and thick impasto, the sitters set in

Rembrandtesque gloaming. RSA 1871; also painted genre and landscape.

LOCATION: RSA.

LITERATURE: E. Pinnington, *George Paul Chalmers RSA and the Art of his Time* (Glasgow, 1896); Irwin, pp. 344–8.

Chamberlin, Mason RA 1727–87

London painter, began in a city counting-house; then a pupil of *Hayman, whose influence is evident in early conversation pieces; strong individual likenesses; his men are often cut off at an unusual elongated bust-length, with a single dominant colour in the costume, and other portraits show compositional originality. Painted Benjamin Franklin 1762. Had a thriving practice with middle-classes, but also patronized by royalty. Foundation RA; sometimes called 'the Elder' or 'Senior'; his son, Mason C. (*fl.* 1786–1826), was a landscape painter.

LOCATIONS: Nat. Marit. Mus.; Yale.

Chandler, John Westbrooke 1764–1804/5

Natural son of 2nd Earl of Warwick; based in London but Aberdeen 1800 and then Edinburgh; did many portraits of children, also Eton leaving portraits. Influenced by *Romney and perhaps *Hoppner; could paint full-lengths on a large scale; a real if unsettling originality is evident in many works; he finally went mad, and died in Edinburgh.

LOCATIONS: Eton Coll.; NPG; N. Trust for Scotland, Leith Hall.

LITERATURE: EKW.

Chandler, Winthrop 1747–90

b. & d. Woodstock, CT; perhaps trained as house painter in Boston; today much admired as a primitive limner and one of the best of this type, capable of powerful effects; working professionally around Woodstock by 1770; tried Worcester, MA, from 1785 but returned to Woodstock 1789 and died insolvent.

LOCATIONS: American Antiq. Soc., Worcester, MA; Brookline Hist. Soc.; NG Washington; Campus Martius Mem. Mus., Columbus, OH.

LITERATURE: N.F. Little, *Art in America*, XXV (1947), pp. 77–168.

Chase, William Merritt NA 1849–1916

b. Williamsburg, IN, d. NYC; one of the most influential teachers of the last quarter of the nineteenth century; studied NYC, including NA, and then Munich 1872–8 under von Piloty, where he knew *Duveneck, and he adopted a typical 'Munich School' style;

119

119. Mason Chamberlin (the Elder), *Conversation Piece*. Oil on canvas, 63.5 × 68 cm (25 × 26¾ in). 1761. New Haven, CT, Yale Center for British Art, Paul Mellon collection

120

120. John Westbrooke Chandler, *Four Daughters of a Gentleman at Play as Macbeth and the Witches*. Oil on canvas, 195.5 × 147.5 cm (77 × 58 in). 1787. Sotheby's, 6.VII.83 (241)

visited Venice, Spain and France at various times; met *Whistler in London 1885, who also influenced him. His brushwork is expressive and precise, and his style developed further under the influence of Impressionism, with an increase in his range of colour; his dazzling surface effects are allied to a profound grasp of structure. Taught at Art Students' League, Brooklyn, Pennsylvania AFA, and had his own Chase School

121

121. George Chinnery, *John Robert Morrison and his Father's Secretary Mr Thomas*. Oil on canvas, 48.2 × 44.4 cm (19 × 17½ in). *c.* 1830. Christie's, 18.III.77 (116)

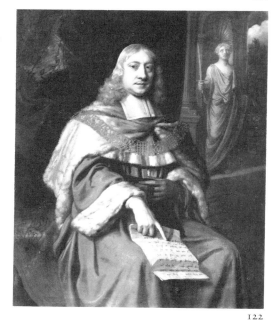

122

122. Wolfgang William Claret, *Sir Thomas Jones*. Oil on canvas, 127 × 101.6 cm (50 × 40 in). *c.* 1690. London, Lincoln's Inn

American Art, William Merrit Chase 1849–1916, exh. cat. (R. G. Pisano) (Henry AG, Seattle, 1983).

Chinnery, George 1774–1852

b. London, d. Macao; prolific; often small-scale portraits, busts, half-lengths, full-lengths and groups, turned out rather to a formula, with high flesh colouring, a vague air of *Lawrence, typical dabs of red about the eyes, and often a sense of there being too much space for the figures, but fluent and accomplished, even slick. Studied at RA Schools 1792, and began as miniaturist; in Dublin 1797, Madras 1862, and Calcutta 1807–25, thence to Macao.

LOCATIONS: Tate; NPG.

LITERATURE: H. and S. Berry-Hill, *George Chinnery, 1774–1852; Artist of the China Coast* (Leigh-on-Sea, 1963).

Clack, Richard Augustus *fl.* 1827–75

b. Devon, d. (?)London; son of clergyman; studied RA Schools; Exeter 1845–56 then based in London, exhibited RA 1830–57; attractive painter with strong sense of likeness, his sitters appear both dignified and informal; good landscape backgrounds (he also painted landscapes). His son, Thomas C., 1830–1907, was mainly a genre and landscape painter but showed ability as portraitist (e.g., *Young Violinist*, Sotheby's, 2.xi.76 (431)).

LOCATION: N. Trust, Stourhead.

LITERATURE: Redgrave.

Claret, Wolfgang William *fl. c.* 1670–1706

Sometimes dismissed as a follower of *Lely, he was an assured portraitist in a somewhat French style; perhaps from Brussels or Brabant; died in comfortable circumstances in his house in Lincoln's Inn Fields. His prices comparable to those of *Lely and *Kneller.

LOCATIONS: NPG; Lincoln's Inn; HMQ.

LITERATURE: G. C. Williamson, *Burlington Magazine*, xxxv (July, 1919), pp. 57–8, letter; J. D. Stewart, p. 189.

Clark, Alvan 1804–87

b. Ashfield, MA, d. Cambridge, MA, opened portrait studio Boston 1835, having worked as engraver; also miniaturist; best-known for his manufacture of telescopes after 1844; portraits often busts or with one hand.

LOCATIONS: NG Washington; Boston MFA.

Clark, James *c.* 1745–99

b. Inverness, d. Naples; patronized by Sir Ludovic Grant, the Dalrymple family and,

1896–1908. NA 1890; one of The Ten, 1902. (See Plate 13)

LOCATIONS: Cleveland Mus.; Detroit Inst.; Santa Barbara Mus.; Boston MFA; Century Assoc., NYC.

LITERATURE: R. G. Pisano, *William Merritt Chase* (New York, 1979); *A Leading Spirit in*

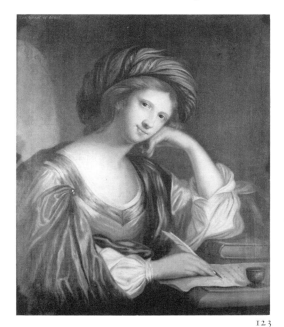

123

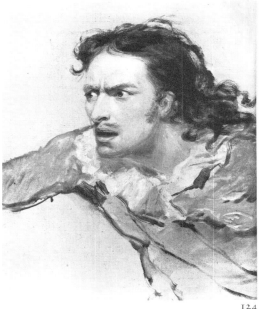

124

123. James Clark, *Miss Grant of Grant (as a Sybil)*. Oil on canvas, 76.8 × 64.2 cm (30¼ × 25½ in). *c.* 1767–70. In a private Scottish collection

124. George Clint, *Edmund Kean as Sir Giles Overreach in 'A New Way to Pay Old Debts'*. Oil on canvas, 27.9 × 22.9 cm (11 × 9 in). 1820. London, Victoria and Albert Museum

after his departure for Naples *c.* 1768, by Sir William Hamilton; provincial but surprisingly competent; his signature shows his surname to be without a final 'e'.

LOCATIONS: Earl of Stair, Oxenfoord; Earl of Rosebery, Dalmeny.

LITERATURE: EKW.

Clarke, Theophilus ARA 1776–*c.* 1832

RA Schools 1793, ARA 1803; his style appears to confirm that he was a pupil of *Opie; faces have a mannered, long-nosed elegance, constructed with a loaded brush, a few clear planes and strokes, emerging from dark surroundings; some hints of influence of *Hoppner and *Lawrence, and other works not unlike those of *Thomas Phillips; evidently had some Scottish patronage.

LOCATIONS: NPG; Eton Coll.

LITERATURE: EKW.

Clausen, Sir George RA 1852–1944

b. London, d. Newbury; studied South Kensington and Paris with Bougereau; influenced by Bastien-Lepage; then in Long's studio; wide range of production including interiors, still-life, genre but accepted portrait commissions up to *c.* 1910; knighted 1927; Director RA Schools; later works show his readiness to adapt and develop his range. RA 1908.

LOCATIONS: RA; Tate.

LITERATURE: *Sir George Clausen RA 1852–1944*, exh. cat. (Cartwright Hall, Bradford, RA, Bristol CAG, Laing AG, 1980).

Clint, George ARA 1780–1854

First trained as miniaturist and engraver; could work on a large scale, but was very successful with small-scale portraiture; both male and female sitters are strongly individualized; when interested, showed unusual brilliance, e.g., in portraits of actors (with whom he mixed); painted many scenes from plays. ARA 1821, but resigned when he failed to become RA 1836.

LOCATIONS: NPG; Yale; N. Trust, Felbrigg.

Closterman, John 1660–1711

b. Osnabrück, d. London; one of the most individual Baroque painters working in England; trained by father in Osnabrück, then with de Troy in Paris *c.* 1679 until 1680/1 when he was in England; formed partnership with *Riley, the latter apparently painting the heads, in 1680s; went to Spain and Italy 1698–9; by *c.* 1706 seems to have stopped painting; created some highly original portraits, especially for the Earl of Shaftesbury, *c.* 1700–3. His brother, John Baptist C., d. 1713 or later, was also a painter but his works are more obscure and much inferior. (See Chp. Two, Fig. 59)

LOCATIONS: NPG; NMW; Royal Soc.

LITERATURE: #M. Rogers, *Walpole Society*, XLIX (1983), pp. 224–79.

Clover, Joseph 1779–1853

b. Aylsham, Norfolk, d. (?)London; pupil of *Opie 1807–11 but already painting Mayor of Norwich 1809; exhibited RA 1804–36; to Paris 1816; evidently owned property in

Norwich by 1817 but also based in London; early portraits are rather primitive, later ones accomplished in a restrained sub-*Lawrence manner not unlike *Chinnery in touch. Mainly busts and half-lengths, but some seated; also genre. Painted the landscape artist James Stark (who did landscape background for it), 1818; also landscape painter.

LOCATIONS: NG Canada; Royal Coll. of Surgeons; Norwich Castle Mus.

LITERATURE: M. Rajnai (with assistance of M. Stevens), *Norwich Society of Artists*, &c., Norfolk Museum Service (1976); H. A. E. Day, *East Anglian Painters*, 3 vols (Eastbourne, n.d., 1968, 1969), III, pp. 123–9.

Cochran, William 1738–85

b. Strathaven, d. Glasgow; studied Glasgow, Foulis Acad., 1754; in Rome *c.* 1761–6, then based in Glasgow; distinct, powerful style with strong likenesses and some unusual poses, his works are pleasant and professional.

LOCATIONS: SNPG; Glasgow AG.

Cole, Philip Tennyson 1862(?)–1939

London painter, d. probably St. Leonards-on-Sea; exhibited extensively 1880–1930 and had distinguished sitters; twice painted, seated and standing (on scale of life), Edward VII, in 1907 and 1908, to whom he managed to give a surprisingly thoughtful air.

LOCATIONS: NPG; Bart's Hospital, London.

Collier, The Hon. John 1850–1934

b. & d. London; second son of first Lord Monkswell; sophisticated portrait painter,

with a full European training at the Slade School, Paris (with Laurens), and Munich; his portraits are beautifully painted with a fine sense of light and colour; the likenesses are strong and vigorous; sitters include a large number of academics, and he himself was married (successively) to two daughters of T. H. Huxley (whose portrait by C. is in NPG); wrote a number of books on painting. His numerous histories and dramatic subjects are unexpectedly unsatisfactory. (See Chp. One, Fig. 25)

LOCATIONS: NPG; Athenaeum, London.

Collins, Alfred Quinton ANA 1853–1903

b. Portland, ME(?), d. NYC; studied Paris, Acad. Julian, then in studio of Bonnat; perhaps in S. Francisco, Buffalo and Boston, and by late 1850s NYC; painstaking in his preparation, like *Eakins, and with a similar aesthetic, and a constant student of European art in America and Europe; much admired by his fellow American artists, but he destroyed almost all his work shortly before his death.

LOCATIONS: Met. Mus., NYC; Brooklyn Mus.

LITERATURE: Met. Mus. Cat., III.

Collins, Richard *fl.* 1726–32

b. Peterborough and worked in Lincs. and Leics.; pupil of *Dahl whose influence is not very evident; of interest as author of rather primitive early conversation pieces, he often introduced everyday details into his rather charming portraits, which retain a kind of wide-eyed naivety; a pleasing draughtsman; also painted landscapes and religious works.

LOCATION: V & A.

LITERATURE: A. C. Sewter, *Apollo*, XXXVI (September, October, 1942), pp. 71–3, 103–5.

Comer, Alexander *fl.* 1677–*c.* 1700

York artist whose style has some affinity with that of *Mary Beale whom he apparently knew: knowledge of him is based on documented works at Welbeck.

LOCATIONS: York City AG; Duke of Portland, Welbeck Abbey.

LITERATURE: N. Gillow, *York City AG Preview*, 98 (1972).

Conder, Charles Edward 1868–1909

b. London, d. Virginia Water; spent early years in India; 1885 in Australia where trained and then Paris at Acad. Julian; in London from 1897; prolific, highly talented artist, landscapes and histories as well as portraits, of which too few were completed during his

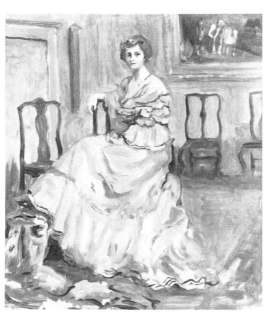

125. Charles Edward Conder, *Portrait of Mrs Aikins*. Oil on canvas, 61 × 50.8 cm (24 × 20 in). Ottawa, The National Gallery of Canada. The Massey Collection of English Painting

short life; style similar on occasion to that of *G. W. Lambert.

LOCATIONS: Manchester CAG; City of Leicester AG.

LITERATURE: J. Rothenstein, *The Life and Death of Conder* (London, 1938).

Coning, Daniel de 1668–*c.* 1727

b. Amsterdam, was in Oxford 1690, and in England certainly until 1727; style like that of *H. Van der Mijn (EKW).

LOCATION: NPG.

LITERATURE: EKW.

Cooper, J. *c.* 1695–*c.* 1754

Probably, as Groce indicated, an artist working only in England although works have been found in America; evidently identical with the artist cited in EKW as 'extremely provincial . . . a style remotely derived from Kneller.'

LITERATURE: G. Groce, *Art Quarterly*, XVIII (Spring, 1955), pp. 73–82.

Cooper, Washington Bogart 1802–89

b. nr Jonesboro, TN, d. Nashville, TN; perhaps a student of *R. E. W. Earl, then worked with *Sully and *Inman; 1830 started studio in Nashville, and was a successful and accomplished local portraitist.

LOCATION: Tennessee Hist. Soc.

Cope, Sir Arthur Stockdale RA 1857–1940

London-based, son of the artist C. W. Cope RA (1811–90); studied RA Schools; highly successful portrait painter of royalty, aristocracy, bishops and, e.g., also painted Kaiser Wilhelm II; worked in an imperial style and scale for grand imperial society; had many pupils; knighted 1917.

LOCATIONS: Diocese of Llandaff; NPG; Grimsthorpe Castle.

LITERATURE: Waters.

Copley, John Singleton RA 1738–1815

b. Boston, MA, d. London; influenced by *Smibert but largely self-taught; finest of New England portraitists; went to London and Rome 1774, settled London 1775; his English style was more sophisticated, and he further developed his capacity for extraordinarily original compositions, both with individuals and groups; perfected a blend of history and portraiture with large depictions of contemporary events full of powerful portraits, e.g., *The Siege of Gibraltar*, 1783–91 (Guildhall, London), all made possible by

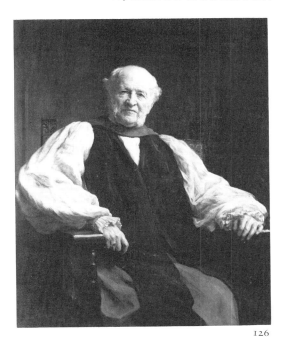

126. Sir Arthur Stockdale Cope, *Dr Richard Lewis, Bishop of Llandaff*. Oil on canvas, 121.9 × 96.5 cm (48 × 38 in). *c.* 1912. Llandaff, Llys Esgob (The Church in Wales)

scrupulous preparation. RA 1779. His son became Lord Chancellor of England as Lord Lyndhurst. (See Chp. Two, Figs 9, 67, 67a, 69; Plate 4)

LOCATIONS: Tate; Boston MFA; Yale; Fogg; NG Washington; HMQ.

LITERATURE: # J. D. Prown, *John Singleton Copley*, 2 vols (Cambridge, MA, 1966).

Copnall, Frank Thomas 1870–1949

b. Ryde, I.O.W., then based in Liverpool; took up portraiture full-time 1897; member of Liverpool Acad.

LOCATIONS: Walker AG, Liverpool; Royal Coll. of Surgeons.

Corner, Thomas Cromwell 1865–1938

b. & d. Baltimore, MD; locally trained and at Art Students' League NYC, then Paris 1888 at Acad. Julian under Lefebvre and Constant; 1892 returned to Baltimore where he was very successful in a 'photographic' studio manner.

LOCATION: Baltimore Mus. of Art.

LITERATURE: *Thomas Cromwell Corner*, &c. (Baltimore, 1940), privately printed.

Corwine, Aaron Houghton 1802–30

b. nr Maysville, KY, d. Philadelphia of tuberculosis; pupil of *Sully 1818–20 when he set up in practice in Cincinnati, very successfully; in England 1829. Most of his Cincinnati works are in a restricted rather provincial style and the influence of Sully is not apparent until *Self-Portrait* painted in

127. Aaron Corwine, *Self-portrait*. Oil on canvas, 76.2 × 63.5 cm (30 × 25 in).). 1829. Maysville, KY, Mason County Museum

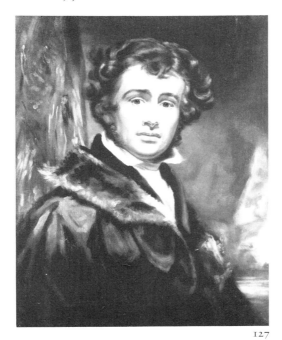

127

128. John da Costa, *Miss Vera Butler*. Oil on canvas, 172 × 99.1 cm (68 × 39 in). *c.* 1912. London, Christopher Wood Gallery

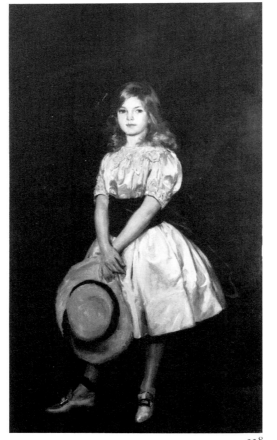

128

England, 1829 (Co. Public Lib., Maysville, KY); the great promise of this, his masterpiece, was tragically unfulfilled.

LOCATION: Co. Public Lib., Maysville, KY.

LITERATURE: E.H. Dwight, *Antiques* (June, 1955), pp. 502–4; G & W.

Costa, John da 1867–1931

b. Teignmouth; studied in Paris, Acad. Julian, on advice of *Millais; based in London, also spent time each year NYC after 1905; earlier portraits are restrained, owing much to *Sargent; later portraits employ clashing colour, showing influence of the Newlyn School (Stanhope Forbes was a friend).

LOCATIONS: NG Washington; Mrs E.M. Richards.

LITERATURE: *John da Costa*, exh. cat. (Leighton House, London, 1974).

Cosway, Richard RA 1742–1821

b. Devon, d. London; by 1754 was with *Hudson, then RA Schools 1769; 1785 Principal Painter to Prince of Wales of whom he was a personal friend; mainly known as fashionable and brilliant miniaturist, he painted extensively on a larger scale; these works often have a steely glitter about them, and when working near life size his structure and handling tend rather to disintegrate; claimed to have had several sittings from the Virgin Mary for her picture.

LOCATION: Met. Mus., NYC.

LITERATURE: G.C. Williamson, *Richard Cosway RA and his Wife and Pupils* (London, 1897); *ibid.*, *Richard Cosway RA* (London, 1905).

Cotes, Francis RA 1726–70

b. London, a pupil of *Knapton; at first worked mainly in crayons (pastel) but increasingly in oils (especially after 1764); influenced somewhat by *Liotard, and himself taught *John Russell. He was one of the most important portraitists of his day, and was attracting royal patronage at the time of his death, which was due to his choking on a soap cure for 'the stone'. He is one of the most inventive and original composers of portrait groups; shared a drapery painter, Peter Toms, with *Reynolds for a period in the mid-1760s (compare Fig. 129, Plate 22).

LOCATIONS: Tate; NPG; Yale.

LITERATURE: #E.M. Johnson, *Francis Cotes* (Oxford, 1976).

Crane, Thomas 1808–59

b. Chester, d. London; father of the well-known illustrator Walter C.; studied RA Schools then moved to Liverpool *via* Chester, then London, Liverpool again, and Torquay; London 1857. Best known for portraits of women and children.

LOCATION: Walker AG, Liverpool.

LITERATURE: Wood.

Cranke, James 1707–80

Lancashire painter, d. Urswick; by 1740s in London when he was painting good, distinct likenesses in quite a polished manner; his son, James C. (1748–*c.* 1798), was also a portrait painter.

LOCATION: Yale.

LITERATURE: EKW.

Cregan, Martin PRHA 1788–1870

b. Co. Meath, trained Dublin; 1812–21 London then returned to Dublin; founding member RHA, of which he was President 1832–56; prolific, rather uneven, but sometimes with a soft, pleasing style; tried most types of portrait; continued to do some small-scale portraits in manner of *Shee whose pupil he was (but not, as sometimes said, Shee's only pupil).

LOCATION: Ulster Mus., Belfast.

Dacre, Isabel Susan 1844–1933

b. Leamington, d. London; in Manchester as a child; 1858–68 Paris as pupil then governess; 1869 to Italy; left Paris 1870 but returned and caught up in the commune; then decided to study art and trained Manchester School of Art 1871–4; 1874–6 Rome with her friend the artist *Annie Louisa Swynnerton; trained Paris 1877–80; in London 1880–3, Manchester 1883–1904. A suffragette, and from 1880 President, Manchester Soc. of Women Painters; 1904 moved with her companion the artist Francis Dodd to Blackheath. Spent much time in Italy and also exhibited both there and in France.

LOCATION: Manchester CAG.

D'Agar, Charles 1669–1723

b. Paris, d. London (suicide); son of artist Jacques d'Agar (1642–1715) and with him in England 1681 and to Copenhagen *c.* 1685, Charles alone returning to England 1691; style akin to that of a *Kneller follower such as *Robert Byng.

LOCATIONS: Duke of Buccleuch, Drumlanrigg; Trustees of Lamport Hall; Burghley House Colln.

LITERATURE: EKW.

Dahl, Michael 1659–1743

b. Stockholm, d. London; studied Sweden with Ehrenstrahl; 1682 to London, and perhaps worked with Kneller; 1684/5 went to Europe with *Tilson, especially working in Rome until late 1688; in London from 1689, when he became chief rival of *Kneller, whose

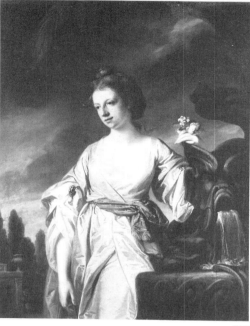

129

style his resembles, although somewhat more relaxed, and often with a higher finish and more pleasing colour; continued his late-seventeenth-century Baroque manner right up to the period of *Hogarth's maturity.

LOCATIONS: Tate; Nat. Marit. Mus.

LITERATURE: W. Nisser, *Michael Dahl and the Contemporary Swedish School of Painting in England* (Uppsala, 1927).

Dance, Nathaniel RA 1735–1811

b. London, d. Winchester, by which time he was Sir Nathaniel Dance-Holland, Bt (since 1800), MP, having retired as professional painter 1782; foundation member RA, resigned 1790. Third son of George Dance, architect of Mansion House; pupil of *Hayman from *c.* 1748; in Rome 1754–65; works survive from 1759 onwards, initially small-scale individual or conversation pieces, often with classical props suggesting the Grand Tour; became a distinguished portraitist on scale of life, patronized by the royal family, with a distinctive style using strong effects of light and shade.

LOCATIONS: N. Trust, Upton House, Powis Castle; Guildhall AG; NPG; HMQ.

LITERATURE: *Nathaniel Dance 1735–1811*, exh. cat. (Kenwood, 1977); D. A. Goodreau, Ph.D. (U.C.L.A. 1973; Ann Arbor, 1979).

Dandridge, Bartholomew 1691–*c.* 1755

b. London, his career runs parallel with *Hogarth's, especially in conversation pieces which he did from *c.* 1728; some of his later, larger-scale works are effective (*The Ladies*

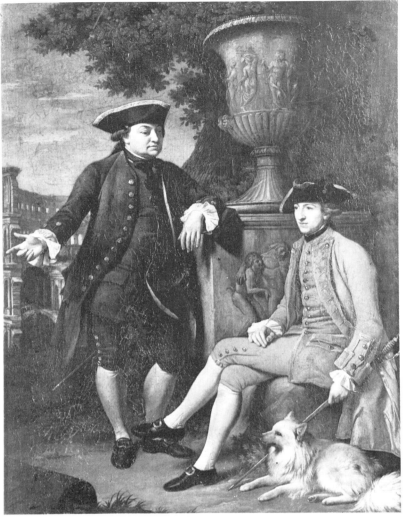

130

130. Nathaniel Dance, *Hugh, Lord Warkworth, later 2nd Duke of Northumberland, and the Revd Jonathan Lippyat.* Oil on canvas, 94.6 × 69.9 cm (37¼ × 27½ in). 1763. The Duke of Northumberland

Noel, Manchester CAG, 1736–7); early on he used an awkward *Kneller-like method. He often appears to imitate *Hogarth's manner, but he lacks the sense of structure that should underpin his superficially attractive rococo handling.

LOCATIONS: Manchester CAG; Met. Mus., NYC.

LITERATURE: C.H. Collins Baker, *The Burlington Magazine*, LXXII (March, 1938), pp. 132ff.

Daniels, William 1813–80

b. & d. Liverpool; protégé of *Mosses and apprenticed as engraver to him until 1833, but self-taught as painter; patronized by Sir Joshua Walmsley. Successful practice in Liverpool and perhaps tried London. Gifted, prolific artist fond of strong chiaroscuro effects. Reportedly dissipated.

LOCATION: Walker AG, Liverpool.

LITERATURE: Walker AG Cat.

Danloux, Henri-Pierre 1753–1809

b. & d. Paris; Rome until 1780 then at Lyons; fled French Revolution for London 1791, returning to Paris 1800. Successful in England, he also worked in Scotland 1796 (perhaps until 1798); adapted cleverly to English taste, painting complex conversation pieces as well as large-scale portraits and contemporary history portrait groups of the *Copley kind.

LOCATIONS: NPG; Duke of Buccleuch, Bowhill.

Davis, John Phillip, 'Pope' 1784–1862

Welsh, based in London; first exhibited portrait RA 1811 and then portraits at various institutions for next ten years; in Rome 1824 and painted *The Talbot Family receiving the Benediction of the Pope* (hence nickname); a friend of *Haydon.

LOCATION: Christie's, 26.vi.81 (129).

LITERATURE: Redgrave.

Davison, Jeremiah c. 1695–1745

Scottish, trained in London, worked there with important visit to Scotland; successful, and *Van Aken did draperies for him in 1730s; accomplished, with an air of *Highmore and *Hogarth, with attractive handling, but more stately.

LOCATIONS: Duke of Atholl, Blair Castle; Earl of Morton, Dalmahoy House.

Dawe, George RA 1781–1829

b. & d. London, son of engraver Philip D.; RA Schools 1794; began with histories, but almost all portraits from c. 1809; travelled in Europe after Waterloo, painting successful leaders; St Petersburg 1819–28; briefly in England, then late 1828 back to Russia via Berlin; left Russia in ill-health and died on return. Apparently influenced by French painting, his portraits have an over-smooth finish. RA 1814. He earned vast sums, partly lost through money-lending. His brother Henry (1790–1848) engraved some of his portraits.

LOCATIONS: NPG; HMQ; Duke of Wellington, Stratfield Saye.

LITERATURE: Redgrave.

DeCamp, Joseph Rodefer ANA 1858–1923

b. Cincinnati, d. Florida; studied Cincinnati, then Munich 1878–80 and with *'Duveneck Boys' there and in Florence and Venice; Boston MFA 1881 under *Tarbell, then Cincinnati 1883, settling Boston 1885; member of The Ten; his style is a more conservative version of the Munich manner, being influenced by *Tarbell c. 1890 towards a

lighter palette, and founded on lucid composition that owes something to the study of Vermeer. Highly regarded as a portraitist, he was also a teacher at a number of leading schools, including Pennsylvania AFA in 1906.

LOCATIONS: Harvard; Pennsylvania AFA; Cincinnati Mus.; Worcester Art Mus.

LITERATURE: P. J. Pierce, *The Ten* (North Abington, MA, 1976).

Delanoy, Abraham 1742–95

b. NYC, d. Westchester, NY; pupil in London 1766–7 of *West, from whom he learnt little, preferring to stay with the primitive Dutch colonial tradition of NY; d. in poverty, of tuberculosis, as a sign painter.

LOCATION: N.-Y. Hist. Soc.

Dellow, R. *fl.* 1711–49

French (?); *Kneller's Acad. 1711; sometimes appears as 'Dellon'.

LOCATIONS: St. John's Coll., Oxford; Sotheby's, 16.v.84 (163).

De Nune, William *fl.* 1729–50

b. (?) Edinburgh, d. Edinburgh; dated portraits known from 1742; in later portraits, of *c.* 1749, style indebted to *Ramsay; often busts or half-length in elongated 'sculpted' oval.

LOCATIONS: Marquess of Zetland; SNPG; NGS; Christie's, 16.v.80 (22).

LITERATURE: Colnaghi, *English Ancestors*, exh. cat. (1983), no. 7.

Desanges, Chevalier Louis William *fl.* 1831–87

Surprisingly successful, indifferent society portraitist; figures are insubstantial, and he attempted to vary his style rather wildly.

LOCATION: Christie's, 25.i.74 (170).

Devis, Arthur *c.* 1711–87

b. Preston, d. Brighton; pupil of sporting painter Peter Tillemans; working professionally by 1745; specialized in small-scale full-lengths and conversation pieces, indifferently using interchangeable costumes, landscapes and interiors, but all carefully detailed; his sons *Arthur William D., and Thomas Anthony D. (1757–1810), also painted, the latter ineptly.

LOCATIONS: Harris AG, Preston; Leicester CAG; Tate; Yale.

LITERATURE: *Polite Society by Arthur Devis 1712–1787*, exh. cat. (S. V. Sartin) (Harris AG,

Preston, NPG, 1983–4); *The Conversation Piece, Arthur Devis and his Contemporaries*, exh. cat. (E. G. d'Oench) (Yale, 1980).

Devis, Arthur William 1762–1822

b. & d. London; son and pupil of *Arthur D.; RA Schools 1774; sent on Capt. Wilson's circumnavigation, thus India 1785–95; like his father, small-scale portraits, but also very large, including groups, all in a more relaxed elegant manner; he evidently looked closely at *Gainsborough and, later, *Lawrence; important as recorder of Indian life.

LOCATIONS: Harris AG, Preston; Nat. Marit. Mus.; NPG.

LITERATURE: S. H. Pavière, *The Devis Family of Painters* (Leigh-on-Sea, 1950).

Dewing, Thomas Wilmer NA 1851–1938

b. Boston, MA, d. NYC; started as lithographer and portrait draughtsman; then Paris, Acad. Julian, under Boulanger and Lefebvre 1876–8, and in Munich; then based NYC, teaching at Art Students' League 1881–8; one of The Ten 1897; NA 1888. Best known for his figures of women in interiors, he was also an outstanding portraitist although he did few, chiefly late-1880s and 1890s, in highly decorative manner like that of his figure pieces (sometimes with lettering). (See Chp. One, Fig. 30)

LOCATION: Mus. of City of NY.

LITERATURE: P. J. Pierce, *The Ten* (North Abington, MA, 1976), pp. 77–82.

Dickinson, Lowes Cato 1819–1908

b. & d. London; son of a lithograph publisher, three years in Italy from 1850; taught at Working Men's Coll. with Rossetti and Ruskin; became successful society portraitist in watercolour as well as oils; usually a thin paint surface, strong lighting; portraits with landscape are more interesting; painted 'Chinese' Gordon (of Khartoum) and Queen Victoria. Lived in London; exhibited RA 1848–91.

LOCATIONS: NPG; Inst. of Directors; Duke of Norfolk, Arundel Castle.

LITERATURE: Mallalieu.

Dicksee, Sir Frank Bernard PRA 1853–1928

b. & d. London; RA Schools 1871; his masterpiece *The House Builders* made a sensation in RA 1880 and portraits dominated his output thereafter although he wished to appear as history and genre painter: the portraits have lasted, and show off his excellent painterly technique. ARA 1881, RA

131. Samuel Drummond, *Sir W. E. Parry*. Oil on canvas, 128 × 101.6 cm (50⅜ × 40 in). *c.* 1820. London, National Portrait Gallery

131

1891, PRA 1924, knighted 1925 (KCVO, 1927).

LOCATION: Sir Bruno Welby, Bt, Denton House.

Doughty, William 1757–82

b. York, d. Lisbon; RA Schools 1775 and a pupil of *Reynolds (1775–8) whose manner he absorbed; like the young Reynolds, also painted caricature groups; in Ireland 1778; died on way to India; portraits are slickly executed and he was evidently gifted.

LOCATIONS: York CAG; NGI; V & A.

LITERATURE: J. Ingamells, *Apollo*, LXXX (July, 1964), pp. 33–7.

Downman, John ARA 1750–1824

b. nr Ruabon, d. Wrexham; pupil of *West 1768, RA Schools 1769; in Rome 1773–4; Cambridge 1777–8; from 1779 mainly in London then retired to Chester 1817. Mainly chalk and watercolours but also oils, including small busts on copper; kept albums of drawings of portrait types and models for later repetitions. ARA 1795.

LOCATIONS: Tate; Trustees of Chatsworth Settlement; Springfield Mus., MA.

LITERATURE: # G.C. Williamson, 'John Downman ARA, his Life and Works', *Connoisseur*, Extra Numbers, no. 2 (1907); E. Croft-Murray, *British Museum Quarterly*, XIV (1940), pp. 60–66.

Drummond, Samuel ARA 1765–1844

b. London, d. (?)London; ran away to sea at age fourteen; thereafter turned to art; crayons then oils, on small and large scale, the latter

representing a strand of early-nineteenth-century British portraiture independent of the influence of *Lawrence and somewhat influenced by French neo-Classicism. RA Schools 1791; elected ARA 1808; Curator of RA Painting School.

LOCATION: NPG.

Duché, Thomas Spence 1763–90

b. Philadelphia, PA, d. London; pupil of *West in London after loyalist father took him there 1777; a promising portraitist in his few completed pictures; tuberculosis made him give up painting in 1789.

LOCATION: Trinity Coll., Hartford, CT.

LITERATURE: *The American Pupils of Benjamin West*, exh. cat. (NPG Washington, 1980), pp. 106–110.

Dunlap, William 1766–1839

b. Perth Amboy, NJ, d. NYC; pupil of *West in England 1784–7; continued as portrait painter during a career in the theatre and as a writer; author of the remarkable *History of the Rise and Progress of the Arts of Design in the United States* (NY, 1834); often used panel support.

LOCATIONS: Chrysler Mus., Norfolk, VA; Brooklyn Mus.

LITERATURE: O.S. Coad, *William Dunlap*, &c. (NY, 1917).

Dunsmore, John Ward 1856–1945

b. Riley, OH, d. Cincinnati; a fellow-pupil of *DeCamp in Cincinnati, then under Couture in Paris; Cincinnati 1879, then Boston, MA, 1880; 1885 to Europe and 1888 Director of Detroit Inst.; 1894 returned to Cincinnati; then NYC after 1902. Portraits in French realist tradition.

LOCATION: Cincinnati Art Mus.

Du Pan, Barthélémy 1712–63

b. & d. Geneva; trained Paris and Rome; England by 1743, and painted large group of family of Frederick, Prince of Wales (1746, HMQ); French in manner; also small-scale. Visited Ireland 1750. Back in Geneva 1751.

LOCATION: HMQ.

LITERATURE: EKW.

Dupont, Gainsborough 1754–97

d. London; nephew and assistant of *Gainsborough whose later manner he could cleverly imitate, but his portraits generally have a less sound structure to head and figure; fully apprenticed to his uncle 1772 (RA

Schools 1775) and with him until 1788. Did series of actors' portraits 1793 (e.g., Garrick Club) where the glamorous, dashing superficiality of his style seems wholly appropriate; all types including groups.

LOCATIONS: Garrick Club; Trinity House.

LITERATURE: EKW; W.T. Whitley, *Thomas Gainsborough* (London, 1915), pp. 335–53.

Durand, John *fl.* 1766–*c.* 1782

French (?); NYC 1766–*c.* 1769 then CT (where probably influenced Moulthrop) and VA (1770); perhaps the same as exhibited landscapes RA 1777–8; VA 1781–2.

LOCATIONS: N.-Y. Hist. Soc.; Mus. of City of NY; Chrysler Mus., Norfolk, VA.

Duveneck, Frank NA 1848–1919

b. Covington, KY, d. Cincinnati, OH; 1869 to Munich, under Diez and influenced by Leibl; his great gift for brushwork immediately evident; 1874 U.S.A. then Munich again 1875 where he started his own school, a centre for American artists known as 'Duveneck Boys', including *J. W. Alexander and *DeCamp; from 1879 Venice (where he knew *Whistler) and Florence; Paris 1888 and returning same year to Cincinnati on his wife's sudden death, but made later visits to Europe. Important teacher in Cincinnati. The prime American exponent of the 'Munich School' manner, intensely painterly, and revealingly called by Henry James 'an American Velásquez'; one of the most gifted and influential of American artists. NA 1906. (See Plate 14)

LOCATIONS: Cincinnati Art Mus.; Brooklyn Mus.

LITERATURE: J. W. Duveneck, *Frank Duveneck, Painter-Teacher* (San Francisco, 1970).

Duyckinck, Gerardus 1695–1746

Probably b. NYC and based there and Hudson Valley; recently identified with the 'De Peyster Limner'; kept artists' supply store NYC; used many studio props and settings from European portraiture but the figures stiff and unarticulated; the final effect is decorative; his father Geritt D. (1660–1713) was also a 'limner'.

LOCATIONS: Brooklyn Mus.; N.-Y. Hist. Soc.

LITERATURE: Quick; Belknap.

Eakins, Thomas Cowperthwaite NA 1844–1916

b. & d. Philadelphia, PA; trained Pennsylvania AFA (and studied anatomy); Paris 1866–9

132. Gainsborough Dupont, *William Thomas Lewis*. Oil on canvas, 73.3 × 63.5 cm (28⅞ × 25 in). *c.* 1795. London, National Portrait Gallery

132

under Gérôme, the sculptor Dumont, and, most influentially, Bonnat, who sent him to Spain late 1869 to study Velásquez; Philadelphia from 1870. Like *Copley, he prepared scrupulously for each painting, including tonal and perspectival studies and photography (Muybridge was in Philadelphia); from mid-1880s devoted himself almost wholly to portraits, few of them commissioned, of increasing psychological penetration and emotional intensity. An important teacher; resigned as director of PAFA 1886 over his insistence on nude models, hence formation of Art Students' League NYC where he taught for six years. NA 1902. Probably America's greatest painter. (See Chp. One, Figs 24, 26; Plate 11)

LOCATIONS: Philadelphia Mus.; Washington Univ. AG, St Louis, MO; Phillips Colln and NG Washington, DC; Met. Mus., NYC; Smith Coll. Mus. of Art; Brooklyn Mus., NY; Detroit Inst.

LITERATURE: L. Goodrich, *Thomas Eakins*, 2 vols (Cambridge, MA, and London, England, 1982).

Earl, Ralph 1751–1801

b. Shrewsbury, MA, d. Bolton, CT; a loyalist, in England 1778–85, and informally a pupil of *West; briefly adapted to English taste but retained throughout a primitive vision, although with a more sophisticated execution; often used detailed landscape and other settings, in all types of large-scale portraits; died of 'intemperance'. (See Chp. One, Fig. 15)

LOCATIONS: Yale. Univ.; Met. Mus., NYC; NG Washington; Trustees of Lamport Hall, Northamptonshire; Toledo Mus.

133. Jacob Eicholtz, *The Ragan Sisters*. Oil on canvas, 150 × 109.5 cm (59 × 43 in). *c.* 1820. Washington, DC, National Gallery of Art. Gift of Mrs Cooper R. Drewry, 1959

133

LITERATURE: L. Goodrich, *Ralph Earl, Recorder for an Era* (Albany, NY, 1967).

Earl, Ralph Eleaser Whiteside *c.* 1785–1838

b. England, d. Nashville, TN; son of *Ralph Earl by his second wife and so to America as an infant; in England 1809–13 (Norwich), then France; U.S.A. 1815; Nashville 1817 to paint Andrew Jackson, married his niece and became known as 'The King's Painter' because of his many images of that president.

LOCATIONS: Nat. Mus. of Amer. Art, Smithsonian Inst.; Chrysler Mus., Norfolk, VA.

LITERATURE: G & W.

Eaton, Joseph Oriel ANA 1829–75

b. Newark, Licking Co., OH, d. Yonkers, NY; studied NYC; Indianapolis 1846–8, Cincinnati 1850, 1853, 1857–60; New Orleans before 1857; Europe 1873. Also landscape and genre.

LOCATION: Cincinnati Art Mus.

LITERATURE: G & W.

Eccardt, John Giles *fl.* 1740–1779

b. Germany, d. London; assistant of *J.B. van Loo until 1742 and then working independently; patronised by Horace Walpole; often small-scale busts and half-lengths; not very sophisticated.

LOCATION: NPG.

LITERATURE: EKW.

Eddis, Eden Upton 1812–1901

d. Shalford, nr Guildford, Surrey; trained Sass's and RA Schools; at first landscapes, then portraits; a close friend of *George Richmond, and sitters from same fashionable society; he grew deaf and retired to Shalford 1886; handsome portraits, also in chalk and pencil.

LOCATIONS: NPG; Lincoln's Inn; Middle Temple; Grimsthorpe Castle.

LITERATURE: Bryan.

Eddy, Oliver Tarbell 1799–1868

b. Greenbush, VT., d. Philadelphia, PA; NYC 1826–9, NJ until 1840 then Baltimore, MD, 1842–50, and Philadelphia.

LOCATIONS: Newark Mus., NJ; MD Hist. Soc.

LITERATURE: # E. Bishop, *Oliver Tarbell Eddy 1799–1868*, &c. (Newark Mus. and Baltimore Mus., 1950).

Eicholtz, Jacob 1776–1842

b. & d. Lancaster, PA; trained and then worked as coppersmith; some lessons and help from *Sully from 1808 and went to see *Stuart in Boston 1811 or 1812; then worked mainly from Lancaster and, from 1823, based in Philadelphia; early portraits are very primitive and traces of that style survived until *c.* 1820, which gives distinct charm to his pictures; from 1820s noticeably more accomplished and painterly, and he could work well on a large scale; returned to Lancaster 1833.

LOCATIONS: Met. Mus., NYC; NG Washington; Boston MFA; St Mary's Coll., Raleigh, NC.

LITERATURE: R. J. Beal, *Jacob Eicholtz 1776–1842*, &c. (Philadelphia, 1969).

Eksergian, Carnig 1859–1931

b. Constantinople (Istanbul), d. NH; an Armenian, studied in Paris under Carolus-Duran; in Boston 1882 with brother (also portraitist) Télémaque E. (*c.* 1841–91) who moved NYC 1886; Carnig had studio Boston until 1911, living in Somerville, MA; 1911–23 worked NYC. Worked in French realist tradition.

LOCATIONS: Boston MFA; Met. Mus., NYC.

LITERATURE: Met. Mus. Cat., III.

Elder, John Adams 1833–95

b. & d. Frederiksberg, VA; pupil of *Huntington NYC, then under *Leutze in Düsseldorf, returning to Fredericksburg shortly before Civil War, where he fought as Confederate. Later worked in Richmond, VA.

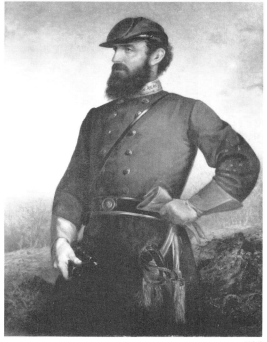

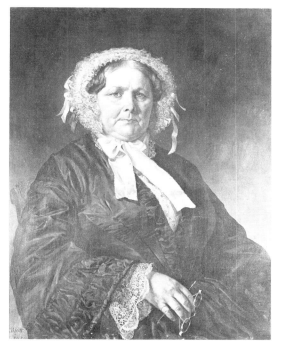

134

135

134. John Adams Elder, *General Thomas Jonathan 'Stonewall' Jackson*. Oil on canvas, 141 × 102.9 cm (55½ × 40½ in). Washington, DC, The Corcoran Gallery of Art. Gift of William Wilson Corcoran, 1884

135. Charles Loring Elliot, *Mrs Thomas Goulding*. Oil on canvas, 87 × 68.6 cm (34¼ × 27 in). 1858. New York, NY, National Academy of Design

LOCATION: Corcoran Gall., NYC.

LITERATURE: G & W.

Elliott, Charles Loring NA 1812–68

b. Scipio, NY, d. Albany, NY; largely self-taught, but in NYC 1829 and helped by *Trumbull and apparently a pupil of John Quidor; then itinerant as portraitist NY, but studied the work of *Stuart; from 1839 NYC where (1844) he came to know *Inman who correctly said, 'When I am gone that young man will take my place'; deservedly employed for many official full-lengths in a commandingly accomplished manner that absorbed but did not imitate the styles of Stuart, Inman and Sully; evidently alert later to continental manner, e.g., of *Leutze, and portraits always marked by intensely realistic portrayal of setting; used photography in preparation. NA 1846.

LOCATIONS: NAD; City Hall, NYC; Vassar Coll. AG, Poughkeepsie, NY; NG Washington; Brooklyn Mus.

LITERATURE: # T. Bolton, *Art Quarterly*, 5 (Winter, 1942), pp. 58–96.

Ellys, John *c.* 1701–1757

d. London; with his friend *Hogarth studied *Vanderbank Acad. 1720 and had been pupil of Sir James Thornhill; succeeded *Mercier as painter to Frederick, Prince of Wales; became Keeper of the Lions in the Tower of London; style heavily dependent on that of *Kneller. Signed 'Jack Ellys'; often theatrical portraits and, like the young Hogarth, was also scene painter.

LOCATIONS: Earl of St Germains, Port Eliot; Lord Sackville, Knole.

LITERATURE: EKW.

Elouis, Jean-Pierre-Henri 1755–1840

b. & d. Caen; trained by Restout; to London, RA Schools 1784, and exhibited RA 1785–7; Baltimore, MD, 1791 but evidently in U.S.A. earlier, 1787, in VA and Annapolis, MD; Philadelphia, PA, 1792–4; also miniaturist. Returned to France from U.S.A. 1807.

LITERATURE: EKW; G & W.

Encke, Fedor 1851–1929

b. & d. Berlin; Berlin Acad. from 1869, then Weimar; 1879–83 in Paris. Based in Berlin but worked in London and U.S.A. and painted, e.g., Roosevelt and J.P. Morgan.

LOCATION: Brooklyn Mus.

Evans, Richard 1784–1871

d. Southampton; exhibited RA 1816–45, almost exclusively portraits; he was an assistant of *Lawrence for backgrounds and draperies; his portrait of Harriet Martineau 1834 (NPG) gave rise to such a 'brutal comment' by the notorious *Morning Chronicle* critic (Constable's enemy) that the critic was at last dismissed from that paper. In later years, he lived much in Rome making copies after Old Masters, some portraits, and

136. Reginald Grenville Eves, *Sir Frank Benson*. Oil on canvas, 74.3 × 61.6 cm (29¼ × 24¼ in). 1924. London, National Portrait Gallery

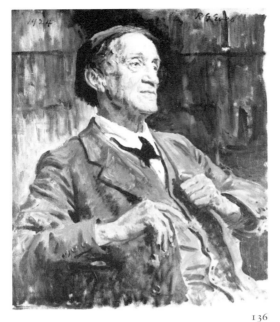

136

attempted frescoes (also copied Raphael's *loggie* designs, V & A).

LOCATIONS: NPG; Christie's, 17.iii.78(82); Nat. Marit. Mus.

LITERATURE: Whitley II, 2, pp. 283–4; Bryan.

Eves, Reginald Grenville RA 1876–1941

b. London, d. Middleton-in-Teesdale; studied Slade under Legros and Tonks (Slade Scholarship); encouraged by *J.S. Sargent; sitters included Thomas Hardy. He retained an expressive, painterly approach even in his many official portraits, and is one of the most appealing British portraitists of his time. Gold Medal, Paris Salon 1926. ARA 1934, RA 1939.

LOCATIONS: NPG; London Mus.; Middle Temple; Bowes Mus., Co. Durham.

LITERATURE: Waters.

Exshaw, Charles *fl.* 1747–71

b. Dublin, d. London; studied under Francis Bindon in Dublin; 1747–55 in France, Flanders and Italy (had been in Paris by 1749), auctioning (as he did at intervals) Old Masters in Dublin on his return; pupil of Carle Van Loo, Paris 1757; Rome 1759, Amsterdam 1760; started drawing Academy in London; Dublin 1762; style rather French in manner and well characterized as 'a modest talent subjected to a wealth of experience' (Potterton); also did etchings after Rembrandt, and mezzotints.

LOCATION: NGI.

LITERATURE: H. Potterton, *Connoisseur*, CLXXXVII (December, 1974), pp. 269–73.

Fagnani, Giuseppe 1819–73

b. Naples, d. NYC; Naples 1840, Paris 1842–4, Spain 1846, Paris 1847; Washington, DC, by 1849; 1852–7 NYC then Europe, including England (1860–5), settling NYC 1865.

LOCATION: NPG.

LITERATURE: E.E. Fagnani, *The Art and Life of a XIXth Century Portrait Painter, Joseph Fagnani* (Paris, 1930).

Falconet, Pierre 1741–91

b. & d.(?) Paris; trained Paris; in London 1765–73 at first to study under *Reynolds; RA Schools 1769 in which year he was selling engraved portraits of his fellow-artists (including *Hayman and *West) after his own drawings; did conversation pieces and other types of portrait in manner adapted to English taste; to St Petersburg 1773, and in Paris by 1778.

LOCATIONS: SNPG; Sotheby's, 29.ix.76 (26).

LITERATURE: EKW.

Fayram, John *fl.* 1713–43

*Kneller's Acad. 1713; dated portraits 1727–43, not unlike *Seeman in manner, but with strong sense of structure and much heavier shadows; patronized for some years by 1st Earl of Bristol (dated Hervey portraits 1734–9); worked in East Anglia, perhaps also in Midlands and North, and certainly visited Bath; usually three-quarter and half-lengths.

LOCATIONS: Marquess of Bristol, Ickworth; Lord Barnard, Raby Castle.

Feke, Robert 1707(?)–1752(?)

b. Oyster Bay, NY, d. Barbados(?); also a mariner, and traditionally travelled to England and Continent – if he did not, his achievement is even more extraordinary; Boston 1741, first known portrait, a group based on *Smibert; Newport, RI, 1742 and evidently based there but working, e.g., Boston (also 1748) and Philadelphia (1746, 1750); left on a voyage (from Newport) 1751, traditionally to Bermuda, but a 'Robert Feak' buried Barbados 1752 was probably him. The most important American-born painter before *Copley and a better artist than Smibert; perhaps self-taught; figures firmly set in clearly-defined space, face and hands sensitively modelled, great care given to differences in texture; used a range of poses and devices taken from British portrait prints, with considerable elegance. (See Chp. One, Fig. 13)

LOCATIONS: Bowdoin Coll., ME; Boston MFA; Met. Mus., NYC; Peabody Mus., Salem, MA.

LITERATURE: H.W. Foote, *Robert Feke, Colonial Portrait Painter* (Cambridge, MA, 1930); R.P. Mooz, *The Art of Robert Feke*, Ph.D. (Univ. Pennsylvania, 1970).

Fellowes, James *fl.* 1719–51

Perhaps active before 1711; his style resembles that of painters trained in *Kneller's Acad.; evidently worked in north west and Cheshire; draperies fluently but superficially painted, rather provincial but with distinct likenesses; three-quarters seated and half-lengths including feigned ovals; may also have painted religious works.

LOCATIONS: Christie's, 5.iii.82 (72); Manchester CAG.

LITERATURE: EKW.

Ferris, Stephen James 1835–1915

b. Plattsburg, NY, d. Philadelphia, PA; studied Pennsylvania AFA 1846; then variously in Europe and won Fortuny prize, Rome 1876. Father of historical painter S.L.G. F (1863–1930). Worked in Philadelphia.

Field, Robert *c.* 1770–1819

b. England, d. Jamaica; RA Schools 1790s; variously working in America before Ontario and Nova Scotia, and exhibited RA from Canada 1810; 1816 to Jamaica; also a miniaturist, but rather more oils after he left England (fifty have been listed, as against sixty miniatures), some of them on copper; mainly busts and half-lengths, and later developed quite a romantic air.

LOCATION: NG, Canada.

LITERATURE: #H. Piers, *Robert Field* (NY, 1927).

Fildes, Sir Samuel Luke RA 1843–1927

b. Liverpool, d. London; studied Chester and Royal Coll. of Art; initially genre and figures and also an illustrator, but from 1890s portraiture, and became leading portraitist to the Royal Family; painted State portraits of Edward VII (1902, HMQ) and of George V (1912, HMQ); usually rich handling, finely controlled; some sitters in costume. ARA 1879, RA 1887, knighted 1906 (KCVO 1918).

LOCATIONS: NPG; HMQ (Osborne House); Bart's Hospital, London.

LITERATURE: L.V. Fildes, *Luke Fildes, RA, A Victorian Painter* (London, 1968).

Fisher, Alvan 1792–1863

b. Needham, MA, d. Dedham, MA; trained Boston as portraitist but painted landscapes from 1811 and best known as the first important American-born landscape artist, as well as painter of rustic genre; but he depended on portraiture for a living, usually bust- and half-length in a competent manner, later being influenced by his study in Paris 1825; mainly in Boston, but Hartford, CT (1822–5) and visiting Charleston, SC; settled in Dedham from 1826.

LOCATIONS: Boston MFA; Yale Univ.

LITERATURE: Boston MFA Cat.; G & W.

Fisher, Samuel Melton RA 1860–1939

b. London, d. Camberley; Dulwich Coll., then France; Lambeth School of Art, RA Schools 1876–81 (gold medal); pupil of Bonaffé in Paris, then lived in Italy for ten years; many Italian and other subjects and figures, often vapid, sometimes fine; in latter years chiefly portraits, with a good touch. ARA 1917, RA 1924.

LOCATION: NPG.

LITERATURE: Waters.

Flagg, Charles Noël ANA 1848–1916

b. Brooklyn, NY, d. Hartford, CT; son and pupil of *The Revd J.B.F.; worked Hartford from 1868, exhibited NA 1872 and studied Paris that year until 1874 under de la Chevreuse; then in Europe again 1877–82; settled Hartford 1887, and began his own Art School. ANA 1908. Quite a painterly style broadly within French academic tradition. Painted Mark Twain, 1890 (Met. Mus., NYC).

LOCATION: Met. Mus., NYC.

LITERATURE: Met. Mus. Cat., III.

Flagg, George Whiting NA 1816–97

b. New Haven, CT, d. Nantucket, MA; nephew of *Allston; to Charleston, SC, 1824, later a pupil there of *Bowman and with him to Boston and New Haven, then NYC from 1843; retired to Nantucket 1879, NA 1871. Brother of *The Revd Jared Bradley F.

LOCATIONS: City Hall, Charleston, SC; Yale Univ.

LITERATURE: G & W.

Flagg, The Revd Jared Bradley 1820–99

b. New Haven, CT, d. NYC; nephew of *Allston, and brother and pupil of *G.W. Flagg; Newark, NJ, 1839; 1840–9 Hartford, CT, then NYC; ordained Episcopalian priest 1855 and incumbent in Brooklyn, NY, until 1863, taking up painting again in New Haven and NYC. NA 1850. Wrote *Life and Letters of Washington Allston*, 1892 (reprinted NY, 1969).

LOCATION: Yale Univ.

LITERATURE: G & W.

Foldstone, John *fl*. 1769–1784

d. London 1784; exhibited RA 1771–83; mainly small half- or three-quarter length in oval, completed in a day at sitter's home, of same type as *Alleyne's, but much more painterly; also large-scale. Perhaps travelled into Scotland 1781.

LOCATIONS: N. Trust, Stourhead; Grimsthorpe Castle; Sotheby's, 14.X.53 (98a).

LITERATURE: EKW.

Forbes, Anne 1745–1834

b. & d. Scotland; grand-daughter of *Aikman; Rome 1767–70 under *Gavin Hamilton; London until *c*. 1772 then returned to Scotland; mainly crayons but some oils, including full-length on scale of life when her manner resembles etiolated Hamilton; generally uneven in quality.

LOCATIONS: NGS; Duke of Hamilton; Sir Christopher Chancellor, Shieldhill.

LITERATURE: EKW.

Fowler, Trevor Thomas *fl*. 1829–69

Irish(?); exhibited RA 1829, then in Dublin and exhibited RHA 1830–5 (all portraits); NYC by 1837; 1840 painted Harrison and Clay; New Orleans; studied Paris 1843; in Dublin again 1844 when he returned to New Orleans and worked there and Cincinnati OH, until *c*. 1853; 1854–69 Germantown, PA, and exhibited Pennsylvania AFA.

LITERATURE: G & W; Strickland.

França, Manuel Joachim de 1808–65

b. Funchal(?) (Oporto?), d. St Louis, MO, Philadelphia, PA, *c*. 1830 until *c*. 1842; St Louis, MO, from 1847; painted Henry Clay; female sitters are given a large-eyed Latin look; quite broad handling.

LOCATIONS: Philadelphia Mus.; Pennsylvania Hospital, Philadelphia; Brooklyn Mus.

Francis, John F. 1808–86

b. Philadelphia, PA, d. Jeffersonville, PA; evidently based Philadelphia, but itinerant as portraitist in PA and outside, including Washington, DC; from 1866 in Jeffersonville, PA; after 1850 almost exclusively still-lifes for which he is most highly-regarded today.

LITERATURE: G.L. Jersey, *Catalogue of Paintings by John F. Francis*, exh. cat. (Bucknell Univ., 1958).

Franzén, August Reynolds NA 1863–1936

b. Norrköping, Sweden, d. NYC; studied locally and Stockholm with Carl Larssen, and in Paris from 1881, Acad. Julian; to U.S.A. 1882 then Paris again 1886; settled NYC 1890. NA 1920. Competent if uninspired; portraits mainly from 1893, also genre and landscape (especially before this date). ANA 1906, NA 1920.

LOCATIONS: Toledo Mus.; Met. Mus., NYC; Yale Univ.; N.-Y. Hist. Soc.

LITERATURE: Met. Mus. Cat., III.

Frazer, Oliver 1808–64

b. Fayette Co., KY, d. Lexington, KY; pupil in Lexington of *Jouett then of *Sully in Philadelphia; with *Healy to Europe 1834 and studied in Paris, Berlin, Florence and London, only returning 1838 to Lexington.

LOCATION: J.B. Speed Art Mus., Louisville, KY.

Frothingham, James NA 1786–1864

b. Charlestown, MA, d. Brooklyn, NY; some instruction from a pupil of *Stuart and then later from Stuart himself whose manner he took up; worked Salem, MA, and Boston, until moving to NYC 1826, and lived in Brooklyn from 1844. Mainly bust-length, in lucid painterly manner that comfortably escapes the monotony of this popular type in America of the period; often used panel support, especially earlier. NA 1832.

LOCATIONS: Boston MFA; City of NY.

LITERATURE: G & W; Boston MFA Cat.

Frye, Thomas 1710–62

b. in or near Dublin, d. London; also did miniatures, crayons and mezzotints; in England by 1735, commissioned to paint Frederick, Prince of Wales, 1736; helped found Bow porcelain factory 1744 and managed it until 1759, but continued to paint portraits; evidently influenced by *Hogarth *c*. 1740 towards a more robust style (as was *Latham), although his own modelling is, finally, less substantial; some portraits are directly inspired by Hogarth (e.g., *Mr Crispe*, 1746, based on Hogarth's *William Jones* of 1740) and he painted Hogarth's friend Richard Leveridge (before 1758, Courthouse, Warwick). An outstanding draughtsman, especially for his mezzotint heads of 1760–1 that may have influenced *Wright of Derby in their marked effects of chiaroscuro. In Wales 1760, and there did heads in oils similar in conception to his mezzotints. (See Chp. Two, Figs 81, 83)

LOCATIONS: HMQ; Royal Coll. Physicians; NGI; NPG; Sir Cenydd Traherne KG, Coedarhydyglyn; Courthouse, Warwick.

LITERATURE: # M. Wynn, *The Burlington Magazine*, CXXIV (October, 1982), pp. 624–8; CXIV (February, 1972), pp. 79–84.

Fuller, George ANA 1822–84

b. Deerfield, MA, d. Boston, MA; took up painting 1841 after going on tour with his elder half-brother, the deaf and dumb miniaturist Augustus F.; initially trained as sculptor, then 1842–7 studied in Boston and then NA; worked Boston (and e.g., Philadelphia) as portraitist; to Europe 1860, returning to take over native Deerfield farm, and thereafter mainly painted landscapes and figures, but also some portraits, all in a moving, painterly manner, with clever lighting.

LOCATIONS: Worcester Art Mus.; Boston MFA; NG Washington.

LITERATURE: G & W; Boston MFA Cat.; Baigell.

Fulton, Robert 1765–1815

b. near Lancaster, PA, d. NYC; worked as portraitist Philadelphia, then to England again (briefly) returning to U.S.A. 1806. A pupil of *West, and RA Schools (?) 1788; exhibited RA 1791, 1793, then became mainly interested in engineering projects including submarines, and after his return to U.S. developed (with Livingston) the first commercially successful steamboat.

LOCATIONS: Rockwood Mus., Wilmington, Nelson Atkins Art Mus. Kansas City; Hist. Soc. of PA.

LITERATURE: G & W; EKW.

Furness, John Mason 1763–1804

b. Boston, d. Dedham, MA; also engraver; as a portraitist, evidently inspired by *Copley's Boston portraits; an impressive artist who could work on a large scale, but most works now lost.

LOCATION: Brooklyn Mus.

LITERATURE: G & W.

Furse, Charles Wellington ARA 1868–1904

b. Middlesex, d. Camberley; son of an archdeacon; Slade School under Legros, then Paris, Acad. Julian, and at the Westminster School under Professor Brown; much influenced by his friend *J.S. Sargent, known as one of 'The Slashing School' because of his love of exciting effects of brushwork; exhibited RA and New English Art Club; lived in Camberley, Surrey, and travelled widely; a

most gifted painter, he suffered long from poor health. All types of portrait including equestrian and sporting; a number left unfinished on his death.

LOCATIONS: NPG; Eton Coll.; Tate; Trinity Coll., Cambridge; Cordwainers Company.

Gainsborough, Thomas RA 1727–88

b. Sudbury, d. London; precocious, and working professionally soon after arrival in London 1740 where he trained with *Hayman and Gravelot at St Martin's Lane Acad.; returned to Suffolk, based Ipswich from *c.* 1751/2, thence to Bath 1759, London 1774; *Reynolds's greatest rival. Early works small-scale, including conversation pieces, clearly influenced by *Hayman and rococo; from 1759 painted large scale of every kind, including figures in movement; greatly influenced by Van Dyck. Foundation RA. One of the great masters of brushwork; also one of the finest of all British landscape painters. (See Chp. One, Fig. 7, Chp. Two, Figs 43, 46, 49; Plate 21)

LOCATIONS: Tate; NPG; NG; NG Washington.

LITERATURE: #E.K. Waterhouse, *Gainsborough* (London, 1958).

Gambardella, Spiridione *fl.* 1842–68

b. Naples, d. Italy; a refugee to Boston, MA, 1834–40 and then in France; London 1841, introduced by Emerson to Carlyle (whom he painted); then Liverpool 1844–5, returning to London until 1852 or later, but exhibited Liverpool 1818; gave Liverpool merchants a dashing, continental air; used strong lighting effects and wide range of settings, especially for successful portraits of women and children; patronized by 2nd Duke of Wellington. His daughter, Julia G., was also a painter.

LOCATIONS: Univ. of London; Walker AG, Liverpool; Duke of Wellington, Stratfield Saye, Apsley House.

LITERATURE: Walker AG Cat.

Gandy, William *c.* 1655–1724

Perhaps b. Kilkenny, probably d. Exeter (buried there); Devon painter, based in Exeter, but itinerant; his pictures traditionally said to have influenced *Reynolds, especially in texture of paint; small ovals, also half- and three-quarter lengths; his father, James G. (1619–89), also portraitist (stilted un-Vandyckian portraits in the Guildhall, Exeter).

LOCATIONS: Albert Mem. Mus., Exeter; Devon and County Hospital, Exeter; Earl of Iddesleigh.

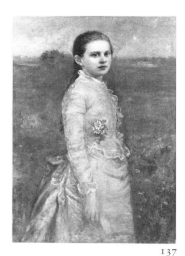

137

137. George Fuller, *Ethel Reynolds Clarke*. Oil on canvas, 117.7 × 76.8 cm (44 × 30¼ in). 1883. Boston, MA, Museum of Fine Arts. Bequest of Harriet A. Clarke

138

LITERATURE: J. Northcote, *Memoirs of Sir Joshua Reynolds* (London, 1813), pp. 411–18; M.K. Talley, *Portrait Painting in England: Studies in the Technical Literature before 1700* (London, 1981), pp. 308 ff.

Gardner, Daniel 1750–1805
b. Kendal, d. London; taught by *Romney, a family friend, in Kendal. RA Schools 1770 and worked briefly in *Reynolds's studio at his invitation; from c. 1773 had a successful practice, sometimes in oils (after 1779), but often rather small-scale portraits in a gouache and crayon mixed technique that is distinctive.
LOCATIONS: Abbot Hall Art Gall., Kendal; Yale; Tate.
LITERATURE: # G.C. Williamson, *Daniel Gardner* (London, 1921); *Daniel Gardner*, exh. cat. (Kenwood, 1972).

Gaspars, John Baptist *fl. c.* 1645–92
b. Antwerp, d. London; drapery painter who did 'postures' for *Lely, *Riley and *Kneller; did a few independent portraits imitative of Lely then of Kneller, e.g., in 1676 and 1690.
LOCATIONS: Trustees of Lamport Hall, Northamptonshire; N. Trust, Blickling.

Geddes, Andrew ARA 1783–1844
b. Edinburgh, d. London; father's death allowed him to become a painter; largely self-taught, working in Edinburgh from 1810; encouraged by Wilkie; had a wide knowledge of Old Masters, and had his own collection; influenced especially by Rubens and

Rembrandt; went to Rome 1828, returning to London early 1831 where he was mainly based; visited Holland 1839; rather linear style; successful with 'fancy portraits'; costume pieces in appropriate styles which he could adopt at will.
LOCATIONS: SNPG; NGS; Walker AG, Liverpool.
LITERATURE: Irwin, pp. 197–202.

Geddes, Margaret, see **Carpenter, Margaret Sarah**

Gibson, Thomas *c.* 1680–1751
d. London where he worked successfully until 1729, when he became ill, but was painting again in 1730s; involved with *Kneller's Acad. from 1711 and his style is based on that of Kneller; sitters mainly academic and professional middle-class; busts in oval, also half-, three-quarter and (rarer) full-length; painted George Vertue, 1723 (Soc. of Antiquaries).
LOCATIONS: Soc. of Antiquaries; Nat. Marit. Mus.; Magdalen Coll., Oxford.
LITERATURE: EKW.

Gilbert, John Graham, see **Graham-Gilbert**

Gill, Charles 1742–after 1828
b. & d. Bath; RA Schools 1769, studied with Reynolds 1771–4 then based in Bath; the signed and dated *Letherbridge Family*, 1785 (Tate), is a delightful portrayal of children in a setting drawn with inadequate perspective.
LOCATION: Tate.
LITERATURE: EKW.

Glass, James William, Jr 1825–55
b. Cadiz, son of the British Consul there, d. NYC; brought up in U.S.A.; studied 1845 with *Huntington; in London from 1847/8 and painted equestrian portrait of Duke of Wellington; 1855 returned to U.S.A. and committed suicide; also painted histories.
LOCATION: HMQ.
LITERATURE: G & W.

Goldbeck, Walter Dean 1882–1925
b. St Louis, MO, d. NYC; studied Berlin, London, Chicago and Paris; sitters included Count John McCormack and Paderewski, and Mrs (Dorothy) Whitney-Straight (c. 1913–14, Dartington Hall); had many international socialite sitters.
LOCATION: Dartington Hall.

Gordon, Sir John Watson PRSA 1788–1864

b. & d. Edinburgh; his name was John
Watson, adding Gordon 1826; studied
Trustees' Acad. under *Graham; much
influenced by *Raeburn, whom he succeeded
as the leading Scottish portraitist, and also by
*Lawrence and Velásquez; RA 1851; PRSA
1850. He could work on any scale; often
original and unusual portraits, with rich,
vigorous handling; excellent with children.

LOCATIONS: NPG; SNPG; Royal Company of
Archers, Edinburgh.

LITERATURE: Irwin, pp. 308–10.

Gouge, Edward *fl.* 1690–1735

d. London; pupil of *Riley; Padua 1705, Rome
1707; 1711 a director of *Kneller's Acad.; his
pedestrian manner is characteristic of native
British portraitists of this generation.

LOCATION: N. Trust, Dyrham Park.

LITERATURE: EKW.

Graham, John 1755–1817

b. & d. Edinburgh; trained as coach painter;
RA Schools 1783; an important teacher after
his return to Edinburgh 1798, first at Drawing
Acad. and then at Trustees' (with which it was
united 1800); few portraits are known, but
they are very accomplished, with rich colour.
*J. W. Gordon was one of his many pupils.
Not to be confused with *John Graham-
Gilbert.

LOCATIONS: Stationers' Hall; V & A.

LITERATURE: Irwin, pp. 94–7.

Graham-Gilbert, John RSA 1794–1866

b. & d. Glasgow; born John Graham and
signed thus until 1841, although he had
become Graham-Gilbert 1834; RA Schools
1821 (gold medal); RSA 1830. After RA, in
Italy for two years, then based Edinburgh until
marriage to an heiress 1834; gifted, but after
his marriage understandably idle; he
subsequently formed a large Old Master
collection, now in Glasgow AG, although he
continued to paint portraits.

LOCATIONS: Glasgow AG; Marquess of Bute,
Mount Stuart.

LITERATURE: Irwin; Wood.

Grant, Sir Francis PRA 1803–78

b. Kilgraston, Perthshire, d. Melton
Mowbray; began as an amateur, but
professional in London from 1831 and became
one of the leading portraitists of his time, his
high social connections being very helpful;
sitters frequently in a sporting setting, with

139

horses and dogs. Despite the Victorian dress,
portraits are characterized by exquisite colour
together with overall assurance and delicacy of
touch; could apparently paint any type of
portrait. PRA (somewhat by default) and
knighted 1866: the Queen was not amused.
(See Plate 25)

LOCATIONS: NPG; SNPG; HMQ; Univ. of
Edinburgh.

LITERATURE: Irwin, pp. 320–2; J. Steegman,
Apollo, LXXIX (June, 1964), pp. 479–85.

Gray, Henry Peters NA 1819–77

b. & d. NYC, studied with *Huntington for a
year, then Italy 1839; returned 1841 working
as portraitist in Boston and NYC, then Europe
1845–6; 1845–71 NYC where he was the
leading portrait painter; also of considerable
significance as history painter along with
Huntington and *Page; President NA 1870–1
when he went to Italy for another four years.

LOCATION: Century Assoc., NYC.

LITERATURE: G & W; Baigell.

Green, James 1771–1834

b. Leytonstone, d. Bath; RA Schools 1791;
NPG has number of large-scale oil portraits,
some of which are clever and original; also
worked extensively in watercolour.

LOCATION: NPG.

LITERATURE: Mallalieu.

Greenwood, Ethan Allen 1779–1856

b. & d. Hubbardstown, MA; working full
time as portraitist in Boston from 1812, taking
over The New England Museum of *Edward

139. James Green, *Sir
John Ross*. Oil on canvas,
132.1 × 111.1 cm
(52 × 43¾ in). 1833.
London, National
Portrait Gallery

Savage (who taught him, NYC, in 1806) in 1818; became a politician in Hubbardstown 1827. Unadorned style that verges on the primitive, but softened probably by the influence of *Sully whom he could have known both in NYC and Boston.

LOCATION: Boston MFA.

LITERATURE: G & W.

Greenwood, John 1727–92

b. Boston, MA, d. Margate, Kent; 1742 apprenticed to chart-maker and armorial artist, then worked as portraitist in Boston from 1745; went to Surinam 1752–8, then trained as mezzotinter in Amsterdam; London 1762, and from c. 1773 mainly dealer and auctioneer; a rather primitive artist, of interest as Boston portraitist when *Copley was beginning; remained a correspondent (and patron) of Copley.

LOCATION: Boston MFA.

LITERATURE: G & W; Boston MFA Cat.; J.T. Flexner, *America's Old Masters*, revised edn (NY, 1980).

Gregory, Eliot 1854–1915

d. Paris; portrait painter and theatrical director NYC; trained Paris under Carolus-Duran. Not to be confused with a primitive artist of the same name (*fl.* 1842).

LOCATION: Royal Shakespeare Gall.

Greiffenhagen, Maurice William RA 1862–1931

b. & d. London; RA Schools 1878; exhibited RA and internationally, mainly portraits, but worked extensively as illustrator; headed Life Department at Glasgow School of Art 1906–29. RA 1922. Had a line in society beauties, but good with official male portraits.

LOCATIONS: NPG; Eton Coll.

LITERATURE: Waters.

Grignion, Charles 1752–1804

b. London, d. Leghorn; son of engraver Charles G.; RA Schools 1769; in Rome 1782–97, when influenced by *Kauffmann, then retired to Leghorn; often ovals about 20 × 16 in (58 × 42 cm), or even smaller, but could work on larger scale; a quite un-English handling and light tonality.

LOCATIONS: NPG; Nat. Marit. Mus.

Grisoni, Giuseppe 1699–1769

b. Mons, d. Florence; trained Italy; in England c. 1720; of interest as teacher of *William Hoare whom he took to Italy on his return

1728; mainly decorative artist but did portraits; straightforward portraits are highly effective, but he also did allegorical settings for others which are overwhelming.

LOCATIONS: NPG; Garrick Club; Fitzwilliam Mus.

LITERATURE: EKW.

Guillaume, Louis Mathieu Didier 1816–92

b. Nantes, d. Washington, DC; studied Paris under Delaroche; U.S.A. c. 1855, working NYC, then Richmond, VA, from c. 1857, until c. 1872, then Washington; his style is impressive, toned-down neo-Classical.

LOCATIONS: R. J. Turnbull Colln.; Valentine Mus., Richmond, VA.

Gullager, Christian 1759–1826

b. Copenhagen, d. Philadelphia; studied Copenhagen Royal Acad. and in Paris; in Boston certainly from 1786 until 1797, then Philadelphia 1798–1806; his last years are mysterious, having left his family; recorded NYC and Charleston, SC, reappearing in Philadelphia only in 1826. Rather a lively French manner.

LOCATIONS: Hist. Soc. of PA; Chrysler Mus., Norfolk, VA.

LITERATURE: G & W.

Guthrie, Sir James PRSA 1859–1930

b. Greenock, d. Row, Dunbartonshire; partly self-taught; visited London 1878, then studied London 1879 under supervision of *Pettie, and then worked in London and Glasgow; visited Paris 1882; influenced by Bastien-Lepage; based in Glasgow from 1885 and was one of the leading figures of the Glasgow School, but also had a house in London from 1879 until 1901, then based in Edinburgh, moving to Row 1915. Also painted landscape and genre, and was a pastellist and book-illustrator. Expert at all types of portrait, with an assured grasp of structure and painterly handling. Much travelled, including West Indies, Spain, France and Italy. ARSA 1888, RSA 1892, PRSA 1902, knighted 1903. Hon. RA 1911.

LOCATIONS: NPG; NGS.

LITERATURE: # Sir J.L. Caw, *Sir James Guthrie PRSA, LLD* (London, 1932); R. Billcliffe, *Guthrie and the Scottish Realists*, exh. cat. (Fine Art Soc., 1982).

Guy, Seymour Joseph NA 1824–1910

b. Greenwich (England), d. NYC; trained London, in U.S.A. by 1854; worked NYC, especially children's portraits; NA 1865. Also

painted genre. Portraits are filled with incidental detail.

LOCATIONS: Brooklyn Mus.; Yale Univ.

LITERATURE: G & W.

Hacker, Arthur RA 1858–1919

b. & d. London; RA Schools 1876–80 and then Paris under Bonnat 1880–1. ARA 1894, RA 1910. Travelled widely in North Africa, Spain, and Italy, notably with his friend *Solomon; also genre and other subjects, the better of them inspired by J.-F. Millet or (more probably) Bastien-Lepage.

LOCATIONS: Cavendish Lab., Univ. of Cambridge; Nat. Westminster Bank Ltd; Royal Shakespeare Gall.; London Mus.

LITERATURE: Waters.

Hall, Sydney Prior 1842–1922

b. Newmarket, d. London; son of sporting artist Harry Hall; after Pembroke Coll., Oxford, trained as artist and began as illustrator for *The Graphic* and remained a gifted portrait draughtsman; enjoyed patronage of the Queen from 1875 until her death, initially through equine connection (?), and for example went on Prince of Wales's tour to India 1875–6. Very good at oil portraits of a *reportage* kind; also did numerous small oils for the Queen of her more exotic subjects, but impressive also in a more formal manner. MVO 1901.

LOCATIONS: HMQ (Osborne House); NPG; NPGI.

Hallé, Charles Edward 1846–1919

b. Paris, d. London; son of musician Sir Charles H.; studied Paris under Marochetti; one of founders of Grosvenor Gallery 1876 and portraits are an unexpected mixture of severe academic tradition lightly touched by greenery-yallery, but he was good at portrait studies, and bad at subject pictures.

LOCATIONS: Col. H.T.W. Clements, Killadoon; Sotheby's Belgravia, 2.xi.71 (35).

LITERATURE: Waters.

Halls, John James 1776–1827

b. Colchester (?); perhaps a pupil of Fuseli, certainly a friend of *Hoppner; RA Schools 1798 and thereafter in London; a good painter who could work on a very large scale; also painted Shakespearian and other histories and, for example, Kean as Richard III (V & A).

LOCATIONS: NPG; V & A; Nat. Marit. Mus.

LITERATURE: Whitley, II, 1; EKW.

140

140. Sydney Prior Hall, *James Balfour (later 1st Earl of Balfour) and Joseph Chamberlain*. Oil on canvas, 61 × 91.8 cm (24 × 36⅛ in). 1880. London, National Portrait Gallery

141. Gavin Hamilton, *Dr John Moore, Douglas, 8th Duke of Hamilton, and Ensign John Moore in Rome*. Oil on canvas, 177.8 × 101.6 cm (70 × 40 in). 1777. Original at Lennoxlove, Haddington

141

Hamilton, Gavin 1723–98

b. Lanark, d. Rome; Rome 1742–8, working London 1752–6, but returned to Rome where he remained save for 1783 visit to Scotland; more famous for histories in neo-Classical manner, a style that he employed for his rather handsome portraits; influenced *West.

LOCATIONS: Duke of Hamilton, Lennoxlove; Holyroodhouse; SNPG; Univ. of Glasgow.

LITERATURE: D. Irwin, *Art Bulletin*, XLIV (1962), pp. 87–102; Irwin, pp. 49–50.

Hamilton, Gawen c. 1697–1737

b. nr Hamilton, Scotland, d. London; in 1730s painted conversation pieces that rivalled *Hogarth's, also small-scale portraits of single figures, unevenly composed and executed but neat and accomplished at their best.

142. Chester Harding, *Dr Samuel A. Bemis*. Oil on canvas, 92.08 × 71.76 cm (36½ × 28¼ in). 1842. Detroit, MI, Detroit Institute of Arts. Gift of Dexter M. Ferry, Jr

142

LOCATIONS: NPG; NG Canada.

LITERATURE: EKW.

Hamilton, Hugh Douglas 1736–1808

b. & d. Dublin, where he studied; initially worked there, but in London from *c.* 1764; early works often small-scale crayon, in ovals; in Rome 1778–91, then Dublin. In Rome painted many British visitors; and continued using crayons in a very pure technique, including conversation pieces; influenced by Flaxman to try large-scale oils in an ingenious neo-Classical style, and was friend and correspondent of Canova; his daughter Harriott H. (Mrs Way) (*c.* 1769–after 1828) was also a portraitist.

LOCATIONS: NPG; NGI; Nottingham Castle Mus.; Uffizi, Florence; Ulster Mus.

LITERATURE: EKW; Strickland; Crookshank & Glin.

Hamilton, William RA 1751–1801

b. & d. London; trained as architectural draughtsman in Rome; then RA Schools 1769; any number of Shakespearian and literary subjects, some are theatrical portraits, and very fine, especially of Mrs Siddons; also busts in oval, full-length and conversation pieces; a refined draughtsman.

LOCATIONS: NPG; HMQ; Lord Scarsdale, Kedleston Hall.

Harcourt, George RA 1868–1947

b. Dunbartonshire, d. Bushey, Herts; exhibited RA 1893–1948 (posth.), from

Bushey 1893, and from Hospitalfield, Arbroath, 1904–9; at first mainly subjects, but increasingly portraits from *c.* 1913. ARA 1919, RA 1926. Gold Medal Paris Salon, 1923. Fluent painter excellent at groups, including *The Arbroath Whist Society,* but usually single portraits often in evocative setting.

LOCATIONS: Lady Lever AG, Port Sunlight; Southampton AG.

Harding, Chester 1792–1866

b. Conway, NH, d. Boston, MA; 1817 a sign painter in Pittsburgh, but turned to portraits; 1820 studied briefly Pennsylvania AFA, then working in KY, MO, OH, and Washington, DC, then 1822 went to Boston to see *Stuart; 1823–6 in England, influenced by *Lawrence; thereafter based in Boston and Springfield, MA, but peripatetic; visited England again 1846; prolific, generally impressive, with a feeling for rich colour; mostly bust-length but he sometimes tried large scale in the grand manner.

LOCATIONS: Boston MFA; Met. Mus., NYC.

LITERATURE: *Chester Harding 1792–1866,* &c., exh. cat. (Connecticut Valley Hist. Mus., Springfield, MA, 1952); Quick.

Hardy, Jeremiah Pearson 1800–87

b. Pelham, NH, d. Bangor, ME; first an engraver in Maine, then went to Boston to try painting; some instruction from *Morse, NYC; by 1827 back in Maine, first Hampden, then Bangor from 1838; elements of his portrait manner have been held to show the influence of the Luminist landscape artists, especially his masterpiece, *Catherine Wheeler Hardy and her Daughter, c.* 1842 (Boston MFA).

LOCATION: Boston MFA.

LITERATURE: Boston MFA Cat.; F.H. Eckstorm, *Old Time New England,* xxx (October, 1939), pp. 41–66.

Hardy, Thomas 1757–*c.* 1805

RA Schools 1778; also mezzotint engraver; painted small-scale full-lengths but also painted large scale; often engraved his own portraits.

LOCATION: NPG.

LITERATURE: EKW.

Hare, St George 1857–1933

b. Limerick, d. London(?); student of N.A. Brophy and at Royal Coll. of Art 1875 and exhibited RA, living in London, 1884–1923. His self-portrait (NGI) shows him in a

ferociously Irish light, but his society portraits are thoughtful and sympathetic; also genre.

LOCATIONS: N. Trust, Stourhead; NGI.

Hargreaves, Thomas 1774–1847

b. & d. Liverpool; RA Schools 1790; apprenticed to *Lawrence 1793–5, returning to Liverpool 1795, then in London 1797 and probably helping Lawrence; in Liverpool again by 1803; also miniaturist. Worked from pencil sketches and noted for strong likenesses; clearly influenced by Lawrence.

LOCATION: Walker AG, Liverpool.

LITERATURE: Walker AG Cat.

Harlow, George Henry 1787–1819

d. London; precocious, gifted and prolific during his short life; much influenced by *Lawrence in whose studio he was allowed to copy aged fifteen; a pupil of De Cort and *Drummond, also encouraged by Fuseli; at his most brilliant and original in portraits of actors and actresses, sometimes in character, and with groups of children; some women sitters are too derivative from the Lawrence type; 1818 in Italy where Canova liked and admired him; died shortly after his return; all types of portrait including conversation pieces; a memorable self-portrait exists in several versions. Lawrence considered him the most promising 'of all our painters'.

LOCATIONS: NPG; Walker AG, Liverpool; Birmingham CAG; Met. Mus., NYC; Garrick Club, London.

LITERATURE: *Firenze e l'Inghilterra, rapporti artistici*, &c., exh. cat. (Palazzo Pitti, Florence, 1971, no. 72).

Harvie, R. *fl.* 1751–63

Presumably Scottish, s. & d. portraits in Scotland 1751–63; most are unarticulated half-lengths with one hand tucked into the waistcoat, in a very recognizable style that perhaps owes something to *Ramsay; many sold Christie's, 27.3.25 (Breadalbane sale).

LOCATION: Lord Haddington, Mellerstain.

Hawker, Thomas *c.* 1650–1722

d. Windsor (a 'poor Knight') aged over eighty; at Windsor by 1716; had taken over *Lely's studio.

LOCATION: Duke of Grafton.

LITERATURE: Th.-B.; EKW, *Painting in Britain*, p. 113.

Haydon, Benjamin Robert 1786–1846

b. Plymouth, d. London (suicide); history painter who, when forced to portraiture through debts in late 1820s, liked doing large groups and unusual, even eccentric, portraits that are sometimes successful; his pictures are rather clumsy and unsatisfactory; he became desperately embittered, and both shot himself and cut his own throat.

LOCATIONS: NPG; Duke of Wellington, Stratfield Saye.

LITERATURE: E. George, *The Life and Death of Benjamin Robert Haydon*, 2nd edn, with additions by D. George (Oxford, 1967).

Hayes, John 1785–1866

York artist who exhibited RA 1814–51, but little else is known; also painted genre; evidently had a sound academic training and could paint half- and three-quarter length; also a gifted watercolourist.

LOCATIONS: NPG; Messrs Spink & Co. (1959).

LITERATURE: *The Pursuit of Happiness*, exh. cat. (Yale, 1977).

Hayman, Francis RA 1708–76

b. Devon, d. London; apprenticed to obscure Devonian, Robert Brown, in London 1718; a highly influential figure in the artistic life of London, notably at St Martin's Lane Acad. where he collaborated with Gravelot and taught, e.g., *Gainsborough, and closely associated with *Hogarth; played an important part in the adaptation of French rococo forms to English art. Executed many decorations for Vauxhall Gardens, histories, and worked on large scale, but mainly small-scale full-lengths and conversation pieces; distinctive style, the figures disproportionately elongated, especially on a larger scale, but the individual parts often beautifully observed; in many ways he is the quintessential native artist during the period of emergence of the British School. Foundation RA. (See Chp. Two, Figs 52, 53, and frontispiece)

LOCATIONS: Yale; NPG.

LITERATURE: # B. Allen, *Francis Hayman and the English Rococo*, Ph.D. (Courtauld Inst. of Art, 1984).

Hayter, Sir George 1792–1871

b. & d. London; son of miniaturist Charles H. (1761–1835); studied RA Schools then Rome 1815–18 and Paris; also lived in Paris 1829–31 and developed a noticeably continental manner; he could be brilliant and painterly but was often content to be adequate; he derived something of his style from *Lawrence but without any romantic air; his royal portraits are often over-finished. Portrait and historical painter to the Queen 1837; knighted 1842. His

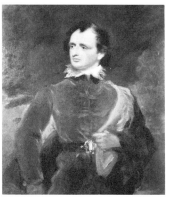

143

143. George Henry Harlow, *Benjamin Robert Haydon*. Oil on panel, 53.3 × 41.6 cm (21 × 16⅜ in). *c.* 1816. Birmingham, City Art Gallery

144. Sir George Hayter, *Alfred, Count d'Orsay.* Oil on canvas, 127.3 × 101.6 cm (50⅛ × 40 in). 1839. London, National Portrait Gallery

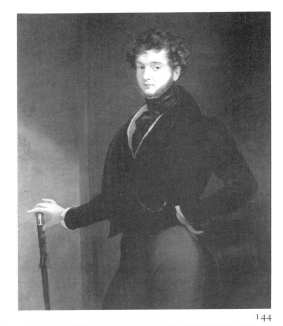

144

145. Guy Head, *Horatio, Viscount Nelson.* Oil on canvas, 222.9 × 168.9 cm (87¾ × 66½ in). 1798–1800. London, National Portrait Gallery

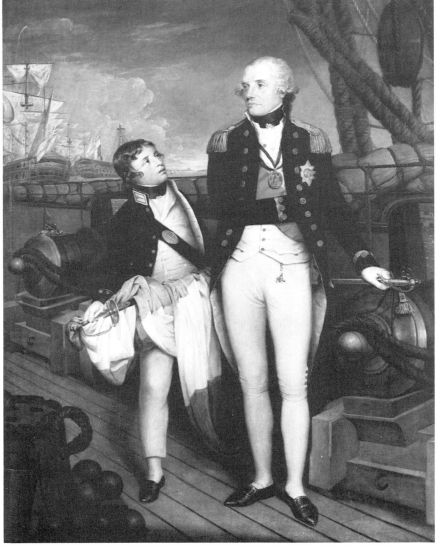

145

brother John H. (1800–91) was also a portraitist (mainly drawings, but an example, Shipley AG, Gateshead) who collaborated on occasion with *Barraud.

LOCATIONS: NPG; The Earl Spencer, Althorp; Duke of Wellington, Stratfield Saye; Trustees of the Chatsworth Settlement; HMQ.

Haytley, Edward *fl.* 1740–65

Probably from North of England, knew *Devis and shared a number of patrons with him in Wigan and Preston area, although also active elsewhere; small-scale full-lengths and conversation pieces, the figures like Devis's; pretty, naturalistic and extensive landscape settings are usual, and he presented two landscapes to Foundling Hospital 1746; also large-scale portraits.

LOCATIONS: Metropolitan Borough of Wigan; Sotheby's, 21.iii.79, pair (74), 12.iii.80 (131), 17.iii.82 (20).

LITERATURE: EKW; *Polite Society by Arthur Devis 1712–1787,* exh. cat. (S. V. Sartin) (Preston and London, 1983–4), no. 54.

Head, Guy 1762–1800

b. Carlisle, d. London; although chiefly history painter and copyist, he is of interest as an occasional portraitist of high quality in a distinctly neo-Classical manner. Lived on the Continent from 1781 until *c.* 1800. Florence *c.* 1787, Rome from *c.* 1790, and then took refuge with Admiral Nelson at Naples on French invasion.

LITERATURE: EKW.

Healy, George Peter Alexander 1813–94

b. Boston, d. Chicago; at first self-taught and, with *Sully's encouragement, working in Boston 1831, then studied 1834 in Paris with Baron Gros and met Couture; met with early success in Europe, including London (married there 1839); returned to U.S.A. 1842, commissioned by Louis-Philippe (whom he painted) to portray prominent Americans; 1848–55 worked both in Paris and U.S.A.; 1855–66 Chicago, then Paris again, and Rome, finally Chicago 1892. He was the first internationally-known, transatlantic commuting American portrait painter (he made thirty-four crossings); could paint any type of portrait; his style is fluent, lucid, impressive, with excellent landscapes, and distinctively American. (See Plate 12)

LOCATIONS: Boston MFA; NG Washington; Union League Club, Chicago; Nat. Mus. Amer. Art, Smithsonian Inst.; Santa Barbara Mus. of Art.

LITERATURE: M. de Mare, *G.P.A. Healy: American Artist* (New York, 1954); G & W; Baigell.

Heins, John Theodore (Dietrich) 1697–1756

German, working in Norwich from 1720; in 1720s signed 'D. Heins' (i.e., for Dietrich, the German form of Theodore), thereafter usually 'Heins pinxit'. A tiny *Self-Portrait* of 1726 in oil on metal (Sotheby's, 26.vi.74 (93)) gives his birth-date; d. Norwich. Numerous s. & d. portraits of all types are known, especially from late 1720s in a distinctive German manner often with smooth, rather heavy modelling; full-lengths are often small scale, and he also painted conversation pieces, miniatures, and genre. Throughout, his distinctive method of painting wigs almost amounts to a signature. His son, J.Th., Jr (1732–71), b. Norwich, d. London (in Chelsea, 11 May), painted in a similar manner to his father, if the signature and date on a small-scale full-length couple in a park of 1764 has been correctly recorded (Sotheby's 2–3.v.28 (128)); but his work is obscure, although some of his drawings were etched for Bentham's *History of Ely Cathedral* of 1771; he had been apprenticed to a snuff-maker but then became a painter, miniaturist and engraver in Norwich and London; exhibited Free Soc. and Soc. of Artists 1767–70.

LOCATIONS: Norwich Civic Portrait Colln; N. Trust, Felbrigg; Registry, Univ. of Cambridge.

LITERATURE: # T. Fawcett, *Walpole Society*, XLVI (1976–8), pp. 73ff.

Henri, Robert NA 1865–1929

b. Cincinnati, OH, d. NYC; one of the most influential and accomplished of all American painters, notably as a teacher in NYC; led 'The Eight', dedicated to social realism, and dubbed the 'Ash Can School'. Taught by Anshutz at Pennsylvania AFA, he was an admirer of *Eakins, and of Rembrandt, Courbet, Velásquez, Manet and Hals; in Paris 1888–91, including study at Acad. Julian, then taught in Philadelphia; in Paris again 1894–5, and mainly in Europe until he settled NYC 1900; he brought his vivid, *premier coup* style of powerful brushwork, sharply contrasting tones and colours to bear on his relatively few but imposing portraits. (See Chp. One, Fig. 29)

LOCATIONS: NG Canada; Whitney Mus., NYC; NG Washington.

LITERATURE: W.I. Homer, *Robert Henri and His Circle* (Ithaca and London, 1969).

Henry, George RA 1858–1943

b. Ayrshire, d. London; Glasgow School of

146. John Theodore Heins (Senior), *Matthew Goss*. Oil on canvas, 76.2 × 63.5 cm (30 × 25 in). 1756. Norwich, Castle Museum

147. Robert Henri, *Gertrude Vanderbilt Whitney*. Oil on canvas, 127 × 182.9 cm (50 × 72 in). 1916. New York, Collection of the Whitney Museum of American Art

146

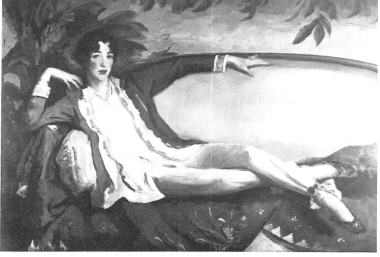

147

Art; mainly based in Glasgow; a friend of *Guthrie; to Japan 1893–4 with E.A. Hornel and did Japanese subjects, but no real influence of Japanese art is discernible; moved to London 1901; portraits include many bland, fashionable, society women, often three-quarter or full-length in evening gowns; his portraits of men brought the best out of him, with stronger lighting effects and crisper handling. ARA 1907, RA 1920. A fine watercolourist and landscape painter.

LOCATIONS: Walker AG, Liverpool; Royal Soc.

LITERATURE: Waters; R. Billcliffe, *The Glasgow Boys* (London, 1985).

Herkomer, Sir Hubert von RA 1849–1914

b. Waal, Bavaria, d. Budleigh Salterton; to Southampton with family 1857; studied South

148

148. Sir Hubert von Herkomer, *Edward Gordon Douglas, Baron Penrhyn of Llandegai*. Oil on canvas, 125.7 × 88.9 cm (49½ × 35 in). 1881. Private collection

149. John Hesselius, *Charles Calvert*. Oil on canvas, 127.7 × 101.3 cm (50¼ × 39⅞ in). 1761. Baltimore, MD, The Baltimore Museum of Art. Gift of Alfred R. and Henry G. Riggs in memory of General Lawrason Riggs

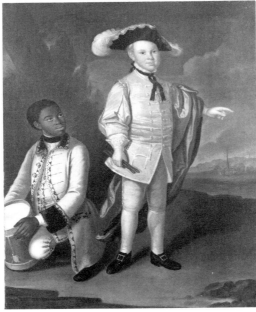

149

Kensington School, much influenced by *Fildes; exhibited RA from 1869; mainly interested in genre, he enjoyed great success and esteem as portraitist and even painted the dead Queen Victoria (HMQ, Osborne House) unexpectedly looking like Millais's Ophelia; rather severe portraits, the surface sometimes rather dull, worked on large-scale including groups; founded a painting school at Bushey, Herts, 1883, and had considerable influence; also a composer, theatrical designer, pioneer of early films and graphic artist. ARA 1879, RA 1890; knighted 1907, and made a 'von' by Kaiser 1899.

LOCATIONS: NPG; Tate; HMQ; Bristol AG; Lambeth Palace.

LITERATURE: J.S. Mills, *Life and Letters of Sir Hubert Herkomer, CVO, RA* (London, 1923); *A Passion for Work*, exh. cat. (Watford Mus., 1982); *Stand to Your Work*, exh. cat. (Watford Mus., 1983)

Hesselius, Gustavus 1682–1755

b. Falun, Dalecarlia, Sweden, d. Philadelphia, PA; trained Europe, supposedly by *Dahl in England although no trace is discernible in his style; Philadelphia 1712 and based there with visits to DE, MD, and VA; used quite heavy modelling in marked light and shade; also painted religious and other subjects (badly). Father of *John H., and was also an organ-builder.

LOCATIONS: Hist. Soc. of PA; Detroit Inst.; MD Hist. Soc.; Chrysler Mus., Norfolk, VA.

LITERATURE: G & W; *Gustavus Hesselius 1682–1755*, exh. cat. (Philadelphia, 1938).

Hesselius, John 1728–78

b. Philadelphia, d. nr Annapolis, MD; son and no doubt pupil of *Gustavus Hesselius; working from 1750 then in MD (mainly), VA, DE, and Philadelphia; influenced by *Feke and *Wollaston; married 1763 a rich widow with an estate near Annapolis but he continued to paint portraits; usually busts and half-lengths but occasionally three-quarters and even full-length; distinctive style with a habit of giving his sitters bulging faces; *C.W. Peale had his first lessons from him 1762 (in return for a saddle).

LOCATIONS: Baltimore Mus.; Brooklyn Mus.

LITERATURE: G & W.

Hickel, Karl Anton 1745–98

b. Česka Lipa (then Austria), d. Hamburg; studied Vienna, worked in France then England, at time of French Revolution, in early 1790s; painted *William Pitt addressing The House of Commons*, 1793 (NPG), heads in ovals, and also half-lengths, producing a curious mixture of his continental court manner applied to bluff English sitters.

LOCATIONS: NPG; HMQ.

Hickey, Thomas 1741–1824

b. Dublin, d. Madras; was taught in Dublin 1753–6, and went to Italy c. 1760–6, returning to Dublin; RA Schools 1771 and then worked in Bath (certainly in 1778); then Lisbon 1782–4, thence to India until 1791, then to China until 1794, returning to India; rather elegant, superficial portraits, often marked by strong lighting from one side.

LOCATIONS: Tate; Guildhall, Bath; NGI.

LITERATURE: EKW.

Hicks, George Elgar 1824–1914

b. Lymington, d. Odiham; studied medicine at Univ. Coll., London, 1840–2; Sass's Acad., 1843, RA Schools 1844; in London until 1890 when he moved to Colchester and, after a few years, to Odiham. Famous for his scenes of modern life, especially *Dividend Day. Bank of England*, 1859 (Governor & Co. of Bank of England) of a type then recently developed by W.P. Frith; had a thriving portrait practice, his pictures inventive and carefully prepared in attractive oil sketches; he was a fine draughtsman.

LOCATION: Southampton AG.

LITERATURE: *George Elgar Hicks, Painter of Victorian Life*, exh. cat. (Geffrey Mus., London and Southampton AG, 1982–3).

Hicks, Thomas NA 1823–90

b. Newtown, Bucks Co., PA, d. Trenton Falls, NY; precocious, apparently pupil of his cousin Edward Hicks (of *The Peacable Kingdom*) aged thirteen, and himself then taught Martin Johnson Heade; 1837 studied Pennsylvania AFA, then at NA 1838; from 1845 in Europe, London, Florence, Rome, and in studio of Couture in Paris; 1849 returned to NYC; also landscape and genre painter; he was an inventive portraitist in a somewhat thin, dry manner, often on large scale, introducing suitable settings to good effect. ANA 1841, NA 1851. Painted first oil portrait of Lincoln 1860.

LOCATIONS: Century Assoc., Union League Club, City Hall, Mus. of City of NY, all NYC; Brooklyn Mus.

Highmore, Joseph 1692–1780

b. London, d. Canterbury; trained for the law, then studied painting at *Kneller's Acad. for ten years from 1715 and working as portraitist; retired from painting to Canterbury 1761. Famous in his day for conversation pieces, he also worked larger scale in most types of portrait with an unusually arresting informality to many of his images. With *Hogarth (who was related to him by marriage), he helped to reveal a new vocabulary for native British portraiture, and was capable of painting with the greatest refinement. His son, Anthony H. (1718–99), was also a portraitist and topographical artist.

LOCATIONS: Tate; Yale; Coram Foundation, London.

LITERATURE: # A.S. Lewis, Ph.D. (Harvard, 1976).

Hill, David Octavius RSA 1802–70

b. Perth, d. Edinburgh; studied Edinburgh; exhibited RA 1832–68; helped found NGS; mainly landscape painter, but of interest in portraiture as pioneer of photography and adaptation of its usefulness to painting, including *The First General Assembly of the Free Church of Scotland*, begun 1843, finished 1865, and containing four hundred and seventy-four likenesses, the actual photography having been carried out by Robert Adamson; it would seem that Hill's later work in this area was also as 'artistic director'.

LOCATION: Assembly Hall of the Free Church of Scotland, Edinburgh.

Hill, Thomas 1661–1734

d. Mitcham, Surrey; worked in London and West Country; a friend of *Tilson and similarly charming portraitist, especially of

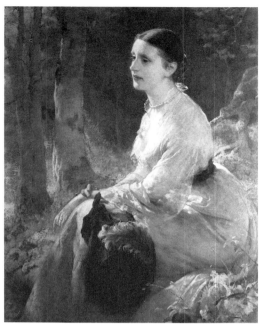

150. George Elgar Hicks, *Evelyn, Countess Bathurst*. Oil on canvas, 111.8 × 86.3 cm (44 × 34 in). 1879. Private collection

151. Joseph Highmore, *The Family of Eldred Lancelot Lee*. Oil on canvas, 237.5 × 289.1 cm (93½ × 114 in). 1736. Central Art Gallery, Wolverhampton

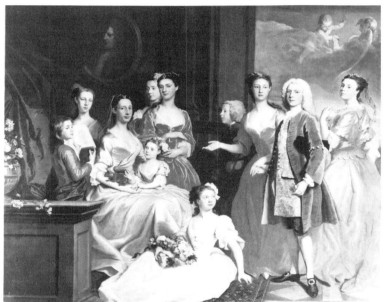

young sitters; may have formed West Country link through Tilson who also had sitters particularly from that area; taught drawing by William Faithorne. His style shows him to belong to a line of British portrait painters more indebted to *J.M. Wright (like Tilson) than to *Lely. All types of large-scale portrait, including vast groups.

LOCATIONS: NPG; Bishop's Palace, Hereford; Earl of Ilchester, Melbury House; Soc. of Antiquaries, London.

Hoare, Prince 1755–1834

b. Bath, d. Brighton; son and pupil of *William H.; RA Schools 1773; studied under

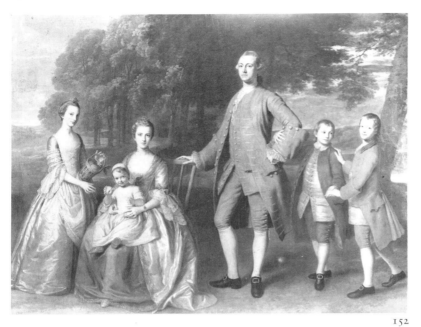

152

152. William Hoare, *The Drake Family*. Oil on canvas, 213.2 × 271.6 cm (84 × 107 in). Christie's, 18.VI.72 (42)

153

153. Frank Holl, *Portrait of My Mother*. Oil on canvas, 61 × 50.8 cm (24 × 20 in). 1882. London, Tate Gallery

Mengs in Rome 1776, returning with *Northcote 1779/80; until 1785 (when he gave up professional portrait painting) he dabbled in attempting a more romantic manner (he was a friend of Fuseli); later mainly literary career, but retained connection with RA; also crayons.

LOCATIONS: Lady Lever AG, Port Sunlight; N. Trust, Stourhead; Coram Foundation, London; Fitzwilliam Mus., Cambridge.

LITERATURE: EKW.

Hoare, William RA 1707–92

b. Eye, Suffolk, d. Bath; a pupil of *Grisoni who took him with him on his return to Italy 1728, and then of Imperiali (like *Ramsay) in Rome until 1737; Bath from 1739, although he tried London c. 1751/2, and the first and most important portraitist in Bath until *Gainsborough 1759; usually rather constrained handling, he did most types of portrait including conversation pieces and larger groups; also numerous crayons. RA 1769.

LOCATIONS: NPG; The Earl Bathurst; Rhode Island School of Design; N. Trust, Plas Newydd.

LITERATURE: EKW.

Hogarth, William 1697–1764

b. & d. London; trained as an armorial engraver, made himself the most original and various of all British painters; *Vanderbank Acad., 1720, and then an independent engraver, and probably worked as sign- and scene-painter; largely self-taught in portraiture, he found early success with conversation pieces and small full-lengths, turning to larger scale in late 1730s especially with busts in ovals, half-lengths and seated (no standing full-lengths on larger scale). One of the great masters of brushwork, he effectively invented an entirely new type of British portraiture, adapting continental late-Baroque and rococo forms to unaffected middle- and upper-class English sitters, partly through his profound understanding of contemporary French painting. (See Chp. One, Fig. 4, Chp. Two, Figs 51, 54, 55, 77, 78, 80, 84; Plate 24)

LOCATIONS: NG; Tate; Yale; Fitzwilliam Mus., Cambridge; Frick Colln, NYC; Walker AG.

LITERATURE: R.B. Paulson, *Hogarth, his Life, Art and Times*, 2 vols (New Haven and London, 1971).

Hoit, Albert Gallatin 1809–56

b. Sandwich, NH, d. West Roxbury, MA; Dartmouth Coll. (grad. 1829), then working as portraitist various in Maine, then married and in Boston from 1839 after brief spell in Canada; in Europe 1842–4. His style is rather varied, from severe to sentimental, but often effective and straightforward. Painted Whittier and Webster, and was generally successful in his last years at Boston.

LOCATION: NPG Washington.

LITERATURE: G & W.

Holl, Frank (Francis Montague) RA 1845–88

b. London, d. Madrid; son of engraver Francis Holl, ARA; RA Schools 1860 (gold medal 1863); to Italy 1868–9; portraits especially after 1878 (successful RA exh.) and became highly sought-after, too much so for his health; very painterly at his best, using free impasto and chiaroscuro; influenced by Dutch seventeenth-century art; sitters included Pierpoint Morgan, the Prince of Wales and W.S. Gilbert; the major rival to *Millais and *Watts. ARA 1878; RA 1882.

LOCATIONS: NPG; Tate; Castle Mus., Norwich (on deposit); Thomas Agnew & Sons; Bristol CAG; NGI.

LITERATURE: A.M. Reynolds, *The Life and Work of Frank Holl* (London, 1912).

Hollingsworth, George 1813–82

b. & d. Milton, MA; studied in Boston and Italy and taught drawing at the Lowell Inst., Boston 1851–79; probably influenced by *Harding. He had worked in Boston from 1839; good at individual figures, his perspective is rather awkward.

LOCATION: Boston MFA.

LITERATURE: G & W; Boston MFA Cat.

Hollins, John ARA 1798–1855

b. Birmingham, d. London; 1822 to London;
Italy 1825–7; ARA 1842. Also landscape and
literary subjects; usually good, lucid
straightforward portraits, half-length and
seated, especially of clerical and legal sitters.

LOCATIONS: NPG; Nottingham Castle Mus.;
Lord Methuen, Corsham Court.

Home, Robert 1752–1834

b. Hull, d. Cawnpore (Kanpur); RA Schools
1769 and pupil of *Kaufmann; studied Rome
1773–8; Dublin by 1779 until 1789 but must
also have worked in London; then to India via
London 1790. Brother-in-law of the surgeon
John Hunter. Earlier portraits somewhat
indebted to Kauffmann. Distinctively thin
paint surface, in a very dry, restrained manner;
most types of portrait, including
contemporary histories of the *Copley type of
Indian events, which have charm but display
his limitations; successful in India, retiring to
Cawnpore 1825. Keenan was his pupil and
probably came with him to London 1789.

LOCATIONS: NPG; Royal Coll. of Surgeons;
Duke of Wellington, Apsley House; Royal
Soc.

LITERATURE: EKW; Archer, pp. 298 ff.

Hone, Nathaniel RA 1718–84

b. Dublin, d. London; perhaps self-taught;
until advantageous marriage 1742, probably
itinerant in England, especially as miniaturist;
then in London. Italy 1750–2, abandoning
miniatures early 1760s; foundation member
RA 1768. A sensitive student of old masters,
Dutch and Italian, his own style is rather
eclectic, owing more to *Reynolds than he
would have liked to admit; like Reynolds, he
experimented with styles and approaches to
portraiture in self-portraits (and, in his own
case, portraits of his family). His sons, Horace
H. (1754–1825), and John Camillus H.
(1759–1836), were also painters (miniaturists),
the latter also painting portraits on larger
scale.

LOCATIONS: NPG; Lord Scarsdale, Kedleston
Hall; RA.

Hopkinson, Charles Sydney 1869–1962

b. Cambridge, MA, d. Manchester, MA;
educated at Harvard, then studied NYC, Paris,
and Boston and Cambridge, MA; had a studio
in Boston. An adaptable and imaginative
portraitist in a style marked by vigorous

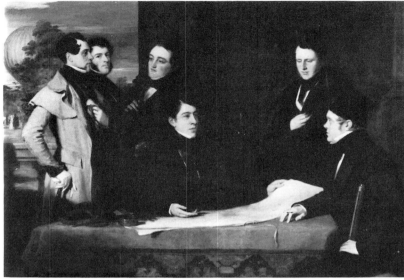

154

execution; one of the official National Art
Committee portraitists of World War I
leaders, 1919.

LOCATIONS: Cleveland Mus., OH; Harvard
Law School; Yale Univ.; The White House;
Smithsonian Inst.; Vassar Coll.

LITERATURE: *Who Was Who in America*, IV.

Hoppner, John RA 1758–1810

b. & d. London; RA Schools 1775 (gold medal
1782); early style based on *Reynolds but
decisively influenced by *Romney in the
direction often of a simpler dependence on
genuinely painterly execution and more
straightforward conception, a tendency
reinforced by feelings of rivalry towards the
young *Lawrence; created a very English
'fresh-air' version of romantic portraiture.
Immensely popular in the early twentieth
century, his reputation has suffered an
exaggerated reversal, for he was comfortably
one of the three of four best portraitists of his
day. Painter to the future Prince Regent from
1789. ARA 1793, RA 1795. All types of
portrait including excellent groups of children.
A difficult, sarcastic man but well read and
often amusing. Two sons, Lascelles and
Belgrave H., were also painters. (See Chp.
One, Fig. 20)

LOCATIONS: Tate; Detroit Inst.; Met. Mus.,
NYC; HMQ.

LITERATURE: Whitley II, 1, pp. 158 ff.; #W.
McKay and W. Roberts, *John Hoppner*,
London, 1909 (supplementary vol., 1914).

Horstmeier, Albert c. 1865–1940

b. Baltimore, MD, d. Boston, MA; locally
trained, then Paris, Acad. Julian, under

154. John Hollins, *A
Consultation prior to the
Aerial Voyage to
Weilburg.* Oil on canvas,
147.3 × 206.4 cm
(58 × 81½ in). *c.* 1836–8.
London, National
Portrait Gallery

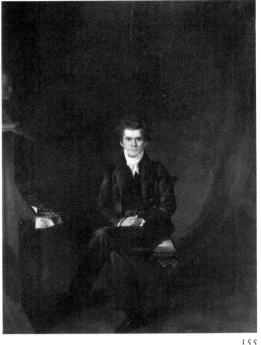

155. William James Hubard, *John C. Calhoun.* Oil on panel, 49.5 × 37.2 cm (19½ × 14⅝ in). *c.* 1830. Washington, DC, Corcoran Gallery of Art, Museum Purchase, 1889

155

Bouguereau and Ferrier; settled in Boston; a painter of some quality.

LOCATION: Baltimore Mus.

Howard, Henry RA 1769–1847

b. London, d. Oxford; a pupil (and later son-in-law) of *Philip Reinagle from 1786; RA Schools 1788 (gold medal 1790); 1791 Rome (friend of Flaxman), returning via Vienna and Dresden 1794. Best known in his day for histories and literary subjects, but he also painted good, realistic portraits with excellent settings and props, thoughtfully composed in a resolutely non-romantic manner as if *Lawrence, e.g., had never existed, an Augustan conservatism (rather than neo-Classicism) that extends to his histories and lends them charm also; most types of portrait including small busts in 'close-up' very vigorously brushed. ARA 1801, RA 1808, Secretary RA 1811, Professor of Painting RA 1833.

LOCATIONS: NPG; Trustees of the Chatsworth Settlement; The Earl Spencer, Althorp; Athenaeum, London.

Howard, Hugh 1675–1738

b. Dublin, d. London; with family to England 1688 and with 8th Earl of Pembroke to Holland 1697 and Rome same year, via Padua, studying under Carlo Maratta until 1700, when he returned to Ireland, but settled in London, although visiting Ireland, e.g., 1710; married heiress 1714 and abandoned portraiture but continued as remarkable

collector and connoisseur; Keeper of Records and Papers of State, and 1726 Paymaster General of the Royal Works.

LOCATIONS: Royal Soc. of Musicians; Trinity Coll., Dublin; Trustees of Lamport Hall, Northamptonshire.

LITERATURE: *Irish Portraits 1660–1860*, exh. cat. (NGI, Ulster Mus., NPG, 1969–70).

Hubard, William James 1807–62

b. Whitchurch, Shropshire, d. Richmond, VA; started as silhouettist 'infant phenomenon' arriving with his manager NYC 1824; late 1820s started painting in Boston probably with encouragement of *Stuart; in England 1826–8 but then Philadelphia; in Baltimore, MD, 1830–2, then settled Gloucester Co., VA; small-scale full-lengths are typical, the sitter set well back in picture space, with strong lighting; often panel support.

LOCATION: Baltimore Mus.

LITERATURE: G & W; Baltimore Mus. Cat.

Hubbell, Henry Salem 1870–c. 1960

b. Paola, KS; studied Art Inst., Chicago, variously in Paris from 1899 with *Whistler, Collin and Laurens, and in Madrid. Began as an illustrator and then subject pictures after exhibiting Paris Salon 1901, but turned increasingly to portraiture. Head of School of Painting, Carnegie Inst., Pittsburgh, 1918–21. Nat. Assoc. of Portrait Painters 1912. Attractive, painterly manner.

LOCATION: Smith Coll., Northampton, MA.

LITERATURE: *Who Was Who in America*, V (date of death not recorded).

Hudson, Thomas 1701–79

b. Devon, d. Twickenham; pupil and son-in-law of *Richardson; worked both in West Country and London until *c.* 1740, then London, becoming after the departure of *J.B. Van Loo in 1742 the most fashionable portraitist until 1750s (and the return from Italy of his pupil *Reynolds); *Ramsay was his main rival and they both (with others) shared the services of *Van Aken for drapery; all types of portrait, including some immense groups up to 16 feet wide, but he was also an admirer of Rembrandt and some portraits demonstrate a more robust handling and lighting; he always displays a firm grasp of structure in his heads; did little painting after 1760. *Mortimer and *Wright of Derby were also his pupils. (See Chp. One, Fig. 56, Chp. Three, Figs 91–3, 95, 99)

LOCATIONS: NPG; Goldsmiths Company, London; Duke of Marlborough, Blenheim Palace; Yale.

LITERATURE: #E. Miles, *Thomas Hudson,
1701–1779, Portraitist to the British
Establishment* (Ph.D., Yale Univ., 1976; Ann
Arbor, 1977); *Thomas Hudson*, exh. cat.
(Kenwood, 1979).

Hughes, Edward 1829–1908

b. & d. London; son and no doubt pupil of
landscape and portrait painter George H. (*fl.*
1813–58); exhibited RA 1847–84; often full-
length portraits of women in exterior setting,
on a very large scale, standing or seated, with
good strong colour, and enjoyed extensive
aristocratic patronage; working certainly until
1903. Also genre, and worked as an illustrator.

LOCATIONS: Duke of Norfolk, Alton Towers;
Grimsthorpe Castle; Earl of Leicester,
Holkham; Royal Coll. of Surgeons.

Humphry, Ozias RA 1742–1810

b. Honiton, d. London; at first a miniaturist,
trained Shipley's Acad. 1757 and, 1760–2,
with Samuel Collins in Bath; then to London.
Suffered from eye trouble from 1771 and
turned to oils; with *Romney (who influenced
him) to Rome 1773 and there until 1777; to
India 1785; on returning tried miniatures again
only to turn to crayons; 1792, crayon painter
to the King; finally went blind 1797. ARA
1779; RA 1791. All types of oil portrait,
including conversation pieces and large
groups.

LOCATIONS: Capt. P.J.B. Drury-Lowe, Locko
Park; Trustees of Berkeley Castle; Sotheby's,
22.iii.72 (104).

LITERATURE: # G.C. Williamson, *Life and
Works of Ozias Humphrey* (London, 1918);
EKW.

Hunt, William Morris ANA 1824–79

b. Brattleboro, VT, d. Appledore, Isle of
Shoals (drowned); left Harvard early and to
Rome 1843 where he studied sculpture under
H. Kirke Brown; studied painting 1845–6 at
Düsseldorf Acad. and 1847–52 in Paris at
Couture's studio; became a friend of J.-F.
Millet who also influenced him (he owned
version of *The Sower*) and worked on figures
and landscape in Barbizon until returning to
U.S.A. 1855; finally settled Boston 1862 and
turned chiefly to portraiture, helped by society
marriage (1855); in Europe 1866–8; became
an influential teacher and generally introduced
an advanced taste for contemporary French
painting into Boston. On occasion used
photography in portrait preparation; sitters
are often shown in strong tonal contrast to
background. (See Chp. One, Fig. 28)

LOCATIONS: Toledo Mus.; Essex Bar Assoc.,
Salem, MA; Boston MFA.

156

156. William Morris
Hunt, *Francisca Paim da
Terra Brum da Silveira*.
Oil on canvas,
103.5 × 76.1 cm
(40¾ × 30 in). 1858.
Toledo, OH, The Toledo
Museum of Art, Museum
Purchase Fund

LITERATURE: *William Morris Hunt: A
Memorial Exhibition*, exh. cat. (Boston MFA,
1979).

Hunter, Robert *fl.* 1750–*c.* 1803

b. Ulster(?), d. Dublin(?); crayons and oils,
working successfully Dublin by 1753 and the
main portraitist there for some twenty to
thirty years; apparently influenced early by
*Ramsay (and in fact had Scottish sitters),
later by *Reynolds; copied head of
*Gainsborough's *Queen Charlotte* (1781) in
pastel; most types of portrait; small-scale full-
lengths have sometimes been confused with
those of *Arthur Devis; an appealing
portraitist.

LOCATIONS: Marquess of Lothian, Monteviot;
Russian Embassy, London; Ulster Mus.,
Belfast; NGI.

LITERATURE: *Irish Portraits 1660–1860*, exh.
cat. (NGI, NPG, Ulster Mus., 1969–70); EKW.

Huntington, Daniel NA 1816–1906

b. & d. NYC; met *Elliott who was visiting
Hamilton Coll. and decided on portraiture;
studied under *Morse and *Inman, NYC;
1839 to Rome, Florence and Paris, and again in
Europe (mainly Rome) 1842–4, and then
worked 1851–8 in England; last visit to
Europe 1882. Made his reputation *c.* 1840 with
genre and subject pictures, but mostly painted
portraiture, especially after 1850. He had a
wide range, and could paint both in a grand
'European' manner and in a more initimate
simpler 'American' style, according to the

157. Charles Cromwell Ingham, *Coralie Livingstone (?)*. Oil on canvas, 91.4 × 71.1 cm (36 × 28 in). *c.* 1833. Washington, DC, National Gallery of Art, Andrew W. Mellon collection

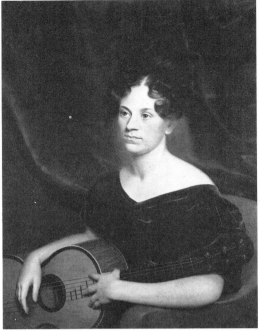

157

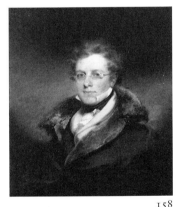

158

158. Henry Inman, *John Inman*. Oil on canvas, 76.2 × 63.5 cm (30 × 25 in). *c.* 1828. Boston, MA, Museum of Fine Arts. William Wilkins Warren Fund

nature of his sitters who are often shown seated. Also landscapes. ANA 1839, NA 1840, PNA 1863–9 and again 1877–90.

LOCATIONS: N.-Y. Hist. Soc., Century Assoc., NYC; Yale Univ.

LITERATURE: Quick.

Hurlstone, Frederick Yeates 1801–69
RA Schools 1820; studied also with *Beechey, *Lawrence, and *Haydon; exhibited RA 1821–45; travelled to Spain, Morocco and Italy, and followed vogue for depicting sultry Spanish gypsies and winning Italian urchins, but he was a very good portraitist.

LOCATIONS: Duke of Argyll, Inveraray Castle; Lord Petre.

Huysmans, Jacob *c.* 1633–96
b. Antwerp(?), d. London; apprenticed to Wouters in Antwerp 1649/50; in London from 1662 with a studio in Westminster; a Roman Catholic, he was patronized by that part of the court, especially the Queen, Catherine of Braganza; lavish continental Baroque manner; he often portrayed sitters in an allegorical or religious guise, in unusual compositions packed with detail of all kinds; to Pepys he was 'said to exceed Lely', but that was the effect of his supporters' propaganda. Also painted religious works.

LOCATIONS: NPG; HMQ; Marquess of Lothian, Melbourne Hall.

LITERATURE: EKW, *Painting in Britain*, pp. 104–5.

Hysing, Hans 1678–1753
b. Stockholm, d. London; trained in Stockholm at first as a goldsmith; London 1700 under *Dahl, independent by 1715; style not unlike that of Dahl; all types of large-scale portrait; *Ramsay was his pupil in 1732–3.

LOCATIONS: NGS; King's Coll., Cambridge.

LITERATURE: W. Nisser, *Michael Dahl and the Contemporary Swedish School of Painting in England* (Uppsala, 1927), pp. 97–105.

Illidge, Thomas Henry 1799–1851
b. Birmingham, d. London; studied under *Mather Brown and *William Bradley; based Manchester 1827–31 then Yorkshire, and lived London from 1842. Painted a number of his fellow-artists, including *Haydon; competent in all types of portraits, including larger full-lengths and seated.

LOCATION: Walker AG, Liverpool.

LITERATURE: Walker AG Cat.

Ingham, Charles Cromwell NA 1796–1863
b. Dublin, d. NYC; in America 1816 and worked in NYC; founder-member NA; successful and, e.g., painted Martin van Buren. Many portraits are severe half-length or busts typical of the period in America, but he could paint attractively and interestingly, especially women.

LOCATIONS: Washington Univ.; Newark Mus., NJ; Met. Mus., NYC; Wadsworth Athenaeum.

Inman, Henry NA 1801–46
b. Utica, NY, d. NYC; in NYC 1812, apprenticed to *J. W. Jarvis 1814–22; Boston, then settled NYC 1824; founder-member NA 1826. In England 1830 (13 Tavistock St, London) and exhibited Royal Soc. of British Artists his *William Charles Macready as William Tell* (Met. Mus., NYC); 1831 Philadelphia, a partner of Col. Childs in lithography, and with him involved in Pennsylvania AFA; 1834 returned to NYC; in England again 1844–5 painting Wordsworth, Macaulay; died on his return. The leading NYC portraitist of his day. Also miniatures, genre, landscape. Fluent and versatile.

LOCATIONS: Met. Mus., City Hall, N.-Y. Hist. Soc., NYC; Boston MFA.

LITERATURE: Whitley II; G & W; Baigell.

Irvine, James 1833–99
b. Menmuir, Forfar, d. Montrose; pupil of *Colvin Smith at Brechin, and was then at

Edinburgh Acad.; based at Arbroath, then Edinburgh 1880s, then Montrose by 1889; finally, very successful.

LOCATION: NPG.

LITERATURE: Wood.

Jack, Richard RA 1866–1952

b. Sunderland, d. Montreal, Canada; studied York School of Art then Royal Coll., in Paris, at Acad. Julian, and was still there 1893; in London by 1895; went to Montreal 1932. ARA 1914, RA 1920. Painted George V (who turned up for sittings after the picture was begun: it had not been commissioned), then the Queen, and the then Princess Elizabeth, 1926–30. Chameleon-like, picking up styles in vogue, but always imposing, with a good touch and sense of colour.

LOCATIONS: Royal Coll. of Surgeons; Leeds General Infirmary; HMQ.

LITERATURE: Wood; Waters.

Jackson, John RA 1778–1831

b. Lastingham, Yorks, d. London; initially apprenticed to his tailor father, then patronised by Mulgrave and Beaumont went to RA Schools, where he was a friend of Wilkie and *Haydon; ARA 1815, RA 1817. A prolific artist, at his best his portraits are strong, incisive, highly individualized likenesses; not unlike *Raeburn, somewhat influenced by *Lawrence, the particular air he gives his sitters is distinctive, with attractive handling and colour. Wesley (whom he followed) was the subject of one of his first (primitive) portraits.

LOCATION: NPG.

Jacomb-Hood, George Percy 1857–1929

b. Redhill, d. London; studied Slade, and Paris under Laurens; travelled as newspaper illustrator and portraitist; in India with Prince of Wales 1905–6 and again, with the King's staff, 1911. His subject pictures are very bad; his portraits are much better, often with lettering, and have a greenery-yallery air (exhibited Grosvenor Gallery).

LOCATIONS: Trinity Coll., Oxford; NPG; Manchester CAG.

James, George ARA fl. 1755–95

b. London, d. Boulogne (in prison); son of well-to-do bookseller; apprenticed 1749 to *Pond; in Naples 1755, Rome until 1760, then London, bringing Biagio Rebecca (partly as assistant); to Bath c. 1780. Inherited, and

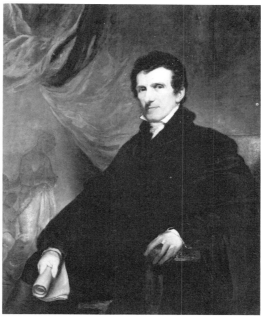

159

married, money, and retired from painting to Boulogne; a victim of the Terror. Several delightful groups of children on scale of life are known, and half-lengths, all with careful attention to light and shade.

LOCATIONS: Christie's, 22.iv.83 (84); 19.xi.76 (7); Sotheby's, 18.iii.70 (28).

LITERATURE: EKW; Lippincott.

Jarvis, Charles Wesley 1812–68

b. NYC, d. Newark, NJ; son of *John Wesley J., he was a pupil of *Inman (his father's former pupil), and with him in NYC and Philadelphia; after 1834 based NYC; competent and successful, though less interesting than his father, he could work on a large scale.

LOCATION: City Hall, NYC.

LITERATURE: G & W.

Jarvis, John Wesley 1780–1840

b. S. Shields, d. NYC; with family to Philadelphia c. 1785; apprenticed to *Edward Savage 1796–1801; worked in NYC 1802–10, then Baltimore, returning NYC 1813; when *Stuart quarrelled with a sitter, J. took over commission to paint heroes of 1812 War for City Hall, including well-known *Oliver Hazard Perry* (1816), a good example of how his originality could overcome technical limitations; the most important NYC portraitist of the first quarter of the nineteenth century, superseded by his pupil *Inman.

LOCATION: City Hall, NYC.

198 JEFFERYS, WILLIAM

160. John Wesley Jarvis,
Oliver Hazard Perry. Oil
on canvas,
243.7 × 152.4 cm
(96 × 60 in). 1816. New
York, NY, Art
Commission of the City
of New York

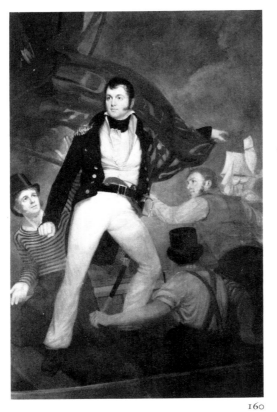

160

LITERATURE: H.E. Dickson, *John Wesley
Jarvis, American Painter, 1780–1840* (NY,
1949).

Jefferys, William 1723 (1730?)–1805
b. & d. Maidstone; pupil of *Hayman; small-
scale full-lengths of *Devis type are known;
father of the remarkable draughtsman James
J. (1751–84).
LOCATION: Christie's, 28.vii.55 (53).
LITERATURE: EKW.

Jenkins, Thomas 1722–98
b. Sidbury, Devon, d. Yarmouth; pupil of
*Hudson; from c. 1753 mainly in Rome
(where he knew *Wilson) as dealer and
'antiquary'; early small-scale full-lengths
painted in the West Country are imitative of
*Hayman, but he also painted half-length and
seated.
LOCATION: Earl of Wemyss and March,
Gosford.
LITERATURE: B. Ford, *Apollo*, XCIX (June,
1974), pp. 416–25.

Jennys, William *fl. c.* 1790–1807
Presumably the younger brother, but
conceivably the son, of the even more
primitive Richard J. (*fl.* 1766–c. 1799), more
biographical details being known of the latter

but more pictures by the above, and some
confusion still surrounds their activities; both
usually painted busts in oval. William J.
worked in CT, NYC, MA, VT and NH, and
his portraits are fairly naturalistic. Jointly
signed portraits are known (Huntington, CT)
from 1799. Richard J. is recorded in Boston,
Charleston, SC, W. Indies and CT.
LOCATIONS: Lyman Allyn Mus., Connecticut
Coll.; Chrysler Mus., Norfolk, VA.
LITERATURE: W.L. Warren, *Connecticut
Historical Society Bulletin*, XXI (April, 1956),
pp. 33–64; G & W.

Jervas, Charles *c.* 1675–1739
b. Ireland, d. London; briefly with *Kneller; in
Paris 1699, based in Rome *c.* 1703–8, then
London, making visits to Ireland; painted
Swift and other literary figures whom he
knew; most types of portrait including large
groups; on Kneller's death became Principal
Painter to the King. There is sometimes a
characteristic harshness of modelling, and also
of colour.
LOCATION: NPG.
LITERATURE: EKW.

Jewett, William ANA 1789/90–1874
b. East Haddam, CT, d. Bergen, NJ;
apprenticed to coach-maker, bought himself
out 1812 to study with *Waldo in NYC;
1818–54 formed portrait partnership of
Waldo & Jewett, NYC, being less prominent
independently than *Waldo; retired 1854. Not
to be confused with *William S. Jewett.
LOCATION: N.-Y. Hist. Soc.
LITERATURE: G & W.

Jewett, William S. (Smith?) ANA 1812–73
b. South Dover, NY, d. Springfield, MA; based
NYC 1833–49, and from 1841 had a studio in
NY Univ.; ANA 1845, left for San Francisco
1849 where he worked 1850–69, and also had
studio in Sacramento 1850–5; first
professional portraitist in California; retired
to NYC 1869; certainly in England 1873 just
before his death.
LOCATIONS: De Young Mus., San Francisco;
Bowers Memorial Mus., Santa Ana; Sutter's
Fort, State Capitol, Sacramento; NAD.
LITERATURE: H.C. Nelson, *Antiques*
(November, 1942), pp. 251–3.

John, Augustus Edwin OM, RA 1878–1961
b. Tenby, d. Fordingbridge; Slade School
1894–8; extravagantly talented draughtsman
and painter whose facility perhaps ultimately

betrayed him, but a dynamic painter and inventive portraitist and, in that sphere, far the superior of his gifted sister Gwen J. (1876–1939). ARA 1921, RA 1928. Any type of portrait came easily to him, and he was one of the few British artists among his contemporaries (perhaps the only one) capable of dramatic portraiture in the Grand manner.

LOCATIONS: NMW; Tate; NPG.

LITERATURE: M. Easton & M. Holroyd, *The Art of Augustus John* (London, 1974).

Johnson, Jonathan Eastman NA 1824–1906

b. Lovell, ME, d. NYC; began as lithographer in Boston, then itinerant portrait draughtsman *c*. 1841–9; went to Düsseldorf 1849, 1851 under *Leutze, then visited England, Italy, France and Holland (where he worked successfully). Paris 1855 with Couture and returned to USA. Successively in Washington, Superior, WI, and Cincinnati; based NYC from 1858. Famous for his genre scenes of American life, notably *Old Kentucky Home: Life in the South*, 1859 (N.-Y. Hist. Soc.), he painted many portraits, relying on them after 1880. Could work on any scale, often with grand effects and intensity of vision; some portraits have Rembrandtesque handling, others a sophisticated 'eighteenth-century' formality; gifted, knowledgeable and adaptable. ANA 1859, NA 1860. (See Chp. One, Fig. 27)

LOCATIONS: City Hall, N.-Y. Hist. Soc., NYC; Union League Club, Chicago; NG Washington; Cleveland Mus.

LITERATURE: *Eastman Johnson*, exh. cat. (Whitney Mus. of American Art, NYC, 1972).

Johnston, John 1753–1818

b. & d. Boston, MA; apprenticed to sign- and house-painter, free 1773; fought as patriot in Revolution, wounded, and thereafter known as 'Major' J.; in partnership with brother-in-law Daniel Rea for all kinds of house- and sign-painting but including portraits and miniatures; good, lucid manner. Same family as *William Johnston.

LOCATIONS: Bowdoin Coll. Mus. of Art; Sotheby Parke Bernet, 10.vi.76 (61, pair).

LITERATURE: F. W. Coburn, *Art in America*, XXI (4 October, 1933), pp. 132–8.

Johnston, William 1732–72

b. Boston, MA, d. Bridgetown, Barbados; of the same family as *John Johnston; trained by his father; married in Boston 1766, and in Barbados by 1770; worked variously in NH and CT in 1750s to mid-1760s. He was a friend

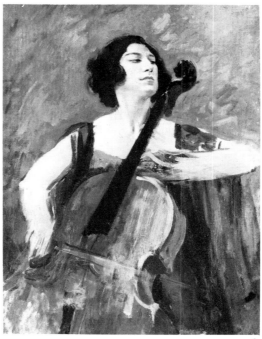

161. Augustus Edwin John, *Madame Suggia*. Oil on canvas, 101.6 × 76.2 cm (40 × 30 in). *c*. 1922–3. Cardiff, National Museum of Wales

162. Sir Thomas Alfred Jones, *Miss Mary Banks*. 127.6 × 102 cm (51 × 41 in). *c*. 1868. Christie's, 18.III.83 (71)

of *Copley and may have taught *Earl.

LOCATIONS: Brooklyn Mus.; CT Hist. Soc.

LITERATURE: L. P. Lyman, *N.-Y. Hist. Soc. Quarterly*, XXXIX (January, 1955), pp. 63–78.

Jones, Sir Thomas Alfred PRHA *c*. 1823–93

b. & d. Dublin (a foundling); precociously studied art at Royal Dublin School from age ten; T.C.D. 1842, travelling in Europe 1846–9; highly successful Dublin portrait practice with a noticeably continental manner. RHA 1860, PRHA 1869, knighted 1880.

LOCATIONS: NGI; Belfast City Hall.

Joseph, George Francis ARA 1764–1846

b. Dublin (?), d. Cambridge; RA Schools 1784;
also painted histories, miniatures and fancy
pictures. Portraits are quite independent of any
*Lawrence influence, rather, vaguely French
neo-Classical, with carefully depicted settings.

LOCATIONS: NPG; Mr and Mrs Anthony
Jarvis, Doddington Hall, Lincs.

LITERATURE: EKW.

Jouett, Matthew Harris 1787–1827

b. nr Harrodsbury, KY, d. nr Lexington, KY;
self-taught, briefly pupil of *Stuart 1816, his
detailed notes on that master being of the
greatest interest; based mainly KY. Could do
full-lengths, but mostly severe half-lengths and
busts typical of the time, sometimes on panel
in standard canvas sizes.

LOCATIONS: State Capitol, Frankfort, KY; KY
Hist. Soc.

LITERATURE: E.A. Jonas, *Matthew Harris
Jouett, Kentucky Portrait Painter, 1787–1827,*
(Louisville, KY, 1938); J.H. Morgan, *Gilbert
Stuart and his Pupils* (New York, 1939;
reprinted 1969).

Kauffmann, Angelica RA 1741–1807

b. Coire, Switzerland, d. Rome; England
1766–81 arriving through an attachment to
*Dance; immediately became close to
*Reynolds; trained in Italy, best known for
decorative works, her portraits, both large and
small scale, are fairly accomplished; very fond
of Van Dyck costume; some are faintly neo-
Classical; married Zucchi, to Italy 1781.

163. Angelica Kauffmann,
Sir Joshua Reynolds. Oil
on canvas, 127 × 101.6 cm
(50 × 44 in). 1767. The
National Trust, Saltram
(Morley collection)

163

LOCATIONS: N. Trust, Saltram; The Earl
Spencer, Althorp.

LITERATURE: V. Manners and G.C.
Williamson, *Angelica Kauffman* (London,
1924; reprinted, 1976).

Keable (or Keeble), William 1714(?)–74

b. E. Anglia(?), d. Bologna; small-scale full-
lengths in manner of, e.g. *Hayman (K. was
member St Martin's Lane Acad. 1754); a letter
from an American sitter of *Ramsay shows he
also painted large scale in an impasted
manner, confirmed by surviving pictures
(*Thomas Smith,* 1749, Charleston, SC); in
Italy by 1761, from 1765 Bologna.

LOCATIONS: Yale; Marquess of Salisbury,
Hatfield House.

LITERATURE: A.W. Rutledge, *Connoisseur,*
CXLI (May, 1958), p. 267.

Keeling, Michael 1750–1820

b. Stafford(?), working there 1774; 1800–9 he
lived at 29 Mortimer Street, Marylebone; early
works are well, if heavily, constructed, but he
later developed a richer, more fluent style
influenced by *Raeburn (there are pictures in
Scottish as well as English collections). There
were four other artists with this surname
active in the nineteenth century.

LOCATIONS: Phillips, 6/7.x.76(157–60); Brodie
Castle.

Kellogg, Miner Kilbourne 1814–89

b. Manlius Square, NY; 1840 Cincinnati,
1841–5 in Italy, then NYC in 1851; in Europe
1854–8, Baltimore 1867–70; Hon. NA 1851.

LOCATIONS: City Hall, NYC; MD Hist. Soc.;
Cincinnati Art Mus.

LITERATURE: G & W.

Kettle, Tilly 1734/5–1786

b. London, d. nr Aleppo; student at St
Martin's Lane Acad. and 3rd Duke of
Richmond's Acad.; working professionally *c.*
1760, influenced by *Reynolds; itinerant in
Midlands 1762–4, then based London until
1769, when he went to India until 1776,
painting both Indians and British; less
successful on his return and tried Dublin and
Brussels, dying on way back to India. Showed
unusual sympathy for wide variety of sitters
and with unusual compositions.

LOCATIONS: Yale; Nat. Marit. Mus.; NPG.

Kilburn, Laurence 1720–75

b. Denmark (as Lorenz Kielbrunn), d. NYC;
arrived NYC from London 1754, in Albany

briefly 1761; ended as 'merchant'; strictly limited abilities.

LOCATION: Beekman Family Assoc., NYC.

LITERATURE: Flexner, I.

King, Charles Bird NA 1785–1862

b. Newport, RI, d. Washington, DC; pupil of *Edward Savage NYC, 1800, then of *West in London 1805–12, returning at first to Philadelphia; Washington from 1816; a leading portraitist of his time, he is famous for his portraits of 1821 Indian delegation to the capital.

LOCATION: Chrysler Mus., Norfolk, VA.

LITERATURE: *The Paintings of Charles Bird King*, exh. cat. (Nat. Colln of Fine Arts, Washington, DC, 1977).

King, John, 'of Dartmouth' 1788–1847

b. & d. Dartmouth; in London 1820, RA Schools and exhibited regularly RA, probably from 1817 but certainly 1821–47 and partly from Bristol (1824–6) as well as London; portraits and also a number of Shakespearian and other subjects; painted his friend Francis Danby 1828 (Bristol CAG); rather provincial half- and three-quarter lengths, often of West Country sitters.

LOCATIONS: NPG; Bristol CAG.

King, Thomas *fl.* 1735–*c.* 1769

Pupil of *Knapton 1735, assistant to *Pond 1744–8, only later working (which he was disinclined to do at all) independently, and the few known portraits are typical of a competent drapery painter but no more; of interest in theatrical history.

LOCATION: Christie's, 14.ii.38 (30).

LITERATURE: Lippincott.

Kirkby, Thomas 1775–*c.* 1847

British, not American painter; RA Schools 1795, exhibited RA 1796–1846 and British Institution until 1847 from London address, save for 1808 (Lichfield); competent, restrained (limited) style, in good practice, busts, half-length and seated, occasional child full-length; did Eton leaving portraits.

LOCATIONS: Wadham Coll., Oxford; Eton Coll.; Christie's, 7.xi.80 (134).

Knapton, George 1698–1778

b. & d. London; apprenticed to *Richardson, whose books the Knaptons published, 1715–22, then Italy 1725–32; important in establishment of crayon portraiture in England. An underestimated artist with a wide range, demonstrating ingenuity and variety in portraits of twenty-three of the Soc. of Dilettanti; most types of portrait except small scale, and at least one huge group. A key figure in line of native English painters (including his friends *Hudson and *Pond) who paid no heed to the innovations of *Hogarth and *Highmore. He probably retired from painting mid-1750s, but continued to play major role in artistic life.

164

164. Tilly Kettle, *An Indian Dancing Girl with a Hookah*. Oil on canvas, 193 × 119 cm (76 × 47 in). 1772. New Haven, CT, Yale Center for British Art, Paul Mellon collection

165

165. George Knapton, *John House, 4th Baron Chedworth*. Oil on canvas, 76.2 × 63.5 cm (30 × 25 in). 1741. London, The Society of Dilettanti

LOCATIONS: Soc. of Dilettanti, London; Met. Mus., NYC; NPG; HMQ.

LITERATURE: Lippincott; EKW.

Kneller, Sir Godfrey, Bt 1646–1723

b. Lübeck (Gottfried Kniller), d. London; pupil of Ferdinand Bol and probably of Rembrandt himself in 1660s; Italy 1672 (perhaps also 1663), in Rome, and then working professionally in Venice until 1675, then Lübeck briefly; settled in England 1676, where he established the dominant portrait style of the next four decades, a tempered form of high Baroque; immensely successful and prolific, his studio also turned out innumerable workshop replicas and copies; he reserved his best effects of Dutch impasted brushwork for more private portraits, but his Kit-Cat Club series (NPG) demonstrates his versatility within a stereotyped formula. Knighted 1692, baronet 1715, official royal painter from 1688. (See Chp. One, Fig. 2, Plate 1)

LOCATIONS: NPG; HMQ; Yale; VA Mus. of Fine Arts; NG Canada; SNPG; Nat. Marit. Mus.

LITERATURE: # J.D. Stewart, *Sir Godfrey Kneller and the English Baroque Portrait* (Oxford, 1983).

Knight, Harold RA 1874–1961

b. Nottingham, d. Colwall, Gloucs.; studied Nottingham School of Art where he met his wife Laura, the well-known painter of, e.g., circuses; 1894 Paris under Constant and Laurens; influenced by Impressionism; Holland 1905 and influenced by seventeenth-century Dutch and Flemish art; Newlyn 1907, and his palette brightened under that influence; a prolific painter, later in great demand for official portraits, most of which are boring, his best work being done before 1914. ARA 1928, RA 1937.

LOCATION: Nottingham Castle Mus.

Knight, John Prescott RA 1803–81

b. Stafford, d. London; son of comedian Edward Knight; began as a clerk; made copies after *West; subsequently a pupil at Sass's Acad. (with *Clint); RA Schools 1823. He was a gifted if somewhat uneven portraitist, capable of painterly effects although those did not always survive the transfer of likenesses from his excellent oil sketches of heads into larger compositions. ARA 1836; RA 1844. Also genre.

LOCATIONS: NPG; N. Trust, Stourhead; Brinsley Ford, Esq.; Bart's Hospital, London.

LITERATURE: *John Prescott Knight RA 1803–81*, exh. cat. (Stafford Mus. and AG, 1963); # H. Dyson, *John Prescott Knight RA* (Stafford Hist. and Civic Soc., 1971).

Kühn, Justus Englehardt *fl. c.* 1708–17

b. Germany, d. Annapolis, MD, where he had been working since at least the end of 1708; busts are known, and full-lengths of children, stiff and stilted but decorative, with many props and accessories; generally primitive.

LOCATIONS: MD Hist. Soc.; Peabody Inst., Baltimore.

LITERATURE: G & W.

Kyte, Francis *fl.* 1710–45(?)

Author of several very fine portraits of 1740s, including one of G.F. Handel (NPG), akin to those of *Beare; half-length and busts.

LOCATION: NPG.

LITERATURE: EKW.

Lamb, Henry RA 1883–1960

b. Adelaide, S. Australia, d. Salisbury; brought up in Manchester; studied art under *John and *Orpen, and in Paris; a member of the Camden Town Group 1911–12; Official War Artist 1916–18 and again 1939–45. ARA 1940, RA 1949. Best known for his extraordinary portrait of Lytton Strachey fainting in coils, 1914 (Tate).

LOCATIONS: Tate; NPG.

LITERATURE: K. Clements, *Henry Lamb, The Artist and his Friends* (Bristol, 1985).

166. Henry Lamb, *Lytton Strachey*. Oil on canvas, 244.5 × 178.4 cm (96¼ × 70¼ in). 1914. London, Tate Gallery

166

Lambdin, James Reid NA 1807–89

b. Pittsburgh, PA, d. Philadelphia where he had been a pupil of Edward Miles and *Sully 1823–c. 1825, then returning to Pittsburgh. 1832 went to Louisville, KY, finally Philadelphia 1837; taught at Pennsylvania Acad., pupils including his son George Cochran L., NA (1830–96), the flower painter (who also did some portraits).

LOCATIONS: Univ. of Pennsylvania, Peabody Inst., Philadelphia; N.-Y. Hist. Soc.: MD Hist. Soc.

LITERATURE: G & W.

Lambert, George Washington ARA 1873–1930

b. St Petersburg, Russia, of American father; in England 1878, then Sydney, Australia, where he studied under J.R. Ashton; 1891 went to Paris on scholarship for two years; returned to Australia c. 1928; prolific, also painted genre and still-life. Extravagant, whimsical approach that sometimes works, but is sometimes merely silly; generally, his male portraits are more restrained, and benefit from his vivid gifts; style similar to that of *Conder. Father of Constant Lambert.

LOCATION: NPG.

LITERATURE: A. Motion, *The Lamberts* (London, 1986).

Lane, Samuel 1780–1854

b. King's Lynn, d. Ipswich; deaf and almost dumb from birth; pupil of Joseph Farington and of *Lawrence, painted somewhat in *Lawrence manner; friend of John Constable; lived in London and exhibited RA 1804–57 but retired to Ipswich 1853; had a large practice; often full-lengths or seated, many of civic dignitaries and ecclesiastics.

LOCATIONS: Royal Coll. Physicians; NPG; Town Hall, King's Lynn.

Lang, Louis NA 1814–93

b. Württemburg, Germany, d. NYC; studied in Paris 1834, to U.S.A. 1838 at first in Philadelphia; to Italy after a few years, returning to U.S.A. 1847 to NYC where he remained; shared a studio with *Rossiter whom he presumably met in Italy. NA 1852.

LOCATION: N.-Y. Hist. Soc.

LITERATURE: G & W.

László, Philip Alexius de 1869–1937

b. Budapest, d. London; trained Budapest and Acad. Julian, Paris, and in Munich; worked fashionably in Austro-Hungarian Empire,

married a Guinness 1900, and thereafter turned more to England and Ireland, settling London 1907; U.S.A. 1908, sitters including Roosevelt. Immensely successful owing to assiduous self-advertisement, and seen as *Sargent's natural successor; slightly coarse in comparison, although equally glamorous at first sight; all types of portrait.

LOCATIONS: NPG; Imperial War Mus.; many English private collections.

LITERATURE: O. Rutter, *Portrait of a Painter: The Authorized Life of Philip László* (London, 1939).

Latham, James 1696–1747

b. Tipperary(?), d. Dublin; Antwerp 1724/5, then Dublin, but apparently influenced by *Hogarth portraits of c. 1740; the most important Irish painter of his time, rather more uneven than the evidence merely of his best works would suggest; a number are long three-quarter length, also busts, half-lengths.

LOCATIONS: NGI; Tate; Trinity Coll., Dublin.

Latilla, Eugenio Honorius 1808–61

b. Italy (? Naples), d. Chapaqua, NY; exhibited London from 1829; to Rome 1842, 1847–8 in Florence, then London 1849; to U.S.A. 1851 and in NYC until 1859.

Laty, Michael 1826–48

d. Baltimore, MD; gifted but shortlived Baltimore portraitist with some distinguished sitters; ovals are usual.

LOCATIONS: MD Hist. Soc.; Baltimore Mus.

Lauder, Robert Scott RSA 1803–69

b. Silvermills, nr Edinburgh, d. Edinburgh; studied at Trustees' Acad. from 1817 and then in London from 1822/3; to Edinburgh 1827/8; elected to Scottish Acad. 1829; to the continent 1833, mainly Rome, but also, e.g., Florence, Venice and Munich; based in London from his return in 1838; returned to Edinburgh 1852 as influential Master of the Trustees' Acad. but suffered a paralytic stroke 1861. Painted numerous portraits in addition to many subject pictures and histories (often from Sir Walter Scott who had helped him as a youth), with a fine sense of colour. His brother James Eckford L., RSA (1811–69), chiefly painted subjects, but also portraits.

LOCATIONS: SNPG; NGS; RSA; Glasgow AG.

Laurence, Samuel 1812–84

b. Guildford, d. London; exhibited London RA and British Inst. 1834–82; painted or drew

number of literary figures and to U.S.A. 1854
on Thackeray's suggestion, then NYC until
1861 when he returned to England; mainly
portrait drawings but his oil portraits are also
of high quality. Also travelled to Italy.

LOCATIONS: NPG; Nat. Marit. Mus.; Sir M.
Worsley, Bt, Hovingham Hall.

LITERATURE: G & W.

Lavery, Sir John RA, RSA, RHA 1856–1941
b. Belfast, d. Co. Kilkenny; studied Glasgow,
London and Acad. Julian, Paris; influenced by
Bastien-Lepage and *Whistler (a close
associate); Glasgow 1881, London 1897; also
travelled. At his best, a master of brushwork
and of compositions tonally conceived,
notably interior portrait groups that were
planned small and finished on a vast scale; but
astonishingly uneven, the results occasionally
vulgar in conception and colour. ARA 1811;
RA 1921; knighted 1918. (See Chp. Two, Fig.
86)

LOCATIONS: NGI; Ulster Mus., Belfast; NPG.

LITERATURE: *Sir John Lavery RA, 1856–1941*,
exh. cat. (Fine Art Soc., Ulster Mus., NGI,
1984–5).

Lawranson, Thomas *fl.* 1733–86
b. Ireland(?); worked in London; exhibited
Society of Artists 1764–77, and dated works
exist from 1737 and 1748; heads and also
small-scale full-length; also a miniaturist; his
son William L. (*fl.* 1760–*c.* 1783) also painted
portraits.

LOCATIONS: NPG; Messrs Spink & Co. (1960).

Lawrence, Sir Thomas PRA 1769–1830
b. Bristol, d. London; by 1780 in Bath; child
prodigy, mainly self-taught, perhaps with
some instruction from *William Hoare; RA
Schools 1787; he had a sensational success
with *Queen Charlotte*, 1790 (NG). More than
any painter since *Kneller, established his own
style as the dominant manner of the age, based
on exquisitely free brushwork, rich colouring
(notably in use of red) and an overall romantic
air; could work on any scale; *c.* 1800, the
quality fell away owing to over-production,
but he rose magnificently to the opportunity,
after Waterloo 1815, to tour Europe painting
the victors, and achieved a position of
European supremacy. ARA 1791; RA 1794;
succeeded *West as PRA 1820. (See Plate 7)

LOCATIONS: NG; NPG; Chicago Art Inst.

LITERATURE: *Sir Thomas Lawrence*, exh. cat.
(M. Levey) (NPG, 1979); # K. Garlick,
Walpole Society, XXXIX (1964).

Lawson, Thomas Bayley 1807–88
b. Newburyport, MA, d. Lowell, MA; at first a
clerk and then ran a business in Boston;
portraitist from 1841 in Lowell, and in 1858
also had studio in Newburyport; painted
*W. M. Hunt, seated, in a hard, polished style,
1879 (NG Washington).

LOCATION: NG Washington.

LITERATURE: G & W.

Lay, Oliver Ingraham ANA 1845–90
b. NYC; studied Cooper Inst. and NA
Schools, and under Thomas Hills for three
years. ANA 1876.

LOCATION: Royal Shakespeare Gall., Stratford-
upon-Avon.

Lazarus, Jacob Hart ANA 1822–91
b. & d. NYC; pupil of *Inman; worked NYC;
exhibited NA and elsewhere from 1841; ANA
1850. Also a miniaturist.

LOCATION: Met. Mus., NYC.

LITERATURE: G & W.

Le Clear, Thomas NA 1818–82
b. Oswego, NY, d. Rutherford Park, NJ; self-
taught, worked as portraitist in London, Ont.,
and Goderich, Ont., settling NYC 1839, and
had some training from *Inman; then 1844
Buffalo, NY, returning NYC 1860. NA 1863.

LOCATIONS: MD Hist. Soc.; Corcoran Gall.,
NYC.

LITERATURE: G & W.

Lee, Anthony *fl. c.* 1724–67
Irish, d. Dublin; worked on scale of life;
earlier portraits show poor anatomical
structure; later ones seem to show influence
perhaps of *Hudson and of London
portraiture of 1740s.

LOCATIONS: NGI; Lord Molesworth.

LITERATURE: Crookshank & Glin.

Lehmann, Rudolph (Wilhelm August Rudolf)
1819–1905
b. Ottensen, Hamburg, d. London; son of a
portraitist; studied under his brother in Paris,
then in Munich; 1823 to Rome; London 1850.
In Italy (Rome) 1856–66 but lived in London
from 1866.

LOCATIONS: NPG; Baylor Univ., TX.

LITERATURE: Wood; Th.-B.

Leighton, Frederic, Lord Leighton of Stretton
PRA 1830–96

b. Scarborough, d. London; of a distinguished medical family; precocious and had lessons in Rome 1840, thence to Frankfurt, and to Florence to study at Acad. until seventeen, and encouraged by the American sculptor Hiram Powers; then via Frankfurt to Brussels and Paris; to Italy 1852, the while encouraged by von Steinle; influenced by Bouguereau, Gérôme and Robert-Fleury, and by classical Greek sculpture, but above all by his profound understanding of Italian Renaissance painting; one of the very few great British history painters (perhaps the only one), his portraits equally display his prodigious gifts. He travelled to Spain and, e.g., Egypt. Also a sculptor. Baronet 1886 and raised to the peerage 1896 (the first British artist to be so honoured); ARA 1864, RA 1868, PRA and knighted 1878 (in succession to Grant). (See Plate 10)

LOCATIONS: Uffizi; Yale.

LITERATURE: # L. and R. Ormond, *Lord Leighton* (New Haven and London, 1975).

Lely, Sir Peter 1618–80

b. Soest, Westphalia (Pieter Van der Faes, of Dutch parents), d. London; trained Haarlem; Master in 1637; England 1643 painting portraits from 1647; early style delicate and distinctive; later, turned to glittering, rather hectic Baroque manner that adapted many features from Van Dyck but without his refinement, creating what now appears as the quintessence of the Restoration period (when he was the King's official painter); dominated portraiture in England until arrival of *Kneller who continued with the main portrait types that L. established. Like Kneller, had a large studio production, but maintained high personal standard of execution to the end. Knighted 1679/80. (See Chp. One, Fig. 1)

LOCATIONS: Tate; NPG; SNPG; N. Trust, Ham House; Kimbell Art Mus., Fort Worth; J. Paul Getty Mus.

LITERATURE: *Sir Peter Lely 1618–80*, exh. cat. (NPG, 1978).

Leslie, Charles Robert RA 1794–1859

b. London (of American parents), d. London; in Philadelphia as a child, then a pupil in London of *West and *Allston, sharing rooms with *Morse and then going to Italy with *C.W. Peale; then based in London, returning in 1833 to America briefly to take up a post at U.S. Military Acad., only to return within months; best remembered for his autobiographical memoirs and his biographies of John Constable and *Reynolds, he was a successful history painter, but painted a

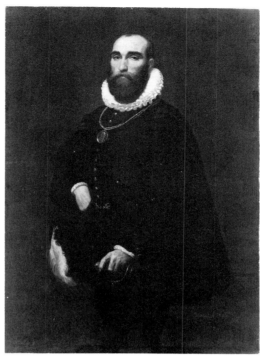

167

number of good portraits in a rather attractive, sometimes dramatic manner. ARA 1825, RA 1826. His sisters Anne L. (1792–post 1860) and Eliza (1787–1858) were portrait painters to some extent in America.

LOCATION: NPG.

LITERATURE: G & W; Flexner, II.

Leutze, Emanuel Gottlieb NA 1816–68

b. Schwäbisch-Gmünd (Germany), d. Washington, DC; grew up in Philadelphia, a pupil of *John Rubens Smith; 1840 Düsseldorf, Munich, Venice and Rome, settled Düsseldorf until U.S.A. 1859 (NYC, Washington, DC), forging the vital links that led to the great flowering of American portraiture in second half of nineteenth century; equally significant as history painter. His portrait effects are as handsome as those of most of his American or European contemporaries.

LOCATIONS: Union League Club, Met. Mus., N.-Y. Hist. Soc., NYC; NPG Washington; Harvard Law School.

LITERATURE: *Emanuel Leutze, 1816–1868*, exh. cat. (Nat. Colln of Fine Arts, Washington, DC, 1975).

Lewis, John *fl.* 1739–*c.* 1769

English or Irish; probably London 1740s; worked in Ireland certainly 1750–7; also scene-painter, and portraits of Sheridan and Peg Woffington are known, 1753 (NGI and

167. Emanuel Leutze, *Worthington Whittredge*. Oil on canvas, 147 × 102.9 cm (57⅞ × 40½ in). 1856. New York, NY, The Metropolitan Museum of Art. Gift of Several Gentlemen, 1903

another, NPG). Works of later 1740s are not unlike those of *Latham, those earlier being slight and provincial; by 1760s quite sophisticated; ovals, half- and three-quarter lengths, sometimes with scenery 'backdrop'.

LOCATIONS: NGI; NPG.

LITERATURE: EKW.

Lilley, Edmund fl. 1702–16

d. Richmond, Surrey; failed to get commission to paint Queen Anne for Guildhall 1702, but in fact images of her are his best-known works, at full-length and three-quarters; style rather continental, and more *Dahl than *Kneller.

LOCATIONS: HMQ; Royal Coll. of Physicians; Duke of Marlborough.

LITERATURE: EKW.

Lindo, F. fl. 1755–65

b. Isleworth(?) but worked in Scotland; Aberdeenshire 1760–2; perhaps a pupil of *Hayman (EKW); also crayons. Small-scale full-lengths (using large-scale settings) also busts in oval; some tiny busts in oval on panel.

LOCATIONS: Capt. Robt Wolrige-Gordon, Esslemont; P. Maxwell Stuart, Traquair House.

Linen, George 1802–88

b. Greenlaw, Scotland, d. NYC(?) (NJ?); trained RSA; U.S.A. 1834, mainly NYC and NJ, but partly itinerant. His brother John L. (c. 1800–c. 1860) was also a portraitist NYC.

LOCATION: MD Hist. Soc.

Liotard, Jean-Etienne 1702–89

b. & d. Geneva; one of the most influential pastellists of his time, influencing, e.g., *Cotes, his work (often busts) is of the highest quality; also oil portraits of all kinds, some very large; a pupil of Massé in Paris, from 1736 he travelled widely in Europe and was in Constantinople 1738–43; England variously 1753–5, and again in London 1772–4. Especially patronized by his friend Sir William Ponsonby (late Earl of Bessborough) with whom he travelled.

LOCATIONS: HMQ; Nottingham Castle Mus.; Earl of Bessborough.

LITERATURE: #R. Loch and M. Röthlisberger, L'opera completa di Liotard (Milan, 1978).

Livesay, Richard 1753–c. 1823

d. Southsea; RA Schools 1774 initially as draughtsman; lived at the house of *Hogarth's widow 1777–85, then assistant of *West, working for him at Windsor from 1790 and as

royal drawing tutor; mainly small-scale half- and full-lengths of same type as *Alleyne but with distinctive use of impasto even on this scale; from 1796 taught drawing at Royal Naval Coll., Portsea.

LOCATIONS: NPG; Eton Coll.; NGI.

LITERATURE: EKW.

Lockwood, (Robert) Wilton NA 1861–1914

b. Witton, CT, d. Brookline, MA; trained as a glass-designer NYC under La Farge, and also studied Art Students' League and in Paris 1886 under Benjamin Constant; worked as portraitist NYC; then to London 1892 (and married), also Munich and Paris; returned U.S.A. 1896 and lived in Boston, but later also worked NYC. ANA 1902, NA 1912.

LOCATION: Boston MFA.

LITERATURE: Met. Mus. Cat., III.

Lorimer, John Henry RSA 1856–1936

b. & d. Edinburgh; RSA Schools after Edinburgh University, under McTaggart and *Chalmers; pupil of Carolus-Duran in Paris 1884. ARSA 1882, RSA 1900. Also painted landscape and genre, especially domestic interiors. Most types of portrait, highly-finished.

LOCATIONS: Tate; Royal and Ancient Golf Club, St Andrews; Messrs Coutts & Co.

LITERATURE: Waters.

Lowry, Strickland 1737–c. 1785

b. Whitehaven, d. Worcester; active in Ireland in 1760s and again c. 1780, and in Whitehaven; also itinerant in West Midlands.

LOCATION: Ulster Mus.

LITERATURE: Hall, Artists of Cumbria.

Macnee, Sir Daniel PRSA 1806–82

b. Fintry, Stirlingshire, d. Edinburgh; trained Glasgow and then at Trustees' Acad., Edinburgh; 1832 went back to Glasgow; in later life, the dominant Scottish portraitist; influenced by *Raeburn and *Geddes; excellent, distinct characterizations, solidly modelled, vigorous brushwork; most types of portrait. RSA 1829, PRSA 1876. Knighted 1877, and thereafter lived in Edinburgh.

LOCATIONS: NGS; RSA; NPG.

Marchant, Edward Dalton ANA 1806–87

b. Edgerton, MA, d. Asbury Park, NJ; Charleston SC, then mainly NYC from c. 1832; based in Philadelphia from c. 1854 until at least 1860. Painted several presidents including Lincoln and Harrison.

LOCATIONS: Hist. Soc. of PA, Union League Club, Philadelphia.

LITERATURE: G & W.

Marchi, Giuseppe Filippo Literati
1735–1808

b. Rome, d. London; *Reynolds's key assistant, although not all aspects of his role are entirely clear; brought back by Reynolds from Rome and with him thereafter, save for brief interludes, notably Wales 1768–9 (with his close friend, the landscape painter Thomas Jones). The few known independent portraits are in a slightly more Italianate form of Reynolds's style in which, interestingly, the hands are very poor, the anatomy suspect in the drapery areas, but the heads extremely fine; and copies by him after other artists are very clever, e.g., Christie's, 11.v.28 (66).

LOCATION: NMW.

LITERATURE: EKW.

Mare, John c. 1739–c. 1795

b. NYC, and there at end of his life; brother-in-law of *William Williams of Bristol; a contemporary in NYC of *McIlworth; Albany, NY, 1772, but generally active NYC and Hudson Valley. Distinctly naturalistic manner compared with that of McIlworth; portraits include official work for NYC.

LOCATIONS: N.-Y. Hist. Soc.; Met. Mus., NYC.

Martin, David 1737–97

b. Austruther, d. Edinburgh; pupil of *Ramsay and joined him during his second Italian visit 1756–7, remaining his principal assistant until late 1760s; worked independently as portraitist in London until moving to Edinburgh mid-1780s, and was the dominant figure there before *Raeburn; influenced by both Ramsay and *Reynolds; quality uneven, often stilted and hesistant; fond of Van Dyck costume in 1770s, and appears later to have tried Raeburn's manner.

LOCATIONS: Lord Ancaster; The Sutherland Trust; Glasgow AG; Earl of Mansfield, Scone Palace.

Martin, John Blennerhassett 1797–1857

b. Boston, Co. Cork, d. Richmond, VA; NYC 1815 and trained as engraver; Richmond, VA from 1817.

LOCATION: Supreme Court Building, Washington, DC.

Masquerier, John James 1778–1855

b. London, d. Brighton; studied Paris 1789; RA Schools 1792; pupil and assistant of

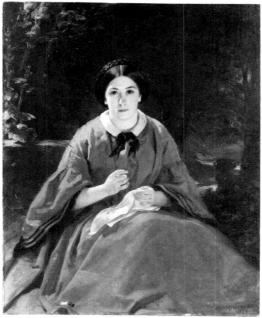

168

168. Sir Daniel Macnee, *Lady in Grey (Portrait of the Artist's Daughter, Mrs Wiseman)*. Oil on canvas, 125.7 × 101 cm (49½ × 39⅜ in). 1859. Edinburgh, National Gallery of Scotland

*Hoppner 1796–9; 1800 in Paris and painted a striking image of Napoleon that was successfully exhibited in London; in Scotland variously after 1802 where he knew *Raeburn; mainly pastel but oils are known; successful, occasionally charming, and eclectic in style, moving successively from Hoppner to Raeburn to *Lawrence.

LOCATIONS: NPG; Holburne of Menstrie Mus., Bath; Royal Soc., Eton Coll.

LITERATURE: R.R.M. Sée, *Masquerier and his Circle* (London, 1922); Whitley, II, I.

Maubert, James 1666–1746

b. Ireland(?), d. London; trained Dublin under Smitz; two main groups have provided the basis for a number of attributions, his style being very distinctive in frenchified sub-*Kneller manner, with very large, blank, oval eyes, a profusion of props (esp. honeysuckle), and bright colouring; extensively employed as copyist.

LOCATIONS: The Earl Bathurst, Circencester Park; NGI.

Mayer, Constant ANA 1829–1911

b. Besançon, d. Paris; studied under Cogniet in Paris; 1857 to NYC and took American citizenship; 1895 returned to Paris; painted Grant and Sherman; photographic manner.

LOCATIONS: Hist. Soc. of PA; Chrysler Mus., Norfolk, VA.

Maynard, Thomas 1752–c. 1812

Worked in London; pupil of *Arthur Devis;

169. Ambrose McEvoy, *Lillah McCarthy*. Oil on canvas, 99.1 × 76.2 cm (39¾ × 30 in). London, National Portrait Gallery

169

170. Gari Melchers, *The Fencing Master*. Oil on canvas, 206.4 × 100.3 cm (91¼ × 39½ in). *c*. 1900. Detroit, MI, Detroit Institute of Arts. Gift of Edward Chandler Walker

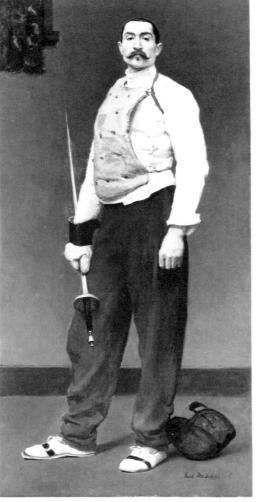

170

small-scale busts, some in oval, in a painterly style quite unlike his master's.

LOCATION: Christie's, 29.iii.63 (39).

LITERATURE: EKW.

McEvoy, Arthur Ambrose ARA 1878–1927

b. Crudwell, Wilts, d. London; encouraged by *Whistler; Slade School from 1893, a friend of *John and *Orpen; exhibited New English Art Club from 1900, influenced by *Sickert; a most fashionable and ingenious society portraitist in a carefully tempered manner that evidently seemed sufficiently 'modern' before the First World War; had transatlantic reputation and one-man show NYC 1920; lived Freshford (Somerset) and London.

LOCATIONS: Manchester CAG; Viscount Cranbourne; Marquess of Salisbury; Imperial War Mus.; Tate.

McIlworth, Thomas *fl.* 1757–*c*. 1770

d. Montreal, Canada(?); worked NYC 1757–62, then apparently Schenectady, NY, until 1767; probably influenced by *Wollaston; some attributed portraits were formerly given to *Blackburn, but his work is less graceful.

LOCATIONS: Smith Coll. Mus. of Art; N.-Y. Hist. Soc.; Baltimore Mus.

LITERATURE: W. & S. Sawitzky, *N.-Y. Hist. Soc. Quarterly* (April, 1951), pp. 116–39.

McInnes, Robert 1801–86

b. Edinburgh, d. Stirling; most types of portrait including quite small-scale groups, usually in a highly-finished meticulous manner; exhibited RA 1841–66; based in London, but evidently in Rome 1844 and Florence 1845, then Shropshire 1858–60, Tunbridge Wells 1866. Had many Scottish sitters. Also painted genre.

LOCATIONS: Hist. Soc. of PA; Capt. C.K. Adam, Blairadam; Earl of Haddington, Tyninghame.

Medina, Sir John Baptist de 1659/60–1710

b. Brussels, d. Edinburgh; London 1686 then first to Scotland 1693/4, taking with him ready-painted 'postures' to which he added heads; settled there, and knighted 1707. Style owes much to *Kneller, mainly busts in oval and generally accomplished, but tried groups, some absurd. *Aikman was his pupil. His son John (II) *c*. 1686–1764 was a curiously primitive portraitist. (See Chp. Three, Fig. 87)

LOCATIONS: Royal Coll. Surgeons, Edinburgh; Earl of Haddington, Tyninghame; Earl of Mar and Kelly, Alloa House; RI School of Design.

LITERATURE: J. Fleming, *Connoisseur*, CXLVIII (August, 1961), pp. 22–5; D. Mannings, *Medical History*, 23 (1979), pp. 176–90.

Melchers, Julius Gari NA 1860–1932

b. Detroit, d. Belmont, nr Fredericksburg, VA; studied Düsseldorf 1877, and 1881 in Paris under Boulanger and Lefebvre; worked variously in Holland, Germany, France and U.S.A., and exhibited Int. Soc. of Artists London; achieved international recognition and awards; settled Fredericksburg, VA, at outbreak of First World War (had been head of Weimar Acad. from 1909). Heavily impasted technique including, in later pictures, frequent use of palette knife. NA 1906.

LOCATIONS: Art Inst. Chicago; Detroit Inst.; NG Washington; Met. Mus., NYC.

LITERATURE: *Gari Melchers, 1860–1932, American Painter*, exh. cat. (Graham Gall., 1978).

Mercier, Philip 1689(?)–1760

b. Berlin (of Huguenot family), d. London; influential in the introduction of French rococo taste and of conversation pieces into England where he arrived 1716, having been in France and Italy; began conversation pieces in mid-1720s and patronized (German connections) by Frederick, Prince of Wales, 1729–38 but then dropped; York 1739–51, visiting Scotland and Ireland; tried Portugal 1752, then London again. Also painted 'fancy pictures'; sometimes blurred distinction between them and portraits. Wholly frenchified in manner, usually bright colours and high key; all types of portrait, and quite capable in full-lengths on scale of life. His wife Dorothy M. (née Clapham) (*fl.* 1735–68), and daughter, Charlotte M. (1738–62), also did some portraits (the latter, e.g., Christie's, 16.iii.82 (70)). (See Chp. One, Fig. 3)

LOCATIONS: N. Trust, Cliveden; HMQ; Tate; Leeds CAG.

LITERATURE: # J. Ingamells and R. Raines, *Walpole Society*, XLVI (1978).

Millais, Sir John Everett, Bt, PRA 1829–96

b. Southampton, d. London; infant prodigy, RA Schools at age eleven; founder Pre-Raphaelite Brotherhood with Rossetti and Holman Hunt; married Ruskin's Effie 1855 and increasingly turned to portraiture which made him immensely rich and successful; later, more sentimental portraits, especially of little girls, can be trying, but he painted some of the finest of all Victorian portraits. ARA 1853; RA 1863; PRA 1896; Baronet 1885. (See Chp. One, Fig. 23; Plate 9)

LOCATIONS: Duke of Norfolk, Arundel Castle; Tate; NG Canada; NPG.

LITERATURE: *Millais*, exh. cat. (Liverpool and London, 1967).

Millar, James c. 1735–1805(?)

b. & d. Birmingham; certainly active 1769; the main portrait painter in Birmingham in second half of the century; most types of portrait including conversation pieces and large-scale full-lengths of some charm and accomplishment.

LOCATIONS: Birmingham CAG; Fitzwilliam Mus., Cambridge; Yale; Lichfield AG.

Millar, William *fl.* 1751–c. 1775

Worked in Edinburgh, much influenced by *Ramsay, whom he knew; half-lengths and busts, many in oval, are typical, of consistently good quality in earlier Ramsay manner, with smooth modelling and chiaroscuro.

LOCATIONS: Earl of Stair, Oxenfoord Castle; NGS.

Millichap, Thomas *fl.* 1813–21

Based Birmingham, apparently one of two of this surname (the other G. T. M.) *fl.* 1842–6, exhibited RA and British Soc. of Artists from Birmingham and London, but not portraits); this one only portraits, exhibited RA and British Inst.; had Scottish patrons; most types of portrait, especially of children.

LOCATIONS: Duke of Argyll; The Sutherland Trust; Duke of Richmond and Gordon; Christie's, 24.vii.80 (135).

Mooney, Edward Ludlow NA 1813–87

b. and d. NYC; pupil of *Inman; NA 1840; mainly worked NYC.

LOCATIONS: Harvard Univ.; City Hall, NYC; Princeton Univ.

Moore, Ernest 1865–c. 1907

b. Barnsley; based in Sheffield; studied London and Paris, exhibited RA 1896–1903; manner derived from French realist tradition.

LOCATIONS: Duke of Norfolk, Arundel Castle; Gray's Inn; NPG.

Mora, Francis Luis NA 1874–1940

b. Montevideo; studied with his sculptor father, then in Boston under *Tarbell and *Benson; NA 1906; accomplished on any scale; also genre and history.

LOCATION: Toledo Mus.

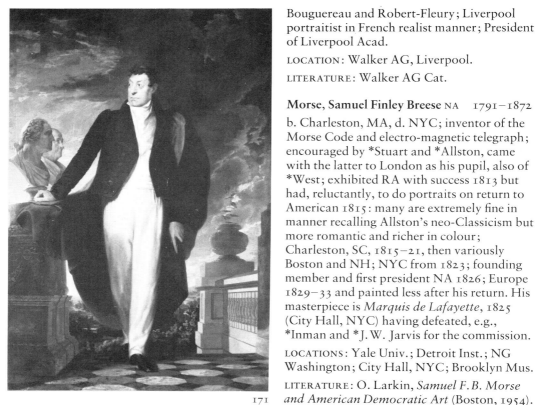

171

Bouguereau and Robert-Fleury; Liverpool portraitist in French realist manner; President of Liverpool Acad.

LOCATION: Walker AG, Liverpool.

LITERATURE: Walker AG Cat.

Morse, Samuel Finley Breese NA 1791–1872

b. Charleston, MA, d. NYC; inventor of the Morse Code and electro-magnetic telegraph; encouraged by *Stuart and *Allston, came with the latter to London as his pupil, also of *West; exhibited RA with success 1813 but had, reluctantly, to do portraits on return to American 1815: many are extremely fine in manner recalling Allston's neo-Classicism but more romantic and richer in colour; Charleston, SC, 1815–21, then variously Boston and NH; NYC from 1823; founding member and first president NA 1826; Europe 1829–33 and painted less after his return. His masterpiece is *Marquis de Lafayette*, 1825 (City Hall, NYC) having defeated, e.g., *Inman and *J. W. Jarvis for the commission.

LOCATIONS: Yale Univ.; Detroit Inst.; NG Washington; City Hall, NYC; Brooklyn Mus.

LITERATURE: O. Larkin, *Samuel F. B. Morse and American Democratic Art* (Boston, 1954).

Morland, Henry Robert 1719(?)–97

d. London; father of the better-known George Morland, 1762/3–1804; he is known for unusual domestic genre in a tenebrist manner, and his approach here, and in his portraits, is generally not unlike that of the mature *Wright of Derby (portraits of 1758 exist in Derby area).

LOCATIONS: Manchester CAG; Viscount Scarsdale, Kedleston Hall; HMG; Chequers.

Morphy (Morphey), Garrett
fl. 1680–1715/16

b. Ireland, d. Dublin; evidently a pupil of Smitz in Dublin, and then presumably went to the continent, and influenced by, e.g., Netscher; in England by 1686 and probably Yorkshire until 1688; in Dublin 1694. Roman Catholic. Most types of large-scale portrait, some unusual in composition; important as early professional Irish portraitist.

LOCATIONS: NGI; Earl of Bradford, Weston Park; Duke of Portland, Welbeck Abbey.

LITERATURE: *Irish Portraits 1660–1860*, exh. cat. (NGI, NPG, Ulster Mus., 1969–70).

Morrison, Robert Edward 1851/2–1924

b. Peele, I.o.M., d. Liverpool; gold medallist Liverpool School of Art then trained Heatherley's and Paris, Acad. Julian under

Mortimer, John Hamilton ARA 1740–79

b. Eastbourne, d. London; pupil of *Hudson and *Pine (1759) and 3rd Duke of Richmond's Acad.; extravagantly gifted, especially as romantic history painter, his portraits are of high quality, including small-scale full-lengths and conversation pieces in a manner far more robust than *Zoffany's, e.g., in the use of cast shadow; his immense energies were, however, also employed elsewhere, notably in drinking and cricket, and he died suddenly.

LOCATIONS: Yale; Tate; Wadham Coll., Oxford; RA.

LITERATURE: # John Sunderland, *Walpole Society*, LI (1987), exh. cat. (Kenwood, Eastbourne, 1968)

Mortlock, Ethel *fl.* 1878–1928

b. Cambridge, d. London(?); pupil of *Orchardson; based in London, exhibited RA 1878–1904; painted one of the earliest portraits showing a sitter smoking a cigarette (3rd Duke of Wellington).

LOCATIONS: Nottingham Castle Mus.; Duke of Wellington, Stratfield Saye.

Morton, Andrew 1802–45

b. Newcastle-upon-Tyne (into a professional family), d. London; RA Schools silver medal 1821; exclusively a portraitist, his style based

on *Lawrence's, but the final effect quite
unlike; most types of large-scale portraiture.
Exhibited RA from 1821 but also in Newcastle
where he worked from 1826; he retained a
flourishing London practice.

LOCATIONS: NPG; Laing AG; Lit. & Phil. Soc.,
Newcastle-upon-Tyne; Apsley House;
Wallace Colln; SNPG.

LITERATURE: Hall, *Artists of Northumbria.*

Moseley, Henry *fl.* 1841–66

London portrait painter, exhibited RA and
British Inst. 1842–66; married to daughter of
H.B. Chalon (and niece of James Ward),
Maria C., miniaturist, probably in 1841, from
which year she exhibited under her married
name; sitters include exotic
travellers/explorers (portrayed in costume and
with frames to match).

LOCATION: NPG.

LITERATURE: Foskett; Th.-B.

Mosman, William *fl.* 1731–71

b. Aberdeen(?), d. nr Aberdeen; perhaps a
pupil of *Aikman; studied Rome *c.* 1732–8
under Imperiali, as *Ramsay did, but clumsier
in his figures and use of elaborate settings, the
perspective, e.g., awry, but tried all types; in
Aberdeen from 1750s.

LOCATIONS: Sir Arthur Boswell Elliott of
Stobs, Bt; N. Trust for Scotland, Culzean
Castle.

LITERATURE: EKW.

Mosnier, Jean-Laurent 1743–1808

b. Paris(?), d. St. Petersburg; trained Paris;
London 1790–6 and adapted to English taste,
but the colours and key quite high; 'slightly
Frenchified Hoppners' (EKW); all types of
large-scale portrait; later court painter St
Petersburg.

LOCATIONS: The Earl Cathcart; Marquess of
Lansdowne; Marquess of Tweeddale; Nat.
Marit. Mus.; Univ. of Michigan.

LITERATURE: EKW; G. Marlier, *Actes du XIXe
Congrès International d'Histoire de l'Art*
(Paris, 1959), pp. 405–11.

Mosses, Alexander 1793–1837

b. & d. Liverpool; apprenticed as engraver to
pupil of Thomas Bewick, then taught by local
painter; small- and large-scale portraits of
local sitters in a style that is far from
provincial; encouraged *Daniels.

LOCATION: Walker AG.

LITERATURE: Walker AG Cat.

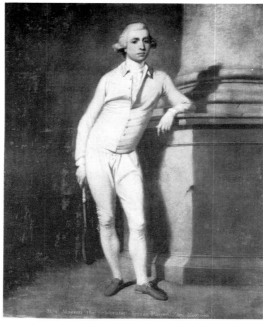

172

172. John Hamilton
Mortimer, *M. Masson,
the French Tennis Player.*
Oil on canvas,
76.2 × 63.5 cm
(30 × 25 in). *c.* 1769.
Private collection

Mount, William Sidney NA 1807–68

b. & d. Setauket, Long Island, NY; pupil of
*Inman and 1826 NA School; working
1827–36 NYC and then Long Island; one of
the most famous American genre painters he
largely depended for his livelihood on
portraits, which are characterized by *Allston-
like clarity. ANA 1831, NA 1832. His two
brothers also painted, Shepard Alonzo M., NA
(1804–68), being a portraitist.

LOCATION: Brooklyn Mus.

LITERATURE: #M.B. Cowdrey and H.W.
Williams, *William Sidney Mount, 1807–1868,
An American Painter* (NY, 1944).

Murray, Thomas 1663–1735

b. Scotland, d. London; pupil of one of de
Critz family then of *Riley; very successful but
limited portraitist; used props and settings
after about 1700 like those of *Closterman; all
types of large-scale portrait. The Tuscan
ambassador accurately assessed him in 1708 as
one of the more mediocre portrait painters
around, not having heard of him beforehand,
even though by that time Murray had, e.g.,
painted the Queen.

LOCATIONS: NPG; Trinity Coll., Cambridge;
Middle Temple; Royal Soc.

LITERATURE: *Firenze e l'Inghilterra*, exh. cat.
(Palazzo Pitti, Florence, 1971); A.M. Crinò,
Rivista d'Arte, XI (1963).

Nasmyth, Alexander 1758–1840

b. & d. Edinburgh; after mid-1790s gave up
portraits for landscape; mainly conversation

173. John Neagle, *Pat Lyon at the Forge*. Oil on canvas, 236.1 × 172.6 cm (93 × 68 in). 1826-7. Boston, MA, Museum of Fine Arts. Herman and Zoe Oliver Sherman Fund

173

174

174. George Hall Neale, *'Solomon' – John Thomas Harris, 'Lusher' of Top-hats at New and Lingwood, Eton.* Oil on panel, 62.8 × 49.5 cm (24¾ × 19½ in). *c.* 1926. Eton College

pieces, some large, not unlike groups of *David Allan; trained at Trustees' Acad., then worked for *Ramsay 1774 London; Edinburgh 1778; Italy 1782, Rome 1783–5, then Edinburgh.

LOCATION: NPG.

LITERATURE: P. Johnson and E. Money, *The Nasmyth Family of Painters* (Leigh-on-Sea, 1977).

Neagle, John 1796–1865

b. Boston, MA, d. Philadelphia, PA; brought up in Philadelphia and lived there; apprenticed to coach painter then pupil of *Otis and *Sully, became Sully's son-in-law, and much influenced by him, employing a soft, romantic, painterly rather high-coloured style; also influenced by *Stuart whom he went to see in Boston 1825. One of the most impressive American portraitists of second quarter of nineteenth century; all types of large-scale portrait.

LOCATIONS: NG Washington; Boston MFA; Pennsylvania AFA; Newark Mus.

Neal, David Dalhoff 1838–1915

b. Lowell, MA, d. Munich; 1861 studied Munich under von Wagner and von Piloty, and 1869 in the latter's atelier; histories at first, then became a society portraitist commuting between his home in Munich and U.S.A., e.g., NYC and Baltimore 1887; his strong lighting is typical of Munich manner but portraits are more highly finished.

LOCATION: Baltimore Mus.

Neale, George Hall *fl.* 1883–1940

b. Liverpool, d. London; probably born *c.* 1870; studied Liverpool then Paris under Laurens and Constant; based in Liverpool; exhibited RA from 1891; married portraitist Maud Rutherford and he would paint husband while she did the wife; to London *c.* 1914.

LOCATIONS: Athenaeum, London; Walker AG, Liverpool.

LITERATURE: Walker AG Cat.

Newell, Hugh 1830–1915

b. nr Belfast, d. Bloomfield, NJ; America *c.* 1851; Baltimore, Md., until *c.* 1860 then Pittsburgh PA, and Baltimore 1879–1892.

LOCATION: Baltimore Mus.

Newenham, Frederick 1807–59

b. Co. Cork, d. London; in London 1842, commissioned to paint portraits of Queen Victoria and Prince Albert; exhibited RA 1838–55; he was a fashionable portraitist, especially of women; also history pictures of the cavaliers and roundheads variety.

LOCATION: Inst. of Directors.

Newton, Gilbert Stuart RA 1795–1835

b. Halifax, Nova Scotia, d. London; pupil of *Stuart, his maternal uncle; to Italy 1817 then Paris and RA Schools; went mad December 1832, recovering only four days before his death; a friend of *Leslie (cf. *Autobiographical Recollections*, I, pp. 137 f.) and Washington Irving. He sometimes imitated his uncle's manner, but generally his portraits are distinguished by their lack of structure. Painted many subject pictures which were inexplicably popular; he and his Bostonian wife Sally were a great success in English society. ARA 1828, RA 1832.

LOCATIONS: Walker AG, Liverpool; Harvard Univ.; Marquess of Lansdowne.

LITERATURE: Whitley II, 2, pp. 22 f., 260–1.

Nicholson, William RSA 1784–1844

b. Ovingham, d. Edinburgh; grew up in Newcastle-upon-Tyne and trained there; began as miniaturist and tried Hull, but back to Tyneside, working large scale; 1814 to Edinburgh; founding member Scottish Acad.; exhibited portrait of Thomas Bewick RA 1816 and kept up Newcastle connections. Also painted small-scale full-length and busts, sometimes using panel support, portrait drawings and watercolours and also a landscape painter. His larger oils have an element of *Raeburn in them.

LOCATIONS: Nat. Army Mus.; RSA; SNPG.

LITERATURE: Hall, *Artists of Northumbria*.

Nicholson, Sir William Newzam Prior 1872–1949

b. Newark-upon-Trent, d. Blewbury, Berks.; a pupil of *von Herkomer at Bushey 1888–9, then at Acad. Julian, Paris 1889–90. Of great importance in the history of poster design with his brother-in-law James Pryde as 'J. & W. Beggarstaff', and as a print-maker, he maintained a steady portrait practice and was a founder-member of the National Portrait Soc. 1911. Knighted 1936. Travelled widely, to U.S.A. as well as in Europe and the Empire.

LOCATIONS: NPG; Tate.

LITERATURE: Waters; M. Steen, William Nicholson (London, 1943).

Northcote, James 1746–1831

b. Plymouth, d. London; London 1771, assistant to *Reynolds 1771–5; then Plymouth; Rome 1777–80 then London; wrote Reynolds's biography 1813; style based on Reynolds, with similar classicizing tricks and props, uneven in quality; also histories. (See Plate 29).

LOCATIONS: Albert Mem. Mus., Exeter; NPG; Shire Hall, Bedford; Cyfarthfa Castle AG, Merthyr Tydfil.

Oliver, Archer James ARA 1774–1842

d. London; RA Schools 1790. Early pictures are naive as if self-taught, but he rapidly assumed a fashionable manner under the influence of *Lawrence, and had a good practice until ill-health *c.* 1820.

LOCATION: Duke of Norfolk, Arundel Castle.

Opie, John RA 1761–1807

b. St Agnes, Cornwall, d. London; one of the most interesting artists of his time; discovered by 'Peter Pindar' (John Wolcot) who presented him (after training) as an untutored genius, the 'Cornish Wonder', in London 1781. He had a natural capacity for strong effects of chiaroscuro and became very fashionable as 'the English Rembrandt'; his later aristocractic portraits, however, are eclectic (e.g., imitating Gainsborough) and surprisingly poor; also painted history and other subjects; he remained a man of 'invincible vulgarity'. ARA 1787, RA 1788, Professor of Painting, RA, 1805.

LOCATIONS: Duke of Norfolk, Arundel Castle; Duke of Argyll, Inveraray Castle.

LITERATURE: M. Peters, *John Opie 1761–1807*

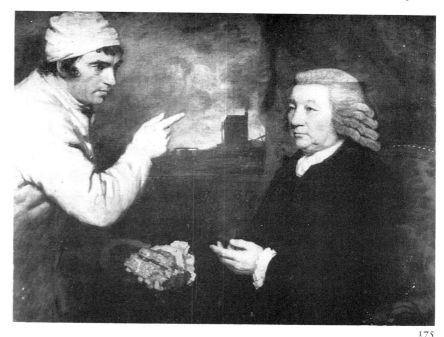

175

(1962); # A. Earland, *John Opie and His Circle* (London, 1911).

Orchardson, Sir William Quiller RA 1835–1910

b. Edinburgh, d. London; studied Trustees' Acad. with, e.g., *Pettie; began working in Edinburgh then settled London and exhibited RA from 1863; famous for genre ('the Hogarth of the Victorian drawing room') he was also an excellent portraitist in a freely-brushed, painterly manner; most types of portrait, some set in interiors, sitters occasionally in costume. ARA 1868, RA 1877, knighted 1907.

LOCATIONS: Manchester CAG; RSA; Tate; Univ. of Glasgow; NGS.

LITERATURE: *Sir William Quiller Orchardson RA*, exh. cat. (Scottish Arts Council, 1972).

Ord, Joseph Biays 1805–65

b. & d. Philadelphia, PA; son of a naturalist, he worked in Philadelphia in a looser, more attractive style than that of most of his contemporaries in 'provincial' practice and exhibited quite widely; also still-life and religious pictures.

Orpen, Sir William Newenham Montague RA 1878–1931

b. Stillorgan, Co. Dublin, d. London; studied Dublin Met. School of Art 1890–7 and Slade School 1897–9. He had great gifts, especially for expressive brushwork and sensitive colour, and his early works have immense appeal and interest, one of his best groups being the significantly entitled *Hommage à Manet* (1910, Manchester CAG); but his portraits, many of

175. John Opie, *Thomas Daniell and Captain Morcan, with Polperro Mine, St Agnes, in the background*. Oil on canvas, 99 × 124.5 cm (39 × 49 in). 1786. Truro, County Museum and Art Gallery

them official or presentation, became increasingly staid and conservative in later life. War artist 1917–19. RHA 1908; ARA 1910, RA 1920; knighted 1918. Also genre and figures.

LOCATIONS: NPG; Petworth; Nat. Marit. Mus.; NG Canada; Manchester CAG.

LITERATURE: B. Arnold, *Orpen: Mirror to an Age* (London, 1981).

Osborne, Walter Frederick RHA 1859–1903

b. Dublin, d. London; studied RHA School and in Antwerp under Verlat: based Dublin but often working in England; influenced by *Whistler; Spain 1895, Holland 1896. RHA 1886. Dublin's most fashionable portraitist; declined knighthood 1900; exhibited RA and with New English Art Club.

LOCATIONS: NGI; Colln. Belfast Harbour Commissioners.

LITERATURE: # J. Sheehy, *Walter Osborne* (Ballycotton, 1974).

Osgood, Samuel Stillman ANA 1808–85

b. New Haven, CT(?), d. California; brought up in Boston where he trained until 1829; was then in Charleston, SC; in Europe 1835–9, then Charleston and Boston, Philadelphia in 1847 and 1849, then NYC where based until moving to California 1869. His style shows

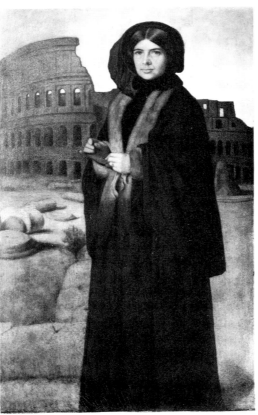

176. William Page, *Mrs William Page*. Oil on canvas, 153.04 × 92.08 cm (60¼ × 36¼ in). 1860. Detroit, MI, Detroit Institute of Arts

awareness of contemporary European developments.

LOCATIONS: Boston MFA; N.-Y. Hist. Soc.

Otis, Bass 1784–1861

b. Bridgwater, MA, d. Philadelphia, PA; taught informally by a coach-maker, working NYC as portraitist 1808; 1812 went to Philadelphia where he invented perspective protractor; produced first American lithograph 1818 or 1819; 1845 went to NYC, and shortly after to Boston; Philadelphia from 1858; a competent painter, his portraits of women and children have naive charm.

LOCATIONS: NG Washington; Boston MFA.

LITERATURE: G & W.

Ouless, Walter William RA 1848–1933

b. St Helier, Jersey, d. London; RA Schools 1865–9; prolific, immensely successful society portraitist; his portraits are determinedly straightforward, vigorously handled, often in rather hot colours; apparently untouched by most continental fashions. ARA 1877; RA 1881. (See Plate 30)

LOCATIONS: NPG; Lancashire CCC; Walker AG, Liverpool.

Owen, William RA 1769–1825

b. Ludlow, d. London; in London 1786, apprenticed to Charles Cotton RA (coach painter); RA Schools 1791. He represents a calmer strain of Regency portraiture than that of *Lawrence, although influenced by him; highly successful, succeeded *Hoppner as Prince Regent's painter 1810. All types of portrait, including any number of bishops; excellent with children. Disabled after 1820. ARA 1804, RA 1806.

LOCATIONS: NPG; Dulwich Coll. AG; Nat. Marit. Mus.

Page, William NA 1811–85

b. Albany, NY, d. Long Island, NY; pupil of *Morse; NYC 1833–43 then Boston until he went to Europe 1849, remaining there until 1860, mainly in Florence and Rome; made technical experiments, and so the colour has fled from some pictures; strongly influenced by Old Masters. In NJ on return to U.S.A., then Staten Island, NY, 1866. NA 1837 and President of NA 1871–3.

LOCATION: Boston MFA.

LITERATURE: J. Taylor, *William Page: The American Titian* (Chicago, 1957).

Palmer, William 1763–90

b. Limerick, d. Bruff, Ireland: studied Royal Dublin Schools (until 1781) then RA Schools

1783, and a pupil of *Reynolds, returning Limerick 1788; clearly gifted, died of consumption.

LOCATION: NPG.

LITERATURE: Strickland; C.K. Adams, *Connoisseur*, LXXXVIII (July, 1931), pp. 3–5; EKW.

Paradise, John Wesley ANA 1809–1862

b. NJ, d. NYC; son of portraitist John P., NA (1783–1833), a founding member of NA; trained NYC as engraver with Asher B. Durand; worked NYC; his portraits are pleasing though unoriginal.

LOCATION: NG Washington.

LITERATURE: G & W.

Parry, William ARA 1742–91

b. & d. London; son of the great blind Welsh harpist painted by *Hogarth and, like *Richard Wilson, patronised by Sir Watkin Williams-Wynn; studied variously in London, a pupil of *Reynolds (who influenced him) 1766, RA Schools 1769. Working in Wales, c. 1769–70, then Rome until 1775; Wales again, then Rome from 1780 until death on his return. An accomplished painter of considerable originality; small-scale full-length and large-scale (including group) portraits are known. ARA 1776.

LOCATIONS: Sotheby's, 17.vi.81 (43); Christie's, 2.iv.65 (35).

LITERATURE: EKW.

Partridge, John 1790–1872

b. Glasgow, d. London; in London 1814, a pupil of *Thomas Phillips; France 1823 then Italy until 1827; fashionably successful on his return, maintaining extensive Scottish patronage; official court painter from 1842 but superseded by *Winterhalter. Male portraits often intense, women and children sentimental; clearly enjoyed working on a very large scale.

LOCATIONS: NPG; NGI; Royal Soc. of Musicians; Messrs Coutts & Co.; Lincoln's Inn (loan).

Partridge, Nehemiah 1683–c. 1729/37

Now identified with 'Aetatis Suae Limner' and 'Schuyler Painter'; in Boston 1713–15, NYC 1717–18, and significant as one of the earliest portraitists of Hudson Valley; worked full-length on scale of life in wooden, naive interpretations of Grand manner.

LOCATIONS: City of Albany, NY; Mrs David Van der Planck.

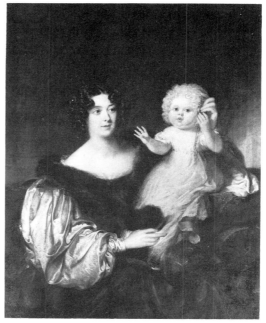

177

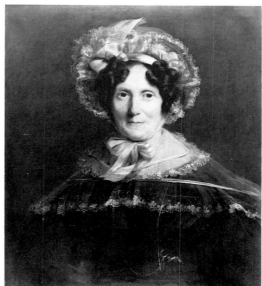

178

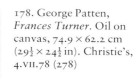

177. John Partridge, *Catherine, Lady Doughty, with her son, Henry Doughty Tichbourne*. Oil on canvas, 125.7 × 100.3 cm (49½ × 39½ in). 1830. Christie's, 16.x.72 (347). Present whereabouts unknown

178. George Patten, *Frances Turner*. Oil on canvas, 74.9 × 62.2 cm (29½ × 24½ in). Christie's, 4.VII.78 (278)

LITERATURE: M. Black, *The American Art Journal* (Autumn, 1980), pp. 4–31.

Patten, George RA 1801–65

b. & d. London(?); based in London; trained as miniaturist with father William P.; RA Schools 1816; oil portraits by 1825; painted Paganini 1837, then went to Italy, and in 1840 to Germany to paint Prince Albert. ARA 1837, RA 1840; could work comfortably on large scale; many Liverpool and northern sitters. Exceptionally straightforward and sympathetic painter of women.

LOCATIONS: Walker AG, Liverpool; Christie's, 3-4.viii.78 (278).

179. Rembrandt Peale, *Eleanor and Rosalba Peale*. Oil on canvas, 106.7 × 83.3 cm (42 × 32¹³⁄₁₆ in). 1826. Brooklyn, NY, The Brooklyn Museum. A. Augustus Healy Fund

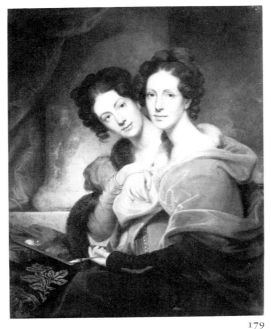

179

Peacock, Ralph 1868–1946

b. & d. London; destined for Civil Service, studied part-time South Lambeth Art Schools; *Pettie encouraged him, and he went to St John's Wood Art School then, 1887, RA Schools; in Europe, e.g., Switzerland and Italy 1891–3, and successful there as at home; thereafter a successful society portraitist based in London; also illustrator and painted subject pictures. Especially popular as a painter of children and the young, in a straightforward unaffected way.

LOCATIONS: Trustees of the Chatsworth Settlement; Tate; J.B. Speed Art Mus., Louisville, KY.

LITERATURE: *The Studio* (October, 1900), pp. 3 ff.

Peale, Charles Willson 1741–1827

b. Queen's County, MD, d. Philadelphia; variously saddle-maker, wood-carver, palaeontologist, wax-modeller, miniaturist, taxidermist, and inventor of, e.g., types of velocipede, windmill, bridges, spectacles and false teeth; also a naturalist, and father of seventeen children, five of them well-known painters. He exchanged a saddle for painting lessons from *John Hesselius in Philadelphia; 1765 Boston, met *Copley, then 1767–9 with *West in London; then Annapolis, MD, 1769–75; 1776 in Revolutionary Army; 1778 settled Philadelphia, assisted *Pine, established his own gallery and museum. Portraits are highly original, in a rather linear manner, and he would attempt any kind, including allegories and *trompe l'oeil (Staircase Group,*

1795, Philadelphia Mus.). (See Chp. One, Fig. 14)

LOCATIONS: Boston MFA; Philadelphia Mus.; N.-Y. Hist. Soc.; NPG.

LITERATURE: C.C. Sellers, 'Charles Willson Peale', 2 vols, *Memoirs of the American Philosophical Soc.*, vol. 23, pts. 1–2 (Philadelphia, 1947).

Peale, Rembrandt NA 1778–1860

b. Bucks County, PA, d. Philadelphia; son of *C.W. Peale, who taught him; helped his father with museum and exhumation of mastodon 1801, exhibiting some of it in England 1802–3, when he met *West and went to RA classes; Europe again 1808 and 1809–10, mainly Paris, and thereafter much influenced by French neo-Classicism, especially art of J.-L. David. 1814 opened his father's Peale Museum in Baltimore, MD; then lived NYC from 1822; Philadelphia after 1831, but had studios in a number of cities. Washington first sat to him 1795, and R's development of his 'porthole' likeness of Washington made his fortune (helped in replicas by his wife Harriet Cany P.). Most portraits are characterized by high degree of finish and lucidity in the French manner, and a personal intensity of vision. Founder member NA 1826.

LOCATIONS: Met. Mus., NYC; N.-Y. Hist. Soc.; Toledo Mus.; Baltimore Mus.

LITERATURE: *The Peale Family*, exh. cat. (Detroit Inst., 1967).

Peale, Sarah Miriam 1800–85

b. & d. Philadelphia, PA; daughter of James P., the brother of *C.W. Peale; taught by her father. After 1831 in Baltimore, MD, then St. Louis, MO, 1847, returned to Philadelphia 1877; influenced by her brother *Rembrandt P.'s neo-Classicism, she was the most important woman painter in America in the first three-quarters of the nineteenth century.

LOCATION: Baltimore Mus.

LITERATURE: *Miss Sarah Miriam Peale, 1800–1885: Portrait and Still-Life*, exh. cat. (Peale Mus., Baltimore, 1967).

Pearce, Stephen 1819–1904

b. & d. London; RA Schools 1840, then a pupil of *Shee 1841–3; travelled in Holland and Germany as tutor, then independently to Italy; from 1848 worked in London, his main opportunity being in 1850, *The Arctic Council* (NPG), which led to forty further separate portraits, those of explorers in arctic gear being especially successful.

LOCATIONS: NPG; Royal Soc.

LITERATURE: G. Paget, *Apollo*, L (November, 1949), pp. 142–4.

Pegler, Charles William *fl.* 1823–34

London portraitist, exhibited RA 1823–32, and Royal Soc. of British Artists, 1826–34, exclusively portraits; half-lengths and groups known, all accomplished, including *Family of 1st Earl of Zetland* (Private Colln); style a little like that of *Owen.

LOCATIONS: Bart's Hospital, London; Royal Coll. of Surgeons.

Peixotto, George Maduro 1859–1939

b. Cleveland, OH; studied Dresden Acad. (silver medal), and in Paris, a pupil of Meissonier and Munkácsy; lived NYC (apparently at the Waldorf-Astoria); presumably related to the decorative painter Ernest Clifford P. (1869–1940). Highly accomplished in European realist manner.

LOCATION: Brooklyn Mus.

Pellegrini, Domenico 1759–1840

b. Galliera (Bassano), N. Italy, d. Rome; trained Venice and Rome; London 1792, RA Schools 1793, and mainly in London until *c.* 1812; greatly influenced by British portraiture, he produced his best work in a resultantly more restrained manner.

LOCATIONS: NPG; Nat. Marit. Mus.

LITERATURE: EKW.

Penny, Edward RA 1714–91

b. Knutsford, d. Chiswick; pupil of *Hudson, then studied in Rome under Benefial; England 1743, working Cheshire 1744 but soon based London. Many portraits are small-scale full-lengths not unlike *Devis's; also larger scale on return from Italy, e.g., busts in ovals; pioneered type of moralising histories using recent incidents that anticipates *Copley's subject-matter but of a non-dramatic, domestic type. Foundation member RA and Professor of Painting at RA 1769–83.

LOCATIONS: Laing AG, Newcastle-upon-Tyne; Brinsley Ford, Esq.; RA; Tate.

LITERATURE: EKW.

Perry, Enoch Wood NA 1831–1915

b. Boston, MA, d. NYC; clerk in New Orleans 1848–52, then to Düsseldorf to train as painter under *Leutze until 1854, then Paris with Couture, followed by Rome and Venice (U.S. Consul 1856–8); 1859 Philadelphia then New Orleans, and from 1862 travelled to

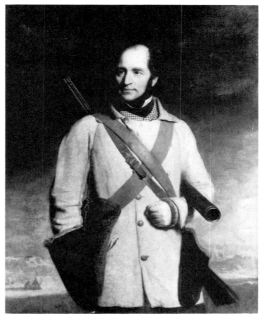

180

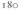

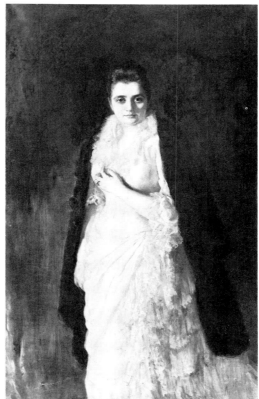

181

California, Hawaii and Utah; 1866 settled NYC. NA 1869. Famous for genre scenes which like his portraits have meticulous detail, especially of interiors, and dramatic light effects; later style is somewhat more impressionistic.

LOCATION: Amer. Art. Assoc., NYC.

LITERATURE: G & W; Baigell.

180. Stephen Pearce, *Sir Robert McClure*. Oil on canvas, 127.3 × 101.6 cm (50⅛ × 40 in). 1855. London, National Portrait Gallery

181. George Maduro Peixotto, *Portrait of Fedelia Wise*. Oil on canvas, 172.7 × 101.3 cm (68 × 39⅞ in). 1882. Brooklyn, NY, The Brooklyn Museum. Gift of Mr A. Piza Mendes

182. The Revd Matthew William Peters, *Edward Wortley Montagu in Eastern Dress*. Oil on canvas, 116.8 × 82.5 cm (46 × 32½ in). *c.* 1776. London, National Portrait Gallery

182

Peters, The Revd Matthew William RA 1741/2–1814

b. Freshwater, I.o.W., d. Brasted, Kent; in Dublin as a child; a pupil of Robert West at Royal Dublin Schools, then of *Hudson in London late 1750s; in Rome (under Batoni) and Florence *c.* 1762, returning Dublin 1765 then in London from 1766; France and Italy 1772–6 (Venice 1773), probably influenced by Greuze; famous for painting seductive young women with prominent nipples; his respectable female sitters are cast in a similarly coquettish mould, an obsession that limited his range as a portraitist. A gifted and thoughtful painter, he tried all types of portrait, some Rembrandtesque, others wildly allegorical; often employed tricks of shadow across the face. In holy orders from 1781 and gradually ceased painting.

LOCATIONS: Trinity Colln., Cambridge; Duke of Rutland; Burghley House Colln.

LITERATURE: #Lady Victoria Manners, *Matthew William Peters* (London, 1913).

Peticolas, Edward F. 1793–*c.* 1853

b. Pennsylvania, d. Richmond(?), VA; son of French miniaturist Phillippe Abraham P.; in Richmond 1804; trained by *Sully, and was a friend of *Neagle. 1815 to England, France and Italy, returning VA 1820, and became well known as portraitist; Europe again 1825 and 1830–3; abandoned painting *c.* 1845 through rheumatism. Style is cool, faintly neo-Classical in rather a French manner.

LOCATIONS: Private collections, U.S.A.

LITERATURE: G & W.

Pettie, John RA 1839–93

b. Edinburgh, d. Hastings; studied Trustees' Acad. alongside, e.g., *Orchardson and *G.P., Chalmers, under *R.S. Lauder; 1862 to London sharing studio with Orchardson; mainly painted genre and costume histories of the 'scheming cardinal' type, but increasingly portraits; sitters tend to look smug, a number of them painted in seventeenth-century dress, but he had considerable gifts of vigorous execution. ARA 1866, RA 1873. (See Chapter One, Fig. 34)

LOCATIONS: Glasgow AG; Dundee CAG.

LITERATURE: M. Hardie, *John Pettie* (London, 1908).

Phelps, Richard *c.* 1710–85

b. & d. Porlock; local Somerset painter, with touches of *Highmore and even *Hogarth in his manner; exh. Soc. of Artists in London 1764.

LOCATIONS: Bristol CAG; N. Trust, Dunster Castle; Crowcombe Court.

LITERATURE: EKW.

Philips, Charles 1708–47

b. & d. London; son of portraitist Richard P. (*c.* 1681–1741); patronized by Frederick, Prince of Wales; specialized in conversation pieces and small-scale full-lengths, imitative of *Hogarth, especially in early 1730s, but which lack a sound grasp of figures and perspective; his trouble with relative proportions persisted in his later large-scale portraits.

LOCATIONS: NPG; Yale.

LITERATURE: EKW.

Phillips, Henry Wyndham 1820–68

b. & d. London; son and pupil of *Thomas P; exhibited RA 1839–68; also painted religious subjects. In Paris 1848, Florence *c.* 1852. Evidently much enjoyed painting sitters in exotic costume, and was sensitive to adapting portraiture of the past, e.g., that of Van Dyck.

LOCATIONS: NPG; Viscount Wimborne; HMQ (Osborne).

Phillips, Thomas RA 1770–1845

b. Dudley, d. London; trained as glass-painter in Birmingham; RA Schools 1791; then briefly helped *West. ARA 1804, RA 1808, after which date exclusively portraits (he had earlier painted histories). Represents the 'alternative' strain of Regency portraiture to that of *Lawrence, painting in a more subdued

manner, but often carefully based on study of Old Masters. Sitters often academic and clerical, but also enjoyed aristocratic patronage. (See Chp. One, Fig. 21)

LOCATIONS: NPG; NMW; Trustees of the Chatsworth Settlement.

Philpot, Glyn Warren RA 1884–1937

b. & d. London; studied Lambeth School of Art from 1900, then Acad. Julian, Paris, under Laurens 1905. Convert to Roman Catholicism 1905 when he set up his own studio and was successful from the start. Went to Spain and was influenced by Velásquez. Precocious and brilliant, he was sensitive to many contemporary developments in art, adapting them to his thriving society portrait business. (See Plate 32)

LOCATIONS: NPG; Fitzwilliam Mus., Cambridge; many private collns in England.

LITERATURE: *Glyn Philpot: Edwardian Aesthete to Thirties Modernist*, exh. cat. (NPG, 1984–5).

Pickering, Henry *fl*. 1740–*c*. 1771

d. Manchester and probably from that area; evidently in Italy *c*. 1739; employed *Van Aken for drapery along with *Hudson whose style his resembles, being even smoother in modelling with rather more accentuated shadows. Could handle complex groups. In London 1745–6 then in the North of England, presumably based in Manchester (1759).

LOCATIONS: Walker AG, Liverpool; Nottingham Castle Mus.

LITERATURE: EKW; Walker AG Cat.

Pickersgill, Henry William RA 1782–1875

b. & d. London; pupil of the landscape artist George Arnald, ARA; RA Schools 1805; exhibited extensively RA 1806–72, almost exclusively portraits, but also painted landscape and genre and often enlivened his portraiture with such details; had a very large and often very grand practice, and could paint with considerable finesse. Sitters include *Copley's son, Lord Lyndurst (Lincoln's Inn). If he was not a pupil of *Lawrence, then he had studied his work closely. ARA 1822, RA 1826. His brother and nephew were also painters, and his son, Henry Hall P. (1812–61), painted portraits but mostly genre.

LOCATIONS: NPG; HMQ; Duke of Norfolk, Arundel Castle; Palace of Westminster; Lincoln's Inn.

Pine, Robert Edge *c*. 1730–88

b. London, d. Philadelphia, PA; son of

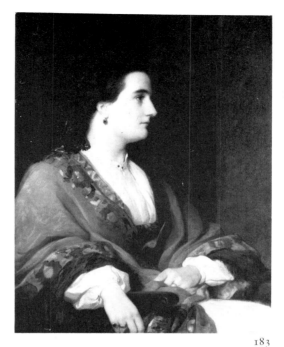

183. Henry Wyndham Phillips, *Lucie, Lady Duff-Gordon*. Oil on canvas, 91.7 × 71.1 cm (36⅛ × 28 in). 1851. London, National Portrait Gallery

183

184. Glyn Philpot, *Mrs Basil Fothergill and her Daughters*. Oil on canvas, 198.1 × 137.2 cm (78 × 54 in). Brighton, Royal Pavilion and Art Gallery and Museums

184

engraver; London late 1740s to 1772 then Bath until 1779; emigrated to America, 1783, in Philadelphia by 1784. He had great aspirations to be a history painter. His best portraits (all large scale) show sitters 'in action', and many have ingenious settings, but some show slightly uncertain anatomy, even in 1760s when he was much in demand. In Philadelphia he was helped by *C. W. Peale; Washington sat to him, and he met with much success.

185. Robert Edge Pine, *Charles Weston and his Son, Charles*. Oil on canvas, 124.5 × 100.4 cm (49 × 39½ in). Early 1760s. P. and D. Colnaghi Ltd (1986)

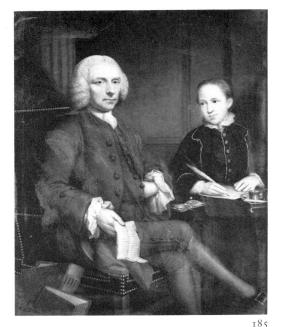

185

186. William Henry Powell, *General George Brinton McClellan*. Oil on canvas, 269.2 × 208.3 cm (106 × 82 in). 1865. New York, NY, Art Commission of the City of New York

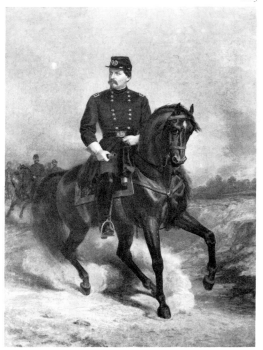

186

LOCATIONS: Middlesex Hosp., London; NPG; Independence Hall, PA Hist. Soc., Philadelphia; Palace of Westminster.

LITERATURE: *Robert Edge Pine*, &c., exh. cat. (NPG Washington, 1979).

Polk, Charles Peale 1767–1822

b. MD, d. Washington, DC; orphaned (1777) nephew and adopted son and pupil of *C. W. Peale; from 1785 working Baltimore, MD; kept his large family by running a dry goods business, and was a government clerk in Washington by the end. 1787 Philadelphia, 1791–3 Baltimore, then Richmond VA, 1799–1800. Painted Washington and Jefferson. Surprisingly, his work verges on the primitive, perhaps as a result of adjusting to a genuine change in taste of the period.

LOCATIONS: Baltimore Mus.; MD Hist. Soc.

LITERATURE: Flexner, II; Baltimore Mus. Cat.

Pond, Arthur FRS 1701–58

b. & d. London; studied *Vanderbank's Acad. from 1720; close associate of *Knapton, and by 1724 probably a pupil of *Richardson, and 1725–7 in Italy. Like Knapton, a fashionable painter in crayons (pastel) but also in oils, especially after *c.* 1740 in a manner continuing that of Richardson; oils have distinctive dark brown underpainting, vigorous, even coarse finish on a large scale, and a slighter grasp on structure than, e.g., *Hudson; variously itinerant late 1730s but then London. Important as connoisseur and dealer at the heart of the eighteenth-century British art world. FRS and FSA 1752.

LOCATIONS: NPG; N. Trust, Stourhead; Mr and Mrs Anthony Jarvis, Doddington Hall, Lincs.

LITERATURE: Lippincott.

Porter, Benjamin Curtis 1845–1908

b. Melrose, MA, d. NYC; pupil of William Rimmer; 1872–5 in Paris and Venice; then in Boston and NYC; with *Sargent, the main late nineteenth century American practitioner of a manner based on eighteenth-century English portraiture, often with outdoor setting; also used his own version of *R. Peale's 'port-hole' to curious effect.

LOCATION: Cooper Union, U.S.A.

Powell, William Henry ANA 1823–79

b. & d. NYC; Cincinnati as a child; taught by *Beard, then NYC *c.* 1840 under *Inman, and based NYC thereafter; 1842 New Orleans; in demand as painter of American history (some painted in France) and portraits, including equestrian, have heroic air, in an almost hyper-realistic, highly-finished style.

LOCATION: City Hall, NYC.

LITERATURE: G & W.

Pratt, Matthew 1734–1805

b. & d. Philadelphia; apprenticed to his 'limner' uncle, James Claypoole; working Philadelphia as portraitist from 1758; pupil of *West (his cousin by marriage) in London 1764–6, then Bristol until 1768 when returned

to Philadelphia where he was based thereafter; England again (and Ireland) 1770, NYC 1772, VA 1773. Best known for conversation piece of West and pupils *The American School*, 1765 (Met. Mus., NYC).

LOCATIONS: Met. Mus., NYC; Hist. Soc. of PA; NG Washington.

LITERATURE: W. Sawitzky, *Matthew Pratt 1734–1805* (NY, 1942).

Prinsep, Valentine Cameron RA 1838–1904

b. Calcutta, d. London; pupil of Gleyre, Paris, 1859, then to Rome with Burne-Jones 1859–60; ARA 1878, RA 1894, Professor of Painting, RA, from 1901. Often used striking poses and settings.

LOCATIONS: Colln Mrs Claudia Prinsep; Aberdeen AG; Christie's, 25.v.79 (148).

LITERATURE: *Val Prinsep RA, A Jubilee Painter*, exh. cat. (South London AG, 1977).

Quinn, James Peter 1871–1951

b. & d. Melbourne, Australia; trained Melbourne, then Paris, Acad. Julian and École des Beaux Arts; London from *c*. 1900, and a successful society portraitist; Official War Artist in World War I; retired to Melbourne; many Australian sitters while in Europe; painterly manner.

Rae, Henrietta 1859–1928

b. & d. London; studied London at Queen's Sq. School and Heatherley's; RA Schools 1877; married painter Ernest Normand 1884. Also painted genre, and classical subjects played out by romping suburban nudes; her portraits are very fine in a painterly style not evident in much of her other work.

LOCATION: Belfast Harbour Commissioners.

Raeburn, Sir Henry RA 1756–1823

b. Stockbridge, Edinburgh, d. Edinburgh; mainly self-taught; went to Rome via London (encouraged by *Reynolds); in Italy 1784–6, then Edinburgh from 1787 where he remained save for rare visits to London, notably once in 1810 with a view to succeeding *Hoppner. The leading Scottish portraitist of his day, only outshone by *Lawrence in Britian; still underestimated, his exceptional virtuosity with paint was allied to profound understanding of effects of light; gradually eliminated his handsome landscape and other backgrounds, and his final, intense manner anticipates that of some later nineteenth-century artists (e.g., *Eakins). ARA 1812, RA 1815, knighted 1822. King's Painter for Scotland, 1823. (See Plate 8)

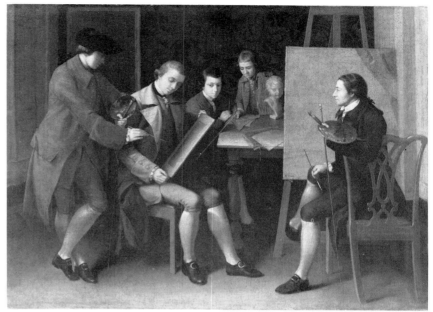

187

LOCATIONS: NGS; NG; Tate; Cincinnati Mus.; Mellon Colln; NG Washington.

LITERATURE: # J. Greig, *Sir Henry Raeburn, RA, &c.* (London, 1911).

Ralph, George Keith 1752–*c*. 1798

Perhaps based E. Anglia; RA Schools 1775, exhibited mainly portraits RA 1778–98; the 'G. Ralph' who exhibited RA 1803 and 1811 perhaps not the same; his London addresses are all different and presumably temporary. Full-length, bust- and three-quarter lengths; also miniatures.

LOCATIONS: Guildhall, Bury St Edmunds; Christie's, 27.x.50 (137).

LITERATURE: EKW; Graves.

Ramsay, Allan 1713–84

b. Edinburgh, d. Dover; son of the poet Allan R.; pupil of *Hysing in London 1732–3; 1736–8 in Italy, under Imperiali at Rome and Solimena in Naples; in London from 1738, with summer studio in Edinburgh until 1755; his continental manner, e.g., in the use of chiaroscuro, distinguishes him from any of his contemporaries although, like *Hudson, he employed *Van Aken, but was more scrupulous about supervising the finished effect, and was far more original than *Hudson. To go to Rome again 1754–7, and thereafter he painted with an even greater degree of refinement and delicacy than before. Painter to George III from 1761. Paris 1765 and some influence of M.Q.de la Tour is visible, but he apparently suffered an injury to his right arm in 1773 and ceased painting, but he employed assistants for his studio to

187. Matthew Pratt, *The American School*. Oil on canvas, 81.4 × 128.3 cm (36 × 50¼ in). 1765. New York, NY, The Metropolitan Museum of Art. Gift of Samuel P. Avery, 1897 (97.29.3)

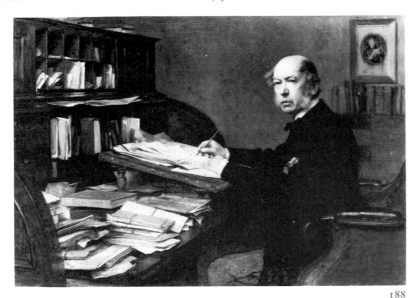

188

188. Sir George Reid, *John Murray III*. Oil on canvas, 50.8 × 71.1 cm (20 × 28 in). 1881. London, John Murray

continue producing replicas. In Italy 1775–7, 1782–4, and died on his way home. (See Chp. One, Fig. 6, Chp. Two, Fig. 66, Chp. Three, Fig. 90)

LOCATIONS: NPG; SNPG; NGS; Tate; Coram Foundation.

LITERATURE: A. Smart, *The Life and Art of Allan Ramsay* (London, 1952). # A. Smart (forthcoming).

Ramsay, James 1786–1854

b. Sheffield, d. Newcastle-upon-Tyne; prolific; exhibited RA 1803–54 mainly portraits but also religious and historical paintings, and occasionally landscapes; exhibited views of Newcastle area from 1816 and painted Thomas Bewick 1816 and in 1823 (NPG), in which year he hoped to succeed *Raeburn as royal painter in Scotland. Son of carver and gilder to whom (Sir) Francis Chantrey was apprenticed in 1797. First left Sheffield 1803 but only firmly settled in London 1807. Moved to Newcastle 1847.

LOCATIONS: NPG; Lord Clifford, Ugbrooke Park.

LITERATURE: Hall, *Artists of Northumbria*.

Rand, Ellen Emmet NA 1876–1941

b. San Francisco; studied NYC and Paris; married William Blanchard Rand; NA 1926; Nat. Assoc. of Portrait Painters 1912; usually rather a tenebrous manner.

LOCATIONS: Vassar Coll.; Univ. Club, NYC; Dept. of State, Washington, DC; Met. Mus., NYC.

Rand, John Goffe ANA 1801–73

b. Bedford, NH, d. Roslyn, Long Island;

started portraiture *c.* 1825; pupil of *Morse; Boston 1828–9 then, e.g., Charleston, SC, until NYC 1833; ANA 1834. 1835–40 in London (exhibited RA 1840; copy of royal portrait by him, HMQ), and invented the screw-top collapsible paint-tube; then NYC 1840.

LOCATION: Essex Inst., Salem, MA.

Read, Catherine 1723–78

b. Forfar, d. on ship returning from India; mainly crayons (pastel) but also oils; after '45 Rebellion studied in Paris under M. Q. de La Tour; then Rome 1751–3; London 1754; very fashionable, and patronized by Queen Charlotte; prices for oils compare with those of *Reynolds, who influenced her; could work full-length on scale of life. India 1777.

LOCATIONS: Grimsthorpe Castle; Duke of Hamilton, Lennoxlove; Duke of Argyll, Inveraray Castle.

LITERATURE: Lady V. Manners, *Connoisseur*, LXXXVIII (December, 1931), 376–86.

Reid, Sir George PRSA 1841–1913

b. Aberdeen, d. Oakhill, Somerset; apprenticed to lithographer; Trustees' Acad., 1862; 1866 to Holland, and became a friend of Jozef Israels at The Hague; studied Edinburgh, Utrecht and Paris; eventually the leading portraitist in Scotland; powerful, dashing handling. His sitters often look rather forbidding, and look away from viewer. He preferred painting landscapes. RSA 1877, PRSA and knighted 1891.

LOCATIONS: SNPG; Manchester CAG; Leeds CAG; Duke of Buccleuch, Bowhill; Aberdeen AG.

Reinagle, Philip RA 1749–1833

b. Edinburgh(?), d. London; son of Hungarian musician; RA Schools 1769 then 1770s replica assistant in *Ramsay's studio; to Norwich 1780, then London from *c.* 1782; portraits include small-scale full-lengths, a little like those of *Zoffany, and variously collaborated with other artists, e.g., *John Russell, to an extent perhaps not fully recognized. ARA 1787, RA 1812. The American painter Hugh Reinagle NA (*c.* 1788–1834), son of Hungarian musician and composer, Alexander R. (1756–1809), was presumably his nephew. His son was *Ramsay Richard R.

LOCATIONS: N. Trust, Upton House; Gibbes AG, Charleston, SC; Earl Ferrers, Hedenham Hall.

LITERATURE: EKW.

Reinagle, Ramsay Richard RA 1775–1862

b. & d. London; son of *Philip R., who taught him; 1793–8 to Holland and Italy; assistant of *Hoppner c. 1810 for whom he claimed to have made seventeen replicas of Hoppner's portrait of Pitt; own early style resembles Hoppner's but his final manner is meticulously finished and 'continental'; all types of portrait, including some small-scale full-lengths and conversations in his father's manner. An unusual artist and an original landscape painter. ARA 1814, RA 1823.

LOCATIONS: Yale; Lord Scarsdale, Kedleston Hall; Lord Coke, Holkham Hall.

LITERATURE: Whitley, II, 1; EKW.

Reinhart, Benjamin Franklin ANA 1829–85

b. nr Waynesburg, PA, d. Philadelphia; NA Schools NYC 1847, then 1850 studied in Düsseldorf, Paris and Rome; NYC 1853, partly itinerant; to England 1861 and successful there (painted Tennyson), returning NYC 1868; ANA 1871.

LITERATURE: G & W.

Renaldi, Francesco 1755–after 1798

Italian(?), d. London; RA Schools 1777; in Rome and Naples 1787, a friend of the Welsh landscape painter Thomas Jones (as was *Marchi); India 1786–96, returning to London. Conversation pieces are usual, with rather etiolated figures.

LOCATIONS: NMW; India Office; Christie's, 13.vii.84 (104).

LITERATURE: EKW; Archer.

Reynolds, Sir Joshua PRA 1723–1792

b. Plympton, Devon, d. London; apprenticed to *Hudson 1740, bought out 1743, and worked independently in Devon and London; 1749 to Italy, in Rome 1750–2 then London from 1753 where he was the dominant portraitist, only challenged variously by *Ramsay, *Gainsborough and *Romney; determined to 'elevate' portraiture by basing it on Old Masters or classical sculpture, and he effectively altered the social status of native painters; first President RA 1768, knighted 1769. Technical experiments at different times made his colours 'fly' or the surface deteriorate; used drapery and other assistants extensively, notably *Marchi. (See Chp. Two, Figs 62, 65, 70, Chp. Three, Fig. 96; Plate 22)

LOCATIONS: NG; Tate; Yale; NG Washington.

LITERATURE: # E.K. Waterhouse, *Reynolds* (London, 1941); N. Penny (ed.), *Reynolds*, exh. cat. (RA, London, 1986).

Reyschoot, Petrus Johannes van 1702–72

b. & d. Ghent; in England c. 1736–43; active in the Midlands and (apparently) Scotland; influenced by *Hudson and *Van Loo; did sporting conversation pieces, some very large, that show influence of native artists (e.g., Wootton), but also half- and full-lengths, and religious and mythological subjects.

LOCATIONS: Capt. Robert Wolridge-Gordon, Esslemont; Duke of Beaufort, Badminton.

LITERATURE: EKW.

Richardson, Jonathan, Sr c. 1665–1745

b. & d. London; the most important British portraitist in the time of *Kneller, continuing something of the manner of *Riley, who taught him 1688–91. The influence of his writings on art can hardly be over estimated on, e.g., *Hogarth and *Reynolds: he had a clear vision of the foundation of an English School. Taught *Knapton; also a great collector and connoisseur. Stopped painting 1740.

LOCATIONS: NPG; Soc. of Antiq.; Manchester CAG; Duke of Buccleuch.

LITERATURE: EKW.

Richmond, George RA 1809–96

b. & d. London; RA Schools 1824, and then a follower of William Blake and friend of Samuel Palmer; best known for brilliant portrait watercolours and drawings, after c. 1846 he also painted oils and was a leading portraitist. 1828 studied in Paris and 1837

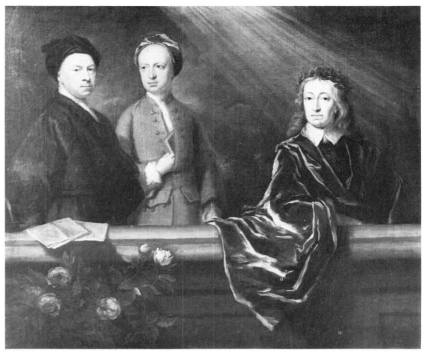

189

189. Jonathan Richardson (Sr), *The Artist and his Son in the Presence of Milton*. Oil on canvas, 63.5 × 76.2 cm (25 × 30 in). c. 1734. Capesthorne Hall, Cheshire, Lt Col. Sir Walter Bromley-Davenport

190

visited Rome for two years, then Italy 1840 and Germany. Landscape backgrounds are especially fine, the painting of figures very rich but colour rather sombre; had a keen sense of the British portrait tradition; copied and even completed some *Gainsboroughs. ARA 1857, RA 1866.

LOCATIONS: NPG; Marquess of Salisbury, Hatfield House; Marquess of Bath, Longleat; Royal Coll. of Surgeons; Lambeth Palace.

LITERATURE: #R. Lister, *George Richmond: A Critical Biography* (London, 1981).

Richmond, Sir William Blake RA 1842–1921
b. & d. London; son of *George R.; RA Schools 1857; friend of *Leighton, whose style his own most resembles, and also painted classical subjects. Surely the most successful of all Victorian portraitists in adapting features of contemporary 'high art' to fashionable portraiture and could hint at styles in vogue, e.g., japonnaiserie; his touch with children was unerringly brilliant. A friend of Ruskin, who would reprove him, e.g., for using shoes in a portrait unworthy of Perugino (*The Liddell Sisters*, 1864). ARA 1888, RA 1895, knighted 1897. Also a sculptor. (See Plate 28)

LOCATIONS: NPG; Earl of Airlie, Cortachy Castle; Duke of Argyll, Inveraray Castle.

Rigaud, John Francis RA 1742–1810
b. Turin, d. Packington Hall (father's name Dutilh); trained variously in Italy including

Turin under C. F. Beaumont; met *Barry in Rome and came to England with him 1771; also decorative and history painter, and many of his best portraits are large complex groups, painted in quite a high key with great attention to detail, in a style quite unlike that of his British contemporaries. ARA 1772, RA 1784. His daughter Elizabeth Anne R. (1776–1852) painted portraits (until marriage 1800), and so apparently did his son, Stephen Francis Dutilh R., 1777–1861.

LOCATIONS: NPG; Nat. Marit. Mus.

LITERATURE: EKW.

Riley, John 1646–91
b. & d. London; pupil of Soest; came to prominence after *Lely's death and 1688 jointly royal painter with *Kneller; in partnership with *Closterman 1680s, Riley doing the heads; an unusual portraitist for his time, painted remarkable pictures of servants, and style generally far more restrained than Lely's, no doubt the result of Soest's influence; taught *Richardson.

LOCATIONS: NPG; HMQ; Ashmolean Mus., Christ Church, Oxford.

LITERATURE: EKW, *Painting in Britain*, pp. 136–8.

Rinck, Adolph D. *fl.* 1840–*c.* 1871
b. Norway, d. New Orleans(?) where he practised from 1840, also as miniaturist; clearly well trained, and is presumably the Adolph R. recorded in the Berlin Acad. until 1835 who then lived in Paris until 1840s; firm modelling with strong sense of light.

LOCATION: Isaac Delgado Mus. of Art, New Orleans.

LITERATURE: Th.-B.

Rising, John 1753–1817
d. London; RA Schools 1778; influenced by *Reynolds who taught him in 1780s, and then by *Romney; works include small-scale full-lengths; highly esteemed in his day as a cleaner and restorer, especially of Reynolds's works, and a clever copyist of them.

LOCATIONS: Wilberforce House, Hull; Nat. Marit. Mus.; N. Trust, Stourhead.

LITERATURE: EKW; Whitley, II, I.

Roberts, Ellis William 1860–1920
b. Burslem, Stoke-on-Trent, d. Brighton; studied Royal Coll. of Art 1882–3, then Italy and Paris including Acad. Julian under Bouguereau and Robert-Fleury 1887–8. Based in London, society portraitist; often large-

scale, full-length women in landscape, in recognizably French academic manner.

LOCATIONS: Duke of Beaufort, Badminton; Duke of Norfolk, Arundel; Duke of Buccleuch, Bowhill.

LITERATURE: Waters.

Robertson, John Ewart 1820–79

b. Kelso, d. in a mental asylum; trained Edinburgh, in Liverpool by 1847 and member Liverpool Acad. 1850; also exhibited RA 1844–65. Somewhat influenced by Pre-raphaelites, his uncompromising style was ideally suited to portraying northern industrialists, usually with strong lighting effects.

LOCATIONS: Manchester CAG; Duke of Roxburghe, Floors Castle; Walker AG, Liverpool.

LITERATURE: Walker AG Cat.

Robineau, Charles Jean *fl.* 1780–7

French; also musical composer; exhibited RA 1785 and 1788(?); small-scale full-lengths of future Prince Regent and musician C.F. Abel; his son(?), Auguste R. (*fl.* 1785–1816), was probably in France from 1790s.

LOCATION: HMQ.

LITERATURE: O. Millar, *The Later Georgian Pictures in the Collection of Her Majesty the Queen*, 2 vols (London, 1969).

Robinson, Hugh 1756–90

b. Malton, Yorks., d. on way home by road from Italy where he went 1783; RA Schools 1779; highly gifted, but his Italian works were lost at sea, and all surviving pictures are in Teesdale family. These pictures show his rapid development from his early Yorkshire works under the influence of London painters after his move there, including *Gainsborough, *Reynolds and (apparently) the even younger *Opie, and include two remarkable portrait-genre paintings, *Boy with a Kite* and *The Piping Boy* (pendents); the portraits, chiefly of his family, include a self-portrait in Rembrandtesque manner, the use of Van Dyck dress, and a copy after Reynolds's *Giuseppe Baretti*.

LOCATION: Private collection.

Robinson, John *c.* 1715–45

d. London; apprenticed to *Vanderbank 1737, independent from 1739; important for early use of Van Dyck costume; very successful, the victim of a closed shop of, e.g., *Hudson and *Davison, who stopped him employing *Van

Aken, and he died suddenly. See Chp. Three, Fig. 89)

LOCATION: The Earl Spencer, Althorp.

LITERATURE: Vertue III, pp. 124–5.

Robinson, Thomas *fl. c.* 1785–1810

b. Windermere, d. Dublin; pupil of *Romney *c.* 1785; specialized in portrait histories, some very large; Dublin from 1790; Belfast 1801–8; then Dublin again.

LOCATIONS: NGI (loan); Abbott Hall AG, Kendal.

LITERATURE: M. Hall, *Artists of Cumbria*.

Robinson, William 1799–1839

b. & d. Leeds; pupil of *Lawrence and then at RA Schools; successful imitator of *Lawrence's manner; returned to Leeds 1825.

LOCATIONS: Inst. of Directors; Wellcome Inst., London; DOE, Wrest Park.

Roche, Alexander Ignatius RSA 1861–1921

b. Glasgow; studied Glasgow School of Art then Paris under Boulanger, Gérôme and Lefebvre; Glasgow from 1883 then Edinburgh from 1896; lost use of right hand 1906, continued with his left (mainly landscape). Also worked in U.S.A. on portrait commissions. A painter with an exquisite touch characteristic of many Glasgow painters of the time.

LOCATION: Walker AG, Liverpool.

LITERATURE: Waters.

Roden, William Thomas 1817–92

b. Birmingham, d. Handsworth; trained as

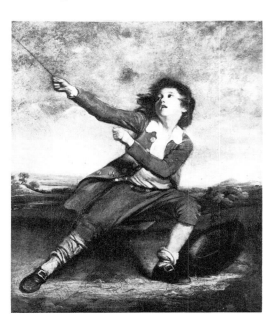

191. Hugh Robinson, *Boy Flying a Kite (Portrait of Thomas Teesdale of Malton)*. Oil on canvas, 124.5 × 99.1 cm (49 × 39 in). *c.* 1782. Private collection

191

engraver, but soon a portraitist, and worked almost exclusively in Birmingham. Exhibited RA and elsewhere in London 1843–79.

LOCATIONS: NPG; Birmingham CAG.

LITERATURE: S & K Morris.

Romney, George 1734–1802

b. Dalton-in-Furness, d. Kendal; apprenticed to *Steele 1755–7, early works small-scale full-lengths; Kendal until 1762 then London and large scale; Italy 1773–5 which reinforced his rather neo-Classical manner and he became fashionable rival of *Reynolds, sometimes using classical sculpture and Old Masters in similar fashion, and admired Reynolds (unreciprocated); famous for portrayals of Lady Hamilton with whom he was obsessed; made violins as a hobby and suffered from mental illness from 1790s and retired 1798 to the care of his neglected wife. A portraitist generally of the greatest technical consistency, often serious and impressive. Never exhibited at RA. His younger brother and pupil Peter R. (1743–77) was mainly a crayon portraitist in Manchester area. (See Plate 2)

LOCATIONS: Wallace Colln; Yale; NG; Tate; NG Washington.

LITERATURE: #H. Ward and W. Roberts, *Romney: A Biographical and Critical Essay* (NY, 1904).

Room, Henry 1802–50

b. Birmingham, d. London; locally trained; still in Birmingham 1829, then lived in London; of an evangelical family; best known

192. John Russell, *Girl Feeding a Rabbit*. Pastel on paper, 43.2 × 58.4 cm (17 × 23 in). c. 1797. Private collection

for *Interview of Queen Adelaide with the Madagascar Princes* (NPG).

LOCATIONS: NPG; Birmingham City Mus. and AG; Royal Coll. of Surgeons.

Rosenthal, Albert 1863–1939

b. Philadelphia, d. New Hope, PA; pupil of his father the lithographer and etcher Max R. (1833–1913); studied at Pennsylvania AFA then in Munich and Paris; an expert on the work of *Stuart.

LOCATION: Hist. Soc. of PA.

Ross, Thomas *fl.* 1730–46

Probably artist of his name in Gloucester before 1730. In Suffolk 1730, a landscape, decorative and portrait painter. Some six signed works are known, all busts, most in feigned oval.

LOCATIONS: NPG.

Rossiter, Thomas Prichard NA 1818–71

b. New Haven, CT, d. Coldspring, NY; studied New Haven working as portraitist by 1838; to Europe including Paris and London 1840 with Asher B. Durand and others; Rome 1841–6, returning NYC sharing studio with *Lang; Paris again 1853–6; on his return to NYC mainly genre and religious; important large group *Merchants of America*, 1857.

LOCATION: N.-Y. Hist. Soc.

LITERATURE: E.R. Bevan, *Thomas Prichard Rossiter* (Ruxton, MD, 1957).

Rothwell, Richard RHA 1800–68

b. Athlone, d. Rome; studied Dublin and was then *Lawrence's chief assistant and finished many of his portraits on his death, and was thought to be Lawrence's natural successor; 1831–4 Italy, returning to London full of ideas (frustrated) for histories, then to Paris; U.S.A. 1854; finally Rome. His subject pictures are uneven: his portraits show why he was originally so highly thought of.

LOCATIONS: NGI; NPG; Ulster Mus., Belfast.

Russell, John RA 1745–1806

b. Guildford, d. Hull; studied crayon paintings with *Cotes until 1767, then RA Schools; also oils; published treatise 1772; royal 'Crayon Painter' 1790. Based in London, made annual trips around the country; extremely fashionable. Works often highly-coloured, displaying brilliant crayon technique, most of them on the scale of oil paintings up to, e.g., 57 × 33 in (144.8 × 83.8 cm). ARA 1772, RA 1788; his son William R. (1780–1870) was

also a portraitist in crayons and oil (example, NPG).

LOCATIONS: NPG; Met. Mus., NYC.

LITERATURE: G. C. Williamson, *John Russell, RA* (London, 1894).

Russell, Sir Walter Westley RA 1867–1949

b. Epping, d. London; studied Westminster School of Art under Prof. Brown; society portraitist, especially of women; also genre and landscape, and a number of portraits have 'fancy' titles. ARA 1920, RA 1926.

LOCATIONS: Tate; Prudential Assurance Co.

Salisbury, Francis (Frank) Owen 1874–1962

b. Harpenden, d. London; Heatherley's School of Art then RA Schools (Landseer Scholarship), then in Italy, Germany and France; early portraits are sometimes sensitively composed and handled, his later style being smooth and glittering; he became the quintessential twentieth-century society portrait painter. Sitters included Lord Simon, Mussolini and Churchill, as well as most of the Royal Family from George V on (coronation portraits, 1937). His studio sale was held in 1985.

LOCATIONS: Christie's, 25.ix.85 (*passim*); Laurens Art Mus., Laurel, MS; Walker AG, Liverpool; NPG.

LITERATURE: B. A. Barber, *The Art of Frank O. Salisbury* (Leigh-on-Sea, 1936).

Salter, William 1804–75

b. Honiton, d. London; to London 1822, pupil of *Northcote 1822–7, then went to Florence, Rome and Parma; 1833 returned to London; painted Duke of Wellington on a number of occasions and a *Waterloo Banquet*, 1833 (NPG). Famous in his time for studies after Correggio, of which there is no trace in his portraits, where his style is rather linear. Also histories.

LOCATIONS: NPG; Duke of Wellington, Stratfield Saye; Walker AG, Liverpool.

Sanders, George 1774–1846

b. Fife, d. London(?) where he came after Edinburgh, but continued to have many Scottish sitters; also a miniaturist until 1811; not to be confused with George Lethbridge Sanders (1807–63), although his own surname spelt variously *Saunders*, *Sandars*. Style quite independent of any *Lawrence influence, perhaps suggesting continental neo-Classical influence; famous for '*Cock of the North*': *George, 5th Duke of Richmond and Lennox* (Goodwood).

LOCATIONS: HMQ; Univ. of Glasgow; N. Trust, Dunham Massey; Duke of Richmond and Gordon, Goodwood House.

Sanders, John 1750–1825

b. London, d. Clifton; son of portraitist John S., Sr (*fl. c.* 1750–*c.* 1783); RA Schools from 1769; at Norwich 1777–81, then London, and Bath 1790; a fine draughtsman; later portraits perhaps suggest influence of *Lawrence.

LOCATION: Lord Lansdowne Colln.

Sant, James RA 1820–1916

b. Croydon, d. London; studied under John Varley and A. W. Callcott and at RA Schools. ARA 1861, RA 1869, appointed royal portrait painter 1872; lived through to the era of *Sargent and adopted some of the freedom of manner of that period in his later works; always impressive on any scale, with pleasing handling, and he was prolific and successful. Also landscape and genre. (See Plate 27)

LOCATIONS: Wallace Colln; HMQ; NPG.

Sargent, Henry NA 1770–1845

b. Gloucester, MA, d. Boston; in Boston 1779; with *West in London 1793–7, exhibited RA 1795, 1796; has been referred to (EKW) as presumed dead 1797, in which year he left England, returning to Boston; somewhat influenced by *Stuart; painted unusual interiors, and most types of portrait, a little stiff in manner; also a politician and mechanical inventor.

LOCATION: Boston MFA.

LITERATURE: J. Addison, *Art in America*, XVII (October, 1929), pp. 279–84; G & W.

Sargent, John Singer RA 1856–1925

b. Florence (of American parents), d. London; trained Accad. in Florence 1870, then travelled to Dresden 1871–2, Venice 1874, where *Whistler encouraged him, then studied under Carolus-Duran in Paris from same year; 1876 to U.S.A.; then travelled variously, including Spain *c.* 1879 and Holland; much influenced by Velásquez and Hals, also by Manet and Degas; working professionally from 1879; 1885 settled in London and became the most successful international society portraitist, working in Europe and U.S.A. Possessed of outstanding natural gifts, of limitless inventiveness, he also learned much from eighteenth-century British portraiture, Impressionism, and photography, and was a master of composition; one of the greatest of all portrait painters and immensely influential. ARA 1890, RA 1891. Largely gave up

portraiture *c.* 1906, for landscape and decorative painting, and late portraits can be remarkably unsatisfactory. (See Chp. One, Figs 32, 33; Plates 18, 20)

LOCATIONS: Boston MFA; Met. Mus., NYC; Tate; NPG.

LITERATURE: R. Ormond, *John Singer Sargent: Paintings, drawings, watercolours* (London, 1970); #R. Ormond, W.G. Adelson, D. Seldin (forthcoming); S. Olson, *John Singer Sargent, His Portrait* (London, 1986).

Savage, Edward 1761–1817

b. & d. Princeton, MA; working Boston from 1785; 1789–91 NYC to paint Washington; 1791–3 in England under *West; Philadelphia from 1795 then NYC 1800/1–1810, then Boston. Could work full-length on scale of life. An engraver and teacher, also had museum.

LOCATIONS: NG Washington; US Naval Acad. Mus., Annapolis, MD; PA. Hist. Soc.

LITERATURE: L. Dresser, *Art in America*, XL (Autumn, 1952), pp. 157–212.

Say, Frederick Richard *fl.* 1826–54

b. London(?); son of mezzotint engraver William S.; a sort of parlour *Lawrence, employing his manner in a clichéd form with considerable success; he had a distinguished clientele.

LOCATIONS: NPG; HMG, Palace of Westminster; N. Trust, Saltram, Powis Castle.

Scarborough, William Harrison 1812–71

b. Dover, TN, d. Columbia, SC; already portraitist when he moved to SC 1830, from 1843 in Columbia; also worked NC, GA, and NYC; in Europe 1857. Also miniaturist.

LOCATION: Athenaeum Club, Columbia, SC.

LITERATURE: H.K. Hennig, *William Harrison Scarborough, Portraitist and Miniaturist* (Columbia, SC, 1937).

Scougall, John, 'Old' *c.* 1645–1730

Scottish, d. Prestonpans; main Edinburgh portraitist in last quarter of seventeenth century; stopped painting *c.* 1715. Perhaps influenced by *J.M. Wright; busts in ovals.

LOCATION: Sir John Clerk, Bt, Penicuik.

LITERATURE: EKW, *Painting in Britain*, pp. 122–3.

Seeman, Enoch *c.* 1694–1745

b. Danzig, d. London; trained by his father who brought him to London; first major commissions George I and Elihu Yale, 1717,

thereafter had wide practice; all types of portrait, of a pedestrian kind and repetitious in pose and drapery. Isaac S., *fl.* 1720–51, was his younger brother, who imitated him.

LOCATIONS: Yale Univ.; NPG; N. Trust, Sudbury Hall.

LITERATURE: EKW.

Seton, John Thomas *fl.* 1758–*c.* 1806

b. London(?), d. Edinburgh(?); pupil of *Hayman at St Martin's Lane Acad.; Rome 1758–9, then in Bath 1766, Edinburgh 1772–4 and went to India 1774 until 1785, returning to Edinburgh. Small full-lengths and conversation pieces, and large scale; an artist of some originality. Name also spelt 'Seaton'.

LOCATION: Lady Antonia Dalrymple, New Hailes.

LITERATURE: Archer, pp. 99–107; EKW.

Shackleton, John *fl.* 1742–67

d. London; perhaps a pupil of *Richardson; from 1749 official painter to George II, whose portraits he painted in a suitably stilted manner; not a pleasing artist but he could take a strong likeness; all types of large-scale portrait.

LOCATIONS: SNPG; NPG.

LITERATURE: J.R. Fawcett-Thompson, *Connoisseur*, CLXV (August, 1967), pp. 232–9.

Shannon, Sir James Jebusa RA 1862–1923

b. Auburn, NY, d. London; studied London from 1878 under Poynter, South Kensington, and stayed on; very successful society portraitist, whose vivid brushwork is sometimes compared with that of *J.S. Sargent, but the final effect of his portraits is quite different; individual portraits are often superb with a dynamic air and dramatic colouring; groups lack the tension of Sargent's compositions. ARA 1897, RA 1909, knighted 1922. Member of New English Art Club. (See Chp. Three, Fig. 85)

LOCATIONS: NPG; N. Trust, Plas Newydd; Lady Lever AG, Port Sunlight; Trustees of the Chatsworth Settlement.

Sharples, James *c.* 1751–1811

b. Lancashire, d. NYC; perhaps a pupil of *Romney; worked mainly in crayons but also oils; Cambridge, 1779, Bath and Bristol 1781–2, and London 1783–5 then Bath and Liverpool; America 1793 in Philadelphia and NYC; back in Bath 1801, until 1809 NYC again. Invented a steam carriage.

LOCATIONS: Boston MFA; Bristol CAG.

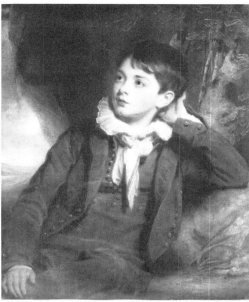

193

194

LITERATURE: G & W; T. Bolton, *Art in America*, XI (April 1923), pp. 137–43; K.M. Knox, *The Sharples: Their Portraits of George Washington and his Contemporaries* (New Haven, 1930).

Shee, Sir Martin Archer PRA 1769–1850

b. Dublin, d. Brighton; a pupil of Francis Robert West in Dublin Society's school; earlier works are in crayon, but oils by the time he was established in London 1788; RA Schools 1790. Early influenced by *Hoppner and *Lawrence, but later portraits have a more continental air to them and a less firm grasp of structure. He was a most successful high society portraitist. ARA 1798, RA 1800, PRA in succession to Lawrence 1830, and knighted.

LOCATIONS: NG; NPG; Walker AG, Liverpool; Met. Mus., NYC.

LITERATURE: Strickland.

Sherlock, William *c.* 1738–*c.* 1806

b. Dublin(?); studied St Martin's Lane Acad.; son of a fencing master. Studied engraving Paris 1761; mainly small-scale full-lengths but some large-scale portraits; also a miniaturist and watercolourist.

LITERATURE: EKW; Foskett.

Sickert, Walter Richard RA 1860–1942

b. Munich, d. Bathampton; to England with family 1868; Slade School 1881 then under *Whistler, a major influence, as was Degas, whose work he encountered Paris, 1883; lived in Dieppe 1899–1905 and also frequent visitor to Venice. A major figure of 'Fitzrovia' and influential in British art from 1905 and a founder of Camden Town Group 1911; was later in Brighton, Bath and Dieppe. Often used photographs as basis for portraits, squared-up in traditional manner. ARA 1924, RA 1934 (resigned 1935).

LOCATIONS: NPG; Beaverbrook AG, Fredericton, NB, Canada.

LITERATURE: W. Baron, *Sickert* (London, 1973).

Sidley, Samuel 1829–96

b. York, d. London(?); studied Manchester and RA Schools, exhibited RA and elsewhere 1855–95; at first genre and history, but later many official portraits, in his later manner apparently influenced by Poynter. Also landscapes.

LOCATIONS: NPG; Sotheby's Belgravia, 11.xi.75 (73).

Simmons, John *c.* 1715–80

b. Nailsea, d. Bristol; leading Bristol portraitist; accomplished; half-lengths (some in oval) are typical.

LOCATION: Bristol CAG.

LITERATURE: EKW.

Simpson, John 1782–1847

b. & d. London; RA Schools, and for a long time assistant to *Lawrence, his own mature style being far more sober; 1834 to Portugal and appointed painter there to the Queen, but soon returned to London. Exhibited portraits almost exclusively, and in great abundance, RA 1807–45.

LOCATIONS: NPG; SNPG.

193. James Sharples, *Joseph Dennie.* Pastel on paper, 22.9 × 17.8 cm (9 × 7 in). *c.* 1800. Boston, MA, Museum of Fine Arts. Bequest of James Dennie

194. Sir Martin Archer Shee, *The Painter's Son William.* Oil on canvas, 73.7 × 61 cm (29 × 24 in). *c.* 1820. London, Royal Academy of Arts

Singleton, Henry 1766–1839

b. & d. London; RA Schools 1783; mainly painted genre, but a talented and thoughtful portraitist in most types, including large complicated group of Royal Academicians under *West 1795 (RA) and small-scale full-lengths; influenced by *Romney.

LOCATIONS: RA; NPG; Earl of Harewood, Harewood House.

LITERATURE: EKW.

Skipworth, Frank Markham 1854–1929

b. Caistor, Lincs., d. London; studied Lincoln, then Royal Coll. of Art under Poynter 1879–82, then Paris with Bouguereau and Robert-Fleury 1883–4. Impressive society portraitist on a large-scale, he also painted small-scale full-lengths of fashionable women in a slightly whimsical manner.

LOCATION: Inst. of Directors.

Skirving, Archibald 1749–1819

b. nr Haddington, d. Inveresk; exhibited RA 1778; in Rome 1790–4 then based Edinburgh; began as miniaturist, then mainly crayons, occasionally simultaneously with gouache (like *Gardner), but also oils. His manner is unlike that of any of his English contemporaries, ingenious, even eccentric, and he was a sensitive draughtsman.

LOCATIONS: NGS; SNPG.

Slaughter, Stephen 1697–1765

b. & d. London; *Kneller's Acad. 1712, then Paris and Flanders for seventeen years,

195. Archibald Skirving, *Robert Boswell of St Boswells*. Pastel on paper, 82.5 × 64.8 cm (32½ × 25½ in). *c.* 1800. In a private Scottish collection

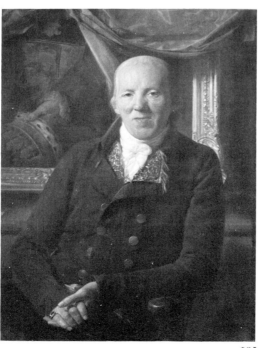

195

returning 1733, then Dublin 1734 and again *c.* 1744–5; Keeper of the King's Pictures, 1744. Style varied and quality extremely uneven, sometimes high; generally not unlike *Knapton but without his originality. All types of portrait including small-scale full-lengths.

LOCATIONS: Tate; Earl of Dunraven, Adare; Minneapolis Inst. of Arts.

LITERATURE: A. C. Sewter, *Connoisseur*, CXXI (March, 1948), pp. 10–15.

Smibert, John 1688–1751

b. Edinburgh, d. Boston, MA; apprenticed to house-painter 1702–9, then London, *Kneller's Acad. 1713, then Edinburgh *c.* 1717; Italy 1719; based in London from 1722 and fairly successful. 1728 with Dean Berkeley on Bermuda expedition: Smibert went to Boston on the way, 1729, settled there, and remained leading Boston portraitist until eye-trouble mid-1740s. One of the first professionally-trained artists in America and highly influential. His gifts were limited, but he had a repertoire of poses and props, kept in close touch with London, and imported many prints. (See Chp. One, Fig. 10)

LOCATIONS: Boston MFA; NPG.

LITERATURE: #H. W. Foote, *John Smibert, Painter* (New York, 1969); R. Saunders, Ph.D. (Yale, 1979).

Smith, Colvin RSA 1795–1875

b. Brechin, d. Edinburgh; studied RA Schools, then to Italy 1826; painted Wilkie in Rome; then went to Belgium, set up in *Raeburn's former studio Edinburgh 1827, and in that year painted Sir Walter Scott of 'the irreducible egghead' too accurately for Scott's taste, although everyone else recognised the likeness, and repetitions were afterwards in great demand. He continued Raeburn's manner throughout his life, with vivid characterization and often forceful handling.

LOCATIONS: NGS; Earl of Stair, Oxenfoord Castle; SNPG: Parliament Hall, Edinburgh; Duke of Hamilton, Lennoxlove.

Smith, Henry *fl.* 1741–69

Perhaps from Norwich; certainly worked in Scotland (mainly) and Devonshire; provincial manner, very repetitious, especially in busts in oval, but also did full-lengths and groups.

LOCATIONS: Duke of Sutherland, Dunrobin; Earl of Wemyss and March.

LITERATURE: EKW.

Smith, John Rubens 1775–1849

b. London, d. NYC; son of famous engraver

John Raphael S.; exhibited RA (portraits) 1796–1811; in Boston, MA, by 1809; Brooklyn, NY, c. 1814, and ran drawing academy there, and in 1830s in Philadelphia where *Leutze was his pupil.

LITERATURE: E.S. Smith, *Connoisseur*, LXXXV (May, 1930), pp. 300–7.

Smith, Stephen Catterson PRHA 1806–72

b. Shipton, Yorks., d. Dublin(?); son of a coach-painter; studied RA Schools, and exhibited RA 1830–58; to Ireland 1840 on a commission, and settled there; PRHA 1859; he had many distinguished sitters; occasionally small-scale, some on panel. His son S.C.S., Jr, (1849–1912) was also a portraitist of some distinction (example, Nat. Army Mus.).

LOCATIONS: The Earl Spencer, Althorp; Earl of Crawford and Balcarres; NPGI; Apsley House.

Smith, Thomas fl. 1680

Doubtfully identified as author of self-portrait and portrait of daughter in Worcester Art Mus., because a 'Major Thomas Smith' was paid for portrait by Harvard 1680; the self-portrait is evidently not by a professionally trained painter, but of interest as an early work in America.

LOCATION: Worcester Art Mus.

LITERATURE: *XVIIth Century Painting in New England* (L. Dresser, ed.) (Worcester, MA, 1935).

Smith, W.A. (William) 1753–c. 1793

Probably RA Schools 1772; worked thereafter in North East Scotland 1780s, 1790s; not dissimilar to *Philip Reinagle in manner.

LOCATION: Sotheby's, 29.v.63 (41).

Smith, William 1707–64

b. & d. Chichester and worked there, e.g., busts in oval; dated portraits 1748–59.

LOCATION: Christie's, 4.vii.36 (78).

LITERATURE: EKW.

Soest, Gerard c. 1600–1681(?)

b. Soest, Westphalia(?), d. London where he arrived c. 1650; widely patronized, but never as much as *Lely, and his approach was surprisingly unflattering and frank, even eccentric, too much so to be popular with women 'which his ruff humour coud never please' (Vertue); lovely, unusual colour. Taught *Riley.

LOCATIONS: NPG; Enoch Pratt Library, Baltimore, MD.

LITERATURE: EKW, *Painting in Britain*, pp. 101–4.

Soldi, Andrea c. 1703–71

b. Florence, d. London; in London by 1735 and successful like, e.g., *Van Loo, either side of 1740, rousing *Hogarth and *Ramsay to extra efforts; later had serious money troubles. Style distinctively continental, rather high key, with solid local colours and great clarity; all types of portrait, including conversation pieces.

LOCATIONS: Yale; Dulwich Coll. AG; York CAG.

LITERATURE: # J. Ingamells, *Walpole Society*, XLVII (1980).

Solomon, Solomon Joseph RA 1860–1927

b. London, d. Birchington, Kent; trained RA Schools 1877–80, Paris and Munich, and developed a style that is nearer to late-nineteenth-century American painting than that of most of his English contemporaries, with expansive brushwork, and sometimes in a high key. Travelled in North Africa, Spain and Italy with his friend *Hacker. ARA 1896, RA 1906. Of great importance in the development of military camouflage techniques.

LOCATION: NPG.

LITERATURE: O.S. Phillips, *Solomon J. Solomon, A Memoir of Peace and War* (London, n.d.).

Somerville, Andrew SA 1808–34

b. & d. Edinburgh; studied Trustees' Acad. and also under William Simson; SA 1832; a most gifted portraitist; also genre.

LOCATION: Balnagown Castle Colln., Ross-shire.

Spencer, Frederick R. NA 1806–75

b. Lennox, NY, d. Wampoville, NY; studied NA then worked from 1831 in NYC until retirement 1858; NA 1846; limited style and repertoire characteristic of much American portraiture of the time.

LOCATIONS: Brooklyn Mus.; NG Washington.

Starr-Canziani, Louisa 1845–1904

née Starr, d. London; perhaps related to the Hull-born artist Sydney Starr, the associate of *Sickert in the New English Art Club (and who later worked in NYC and Washington DC); RA Schools (gold medal, 1867); many society sitters, sometimes fancifully portrayed, but very good at straightforward portraits; had a house and studio in Palace Green,

Kensington, where her daughter Estella Louisa Michaela C. (1887–1964), also a portraitist, was born (a pupil of *Cope).

LOCATION: NPG.

Stearns, Junius Brutus NA 1810–85

b. Arlington, VT, d. Brooklyn, NY; son of portraitist Junius S.; studied NA c. 1838; 1849 he studied Paris and London, and was back in NYC 1850. ANA 1848, NA 1849. Portraits include family groups; also painted genre and Indian scenes.

LOCATION: Sotheby Parke-Bernet, 15.v.75 (11).

Steele, Christopher 'Count' 1733–67

b. & d. Egremont; trained Liverpool with a marine painter and in Paris with Carle Van Loo; *Romney was apprenticed to him in Kendal 1755. S. eloped with a girl pupil to York and Romney followed; back to Kendal 1757, with Romney, and then tried Lancaster; 1758 to Ireland when Romney finally jibbed; 1759 in Middlewich, by 1762 Manchester, and in December had just left for W. Indies. Sobriquet from his continental dress and air. Involved in endless affairs, both of the heart and money. Style neat and lucid, not unlike another of Van Loo's British pupils, *Exshaw, but in small-scale full-lengths.

LOCATION: Colln Mrs F. Rimington Wilson; Town Hall, Kendal (attr.).

LITERATURE: Hall, *Artists of Cumbria*.

Steward, Joseph 1753–1822

b. Upton, MA; after Dartmouth Coll., a non-conformist minister; turned to portraiture through ill-health 1793, first Hampton, CT, then Hartford, CT, 1796, and had museum from 1797. Primitive but appealing.

LOCATION: Dartmouth Coll., Hanover, NH.

LITERATURE: G & W.

Stewardson, Thomas 1781–1859

b. Kendal, d. London; pupil of *Romney in London; had the doubtful distinction of being painter to Queen Caroline; astonishingly good in small oil sketches, but usual portraits are more straightforward half- and three-quarter lengths. *Northcote's observations on his working methods are recorded in E. Fletcher (ed.), *Conversations of James Northcote, RA*, &c. (London 1901), pp. 207 ff.

LOCATIONS: NPG; N. Trust, Tatton Park; Lady Lever AG, Port Sunlight.

Stoppelaer, Herbert (C.H.?) fl. c. 1735–72

b. Dublin; evidently son of portraitist Charles

S. (fl. 1703–after 1745); mainly active in Norwich; half-lengths in oval and full-lengths.

LOCATION: Christie's, 22.i.63 (18).

LITERATURE: EKW.

Story, Julian Russell 1857–1919

b. Walton-on-Thames, d. Philadelphia; after Oxford University studied with *Duveneck in Florence, then in Paris under Lefebvre. Worked in Italy and Paris, settling in Philadelphia. Handsome portrait style that is international American, not British.

LOCATION: Boston MFA.

Strang, William RA 1859–1921

b. Dunbarton, d. Bournemouth; Slade School under Poynter and Legros; etcher, then exhibited oils from age thirty-three; influenced by *Whistler and, being always eclectic, Gauguin; in late portraits, his high Victorian finish mixed with strong 'modern' colours produces a characteristically odd, even quaint, effect. At his best, a powerful portraitist. RA 1921.

LOCATIONS: NPG; Manchester CAG; Glasgow AC; NG Canada.

LITERATURE: *William Strang RA 1859–1921 Painter-Etcher,* exh. cat. (Graves AG, Sheffield, Glasgow AG, NPG, 1980–1).

Stuart, Gilbert 1755–1828

b. North Kingstown, RI, d. Boston, MA; had some instruction from *Cosmo Alexander and left with him for Edinburgh 1771 but Alexander died; worked passage home; tried London again 1775, failed, and 1777 turned to *West for help; independent from 1782 and successful; absorbed the manner of *Gainsborough and *Romney; mostly bust- or half-length, many unfinished, but also a few ingenious full-lengths. Moved westward to avoid debt: first to Dublin 1787, then America 1793 (NYC); Philadelphia 1794, Washington 1803, finally Boston 1805. A brilliant painter, comfortably the best in his time in America; exercised a decisive influence; his daughter Jane S., 1812–88, continued his definitive images of Washington. (See Chp. One, Fig. 18; Plate 5)

LOCATIONS: NG Washington; Boston MFA; Tate; NPG.

LITERATURE: #L. Park, *Gilbert Stuart,* 2 vols (NY, 1926); C.M. Mount, *Gilbert Stuart: A Biography* (NY, 1961).

Stuart, James Reeve 1834–1915

b. Beaufort, SC, d. Madison, WI; studied

Boston under *Ames, then Munich at Royal Acad., 1860. From 1872 lived Madison, WI, where he taught and worked extensively as portraitist.

LOCATION: Wisconsin State Hist. Mus.

LITERATURE: G & W.

Stubbs, George ARA 1724–1806

b. Liverpool, d. London; some training with *Winstanley c. 1741; left for Wigan, Leeds (working as portraitist), and York, 1744, where he studied anatomy; 1752 to Hull then via Liverpool to Rome 1754, and back to Liverpool same year; then Lincolnshire, settling in London 1760; best known for *Anatomy of the Horse* (1766) and other studies, and as a painter of rural life and equestrian and similar groups, usually of conversation-piece type; single portraits date from late 1740s–1750s and show the intensity of vision that was to remain characteristic. ARA 1780, elected RA 1781 but not ratified.

LOCATIONS: Walker AG; NG Washington.

LITERATURE: B. Taylor, *Stubbs* (London, 1971); Walker AG Cat; *George Stubbs 1724–1806*, exh. cat. (Tate, Yale, 1984–5).

Sully, Thomas 1783–1872

b. Horncastle, Lincs, d. Philadelphia, PA; to Charleston, SC, 1792; taught by brother-in-law Jean Belzons and elder brother Lawrence S., both miniaturists; began working c. 1801, and partly worked with brother until 1803 in VA; then married brother's widow 1805, and went to NYC; in Boston 1807 and advised by *Stuart; 1809–10 in London with *West, who got him to see *Lawrence who was the major influence upon him; he was called the 'American Lawrence'. Hon. member Scottish Acad. 1827. 1837 to England to paint Queen Victoria (who never looked so delightful again). Lovely brushwork, soft colouring, ingenious and resourceful compositions; he was at ease on any scale but his full-lengths are especially remarkable. *Neagle was his pupil and married his niece/step-daughter; and his nephew Robert Matthews (1803–55) was also a portraitist. (See Plate 6)

LOCATIONS: NG Washington; Pennsylvania AFA; Worcester Art Mus., Worcester, MA; Detroit Inst.; Boston Athenaeum; Wallace Colln; Cleveland Mus., OH.

LITERATURE: # D. Biddle and M. Fielding, *Life and Works of Thomas Sully* (Philadelphia, 1921).

Swinton, James Rannie 1816–88

b. Edinburgh(?); Trustees' Acad., with Sir

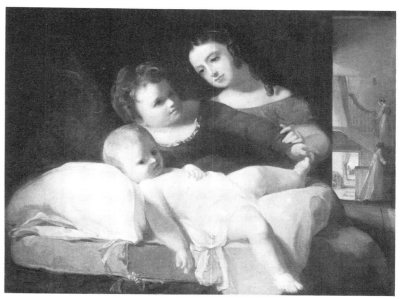

196

William Allan and *Sir John Watson Gordon; 1839 to London, RA Schools 1840; was then in Italy and Spain, and practised in Rome; many chalk portraits, but also oils, usually three-quarter and full-length; painterly drapery but, in contrast, highly-finished heads; some portraits are fanciful in 'historic/heroic' manner.

LOCATIONS: Muncaster Castle Colln; W. J. Stirling of Keir, Dunblane; Marquess of Salisbury, Hatfield House; Marquis of Bath, Longleat.

Swynnerton, Annie Louisa ARA 1844–1933

b. Kersal, Lancs. (née Robinson), d. Hayling Island; studied Manchester School of Art, Acad. Julian, Paris, and in Rome where she met and married the sculptor Joseph Swynnerton. A close friend of *Dacre whose Italian figure and landscape style her own earlier manner closely resembles; later, she developed a distinctive, more linear, highly-coloured portrait manner. ARA 1922, the first woman since *Kauffmann. In Rome until death of her husband 1910. A friend of *Sargent. (See Plate 31)

LOCATIONS: Nottingham Castle Mus.; Tate; Manchester CAG.

Syme, John RSA 1795–1861

b. & d. Edinburgh; studied Edinburgh under *Raeburn; began exhibiting flower pieces but from 1815 almost all portraits; foundation SA 1826; painted *Audubon (exhibited SA 1827 (201)); usually a coarser version of Raeburn's manner.

LOCATIONS: The White House Colln; Duke of

196. Thomas Sully, *The Sicard-David Children*. Oil on canvas, 87 × 112.4 cm (34¼ × 44¼ in). 1826. Washington, DC, National Gallery of Art, Chester Dale collection

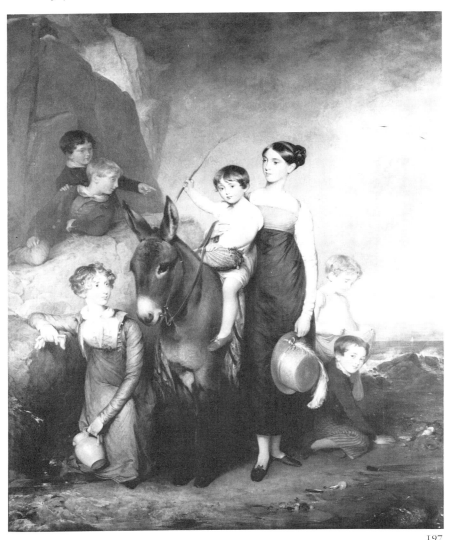

197

197. Henry Thomson, *The Grey Family on the Seashore with a Donkey.* Oil on canvas, 246.4 × 249.9 cm (97 × 98 in). *c.* 1813. Private collection

Buccleuch, Drumlanrig; Parliament Hall, Edinburgh; NGS.

Symonds, William Robert 1851–1934

b. Yoxford, Suffolk; trained London and Antwerp. Exhibited RA 1905–26, and at Paris Salon and Grosvenor Gall. Lived in London.

LOCATIONS: Wallace Colln; Queen's Coll., Belfast; Oriel Coll., Oxford; Duke of Norfolk, Alton Towers.

Tarbell, Edmund Charles 1862–1938

b. West Groton, MA, d. New Castle, VT; brought up in Boston and studied Boston MFA School 1879 then, with *Benson, at Acad. Julian, Paris, under Boulanger and Lefebvre from 1883–6. He became an influential teacher at Boston MFA School 1889–1913; one of The Ten. Mainly an American Impressionist, painting landscape and figures, but a distinguished portraitist in a more traditional manner.

LOCATIONS: Boston MFA; Nat. Mus. of American Art; NG Washington.

LITERATURE: P. J. Pierce, *The Ten* (North Abington, MA, 1976), pp. 115–32.

Tate, William 1748–1806

b. Liverpool, d. Bath; pupil at Liverpool 1769 of *Wright of Derby with whom he and his family remained in close touch; in London 1771/2, then working variously in Manchester, Liverpool, and London, then Manchester probably from 1787; RA Schools 1777; Bath from 1804. Early style akin to that of *Reynolds, later influenced by *Romney and *Hoppner but, surprisingly, not especially close to that of Wright.

LOCATION: Walker AG, Liverpool.

LITERATURE: Walker AG Cat.

Taylor, Robert *fl.* 1737–55

Painter in a heavier version of *Richardson's manner; a good comparison might be with the work of *Worsdale; painted Pope and Prior, 1737, in busts in oval.

LOCATION: NMW.

LITERATURE: EKW.

Theüs, Jeremiah *c.* 1719–1774

b. Felsberg, Grison, Switzerland, d. Orangeburg Township, SC; in SC 1735, Charleston from 1739; also landscape and coach painter and gave lessons; many portraits of SC sitters, often bust- or half-length in oval; restricted colour but quite softly modelled. It is interesting to note that his portraits of the Manigault family were hanging next to a portrait by *Allan Ramsay of Peter Manigault which would, in all probability, have been the best painting in SC at that time.

LOCATIONS: Met. Mus., NYC; Joseph Manigault House, Charleston, SC; Brooklyn Mus.

LITERATURE: M. S. Middleton, *Jeremiah Theüs, Colonial Artist of Charles Town* (Columbia, SC, 1953).

Thompson, Cephas Giovanni ANA 1809–88

b. Middleboro, MA, d. NYC; son and pupil of portraitist Cephas T. (1775–1856, example, Chrysler Mus., Norfolk, VA); somewhat itinerant, then settled NYC 1837; Boston 1849–52, and 1853–60 went to Italy and lived in Rome where he knew Nathanial Hawthorne who mentions him (in journal and *The Marble Faun*); then NYC.

LOCATION: N.-Y. Hist. Soc.

Thompson, Thomas Clement
RHA 1778–1857

b. Belfast(?), d. Cheltenham; Dublin Soc.
Schools 1796; began as miniaturist, only
painting oils from 1803; 1810 was established
successfully in Dublin, then London 1817;
foundation member RHA 1823 and exhibited
also RA; c. 1848 in Cheltenham; several royal
portraits; also genre and landscape. Rather a
hard, unyielding manner, often large-scale
with columns and other similar props, and he
liked introducing a secondary figure.

LOCATIONS: Christie's, 15.x.82 (15); Ulster
Mus., Belfast; Earl of Shrewsbury, Ingestre.

LITERATURE: Wood; Strickland.

Thomson, Henry RA 1773–1843

b. & d. Portsea; spelt 'Thompson' originally;
RA Schools 1790, pupil of *Opie 1791; Italy
1793–8, back via Vienna and Germany 1799.
Deservedly won fame with *Crossing the Brook*
(exhibited RA, 1803), *Lawrence said of him
'there has existed in the Academy no Iago like
that man'. His portraits are often delightful,
employing the manner of his subject pictures:
an 'upper class rural domestic style' (EKW).
ARA 1801, RA 1804, Keeper RA 1825–7.

LOCATIONS: Lady Janet Douglas-Pennant,
Penrhyn; Norwich Castle Mus. (on deposit);
Lady Mary Howick, Howick Grange; N.
Trust, Stourhead.

LITERATURE: Whitley II; EKW; *The News*,
Portsmouth (July, 1973).

Tilson, Henry 1659–95

b. London, d. London (suicide after love
affair); pupil of *Lely; associated with *Dahl
from 1684/5, and with him to Paris (1686) and
Italy, in Rome until late 1688 then returning to
London; a painter of great charm, whose
appeal owes something to Dahl's influence, the
modelling softer, and perhaps also indebted to
*J. M. Wright; a friend of *Thomas Hill.

LOCATION: N. Trust, Belton House, Dyrham
Park.

Tilyard, Philip Thomas Coke 1785–1830

b. & d. Baltimore, MD; initially a sign
painter; some connection with *Sully; by 1814
a portraitist, stopped 1816 and tried business
until 1822, but had to start painting again;
rather talented, fine modelling; successful
locally.

LOCATION: Baltimore Mus.

LITERATURE: W. H. Hunter, Jr, *The William
and Mary Quarterly* (July, 1950), pp. 398–9.

198

198. Henry Tilson,
*William Blaythwayt as a
Boy (in Roman costume)*.
Oil on canvas,
127 × 101.6 cm
(50 × 40 in). 1691. The
National Trust, Dyrham
Park

Troubetzkoy, Prince Pierre 1864–1936

b. Milan, d. NYC; son of Russian diplomat;
studied under Ranzoni and Tominelli; to
England aged eighteen; painted Gladstone
(SNPG, oil sketch, NPG) worked Europe,
Britain and America, finally NYC 1896 but
later in Washington and lived in Albermarle
Co., VA; naturalized American; influenced by
*J. J. Shannon whom he painted; successful
society portraitist; firm modelling in planes, as
though influenced by Bastien-Lepage; his
brother Prince Paul T. was a sculptor.

LOCATIONS: *Society Portraits*, exh. cat.
(Colnaghi, 1986), no. 65; Town Hall, Dover.

Truman, Edward fl. 1741

Painted Governor Thomas Hutchinson of
MA, 1741; two other certain portraits are
known.

LOCATIONS: MA Hist. Soc.; NG Washington.

LITERATURE: L. B. Miller, *In the Minds and
Hearts of the People* (N.Y. Graphic Soc.,
1974), p. 37.

Trumbull, John 1756–1843

b. Lebanon, CT, d. NYC; younger son of
Revolutionary Governor of CT, and was
himself also an army officer and diplomat; met
*Copley while at Harvard (grad. 1773), then
army 1775–7; painted at Boston (*Smibert's
former studio); 1780 to London and *West but
promptly imprisoned; back to America on
release, then London again as pupil of West
1783/4–89; visited Paris and met J.-L. David,
who encouraged him. Turned to modern
portrait-history of West and Copley (and

199. Benjamin
Vandergucht, *Henry
Woodward as Petruchio
in 'Catherine and
Petruchio'*. Oil on canvas,
127 × 101.5 cm
(50 × 40 in). 1774. New
Haven, CT, Yale Center
for British Art, Paul
Mellon collection

199

David) kind. 1789 back in America, then
England again 1794–1804 (as diplomat), NYC
1804–8, England 1808–16, NYC from 1816.
An outstanding draughtsman. His paintings
display his extraordinary development from
wooden, autodidactic early works to mature
freedom of handling, and an air of aristocratic
ease (as he would have liked). A touchy, proud
man, his presidency brought the end of the
American Acad. of Fine Arts, and hence
foundation of NA. Painted a most moving
series of portraits of his wife, including
posthumous one of her on her death bed.
Exchanged his own pictures with Yale Univ.
for an annuity and a gallery of his own design,
1831. (See Chp. One, Fig. 17)

LOCATIONS: Yale Univ.; Detroit Inst.; Met.
Mus., NYC; NG Washington; Boston MFA.

LITERATURE: *John Trumbull: The Hand and
Spirit of a Painter*, exh. cat. (Yale Univ., 1982);
#Th. Sizer, *The Works of Colonel John
Trumbull, Artist of the American Revolution*
(New Haven and London, 1950); revised edn,
with the assistance of Caroline Rollins (New
Haven and London, 1967).

Tuscher, Carl Marcus 1705–51

b. Nuremberg, d. Copenhagen; trained for ten
years at Nuremberg Acad. under Johan
Preisler; May 1728 to Italy, still there 1737; to
London 1741 until mid-1743 when he left for
Copenhagen to be court painter; conversation
pieces and a larger group; also an architect
and engraver.

LOCATIONS: NPG; Geffrye Mus., London.

LITERATURE: B. Allen, *Apollo*, CXXII (July,
1985), pp. 31–5.

Ulke, Henry 1821–1910

b. Frankenstein, Germany, d. Washington,
DC; trained Berlin; 1849 NYC, then
Washington; numerous portraits of
government officials.

LOCATION: Capitol, Washington, DC.

LITERATURE: G & W.

Van Aken, Joseph *c.* 1699–1749

b. Antwerp(?) (Van Haecken), d. London; the
most important drapery painter of his time, of
high quality, working for *Ramsay, *Hudson,
*Davison and others from *c.* 1735, but also
painted genre, and perhaps conversation
pieces, of surprising clumsiness. In London *c.*
1720 with his brothers Arnold and Alexander
(*c.* 1701–57), on his death the latter taking
over the drapery painting for, e.g., Hudson.
Important drawings by him for Ramsay and
Hudson survive (NGS), recognizable for
having heads slightly too large for bodies, and
the whole somewhat awkward. (See Chp.
Three, Figs 90, 91, 93, 94, 95, Plate 23)

LOCATIONS: Tate; Manchester CAG.

Van Bleeck, Pieter 1697–1764

b. The Hague, d. London; probably in London
1719; his *Mrs Gibbon as Cordelia*, 1755
(Yale), is an original conception, and other
portraits include unusual props and designs;
full-lengths and groups. His father Richard (*c.*
1670–*c.* 1733) was also a portraitist and
variously in London. Roman Catholic
patronage.

LOCATIONS: Yale; Christie's, 21.iii.75 (148).

LITERATURE: EKW.

Vanderbank, John 1694–1739

b. & d. London; *Kneller Acad. 1711, then
founded St Martin's Lane Acad. with Louis
Cheron 1720, and thus influenced *Hogarth,
among many; own style indebted to *Kneller
and *Richardson, very uneven in quality
although he had real gifts; as early as 1724
high living made him flee to France, returning
by 1727, but he was always under pressure
from drink and debts; an important decorative
painter and book-illustrator.

LOCATIONS: NPG; Tate; N. Trust, Plas
Newydd.

LITERATURE: Hammelmann, pp. 79–86.

Vandergucht, Benjamin 1753–94

b. & d. London (drowned Chiswick); one of
an army of Vanderguchts, and apparently
thirty-second child of Gerard V (1696–1776);
polished style close to *Zoffany; busts and

half-length, also theatrical portraits-in-character, as also painted by a relation, 'W. Vandergucht' (fl. 1740, Tate).

LOCATIONS: Christie's Colln; Garrick Club.

LITERATURE: Hammelmann, pp. 86–8.

Vanderlyn, John 1775–1852

b. & d. Kingston, NY; some training under *Stuart in Philadelphia. In Paris from 1796, the first decisive period of his career, and he was thereafter much influenced by J.-L. David. NYC 1801, then to Rome and (mainly) Paris again until 1815, reinforcing his commitment to portraying modern histories, but he depended on portraiture for a living; Paris again 1837 for a few years. Handsome portraits on any scale, usually with an air of history, in an uncompromising manner clearly influenced by French neo-Classicism. Died frustrated and embittered, in poverty.

LOCATIONS: City Hall, NYC; City Council, Charleston, SC; Met. Mus., NYC.

LITERATURE: K.C. Lindsay, *The Works of John Vanderlyn, From Tammany to the Capitol*, exh. cat. (Binghampton, NY, 1970); M. Schoonmaker, *John Vanderlyn, Artist 1775–1852* (Kingston, NY, 1950).

Van der Mijn, Herman 1684–1741

b. Amsterdam, d. London; in London c. 1721; father of a number of painters, e.g., Frans (c. 1719–83) and George (c. 1726/7–63), both of whom painted portraits. His style is basically Dutch, but he tried to adapt to English taste, the results painstaking but rather heavy: 'a very laborious neat painter' (Vertue). Returned to Holland 1736/7. Also still-lifes. Patronized by Earl of Exeter. Frans is the most distinct artistic personality of his children (based in London from c. 1750).

LOCATIONS: Christie's, 1.iii.85 (105); Earl of Shrewsbury.

LITERATURE: EKW.

Vandervaart, John 1653–1727

b. Haarlem (Jan van der Vaart), d. London; in London 1674; initially landscapes with small figures; in partnership as drapery painter with *Wissing in 1680s, and occasionally would insert heads by Wissing on separate pieces of canvas into larger compositions; independent portraits after 1687 are less satisfactory, and attributions to him before this date of relevant high-quality portraits should surely be given to Wissing. His own portraits show far less flattering likenesses. Had to abandon portraiture through failing sight, and sold up in 1713 to build a house in Covent Garden.

Also painted landscapes, flowers and, e.g., famous *trompe l'oeil* violin at Chatsworth, and was a mezzotint engraver. (See Chp. Three, Fig. 88; Plate 26)

LOCATIONS: Leicester Mus. and AG; Burghley House Colln.

LITERATURE: Vertue, III, p. 32.

Van Loo, Jean-Baptiste 1684–1745

b. & d. Aix-en-Provence; studied variously, including Rome under Luti; Paris from 1720; England 1737–42 where, with *Soldi, he took most of fashionable practice to chagrin of *Hogarth and even *Ramsay, his style being glamorous and obviously foreign (and quite heartless); mainly full-lengths, seated and groups.

LOCATIONS: HMQ; City of Worcester.

LITERATURE: EKW.

Vaslet, Lewis 1742–1808

b. York, d. Bath; at first a miniaturist, exhibited RA from 1770, later oils and crayons; limbs can appear attenuated but generally accomplished, the colouring pleasantly subdued, with rather naive charm.

LOCATIONS: Christie's, 15.vii.83 (67); Bath AG.

LITERATURE: J. Ingamells, *Apollo*, LXXX (July, 1964), pp. 33–4.

Verelst, Willem fl. 1734–c. 1756

One of a family of Dutch painters and the most accomplished; large-scale and conversation pieces, and a group *The Common Council of Georgia receiving the Indian Chiefs* (1734–5, Dupont Mus.). Others of family are: elder brother, John V. (fl. 1698–1734) whose portraits are very bad (example, NPG); uncle, the flower painter and portraitist Simon V. (1644–1721), who went mad 'and spent his latter years painting enormous roses and other aberrations proper to a flower painter' (EKW); grandfather, Harman V. (fl. 1663–1702), a portraitist of *Closterman type.

LOCATIONS: H.F. Dupont Mus., Winterthur, DE; NPG.

LITERATURE: EKW, *Painting in Britain*, p. 145; EKW.

Vinton, Frederic Porter NA 1846–1911

b. Bangor, ME, d. Boston, MA; studied under William Rimmer at Lowell Inst. 1864, then 1875 in Paris under Bonnat (he had worked in a bank for some years previously) and went with *Duveneck to Munich; 1876 Paris again, under Laurens, and then set up as a portraitist

200

200. Willem Verelst, *The Common Council of Georgia receiving the Indian Chiefs*. Oil on canvas, 123.2 × 153.3 cm (48¼ × 60⅜ in). 1734–5. Winterthur, DE, The Henry Francis du Pont Winterthur Museum

in Boston 1878, where he was a leading figure; 1882 went with *W. M. Chase to Spain to copy Velásquez, and in Europe again 1889–98. These European influences are clear in his manner, which is weighty and distinguished, with scrupulous attention to the play of light, usually on large scale; also landscapes in Impressionist style. NA 1891.

LOCATIONS: Boston MFA; Boston Univ. (Military Hist. Soc. of MA).

LITERATURE: *Memorial Exhibition of the Works of Frederic Porter Vinton*, exh. cat. (Boston MFA, 1911).

Vispré, Francois Xavier　*c.* 1730–*c.* 1790

b. Besançon; good portraitist in crayons; in Paris 1750s, to London *c.* 1760; Dublin 1777, London 1780; friend of sculptor L.-F. Roubiliac whose portrait he painted (Yale). His brother Victor did still-life.

LOCATIONS: Yale; Ashmolean Mus.

LITERATURE: EKW.

Volk, Douglas NA　1856–1935

b. Pittsfield, MA; son of sculptor Leonard Wells V. (1828–95); studied art in Rome and under Gérôme in Paris 1873–8; taught at various American institutions, including Art Students' League 1893–8; could work on a very large scale; one of official portraitists of World War 1 leaders. ANA 1898, NA 1899.

LOCATIONS: Smithsonian Inst.; Brooklyn Mus.; Albright-Knox Gall., Buffalo, NY; West Point, NY.

LITERATURE: *Who Was Who in America*, 1.

Vonnoh, Robert William　1858–1933

b. Hartford, CT, d. Nice (France); grew up in Boston, MA; studied at MA Normal Art School 1875–7, Paris 1881–3 under Boulanger and Lefebvre; established as portraitist in Boston on his return, then 1887–91 Paris again; greatly influenced by Impressionism and one of the first to do landscapes in that manner in America; taught at Pennsylvania

AFA until 1896. Like many American Impressionists, his portraits are executed in a more conservative style indebted to his French realist training.

LOCATIONS: Chicago Hist. Soc.; Pennsylvania AFA.

LITERATURE: E. Clark, *Art in America*, 16 (August, 1923), pp. 223–32; Met. Mus. Cat., III.

Waitt, Richard *fl.* 1706–32

Scottish portraitist; reputedly a pupil of *Scougall; some influence of *Medina is evident; usually busts in oval; often powerful characterizations verging on caricature, features usually rather elongated and lumpish; also painted still-life; his self-portrait (SNPG) shows an improbably grand subject on the easel.

LOCATIONS: SNPG; Sotheby's, 22.v.85 (177); Earl of Seafield.

Waldo & Jewett

See **Waldo, Samuel Lovett,** and **Jewett, William**

Waldo, Samuel Lovett NA 1783–1861

b. Windham, CT, d. NYC; pupil of *Steward in Hartford, CT, *c.* 1799, then with *West in London; RA Schools 1806–8; from 1809 based NYC. *W. Jewett was his pupil and, 1818–54, his partner in portrait firm Waldo & Jewett, and it is possible that they variously shared all parts of the execution. Joint portraits, and Waldo's own, can be on panel, and they are markedly more painterly and firmly-modelled than those of many American artists of the first half of the century. The firm stamped or inscribed on the back. Founding member NA 1826.

LOCATIONS: Met. Mus., NYC; Boston MFA; Toledo Mus.

LITERATURE: F.F. Sherman, *Art in America*, XVIII (February, 1930), pp. 81–6.

Walton, Henry *c.* 1746–1813

b. Dickleburgh, Norfolk, d. London; pupil of *Zoffany *c.* 1769/70; evidently familiar with works of contemporary French painters, especially of Chardin; and painted domestic genre of a kind rare in England; notable for exceptionally fine conversation pieces of 1770s, often outdoors, highly-finished, with careful attention to cast shadow, and original composition; also many small busts in oval, and larger of same; later portraits show influence of *Opie and are painted with much more vigorous brushwork; had a private income and retired to Suffolk after 1779.

201

LOCATIONS: NPG; Norwich Mus.; Reresby Sitwell, Esq., Renishaw Hall.

Walton, John Whitehead *fl.* 1831–85

London portrait painter, exhibited chiefly portraits RA 1834–65 from various London addresses; not very distinguished; both small- and large-scale portraits, including groups.

LOCATIONS: NPG; Duke of Wellington, Stratfield Saye.

Watson, George PRSA 1767–1837

b. Overmains, d. Edinburgh; pupil of *Alexander Nasmyth, then with *Reynolds in London *c.* 1785–7, thereafter Edinburgh; style influenced by *Raeburn, often smooth finish and further exploiting Raeburn's lighting effects; in London 1815 and painted *West (NGS); all types of large-scale portraits, especially good groups, women rather lacking in character.

LOCATIONS: NGS; Shipley AG, Gateshead; RSA; Earl of Morton, Dalmahoy House.

Watt, George Fiddes RSA 1873–1960

b. & d. Aberdeen; studied Gray's School of Art and RSA Schools. Based in Edinburgh, then London from *c.* 1911. ARSA 1910, RSA 1924. A sensitive portraitist in a recognizably Scottish tradition of painterly realism.

LOCATIONS: Lincoln's Inn; Leeds City AG; Middle Temple; Royal Soc.

LITERATURE: Waters.

Watts, George Frederic OM, RA 1817–1904

b. London, d. Guildford; apprenticed to sculptor, then RA Schools 1835, and at school

201. Samuel Lovett Waldo, *Deliverance Mapes Waldo and her Son.* Oil on canvas, 76.2 × 63.5 cm (30 × 25 in). *c.* 1830–1. Boston, MA, Museum of Fine Arts, M. and M. Karolik collection. Gift of Maxim Karolik

202. Henry Weigall (Jr), *David Graham Drummond Ogilvy, 10th Earl of Airlie.* Oil on canvas, 209.5 × 129.5 cm (82½ × 51 in). *c.* 1861. In a private Scottish collection

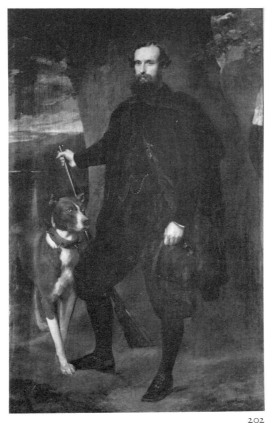

202

of artist and England cricketer 'Felix'. 'England's Michelangelo' (Leighton), he was a man of small intellect and vast pretensions, especially to history and allegorical painting, but became, at first reluctantly, a major portraitist, notably in his 'Hall of Fame' of eminent Victorians painted from 1880s on. At his best, there is a Venetian renaissance quality to his colour, design and texture, but often the surface is overworked and unpleasant; often bust-length. Patronised by Lord and Lady Holland and by Prinsep family, with whom he lived for a long time ('he came to stay three days; he stayed thirty years'). ARA and RA 1867, OM 1902, twice declined baronetcy. (See Chp. One, Fig. 22)

LOCATIONS: NPG; Tate.

LITERATURE: *G.F. Watts, The Hall of Fame,* exh. cat. (NPG, 1975); W. Blunt, *'England's Michelangelo', a Biography of George Frederic Watts OM, RA* (London, 1975).

Webster, Joseph Samuel *fl.* 1757–96
Perhaps a pupil of *Hudson, whose style his own resembles; of interest as the indifferent artist asked to paint Archbishop Herring 1757 after failure of *Hogarth in 1744 to please the sitter when Archbishop of York (and his family), the sitter having recently been translated to Canterbury.

LOCATIONS: Lambeth Palace; Agnew 1957 (Christie's, 15.vii.1955 (154)).

Weigall, Henry, Jr 1829–1925
b. London(?), d. Ramsgate; son of sculptor of same name from Irish(?) family of artists; exhibited RA from 1846 and elsewhere; thoughtful, painterly artist; numerous heads in ovals but at his best in large-scale full-lengths that show off his knowledge of earlier portrait traditions.

LOCATIONS: NPG; N. Trust for Scotland, Leith Hall; Earl of Airlie, Cortachy Castle; Merton Coll., Oxford.

Wells, Henry Tanworth RA 1828–1903
b. & d. London; pupil of J.M. Leigh in Newman St, then studied in Paris. Miniatures until 1861 then oils, chiefly portraits, with a wide society and official practice; good sense of portrait traditions and current painting styles which he adapted to a limited extent to his accomplished portraits. An associate of P.H. Calderon in the St John's Wood Clique. (See Fig. 48)

LOCATIONS: NPG; Earl of Pembroke, Wilton; Capt. P. Drury-Lowe, Locko Park; Lord Barnard, Raby Castle.

Wertmüller, Adolph-Ulrich 1751–1811
b. Stockholm (Sweden), d. Newcastle Co., DE; studied Sweden, then 1772–4 in Paris, under Vien, and with him to Rome until 1779; became Swedish court painter; Spain 1790–4, then Philadelphia; Europe again 1796–1800, returning to Philadelphia, settling Newcastle Co. 1803. Painted Washington and many other portraits, in highly-finished manner, but also history, including notorious (because nude) *Danaë* (exhibited NYC 1806–11). Married a grand-daughter of *Gustavus Hesselius.

LOCATION: Hist. Soc. of PA.

West, Benjamin PRA 1738–1820
b. nr Springfield, PA, d. London; perhaps a pupil of *William Williams (of Bristol) in Philadelphia; local subscribers sent him to Rome in 1760 and he never went back to America; in Italy until 1763, then London; painted many histories and was much patronised by George III; his modern histories, notably *Death of Wolfe,* 1770 (NG Canada), are especially important early examples, and some portraits exploit this kind of setting; but he painted portraits of all types in a distinctive style, a neatly finished, sometimes neo-Classical, somewhat pinched manner. He was of immense importance to the development of the American school, both as contact and

teacher in London, from *C.W. Peale to *Morse; foundation RA 1768; succeeded *Reynolds as PRA 1792. (See Plate 3)

LOCATIONS: Tate; Cleveland Mus., OH; Hist. Soc. of PA; Boston MFA; Chrysler Mus., Norfolk, VA.

LITERATURE: *Benjamin West and his American Students*, exh. cat. (NG Washington, 1980); #H. von Erffa and A. Staley, *The Paintings of Benjamin West* (New Haven and London, 1986).

West, Samuel 1810–67

b. Cork; studied Rome; worked certainly in Scotland and Ireland, and exhibited RA from 1840 and elsewhere in London; polished society portraitist.

LOCATIONS: Brig. Swinton, Kimmerghame House; Sotheby's 24.x.84 (250).

West, William Edward 1788–1857

b. Lexington, KY, d. Nashville, TN; pupil of *Sully in Philadelphia c. 1807; Natchez, MS, 1818, then Italy 1819 where painted Byron and Shelley; 1824 Paris, then London 1825–38; returned to Baltimore, MD, then NYC 1841–55 then Nashville.

LOCATIONS: SNPG; N. Trust, Felbrigg Hall; Vaughan Lib., Harrow School.

LITERATURE: G & W.

Westall, Richard RA 1766–1836

b. Hertford, d. London; RA Schools 1785 after being silver engraver's apprentice; well known as watercolourist and book illustrator, he also painted oil portraits in a style veering from a romantic *Lawrence manner to extreme neo-Classical. ARA 1792, RA 1796.

LOCATIONS: NPG; Sotheby's, 15.iii.78 (40); Lady Lever AG, Port Sunlight.

Westcott, Philip 1815–78

b. Liverpool, d. Manchester; apprenticed to miniaturist and picture restorer and worked as restorer; successful as portraitist in Liverpool from late 1830s, then tried London 1854/5, but in 1862 moved to Manchester; also histories and landscapes, sometimes using latter to good effect in portraits including horses and dogs; highly skilled, sometimes dramatic, always painterly.

LOCATIONS: Manchester CAG; Christie's, 28.i.77 (169); Walker AG, Liverpool.

LITERATURE: Walker AG Cat.

Wheatley, Francis RA 1747–1801

b. & d. London; RA Schools 1769, but largely

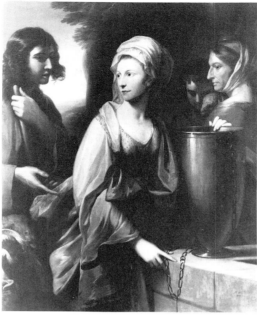

203

self-taught, and collaborated with *Mortimer 1771–3. Dublin (because of debts) 1779–83, then London; also important landscape and genre painter; many portraits are small-scale full-lengths and conversation pieces, lucidly and evenly painted, but he also painted large scale, including groups; influenced by *Zoffany.

LOCATIONS: Yale; Detroit Inst.; NGI; Tate; NPG.

LITERATURE: #M. Webster, *Francis Wheatley* (London, 1970).

Whistler, James Abbott McNeill 1834–1903

b. Lowell, MA, d. London; U.S. Military Acad. 1851–4, then trained as draughtsman; 1855 to Europe and never returned; 1856 Paris, briefly with Gleyre, and moved in *avant garde* circles; settled London 1863 but remained in close contact with Paris; moved away from early realist style, influenced by Velásquez then Japanese art and the Impressionist circle towards a personal form of portraiture in which aesthetic considerations were to be considered paramount, emphasizing this development by giving his pictures musical or other irrelevant titles. Bankrupt after suing Ruskin 1879, went to Venice, then mainly in London until 1892 but also had studio in Paris. A key *fin-de-siècle* aesthete and highly influential (e.g., *J.W. Alexander); his very personal oil technique has left some of his pictures looking very dark. (See Chp. One, Fig. 34)

LOCATIONS: NG Washington; Frick Colln, NYC; Tate; Glasgow CAG; Hunterian AG Glasgow; Honolulu Acad. of Arts, Hawaii.

203. Benjamin West, *Mary, Wife of Henry Thompson of Kirby Hall, as Rachel at the Well*. Oil on canvas, 127 × 99.5 cm (50 × 39¼ in). 1775. Norfolk, VA, Chrysler Museum. Gift of Walter P. Chrysler, Jr

LITERATURE: # A. McL. Young, M. MacDonald, R. Spencer, with the assistance of Hamish Miles, *The Paintings of James McNeill Whistler*, 2 vols (New Haven and London, 1980).

Whood, Isaac 1688/9–1752

d. London; perhaps a pupil of *Richardson or at least of *Kneller's 1711 Academy; his own style similar to that of *Vanderbank; also a copyist; could work on a very large scale.

LOCATIONS: Leicester CAG; Soc. of Antiquaries; Phillips, London, 17.xii.85 (65).

LITERATURE: EKW.

Wight, Moses 1827–95

b. & d. Boston, MA; began portraits 1845, then studied Paris under Hébert and Bonnat 1851–4, returning via Rome to Boston; settled Paris 1873 (two trips there 1860, 1865) returning to U.S.A. shortly before his death.

LOCATIONS: Boston MFA; American Antiq. Soc.

LITERATURE: G & W; Boston MFA Cat.

Wiles, Irving Ramsey 1861–1948

b. Utica, NY, d. Peconic, NY; son of an artist; studied Art Students' League with *Beckwith, and also *W. M. Chase who influenced him; Paris 1882–4 under Carolus-Duran; taught at Chase School and League; began portraits only 1890 and from *c.* 1895 mainly occupied with them, and was much admired. Also painted Impressionist landscapes. His portrait style is vivid and dynamic, with aspects of

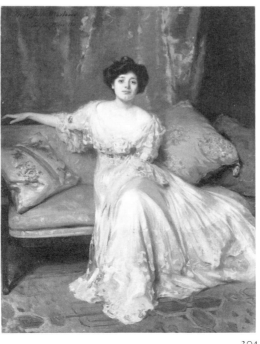

204. Irving Ramsey Wiles, *Miss Julia Marlowe*. Oil on canvas, 188.6 × 140.7 cm (74¼ × 55⅜ in). 1901. Washington, DC, National Gallery of Art. Gift of Julia Marlowe Southern

204

Chase and *Sargent; often large-scale society portraits.

LOCATION: NG Washington.

LITERATURE: Quick; *Irving Ramsey Wiles 1861–1948*, exh. cat. (Chappellier Gall. NY, 1967).

Williams, John Michael *fl.* 1743–*c.* 1780

Pupil of *Richardson; in Ireland from 1777; polished, accomplished manner, and evidently continued working after moving to Ireland, when he was probably in Dublin, where he exhibited 1777.

LOCATIONS: Christie's, 24.iii.70 (280); NPG.

Williams, William, 'of Bristol' 1727–91

b. & d. Bristol; Philadelphia, PA, from *c.* 1747 where he inspired *West; signed and dated works in America each year 1766–76; some portraits by *William Williams (of Norwich) have been wrongly given to him; his own style is naive but attractive, with many theatrical props, and a distinctive line in theatrical and fantastic landscape; by contrast, Williams of Norwich was a landscape painter and his backgrounds are far more naturalistic. The problem has been complicated by the fact that both artists painted small-scale full-lengths and conversation pieces, in addition to large-scale, and further by the fact that this one returned to England and died in Bristol, while the other was nearby in Bath 1785–7; he was also a novelist and writer (*Journal of Llewellyn Penrose*, MS *Lives of the Poets*) but it was Williams of Norwich who wrote *Essay on Mechanic of Oil Colours* published from Bath 1787.

LOCATIONS: Brooklyn Mus., NY; Met. Mus., NYC; H.F. du Pont Mus., Winterthur, DE.

LITERATURE: D.H. Dickason, *William Williams: Novelist and Painter of Colonial America 1727–1791* (Bloomington, IN, 1970).

Williams, William, 'of Norwich' *c.* 1735–97

Won drawing prize Soc. of Artists 1758; in Manchester 1763, Norwich 1768–70; York 1770; Shrewsbury 1780; Bath 1785–7 (published pamphlet, 1787, *Essay on Mechanic of Oil Colours*); Leeds 1793 where he held exhibition of his works; Hull and Leeds 1795; also visited Wakefield, and probably Stockport, Cheshire and N. Wales; small-scale full-lengths and conversation pieces, price one guinea, 'heads large as life for three guineas'; also large-scale landscapes, and Shakespearian and literary histories, and also religious works (in Leeds and Wakefield). Not to be confused with *William Williams of Bristol, although a

number of his portraits have been given to the latter. Sometimes used copper support.

LOCATIONS: NMW; St Andrew's Hall, Norwich; Colln. J. More, Linley Hall, Salop.; Sotheby's, 24.x.84 (233).

LITERATURE: J. Steegman, *Burlington Magazine*, LXXV (July, 1939), pp. 22–7; A. Artley, *Leeds Arts Review* (1972).

Willison, George 1741–97

b. & d. Edinburgh; pupil of Mengs in Rome before 1761 where he painted James Boswell 1765, 'a plain, bold, serious atttude' (Boswell, *Journal*) that Willison then extended and adorned, e.g., with an owl (SNPG); London from 1767. Early manner rather fussy; later simpler and more attractive; also small-scale full-lengths. India 1774–80. Retired to Edinburgh *c.* 1784.

LOCATIONS: Yale; SNPG; Duke of Hamilton, Lennoxlove.

LITERATURE: Archer, pp. 99–107.

Wills, The Revd James *fl.* 1740–77

d. Stanmore; studied in Rome; London from 1740 and involved with *Hayman and others in running St Martin's Lane Acad., 1743–6; best known for conversation pieces and small-scale full-lengths, in a more elegant, better-proportioned style than Hayman's; also busts; ordained 1754 and became Duke of Chandos's Vicar at Cannons. Probably the notorious critic of the *Morning Chronicle* ('Fresnoy') 1769–70.

LOCATIONS: Fitzwilliam Mus., Cambridge; Christ Church, Oxford.

Wilson, Benjamin FRS 1721–88

b. Leeds, d. London; perhaps a pupil of *Hudson; Dublin 1748–50; interested in Rembrandt and imitated his style, rather crudely, on scale of life to some effect, with strong side lighting, sometimes by a window; played, with *Hogarth, a famous trick on Hudson, 1751, by forging Rembrandt etchings; significant in the early history of conversation pieces showing actors in character; employed *Zoffany (rather secretly) to help him 1760–1. Turned more to science *c.* 1770; FRS 1751.

LOCATIONS: Leeds CAG; Dulwich Coll. AG.

LITERATURE: Colnaghi, *The British Face*, exh. cat. (1986), no. 26.

Wilson, Matthew Henry ANA 1814–92

b. London, d. Brooklyn, NY; U.S.A. 1832, pupil of *Inman in Philadelphia and 1835 in

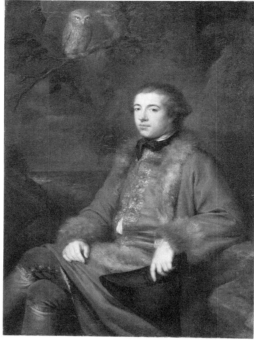

205. George Willison, *James Boswell*. Oil on canvas, 32.7 × 94 cm (52¼ × 37 in). 1765. Edinburgh, Scottish National Portrait Gallery

205

Paris of Dubufe; then mainly in Brooklyn, but travelled variously, e.g., Baltimore 1847, Hartford, CT, 1861–3, then Brooklyn.

LOCATION: J.B. Speed Art Mus., Louisville, KY.

LITERATURE: G & W.

Wilson, Richard RA 1713–82

b. Penegoes, d. nr Mold; the father of British landscape painting but trained as portraitist (by 'T. Wright') in London and practising as such until early 1750s; to Italy 1750–6/7, and thereafter painted only landscape; portraits are highly accomplished in a distinctive style with smooth, liquid modelling and bright highlights, very decorative, and tonally conceived; the few later examples, e.g., *F. Zuccarelli,* 1751 (Tate), show a new freshness of touch and expressiveness of brushwork; busts in oval are typical but also full-lengths and a conversation piece (of royal children); dated works from 1744. Foundation member RA 1768; in alcoholic ill-health and poverty by late 1770s, inherited (too late) a family property in N. Wales and retired there 1781.

LOCATIONS: NMW; Nat. Marit. Mus.; Viscount Cobham; NPG; Tate; SNPG.

LITERATURE: #W.G. Constable, *Richard Wilson* (London, 1953); *Richard Wilson*, exh. cat. (London, Cardiff, Yale, 1982–3).

Winstanley, Hamlet 1694–1756

b. & d. Warrington; studied *Kneller's Acad.

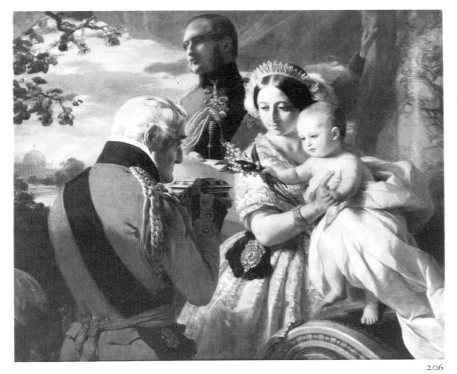

206

206. Franz Xaver Winterhalter, *The First of May*. Oil on canvas, 106.7 × 129.5 cm (42 × 51 in). 1851. Windsor Castle, Royal collection

c. 1718–21; in Italy 1723–5; patronized by Lord Derby; known to have painted heads on separate pieces of canvas for *Van Aken to insert into larger compositions; three-quarter and half-lengths, seated, and groups. Style indebted to *Richardson but more provincial.

LOCATIONS: Walker AG, Liverpool; Tate.

LITERATURE: Vertue, III, p. 91; EKW.

Winterhalter, Franz Xaver 1805–73

b. Menzenschwand, d. Frankfurt; trained as engraver in Freiburg, then studied painting in Munich; settled at Karlsruhe 1828 but mainly Paris from 1835 until 1870 when he returned to Karlsruhe; became painter to many European courts (France, Germany, Austria, Belgium, Russia); 1841 first recommended to Queen Victoria; London 1842 and thereafter occasional visits; the Queen's favourite portraitist, superseding *John Partridge; a glittering full-blown manner that, because of his very dominance, became the recognizable court style of Europe.

LOCATIONS: HMQ; The Sutherland Trust; NPG; Walters AM, Baltimore, MD; Met. Mus., NYC.

Wirgman, Theodore Blake 1848–1925

d. London; of Swedish family, lived in London (conceivably related to Regency jewellers of this name); exhibited RA from 1867; RA Schools from age fifteen; at seventeen, silver medal for drawing; studied Paris under

Hébert; encouraged by *Millais with a commission, he became a most successful society portraitist.

LOCATIONS: NPG; Earl of Bradford, Weston Park; Christie's, 5.v.82 (16).

Wissing, Willem 1656–87

b. Amsterdam, d. Burghley House, Cambs.; trained The Hague; to England via Paris 1676; assistant of *Lely; independent 1684 or earlier, then in partnership with *Vandervaart and did heads for him to finish. An outstanding portraitist, with delightful, liquid modelling of the features, the finished products of the highest overall quality; also apparently assisted on occasion by Francis Barlow (flowers, animals, etc.), and the very excellence of the various parts of each portrait sometimes creates a rather crowded effect. Heads on separate pieces of canvas for insertion into larger compositions are known. All types of large-scale portrait, including groups. (See Chp. Three, Fig. 88; Plate 26)

LOCATIONS: N. Trust, Belton House; The Burghley House Colln; Earl of Verulam, Gorhambury.

Wollaston, John *fl.* 1734–*c.* 1775

b. London, d. Southampton(?); son of portraitist John Woolaston (*sic*), *c.* 1672–1749 example, NPG; to America 1749 where he was successful; NYC 1749–52, MD 1753–4, VA *c.* 1755–7, Philadelphia 1758; influenced *West and *John Hesselius and introduced into America repertory of fashionable poses and accessories; in India 1758–*c.* 1764, returning via W. Indies to America, and at Charleston, SC, 1767, returning that year to Britain; in Southampton 1775.

LOCATIONS: Coll. of William and Mary, Williamsburg, VA; H.F. Du Pont Mus., Winterthur, DE; VA Hist. Soc., Richmond, VA; NPG.

LITERATURE: G & W; EKW; G.C. Groce, *Art Quarterly*, XV (Summer, 1952), pp. 133–48.

Wood, John 1801–70

b. & d. London; trained Sass's Acad. and RA Schools (gold medal 1825); painterly touch; most types of large-scale portrait including good examples of heads only; also literary histories and genre.

LOCATIONS: Nat. Marit. Mus.; NPG; Middle Temple; Dulwich Coll. AG.

Woodforde, Samuel 1765–1817

b. Ansford, nr Castle Cary, d. Ferrara (Italy); RA Schools 1782; taken up by the Hoares of

Stourhead and so to Italy 1785–91, returning with Richard Colt Hoare.

LOCATION: N. Trust, Stourhead.

LITERATURE: EKW.

Woolnoth, Thomas A. 1785–c. 1865
Probably trained by the distinguished engraver James Heath (1757–1834) who made prints after, e.g., *West and *Copley; also genre and history painter; exhibited RA 1842–57, mainly from Soho addresses, and published two books on art 1854, 1865; did lively, fairly small-scale groups, as well as standard large-scale portraits.

LOCATIONS: NPG; Christie's, 28.vi.63 (116).

LITERATURE: Th.-B.

Worlidge, Thomas 1700–66
b. Peterborough, d. London; known as etcher in manner of Rembrandt and thus in touch with important aspect of mid-eighteenth-century taste in London; also oils sometimes in Rembrandt manner; he finally lived in house that had been *Kneller's then *Hudson's, and so evidently successful; also worked in Bath. Busts in oval, half-lengths; painted Garrick in character, 1752 (V & A).

LOCATIONS: V & A; NPG; Peterborough Mus.

LITERATURE: # C. Dack, *Sketch of the Life of Thomas Worlidge . . . with a Catalogue of his Works* (Peterborough, 1907).

Worsdale, James c. 1692–1767
d. London; servant and apprentice of *Kneller, and, according to Pope, employed by him to turn out 'originals', but married Kneller's wife's niece without consent, and was thrown out; 'a little cringing creature' (Vertue), he had some success in Ireland c. 1735, especially with Dublin and Limerick Hell Fire Clubs and, small scale, painted both; in London 1744; claimed to be Kneller's bastard; also painted large scale, e.g., three-quarter length; known portraits very similar to those of *Robert Taylor.

LOCATIONS: NGI; Royal Soc.

Wortley, Archibald James Stuart 1849–1905
Based in London, pupil of *Millais, admired by Ruskin, exhibited RA from 1874; could paint with ease on scale of life at full-length (e.g., King Edward VII); founder and first president of Royal Soc. of Portrait Painters.

LOCATIONS: MCC, London; NPG; Forbes Magazine Colln.

Wright, George Frederick 1828–81
b. Washington, CT, d. Hartford, CT; briefly

custodian of Wadsworth Atheneum; studied NA c. 1848, then Hartford before going to Baden and Rome 1857, returning U.S.A. 1860; painted Lincoln twice that year.

LOCATION: Univ. of Chicago.

LITERATURE: G & W.

Wright, James Henry 1813–83
b. NY, d. Brooklyn, NY; worked New Orleans 1836, then NYC certainly from 1842; painted Daniel Webster.

LOCATIONS: Amer. Art Assoc., NYC; Essex Inst., Salem, MA.

Wright, John Michael 1617–94
b. & d. London; 1636–41 apprenticed Edinburgh to George Jameson; to Rome early 1640s; convert to Roman Catholicism by 1647; active as connoisseur and 'antiquary'; 1656 left for England via France; patronized by Charles II; to Dublin 1679–80 (Popish Plot scare); in James II's embassy to Rome 1686–7, but his career then suffered from that king's expulsion 1688. Has a claim to be the most attractive painter of his time in England, with a love of fanciful costume, eccentric and detailed symbolism, unusual, often charming colour, especially pink, blue and gold; fluent modelling; uncomfortably scrupulous about the portrayal of his sitters' features, and less fashionable than *Lely, whose only real rival he was.

LOCATIONS: HMQ; SNPG; N. Trust, Sudbury Hall; Nottingham Castle Mus.

LITERATURE: S. Stevenson and D. Thomson, *John Michael Wright: The King's Painter*, exh. cat. (SNPG, 1982).

207. John Michael Wright, *James Cecil, 4th Earl of Salisbury, and his Sister, Lady Catherine Cecil.* Oil on canvas, 159.4 × 129.5 cm (62¾ × 51 in). c. 1668. Hatfield House, The Marquess of Salisbury.

207

208

208. Johan Zoffany, *Brook, John and Harry Young*. Oil on canvas, 86.5 × 63.5 cm (34 × 25 in). 1770. Private collection

Wright, Joseph, 'of Derby' ARA 1734–97

b. & d. Derby; pupil of *Hudson 1751–3 and again 1756–7, then Derby, partly itinerant; to Italy 1773–5; tried Bath 1775 then Derby from 1777. Early portraits have a polished finish, in a higher key and with more dramatic colours (reds and blacks) than Hudson's; increasingly sophisticated and inventive, often exploiting his gift for landscape. Also a highly original painter of Industrial Revolution subjects in a candlelit, tenebrist manner. ARA 1781, declined RA 1784, and significant as earliest important British painter to choose to remain in the provinces (other than Bath). All types of portrait; groups are of especial interest. (See Chp. Two, Fig. 61)

LOCATIONS: Derby City Mus. & AG; Tate; Yale; NG; Laing AG, Newcastle-upon-Tyne.

LITERATURE: #B. Nicolson, *Joseph Wright of Derby, Painter of Light*, 2 vols (London, 1968).

Wright, Joseph 1756–93

b. Bordentown, NJ, d. Philadelphia, PA; son of wax modeller and spy Patience W.; England 1773; first American, RA Schools 1775; learned from *West, knew *Trumbull, and brother-in-law of *Hoppner; in Paris 1781 where Franklin helped him, then to America; Washington sat to him 1783; at first in Philadelphia, 1787 NYC, then again in Philadelphia 1790; d. of yellow fever. Painted delightful American variation on *Gainsborough's '*Blue Boy*' in 1785 (Fine Arts Mus., S. Francisco): both sitters were sons of ironmongers. (See Chp. One, Fig. 16)

LOCATIONS: FAM, S. Francisco; Royal Soc.

LITERATURE: Quick.

Yewell, George Henry, NA 1830–1923

b. Havre-de-Grace, MD, d. Lake George, NY; studied NA 1851–6, then Paris under Couture; thence to Rome; NYC from 1878; also genre.

LITERATURE: G & W.

Zoffany, Johan RA 1733–1810

b. nr Frankfurt-am-Rhein, d. London; trained Germany and Rome where he presumably knew *Dance; London 1760 and worked for *Benjamin Wilson; Garrick then helped him to become independent, and he often painted (small-scale) actors in character; patronized by the royal family, and in Florence 1772–8; 1783–9 India, became very rich, and had stopped painting by 1800. Mainly small-scale full-lengths and groups, but he also painted on a large scale, including remarkable groups, and many of his pictures are of the greatest interest as a record of later Georgian England; a flexible, masterly manner, always highly-finished, with careful attention to detail. RA 1769.

LOCATIONS: HMQ; Tate; Yale; Ashmolean Mus.

LITERATURE: *Johan Zoffany*, exh. cat. (NPG, 1976).

Select Bibliography

NOTE: Works on individual artists will be found in the Biographical Dictionary in the relevant entry.

Abrams, Ann Uhry, *The Valiant Hero: Benjamin West and Grand-Style History Painting* (Washington, DC, 1985)

Ackerman, G. M., 'Thomas Eakins and His Parisian Masters Gérôme and Bonnat', *Gazette des Beaux-Arts*, series 6, LXXXIII (1969), pp. 235–56

Adriani, G., *Anton van Dyck: Italienische Skizzenbuch* (Vienna, 1940)

Allen, Brian, *Francis Hayman and the English Rococo*, Ph.D. (Courtauld Institute of Art, 1984)

American Paintings in the Museum of Fine Arts, Boston, 2 vols (Boston, MA, 1969)

Anderson, D. R., *Three Hundred Years of American Art in the Chrysler Museum* (Norfolk, VA, 1976)

Antal, Frederick, *Hogarth and His Place in European Art* (London, 1962)

Archer, Mildred, *India and British Portraiture 1770–1825* (London, 1979)

Ayres, James, *The Artist's Craft, A History of Tools, Techniques and Materials* (Oxford, 1985)

Baigell, Matthew, *Dictionary of American Art* (London, 1980)

Bamford, D., and A. Roy, 'Hogarth's "Marriage à la Mode"', *National Gallery Technical Bulletin*, vol. 6 (1982), pp. 45–67

Belknap, Waldron Phoenix, Jr, *American Colonial Painting, Materials for a History* (Cambridge, MA, 1959)

Bénézit, E., *Dictionnaire critique et documentaire des Peintres, Sculpteurs, Dessinateurs et Graveurs de tous les temps et de tous les pays . . .* 10 vols, (new edn revised and corrected, Paris, 1976)

Billcliffe, Roger, *The Glasgow Boys: The Glasgow School of Painting 1875–1895* (London, 1985)

Burke, Doreen Bolger, ed. Kathleen Luhrs, *American Paintings in the Metropolitan Museum of Art, Volume III, A Catalogue of Works by Artists Born between 1846 and 1864* (New York, 1980)

Bury, J., 'The Use of Candle-Light for Portrait-Painting in Sixteenth-Century Italy', *Burlington Magazine*, CXIX (June, 1977), pp. 434–7

Caw, J. L., *Scottish Painting Past and Present 1620–1908* (Edinburgh, 1908)

Cherry, Deborah and Harris, Jennifer, 'Eighteenth-Century Portraiture and the Seventeenth-Century Past: Gainsborough and Van Dyck', *Art History*, 5, no. 3 (September, 1982), pp. 287–309

Clark, Kenneth, *Rembrandt and the Italian Renaissance* (London, 1966)

Colnaghi Ltd, P. and D., *The British Face: A View of Portraiture 1625–1850* (D. Garstang, ed.), exh. cat. (London, 1986)

Cotton, W., (ed.), *Sir Joshua Reynolds' Notes and Observations on Pictures* (London, 1859)

Cox-Johnston, A., *Handlist of Painters, Sculptors and Architects Associated with St Marylebone 1760–1960* (St Marylebone, 1963)

Crookshank, Anne, and the Knight of Glin, *Irish Portraits 1660–1860*, exh. cat. (National Gallery of Ireland, Dublin, Ulster Museum, Belfast, and National Portrait Gallery, London, 1969–70)

Crookshank, Anne, and the Knight of Glin, *The Painters of Ireland, c. 1660–1920* (London, 1978)

Cunningham, Allan, *The Lives of the Most Eminent British Painters, Sculptors, and Architects*, 6 vols (2nd edn, London, 1830)

Darcy, C. P., *The Encouragement of the Fine Arts in Lancashire 1760–1860* (Manchester, 1976)

Dunlap, William, *History of the Rise and Progress of the Arts of Design in the United States* (1834) (new edition, revised, enlarged and edited by Alexander Wyckoff with Preface by William P. Campbell, 3 vols, New York, 1965)

Evans, Dorinda, *The American Pupils of Benjamin West*, exh. cat. (National Gallery, Washington, DC, 1980)

Edwards, Edward, *Anecdotes of Painters, Who have Resided or been Born in England, with Critical Remarks on their Production*, 1808 (reprinted London, 1970)

Evans, Dorinda, *Mather Brown, Early American Artist in England* (Middletown, CT, 1982)

Fleming, John, 'Sir John Medina and His Postures' *Connoisseur*, CXLVIII (November, 1961), pp. 22–5

Fletcher, E. (ed.), *Conversations of James Northcote* RA *with James Ward on Art and Artists* (London, 1901)

Flexner, James Thomas, *History of American Painting*, 3 vols (1947, 1954, 1962) (reprinted New York, 1969, 1970)

Flexner, James Thomas, *America's Old Masters* (revised edition, New York, 1980)

Foote, Henry Wilder, *John Smibert, Painter* (Cambridge, MA, 1950) (reprinted New York, 1969)

Foskett, Daphne, *A Dictionary of British Miniature Painters*, 2 vols (London, 1972)

Graves, Algernon, *The Royal Academy of Arts: A Complete Dictionary of Contributors and Their Work from its Foundation in 1769 to 1904*, 8 vols (London, 1905) (reprinted, 4 vols, Wakefield and Bath, 1970)

Groce, George C. and Wallace, David H., *The New-York Historical Society's Dictionary of Artists in America 1564–1860* (New Haven and London, 1957)

Gwynne, S., *Memorials of an Eighteenth-Century Painter: James Northcote* (London, 1898)

Hall, Marshall, *The Artists of Cumbria, An Illustrated Dictionary of Cumberland, Westmorland, North Lancashire and North West Yorkshire Painters, Sculptors, Draughtsmen and Engravers born between 1615 and 1900* (Newcastle-upon-Tyne, 1974)

Hall, Marshall, *The Artists of Northumbria, An Illustrated Dictionary of Northumberland, Newcastle upon Tyne, Durham and North East Yorkshire Painters, Sculptors, Draughtsmen and Engravers Born Between 1625 and 1900* (Newcastle-upon-Tyne, 1973) (2nd edn revised and enlarged, 1982)

Hammelmann, Hans, edited and completed by T. S. R. Boase, *Book Illustrators in Eighteenth-Century England* (New Haven and London, 1975).

Hammond, John H., *The Camera Obscura, A Chronicle* (Bristol, 1981)

Hare, Augustus, *Story of My Life*, 6 vols (London, 1896–1900)

Hazlitt, William, *Conversations of James Northcote, Esq, RA* (London, 1830)

Haskell, Francis, and Penny, Nicholas, *Taste and the Antique: The Lure of Classical Sculpture 1500–1900* (New Haven and London, 1981) (2nd printing with corrections, 1982)

Hogarth, William, *The Analysis of Beauty* (J. Burke, ed.) (Oxford, 1955)

Hoopes, D. F., *The Düsseldorf Academy and the Americans*, exh. cat. (Metropolitan Museum of Art, New York, 1980)

Hope, Charles, *Titian* (London, 1980)

Hutchinson, Sidney C., 'The Royal Academy Schools 1768–1830', *Walpole Society*, XXXVIII (1962), pp. 123–91

Hudson, Derek, *Sir Joshua Reynolds, A Personal Study* (London, 1958)

Irwin, David and Francina, *Scottish Painters At Home and Abroad 1700–1900* (London, 1975)

Jackson, William, *The Four Ages, Together with Essays on Various Subjects* (London, 1798)

Jackson-Stops, Gervase (ed.), *The Treasure Houses of Britain, Five Hundred Years of Private Patronage and Art Collecting*, exh. cat. (National Gallery, Washington, New Haven and London, 1985)

Johns, E., *Thomas Eakins, The Heroism of Modern Life* (Princeton, 1983)

Johnson, J., and A. Greuzner, *The Dictionary of British Artists 1880–1940* (Woodbridge, 1976) (reprinted 1980)

Johnston, S. K., *American Paintings 1750–1900 from the Collection of the Baltimore Museum of Art* (Baltimore, MD, 1983)

Kerslake, John, *Early Georgian Portraits*, 2 vols (National Portrait Gallery, London, 1977)

Kitson, Michael, 'William Hogarth's "Apology for Painters"', *Walpole Society*, XLI (1966–8), pp. 46–111

Konstam, Nigel, 'Rembrandt's Use of Models and Mirrors', *Burlington Magazine*, CXIX (February, 1977), pp. 94–8

Latham, R., and Matthews, W. (eds), *The Diary of Samuel Pepys*, 11 vols (London, 1970–83)

Leslie, C. R., and T. Taylor, *Life and Times of Sir Joshua Reynolds, With Notices of Some of his Contemporaries*, 2 vols (London, 1865)

Lippincott, Louise, *Selling Art in Georgian London: the Rise of Arthur Pond* (New Haven and London, 1983)

Macmillan, Duncan, *Painting in Scotland, The Golden Age* (Oxford, 1986)

Mannings, David, 'A Well-Mannered Portrait by Highmore', *Connoisseur*, CLXXXIX (June, 1975), pp. 116–19

Mannings, David, 'Notes On Some Eighteenth-Century Portrait Prices in Britain', *British Journal for Eighteenth Century Studies*, VI (1983), pp. 185–96

De Marly, Diana, 'The Establishment of Roman Dress in Seventeenth-Century Portraiture', *The Burlington Magazine*, CXVII (July, 1975), pp. 443–51

Miles, Ellen (ed.), *Portrait Painting in America: The Nineteenth Century* (New York, 1977)

Miles, Ellen, *Thomas Hudson 1701–1779, Portraitist to the British Establishment* Ph.D. (Yale, 1976) (Ann Arbor, 1977)

Miles, Ellen, and Simon, Jacob, *Thomas Hudson*, exh. cat. (Kenwood, London, 1979)

Millar, Oliver, *The Later Georgian Pictures in the Collection of Her Majesty the Queen*, 2 vols (London, 1969)

Millar, Oliver, *Sir Peter Lely 1618–80*, exh. cat. (National Portrait Gallery, London, 1978–9)

Millar, Oliver, *The Tudor, Stuart and Early Georgian Pictures in the Collection of Her Majesty the Queen*, 2 vols (London, 1963)

Millar, Oliver, *Van Dyck in England*, exh. cat. (National Portrait Gallery, London, 1982–3)

Morris, Sidney and Kathleen, *A Catalogue of Birmingham and West Midlands Painters of the Nineteenth Century* (Stratford-upon-Avon, 1974)

Newall, Christopher, *Society Portraits 1850–1939*, exh. cat. (P. & D. Colnaghi Ltd, and the Clarendon Gallery, 1985)

Nicolson, Benedict, *The Treasures of the Foundling Hospital* (Oxford, 1972)

Nisser, W., *Michael Dahl and the Contemporary Swedish School of Painting in England* (Uppsala, 1927)

Nivelon, F., *Rudiments of Genteel Behavior, An Introduction to the Method of Attaining a Graceful Attitude, an Agreeable Motion, an easy air and a genteel Behaviour*, (1737)

Northcote, James, *The Life of Sir Joshua Reynolds*, 2 vols (2nd edn revised and augmented, London, 1818)

Novak, Barbara, *American Painting of the Nineteenth Century. Realism, Idealism, and the American Experience* (New York, 1969)

Ormond, Richard, *John Singer Sargent: Paintings, Drawings, Watercolours* (New York and London, 1970)

Ormond, Richard, *Early Victorian Portraits*, 2 vols (National Portrait Gallery, London, 1973)

Palazzo Pitti, Florence, *Firenze e l'Inghilterra: rapporti artistici*, exh. cat. (1971)

Park, Lawrence, 'An Account of Joseph Badger, and a Descriptive List of his Work', *Massachusetts Historical Society Proceedings*, 51 (December, 1917), pp. 158–201

Paulson, Ronald, *Hogarth, His Life, Art and Times*, 2 vols (New Haven and London, 1971)

Penny, Nicholas (ed.), *Reynolds*, exh. cat. (Royal Academy of Arts, London, 1986)

Philadelphia Museum of Art, *Benjamin West in Pennsylvania Collections*, exh. cat. (1986)

Pierce, Patricia Jobe, *The Ten* (North Abington, MA, 1976)

Piles, Roger de, *The Art of Painting*, translated from the French by J. Savage (London, 1706)

Piper, David, *The English Face* (London, 1957) (republished London, 1978)

Pointon, Marcia, 'Portrait-Painting as a Business Enterprise in London in the 1780s', *Art History*, 7, no. 2 (June, 1984), pp. 187–205

Prown, Jules D., *John Singleton Copley*, 2 vols (Cambridge, MA, 1966)

Quick, M., *American Portraiture in the Grand Manner: 1720–1920*, exh. cat., with essays by M. Quick, M. Sadik and W. H. Gerdts (Los Angeles County Museum of Art and National Portrait Gallery, Washington, DC, 1981–2)

Rajnai, Miklos, with the assistance of M. Stevens, *Norwich Society of Artists* (Norfolk Museum Service, 1976)

Redgrave, Samuel, *A Dictionary of Artists of the English School: Painters, Sculptors, Architects, Engravers and Ornamentists: With Notices of their Lives and Work* (London, 1873) (new edn, revised to date, London, 1878)

Reynolds, Sir Joshua, *Discourses on Art* (Robert R. Wark, ed.) (New Haven and London, 1975)

Ribeiro, Aileen, *The Dress Worn at Masquerades in England 1730 to 1790, and its Relation to Fancy Dress in Portraiture*, Ph.D. (Courtauld Institute of Art, 1975) (New York and London, 1984)

Richardson, Jonathan, *An Essay on the Theory of Painting* (London, 1715) (2nd edn, London, 1725)

Richardson, Jonathan, *A Discourse on the Dignity, Certainty, Pleasure and Advantage, of the Science of a Connoisseur* (London, 1719)

Richardson, Jonathan, *An Account of Some of the Statues, Bas-Reliefs, Drawings and Pictures in Italy* (London, 1722)

Rogers, Malcolm, 'John and John Baptist Closterman: a Catalogue of Their Works', *Walpole Society*, XLIX (1983), pp. 224–79

Rouquet, Antoine, *The Present State of the Arts in England* (London, 1755)

Rowlands, John, *Holbein* (Oxford, 1985)

Royal Academy Exhibitors 1905–1970: A Dictionary of Artists and their Work in the Summer

Exhibitions of the Royal Academy of Arts, 5 vols (Wakefield, 1973)

The Royal Scottish Academy 1826–1916, A Complete List of the Exhibited Works by Raeburn and by Academicians, Associates and Hon. Members, Giving Details of Those Works in Public Galleries, compiled under the direction of Frank Rinder (1917) (reprinted Bath, 1975)

Sartin, S. V., *Polite Society by Arthur Devis 1712–1787*, exh. cat. (Harris Museum and Art Gallery, Preston, and National Portrait Gallery, 1983–4)

Sellers, Charles Coleman, *Charles Willson Peale*, 2 vols (Memoirs of the American Philosophical Society, vol. 23, parts 1–2, Philadelphia, 1947)

Simon, Robin, and Smart, Alastair, *The Art of Cricket* (London, 1983)

Sitwell, Osbert, *Left Hand Right Hand!* (London, 1945)

Smart, Alastair, 'Dramatic Gesture and Expression in the Age of Hogarth and Reynolds', *Apollo*, LXXXII, 42 (August, 1965), pp. 90–7

Smart, Alastair, *The Life and Art of Allan Ramsay* (London, 1952)

Stebbins, Theodore E., Jr, and others, *A New World: Masterpieces of American Painting 1760–1910*, exh. cat. (Boston, Washington and Paris, 1983–4)

Stewart, J. Douglas, *Sir Godfrey Kneller and the English Baroque Portrait* (Oxford, 1983)

Storer, William, *Storer's Syllabus, to a course of Optical Experiments, on the Syllepsis Optica, or the new optical principles of the Royal Delineator analysed* (London, 1782)

Strickland, Walter George, *A Dictionary of Irish Artists*, 2 vols (Dublin and London, 1913) (reprinted Shannon, 1969)

Strong, Roy, *The English Icon* (London and New York, 1969)

Talley, M. Kirby, *Portrait Painting in England, Studies in the Technical Literature before 1700* (London, privately printed, 1981)

Talley, M. K., and K. Groen, 'Thomas Bardwell and His Practise of Painting: A Comparative Investigation Between Described and Actual Painting Technique', *Studies in Conservation*, 20, no. 2 (1975), pp. 44–107

Thieme, Ulrich, and Becker, Felix, *Allgemeines Lexikon der bildenden Künstler, von der Antike bis zu Gegenwart*, 37 vols (Leipzig, 1907–50)

Vertue, George, 'Notebooks', *Walpole Society*, XVIII (1929–30 Vertue, I), XX (1931–2 Vertue, II), XXII (1933–4 Vertue, III), XXIV (1935–6 Vertue, IV), XXVI (1937–8 Vertue, V), XXIX (1940–2 index), XXX (1948–50 Vertue, VI)

Wainwright, N. B., *Paintings and Miniatures at The Historical Society of Pennsylvania* (revised edn, Philadelphia, PA, 1974)

Walker Art Gallery, Liverpool, *Merseyside Painters, People and Places, Catalogue of Oil Paintings*, 2 vols (1978)

Walpole, Horace, *Correspondence* (W. S. Lewis, ed., and others), 47 vols (London and New Haven, 1937–83)

Ward, H., and Roberts, W., *Romney, A Biographical and Critical Essay*, 2 vols (London and New York, 1904)

Waterhouse, Ellis, *Reynolds* (London, 1941)

Waterhouse, Ellis, *Painting in Britain 1530 to 1790* (Harmondsworth, 1953) (4th edn, Harmondsworth, 1978)

Waterhouse, Ellis, *Gainsborough* (London, 1958)

Waterhouse, Ellis, *Reynolds* (London and New York, 1973)

Waterhouse, Ellis, *The Dictionary of British 18th Century Painters in Oils and Crayons* (Woodbridge, 1981)

Waters, Grant M., *Dictionary of British Artists Working 1900–1950*, 2 vols (Eastbourne, 1975, n.d., respectively)

Weinberg, H. B., *The American Pupils of Jean-Léon Gérôme* (Amon-Carter Museum, Fort Worth, Texas, 1984)

Whitley, William T., *Art in England 1800–1837*, 2 vols (Cambridge 1928, 1930) (reprinted New York, 1973)

Whitley, William T., *Artists and their Friends in England, 1700 to 1799*, 2 vols (London 1929)

Whitley, William T., *Thomas Gainsborough* (London, 1915)

Williamson, G. C. (ed.), *Bryan's Dictionary of Painters and Engravers* (new edn revised and enlarged, 5 vols, (London, 1904)

Wilmerding, John, *American Art* (Harmondsworth, 1976)

Wind, Edgar, *Hume and the Heroic Portrait* (Jaynie Anderson, ed.) (Oxford, 1986)

Wood, Christopher, *The Dictionary of Victorian Painters* (2nd edn Woodbridge, 1978)

Yung, K. K., *National Portrait Gallery Complete Illustrated Catalogue 1856–1979* (Mary Pettman, ed.) (London, 1981)

Index

Figures in italic indicate illustration numbers within the text. *Pl.* refers to a colour plate.

Acknowledgements

The publishers have endeavoured to credit all known persons holding copyright or reproduction rights for illustrations in this book, and wish to thank all the public, private and commercial owners, and institutions concerned.

By permission of the Birmingham Museum and Art Gallery 143; Courtesy Museum of Fine Arts, Boston 10, 28, 33, 100, 101, 114, 137, 158, 173, 193, 201, colour plates 5, 18; Brunswick ME, Bowdoin College Museum of Art, Bequest of Mrs Lucy Flucker Knox Thatcher 13; The Master and Fellows of Trinity College, Cambridge 2; Courtesy of the Fogg Art Museum, Harvard University Art Museums, Gift of Mrs Gordon Dexter 9; Reproduced by permission of the Chatsworth Settlement Trustees (photograph Courtauld Institute of Art) 21; Founders Society Detroit Institute of Arts, American Art © 1986 142, ©1984 170, Gift of Mr and Mrs George S. Page, Blinn S. Page, Lowell Briggs Page and Mrs Leslie Stockton Howell ©1984 176; National Galleries of Scotland, Edinburgh 43, 66, 87, 123, 141, 195, 202, 205, colour plate 23; Glasgow Art Gallery and Museum 31; Leicestershire Museums, Art Galleries and Records Service 138; With Agnew's, London in 1983 83; W. and F. C. Bonham & Sons Ltd, London 85; Reproduced by Courtesy of the Trustees of the British Museum, London 5, 44, 50, 70, 71, 82; Christie's Colour Library, London, colour plates 2, 20; *Country Life*, London 130; photographs from the Courtauld Institute of Art, London 21, 42, 72, 89, 104, 112, 117, 122, 150, 163, 165, 174, 177, 198, 207; Courtesy of The Crown Estate Commissioners and Institute of Directors, London (photograph Bridgeman Art Library) colour plate 25; Prudence Cumming Associates Ltd, London 128; Greater London Photograph Library 92, 93, 95; By permission of the Benchers of Lincoln's Inn, London 122; Mansell Collection, London 58, 60, 64; The Paul Mellon Centre for Studies in British Art, London 191, 192, 197; Reproduced by Courtesy of the Trustees, The National Gallery, London 36, 37, 46, 49, 55, 62, 75, colour plate 7; photograph from National Portrait Gallery, London, colour plate 32; The National Trust photographic Library, London 3; photograph from Royal Academy of Arts, London 90; By kind permission of the Royal Borough of Kensington and Chelsea, colour plate 10; Royal Commission on the Historical Monuments of England, London 73; By Courtesy of the Trustees of Sir John Soane's Museum, London 51; Reproduced by kind permission of Sotheby's, London 53, 91, 106, 120, colour plates 29, 31; By Courtesy of the Board of Trustees of the Victoria and Albert Museum, London 124; Courtesy of the Century Association, New York 107; All Rights Reserved. The Metropolitan Museum of Art, New York 34, 69, 167; Collection of Whitney Museum of American Art, New York. Promised gift of Flora Whitney Miller 147; Norfolk Museums Service 146; Cliché des Musées Nationaux, Paris 35, 39, 63; Reproduced by kind permission of the Harris Museum and Art Gallery, Preston, Lancs. 98; Courtesy of the Earl of Pembroke, Wilton House, Salisbury, Wilts. (photograph A. C. Cooper, Ltd, London) 48; By permission of Sheffield City Art Galleries 32; By permission of the Duke of Wellington, Stratfield Saye, Nr. Reading, Berks. 112; Reproduced by permission of the Provost and Fellows of Eton College, Windsor 174; Worcester, MA, Worcester Museum of Art, Museum Purchase 12.

 Reproduced by Gracious Permission of Her Majesty the Queen 38, 45, 74, 190, 206, colour plate 19; Reproduced by kind permission of His Grace the Duke of Northumberland (photograph *Country Life*) 130; Reproduced by kind permission of Viscount Cobham 89; By kind permission of Lord Barnard 72; Reproduced by Courtesy of the Marquess of Salisbury 207; Photograph from Morgan Wells Associates, ©R. Simon, colour plate 30.